WITHDRAWAL

# A DICTIONARY OF
# VENETIAN PAINTERS

# A Dictionary of

# VENETIAN PAINTERS

## Volume 2. 16th Century

by

### PIETRO ZAMPETTI

Director of Fine Arts, Venice

## F. LEWIS, PUBLISHERS, LIMITED

Publishers by appointment to the late Queen Mary

### LEIGH-ON-SEA

PRINTED AND MADE IN ENGLAND

©

Copyright by

F. LEWIS, PUBLISHERS, LTD

The Tithe House, 1461 London Road

Leigh-on-Sea

SBN 85317 171 8

*First Published 1970*

Published by F. Lewis, Publishers, Ltd, The Tithe House, 1461 London Road,
Leigh-on-Sea, England, and Printed at The Blackfriars Press, Leicester

# PAINTING AT VENICE FROM THE SIXTEENTH TO THE EARLY SEVENTEENTH CENTURY

THE Renaissance was full of all kinds of art experiments yet discernible throughout is a continual and definite search for ideal beauty, further to platonic thinking in favour again among the learned. At the time it was held possible to reconcile philosophical tenets and religious dogma and a number of humanists were very keen on doing so. Federico da Montefeltro in his palace at Urbino wanted two shrines next each other, one dedicated to the muses and the other to the Lord. Raphael in the Vatican "Stanza della segnatura" presented two sublime compositions on facing walls; in the *School of Athens* celebrating human thought, and in the *Triumph of the faith* celebrating Catholic theology superbly. It was a dream for straightway there appeared, alongside Raphael, the figure of Michelangelo. His frescoes for the Sistine chapel in turn unleashed a crisis of conscience. What seemed a Golden age came to a dramatic close, although the ideal was hardly short of achievement at least in some Italian cultural circles.

At Venice, as the star of Giovanni Bellini rose in the sky, a new era dawned in the art world. He left aside developments post-Mantegna and, following on from Piero della Francesca and Antonello, imparted to Venetian art a new warmth which was franker and more friendly, as one might say less remote. As the new century began, he seemed right in touch with changing requirements, and this applied to matters of style too. The times were on the move: colour was becoming more reactive to light and mood; psychological penetration deeper; the rendering of landscape increasingly emotive, lyrical and entirely lumescent.

When Giorgione quit Castelfranco and arrived in Venice, the new century was dawning and Bellini by no means a back-number; indeed, his was the example to pursue, the rich terrain for striking new roots. Giorgione had the inheritance but that was not all. For he had aims in other directions also. His allegiance, amounting to utter devotion, to topics from phantasy or classical themes affirm a breadth of culture not averse to embracing the most resonant pro-classical trends of his day and age. Clearly, the influence that other arts exerted on him cannot be denied: from writings, from philosophical argument, from the reasoning that emanated from Padua, home of a flourishing and far-famed university. Painting is not an art that stands alone, it belongs to the time and place in civilisation where it finds expression. Freedom of thought from any constraint, trying to get at the true nature of things, problems of belief when confronting the new philosophies: artists as open-minded and sensitive beings found themselves involved in the evaluation of these subjects.

Giorgione with his rare artistic awareness ranked as a most eloquent mouthpiece of the intellectual scene, and thus among the leading lights of Venetian civilisation at the start of the century. His impact was profound in getting closer to nature, the main aim of the times. His people come across as part and parcel of creation. Nature was accepted as a contemplative event, and this comprised an intimate and original facet of his creative genius. For him, man lived and was part of creation. Any gulf that had existed at a previous stage between man and the world about him,

between mankind and nature, was bridged. In this wedlock stands the high point of Giorgione's artistic achievement, couched in the light of enchantment and replete with a dream-like and detached contemplation. His art was like that of the young Raphael in celebrating a near-mythical world, a new golden age come upon mankind in their work. Colour with its unending tonal variations and luminous vibrations enabled Giorgione, if it can be put thus, to evoke a more original climate of mood than Raphael.

The two artists were near contemporary, perhaps unaware they both pursued the same ideal, shed at about the same moment. Before he died in 1510, Giorgione was already after something new; and Raphael in the second "Stanza" painted in the Vatican evidenced the classical ideal in the throes of a crisis. The ascendency of Giorgione was such, his creative vision so novel and impelling as to affect all Venetian painting. A school true and proper was formed, a movement which Venturi referred to as "Giorgionism". It may be more appropriate to call some artists "Giorgion-esque", in order to steer clear of the pitfalls of over-simplification. This means in a given artistic situation, there were painters with personality of their own who were deeply indebted to the path-finding done by the master from Castelfranco.

The first among them and the greatest was Titian. His long life and impressive activity led him continually on to new ground and he ranks as the pre-eminent figure of the whole century. But there were others as well. Sebastiano del Piombo was one; he left Venice and was instrumental in making tone painting re-echo in Rome, where he was to be influenced in turn by Michelangelo. Palma il Vecchio was another, of a spirit festive and lavish in his country pieces and women's portraits. Beside these great ones was a host of other painters, in direct or less direct line of descent from Giorgione and diversely influenced by him: from Paris Bordone and Bernardo Licinio, Cariani and Mancini, to the painters of the hinterland foremost among them Romanino and Savoldo. The new artistic vision of Giorgione shook Venetian painting to its foundations and on through the Veneto. Its effect was felt as far away as Bergamo, nor were older artists immune —like Catena and Giovanni Bellini himself, in the closing phase of his long span of activity out-living Giorgione, who died at the age of thirty-three in 1510.

The early work of Titian is so "Giorgionesque" as to sow doubts about who fathered some pictures. The "Concert champêtre" of the Louvre is a typical instance and has been assigned at different times to first the one and then the other artist. They were close and actually worked side by side, as on the Fondaco dei Tedeschi frescoes (1508). This would account for any mis-understandings.

Titian's personality, however, soon had stature of its own. Colour became bolder and brighter; he sought to convey the living reality, unsparingly and dynamic. The spatial dimension was no longer limitless as in Giorgione but meant living space for people. His "Venus" in the Uffizi is indoors not a tiny part of teeming nature as seen in the Giorgione "Venus" at Dresden. The same held good for the "Flora" and again for "Sacred and profane love", the masterpiece it may be deemed of the early period.

6

The "Assumption" of the Frari (completed in 1518) marked the breakaway from Giorgione. A new pictorial concept was given to Venetian art, based upon movement and the dramatic act mirrored in art; that this meant a departure from Giorgione is evident. From then on, Titian's art was continually evolving as he endeavoured to give outward form to a diversity of concepts. The mannerist crisis (more about this later) descended on his head too but he came out on the other side, his art flowing on more original and personal than ever before. His brush-stroke less concise, more enmeshed with light gave his work new intensity, representing human sentiment quintessential rather than descriptively. Progress went on to the late "Deposition", his last work completed by Palma il Giovane owing to his death.

In the course of a long career, Titian may be said to have successfully tried every kind of experiment and of painting. What he wanted was to find a means of expression as close as might be to his intention. No future achievement—the French impressionists not excepted—but drew in some measure on the lesson of this genius in the realm of painting.

Mainstream art in the Lagoon area was led by two painters not themselves Venetian, namely Giorgione and Titian, the one from Castelfranco and the other from Pieve di Cadore. Alongside mainstream art was a third artist who represented, without aiming to found a school, the less literary tendencies, less directly related to humanist culture but engaged in the sphere of everyday life and with life's problems and troubled conscience as the mainspring to action. A true Venetian, he was often away from Venice; his name: Lorenzo Lotto. From his boyhood he was always on the move, far from home; this made him acquainted at first-hand with developments in art in other regions of Italy; at the same time, he was in contact with all kinds of people and knew all about their worries and their woes.

The Recanati polyptych (1508) had broken with all humanist enchantment, a pathos violent if implicit at work on his awareness. A new situation was created. The balanced composition of altar-pieces had to give way in the face of new moral necessities. Colour took on a coldly aggressive note, with tones of grey, light blue, yellow and rose strikingly handled. The compositional manner was quite new; as light literally struck the figures, a scene was in the making, remarkable for tenseness and depth of feeling. (Titian himself took a different direction when it came to the Pesaro altar-piece of the Frari, but much later and very diverse from Lotto.) Lotto lived and worked in the Marches, Rome and Lombardy after leaving Venice and before returning home again; his old age, restive and solitary, he pined away at Loreto in the Marches. The whole time he was a seeker after truth, trying to paint what he saw in troubled spirit. Of this spirit he was at once both slave and master. Leaving aside contacts with Dürer and the many sources of influence on him (the choice alone is significant), Lotto was among the first Italian painters to react to "Mannerism". He treated the crisis in terms of art but it started as a political situation with additional fuel from the religious unrest against the church of Rome. This was rife in Italy though not as elsewhere to the point of conflagration.

Seen in this light, his qualities have only quite recently received due critical appraisal, from

Berenson first and foremost: Lorenzo Lotto is the most modern of the Venetian painters of the sixteenth century. Even in his own lifetime, his reputation outside Venice was higher than at home; he fell victim to his own nature, preferring to follow his own inclination rather than fall in with the predominant features of Venetian painting. It was solemn, majestic and courtly to the extent of seeming declamatory (when not sustained by the genius of men like Titian or Veronese); his was unassuming, lowly and with an eye for hidden things as if an inner truth might be lurking in the shadows. He was not understood; his life a succession of humiliations and failures. Today he is acknowledged among the greatest masters of Venetian painting, a poet of the heart looking at the inner man and doing so to disquieting effect through acute and subtle sensitivity of painting.

In the hinterland, schools of painting flourished that were influenced some direct, some indirect by Lagoon—that is to say, Venetian—work. Among the major centres, Brescia and Bergamo were of especial note for the many painters born there. In Bergamo: Palma il Vecchio, Previtali and Moroni; in Brescia: Savoldo, Romanino and Moretto. The Veneto traditions were markedly different from the true Venetian; characteristic of them was their firmer hold on the everyday down-to-earth world. In this sense Lotto the Venetian was the master who set the example they followed. There is no doubt about his influence over them, especially since he spent a long time in Bergamo and again, was a friend of Moretto's, addressing him in a letter as "brother". The painters of Brescia had a lot in common. The native art tradition was associated with the work of Vincenzo Foppa, the leading Lombard artist of the early Renaissance, and it played a decisive role in their training. They were moved to a kind of compromise; their strict realist tradition of indigenous origin somehow blending with the ethereal new painting to emerge from the Venice of Giorgione and Titian. The result was a new trend in painting; colour was the instrument (often in tones bold and contrasting) to paint the classical world and religious themes in workaday guise. Their painting is readily distinguishable on this ground. The experts have indicated contact with German art and in respect of Lotto this is widely known. The Brescia artists got realist painting off to a good start. Typically Lombard, it traced its further origins from Romanesque. At the end of the century it produced its greatest exponent who revolutionised European painting in the person of Caravaggio.

In other places, Veneto provincial painters offered violent dramatic concepts against the Venetian tradition. Among them, the most bizarre (like Lotto a rover but unlike him, more of a talking point than a man of reserve) in fact was Giovanni Antonio de Sacchis called Il Pordenone after the town in the Friuli where he was born. In his youth a follower of Giorgione, at provincial level meaning nurtured on other experiences. He knew Roman painting and was among the first to bring home Mannerism to Venice and northern Italy as a whole, which is to say art made dramatic and tense by the new departures of Michelangelo.

With his work, a new voice made itself heard in the Veneto, the drama and violence of its expression confirming that the voice in question belonged to an utterly original personality. The frescoes at Cremona or those at Piacenza clearly conjure up the figure of this artist; he died an

untimely death in dubious circumstances and may have been engaged in a secret struggle with Titian. His work was fundamental in the decisive renewal of the Venetian painting manner and in bringing the wind of Mannerist change to bear in those quarters. His death it may be remembered dates back to 1539; at about this time, Titian was going through a stale period (it was gone almost at once) while Jacopo Bassano, Lo Schiavone and others were in the throes of the Mannerist crisis (it affected the young Titian too), in which Pordenone was intensely involved. With these facts in mind, his importance to the future of Venetian painting becomes understandable.

The Mannerist crisis or break with classicism invaded the stronghold of Veneto painting; traces also being found in Bonifazio Veronese. This crisis is basic to the appreciation of some artists like Andrea Schiavone, a painter of great refinement sustained by an intellectual outlook that was subtly poetic. The presence in Venice of artists already abreast of Florentine-Roman culture like Francesco Salviati; engravings by refined Emilian artists (in particular, Parmigianino; the influence exerted by Pietro Aretino, a great admirer of Michelangelo: all these factors contributed to changing the face of Venetian painting. The lingering residue of Giorgionism was eclipsed; it was already on the wane, for lack of life-giving originality as history pursued its course. In some artists, Mannerism was a received cultural fact though without effect in terms of the inner life. Two painters who embarked on their careers about the 1530s were responsible for a further violent shake-up, after the dramatic departures of Pordenone. Two different artists whose contributions were entirely original although they arose from widely accepted cultural points of vantage, namely Jacopo Tintoretto and Jacopo Bassano.

The vision of Tintoretto was constantly tense and dramatic, at times violent when expressing himself most typically. His inventive touch lay in representing movement as a formal means to convey a moral position; his explosive brush-work and dazzling treatment of light illustrate the attempt, not always felicitous. His lack of continuity has caused Tintoretto to be severely taken to task, as for example by Longhi who saw him as more of a propagandist and less of an impassioned interpreter of the new cultural situation, indeed as a "player of Mannerist parts". What remains certain is that the vast canvases of Tintoretto—when his assistants, largely relied on in later works, were not present—unveil a highly strung high flown phantasy which brought within the Venetian environment a dramatic impact never previously achieved. Titian's progress of soul was slower and more searching; Tintoretto's work looked like that of a rebel, violent and extrovert with outbursts of a geniality productive, especially in the series for the Scuola di S.Rocco, of expressions of extraordinary sensitivity. Indeed, the material outcome was inventive in form and setting and of sufficient novelty to rivet the attention of Venetian painting through that century.

The figure of Jacopo Bassano was quite different. A provincial, he lived in a small place and only visited Venice on occasion. By character he was completely different from Tintoretto. His painting was intimate and discrete, as a result of a balanced nature in a man living apart and in contact with nature while at the same time keeping in touch with artistic developments. Around 1540, the key year in the Venetian crisis, he also began to undergo the effects of Mannerism; the

result was immediate and personal solutions, celebrating country life above everything and the poetry of details. His colour was harsh, the tonal violence of some passages—the Adoration of the Magi at Vienna is an instance—seeming to approach the art of El Greco. This great painter passed like a meteor through Venice on the way to Spain, much indebted to Venice for his definitive stylistic formation. Bassano was the first artist to appreciate the values of nature, of landscape in terms of their true originality. In advanced years, his chromatic scale became more severe and contrasted, until he was practising a luminism comparable with that of Tintoretto. But he came to it by his own path, by painting that evidenced continual chromatic evolution without resorting to the violent extremes of Tintoretto. He used a "touch" technique, in a veiled key; his painting tended to focus on certain parts of a picture, but what he rendered were the same commonplace objects as in his early days when his work was full of clear skies and sunshine.

In the great sixteenth-century tradition—where personalities of the most diverse and divergent kinds jostle one another—Paolo Veronese occupies an isolated post. In mid-century he was living and interpreting the lesson of Mannerism in his own way, against a background of rare and idealised culture, rather in the wake of the revived classical approach of Palladio. Particularly in the great cycles of frescoes which are his chief glory, he becomes remote in the treatment of space clearly of literary origin and the expression of renewed attempts to capture the perfection and balance of the ideal. His compositions, open to movement, appeared crystallised, as it were at a standstill in time; his colour is clear, festive and celebratory.

In fact, he detached himself both from the luminism of Tintoretto and the dramatic problem-painting of the late Titian. An ideal of beauty transpired in his work, comprising moral equilibrium and inner conviction. Phidian harmony, luminous enchantment were born again in Veronese; his striving for balanced art went hand in hand with architecture, to which his art was often complementary. Veronese's example was of wide use to all the painters frescoing villas for the patrician families of the Veneto, on the banks of the river Brenta and inland Veneto. None could equal him in creating a harmony out of proportion, light and inner calm of spirit.

Towards the end of the century, the great painters of Venice died within a few years of each other: Titian in 1576, Veronese in 1588, in 1592 Bassano and in 1594 Tintoretto. After this upsurge of genius, the imitators and adherents failed to rise above mediocrity and Venetian painting went through a tired period, which may have been over-stressed but undoubtedly existed. All the same it needs saying that a painter like Palma il Giovane can no longer be thought of as a negligible Mannerist practitioner, considering he produced the 'Messa del Doge Cicogna', a work of graceful composure. He was keenly aware as an artist, further to Tintoretto's explosive treatment of light, of needing a manner both simpler and more austere.

An historical review of Venetian painting at the dawn of the new century ought not to lay the whole blame at the Venetian door. It has to be recognised that the crisis was not only Venetian but Italian in general. Painters like Sante Peranda, like Padovanino cannot be held in disrepute.

The last-named has a new freshness and vigour, a desire for a return to simplicity almost neo-Giorgionesque. This shows a position of independence and autonomy which does him credit. There is a great deal of innocent candour in the two scenes from the life of S.Andrea Avellino, a great deal of artistic involvement in the marvellous Circumcision of Treviso museum as anyone will see who troubles to look. Serious intent, a resolve to have done with magniloquence for the sake of a considered under-statement put him in a parallel position for example with Cesi of Bologna. His work was thus one more fruit of the re-examination of consciences which came in with the Counter-reformation. His position was not an isolated one; even a superficial examination cannot fail to relate him to Peranda mentioned above, to Damini his pupil, to Ponzone, arriving perhaps at the isolated figure of Carboncino in addition, way into the seventeenth century, a kind of voice crying not in the wilderness but amidst the deafening clamour of the more extreme forms of Baroque.

A case apart is represented by Saraceni, one of the first to become aware of the importance of Caravaggio and start following his lead. He remains of the Veneto, indeed Venetian and in works like "S.Rocco" in the Doria gallery, echoes may be discerned from Bassano, right back to Giorgione. Then beside Saraceni are the painters of Verona, pro-Caravaggio reformed style.

If in the early seventeenth century Venice played no part in the renewal of painting then in progress, it is attributable to the fact of certain positions which had already been reached in the previous century.

When Fetti arrived in Venice from Mantua, Strozzi from Genoa and the German Jan Liss, there is no call to say painting was dead, which is the usual practice, and they gave it new life. Instead they contributed to a lot of new thinking with their art, rich in source experiences and full of pointers for the way ahead. These three artists differ from one another, knowledgeable about the great Venetian tradition of the sixteenth century but full of personality. Their work was of importance with regard to developments in Venetian painting during the seventeenth century. With their names, this second part of the work on Venetian painting comes to a close. It began with the new departures of Giorgione and followed its course to the emblematics of the seventeenth century when these currents were first manifest.

Pietro Zampetti

# List of Artists in Chronological Order

## THE LAST FOLLOWERS OF THE QUATTROCENTO TRADITION

Belliniano Vittore
Bello Marco
Caselli Cristoforo
Bissolo Pier Francesco
Buonconsiglio Giovanni
Marco Rocco
Duia Pietro
Busati Andrea
Beccaruzzi Francesco
Agostini (de) Giovanni Paolo
Agabiti Pietro Paolo
Girolamo dei Maggi
Ingannati (degli) Pietro
Oliverio Alessandro
Verla Francesco
Solario Antonio
Santacroce Girolamo
Catena Vincenzo
Basaiti Marco

## AN ISOLATED PAINTER

Bartolomeo Veneto

## THE NEW GENERATION—GIORGIONE AND THE GIORGIONESQUE PAINTERS

Giorgione
Campagnola Giulio
Campagnola Domenico
Paris Bordone
Capriolo Domenico
Cariani (Giovanni Busi called il)
Morto da Feltre (Lorenzo Luzzo called il)
Mancini Domenico
Licinio Bernadino
Torbido Francesco
Previtali Andrea

## OTHER VENETIAN PAINTERS FROM THE PROVINCE OF VENICE

Gavazzi Giovanni
Pagani Francesco
Pelegrino da San Daniele
Florigerio Sebastiano
Girolamo da Triviso (called il Giovane)

Girolamo di Bernardino da Udine
Giovanni da Asola
F.V. Pittore Anonimo
Filippo da Verona
Fogolino Marcello
Caroto Giovanni Francesco
Cavazzola Paolo

## THE MOSAICISTS OF ST. MARKS

The family of Zuccato

## THE GREAT VENETIAN PAINTERS AFTER GIORGIONE

Tiziano
Vecellio Francesco
Polidoro da Lanciano
Boldrini Nicolò
Palma il Vecchio
Sebastiano del Piombo
Lotto Lorenzo
Franco Giambattista called il Semolei
Antonio da Faenza (Domenichi called)

## FOLLOWERS OF LOTTO FROM THE MARCHE

Durante da Caldarola
De Magistris Giovanni Andrea & Simone

## VENETIAN PAINTERS FROM OUTSIDE THE LAGOON

Dosso Dossi
Pordenone Giovanni Antonio
Amalteo Pomponio
Grassi Giovanni Battista, da Udine
Savoldo Girolamo
Romanino Gerolamo
Moretto da Brescia
Moroni Giambattista
Bonifacio Veronese (Pitati called)
Schiavone Andrea (Meldolla called lo)

## THE BASSANO FAMILY

Bassano Francesco da Ponte il Vecchio
Bassano Jacopa
Bassano Francesco (the Younger)
Bassano Leandro
Bassano Gerolamo

## Painting in the Second Half of the Century

Marescalchi Pietro called lo Spada
Salviati (Giuseppe Porta called il)
Sustris Lambert
Badile Giovanni Antonio
Brusasorci Domenico
Veronese (Paola Caliari called il)
Zelotti Battista
Ponchino Giambattista
Fasolo Giovanni Antonio
Farinati Paolo
Montemezzano Francesco
Pozzoserrato Lodovico
Tintoretto (Jacopa Robusti called il)
Galizzi Giovanni
Andrea Vicentino
Vassillacchi Antonio called l'Aliense

## The Last Descendants of the Cinquecento

Palma il Giovane
Corona Leonardo
Maganza Allessandro
Malombra Pietro
Peranda Sante
Varotari Alessandro called il Padovanino
Damini Pietro

## The Innovators at the Beginning of the Seicento

Saraceni Carlo
Le Clerc Jean
Fetti Domenico
Liss Jan
Strozzi Bernardo
Ottino Pasquale
Bassetti Marcantonio
Turchi Alessandro called l'Orbetto
Ponzone Matteo
Renieri Nicolò
Tinelli Tiberio

## AGABITI PIETRO PAOLO

Born at Sassoferrato in the Marches about 1480, he probably removed to the Veneto as a young man. Only a move of this kind serves to explain the profound link with Cima da Conegliano, discernible in the altar-piece depicting the *Madonna enthroned with SS.Peter and Sebastian*, Padua museum. Signed and dated (Petri Pauli Saxiferrati opus, MCCCCLXXXXVII), it is the best known of his works extant, not many in number. The artist's subsequent activity centred almost constantly on the Marches, where he died after 1540, having retired to the Austin monastery at Cupramontana.

His better known works are to be found at Jesi (where he lived for a long time, and married). He painted some frescoes there, between 1522 and 1524, together with Andrea da Jesi. An *altar-piece* formerly at Corinaldo and now in a private collection in Montreal (Canada) also belongs to 1522. A second *Altar-piece* in the church of S.Maria del Piano at Sassoferrato dates from 1518; a *triptych* in the church of S.Croce at Sassoferrato, from 1524; and a *Madonna and child*, now in Jesi art gallery, from 1528

A notable fresco in the church of S.Esuperanzio at Cingoli was attributed to him by Colasanti. L. Venturi, however, deemed it to be by Antonio Solario, and correctly so.

After his early and very evident allegiance to Cima da Conegliano, Pietro Paolo's art showed signs of increasing impoverishment, once direct contact with the master was gone. Instead, the influence of other artists became paramount, oscillating between Luca Signorelli, Marco Palmezzano and Lorenzo Lotto. His finer qualities are to be observed in the small works, particularly predellas with their serene landscapes envisaged in clear light.

BIBLIOGRAPHY

Lanzi L., *Storia Pittorica dell'Italia* II, 1824, p. 39;
Ricci A., *Memorie* etc. II, 1834, pp. 136–8 et seq.;
Venturi L., *Le origini della pittura veneziana*, 1907, p. 264;
Venturi A., *Storia dell'arte italiana*, VII, 1915, p. 678;
Serra L., *L'arte nelle Marche*, 1934, page 175-7 et seq.;
Berenson B., *Pitture italiane del Rinascimento*, Milano, 1936;
Marle (van) R., *The Development of the Italian Schools*, XVII, 1938, p. 481;
Berenson B., *Italian Pictures of the Renaissance*, I, Venetian School, London, 1957;
Zampetti P., in "Dizionario biografico degli Italiani", 1960, under appropriate heading, with full bibliography;
Pallucchini R., *La pala dell'Agabiti per San Francesco di Corinaldo*, in "Festschrift Ulrich Middeldorf", Berlin, 1968.

## AGOSTINI GIOVANNI PAOLO de

A Venetian painter, active in the early decades of the sixteenth century. According to Berenson, he died between 1524 and 1525. He was a follower of Giovanni Bellini and most especially of Giorgione, as his few works indicate, only two of which are signed.

Of these the *Pietà*, also depicting the two donors who may be seen in the background, has undoubted affinities with Giovanni Bellini's late manner. In other works deemed as attributable to him, like the *Concert* (formerly Spinelli collection, Florence), the artist appears closer to Giorgione in manner, though the resemblance is on balance outward and not refined. Berenson further

attributed to him the *Portrait of a man* belonging to the Kress collection and on loan to the Delgado museum, New Orleans (US), a painting of some depth of psychological insight.

The fact, however, remains that this artist's personality is less than clear-cut and little known.

ESSENTIAL BIBLIOGRAPHY

Berenson B., *Italian Pictures of the Renaissance*, I, Venetian School, London, 1957.

## AMALTEO POMPONIO

Born at Motta di Livenza in the Friuli, in the year 1505, his painting activity was extensive and in great part associated with the figure of Pordenone (q.v.), whose pupil he was and whose daughter became his first wife. As the master's heir and successor, his reputation was noteworthy but his work is differenced by more palpable emphases and adherence to a Mannerism that much the more marked and dramatic. Lanzi percipiently commented that in comparison with Pordenone, he "strove for an effect that was original, making the shadows less strong, the colour more sprightly and the scale of figures and concepts less vast . . ." Indeed Lanzi praised him not only for colour, a "Venetian virtue" but also design. Clearly, a profound influence was exerted over him by the Mannerist style of painting, which originated with Michelangelo and reached him through the medium of Pordenone and other artistic components.

He spent his long life entirely in the Friuli and Carnatic, between Belluno, Ceneda, Pordenone, S.Daniele and S.Vito al Tagliamento (where he died in 1585). It was a very prolific and busy life. As time passed, there was a progressive falling off in his work as his originality exhausted itself and he resorted to repeating earlier forms. But his work served to create a local painting tradition, undeniably linked with the towering figure of Pordenone and in continuance of his achievement, and fostering a group of artists of some note in his wake, among whom his younger brother Girolamo may be mentioned.

PRINCIPAL WORKS

Baseglia (Udine), S.Croce, *Frescoes* (1544–1550);
Belluno, Civic museum, *Fragmentary frescoes* from the Palazzo del Consiglio dei Nobili;
Cividale del Friuli, Assunta (the Cathedral), *The Annunciation* (1546);
Pordenone, The Cathedral, *The Flight into Egypt* (1565);
S.Daniele del Friuli, S.Michele, *The Betrothal of the Virgin* and *the Circumcision*;
S.Vito al Tagliamento (Udine), The Cathedral, *Organ doors* with various subjects (1566);
ibid., S.Maria dei Battuti, *Frescoes* with episodes from the Old Testament and the Life of the Virgin;
Udine, Civic museum, *The Descent from the Cross*;
Venice, Correr museum, *Fragment of a fresco* from Belluno, Palazzo dei Nobili.

BIBLIOGRAPHY

Lanzi L., *Storia pittorica dell'Italia*, Bassano, 1789;
Zotti R., *Pomponio Amalteo, Pittore del XVI Secolo*, Udine, 1905;

Fogolari G., *Amalteo Pomponio*, in "Thieme Becker", 1907, under appropriate heading;

Venturi A., *Storia della pittura italiana* etc., Milan, IX, 4, 1928;

Fiocco G., *Il Pordenone*, Padua, 1942;

Querini V., *Pomponio Amalteo nel 450° anniversario*, Pordenone, 1955;

Mariacher G., *Il Museo Correr*, Venice, 1957;

Berenson B., *Italian Pictures of the Renaissance*, I, Venetian School, London, 1957.

## ANDREA VICENTINO (Micheli Andrea, called)

Born about 1540, his name is entered on the register of the painters' guild in Venice from 1583 to 1617, the year he probably died. He belongs within the ranks of the late Mannerists, active in Venice after the golden age of the great masters, Titian, Veronese and Tintoretto.

His output was a large one and his works, which are mainly scenographic, denote affinities with Tintoretto whom he studied assiduously without assimilating the inner message of moral potency and pictorial mastery.

He left countless works in the ducal palace, the "Sala delle quattro porte", the hall of the Senate, that of the "Maggior Consiglio". His commissions there were as wide-ranging as the *Crusaders in St. Sophia, Constantinople* and the *Naval victory of the Venetians at Rhodes*. These along with the compositions of his contemporaries were needed in consequence of the outbreaks of fire in 1574 and 1577, so ruinous for the masterpieces the ducal palace had housed.

Andrea Vicentino also left many works in the churches of Venice: the Carmini, S.Maria dei Frari, Angelo Raffaele, S.Fantin. His work also reached the Veneto and recently there has come news of an *Entry of Christ into Jerusalem* in the parish church of Montebelluna (Treviso).

Much esteemed in his own day, he was praised by Boschini for bold composition and chromatic vigour. The figure of Andrea Vicentino has been re-appraised by modern art historians. He was a facile artist, prodigiously active and always associated with the personalities of Tintoretto, in the first instance, and also Veronese.

He was certainly important with regard to the development of Venetian painting in the direction of the Baroque. Besides some useful indications of a link with Andrea Celesti, Pilo has recently pointed out motifs of style, later developed by Francesco Maffei, one of the leading artists in seventeenth-century Venice.

BIBLIOGRAPHY

Ridolfi, *Le maraviglie dell'arte*, 1648;

Boschini M., *Le ricche minere della pittura veneziana*, Venice, 1674;

Zanetti A. M., *Della pittura veneziana* etc., Venice, 1771;

Lanzi L., *Storia pittorica dell'Italia*, Bassano, 1789;

Venturi A., *Storia dell'arte italiana*, Milan, 1929, IX, 4;

Pallucchini R., *La pittura veneziana del Cinquecento*, Novara, 1944;

Lorenzetti G., *Venezia e il suo estuario*, Rome, ed. 1956;

Mariacher Giovanni, *Il Museo Correr di Venezia*, I, Venice, 1957;

Mullaly T., *Two modelli by Andrea Vicentino*, in "The Burlington Magazine", 1964, no. 740;

Donzelli C.-Pilo G. M., *I pittori del Seicento Veneto*, Florence, 1967 (with further bibliography).

## ANTONIO DA FAENZA (Domenichi, called)

Painter and architect, the recorded information about him is scant and only linked with a few works. He lived in the first half of the sixteenth century, but was noticed for the first time in Civalli, 1611–13.

His best known work is represented by the organ doors that the artist painted for the Basilica della Sanata Casa at Loreto, now on view at the Palazzo Apostolico there. The two panels depict: the first, the Angel of the Annunciation on one side and the prophet Isaiah on the other; the second has a Madonna in an architectural setting of vast proportions, with St. Luke on the dorso. These shutters were commissioned by Pope Julius II and completed during the pontificate of Leo X, 1513-4. At one time they were thought to be by Palma il Vecchio, then reverted to the present artist, to whom they rightly belong. The influences they reveal are diverse, especially of Melozzo da Forlì and Lorenzo Lotto.

Other works by this painter may be found at Monte Lupone (Macerata) and Norcia.

ESSENTIAL BIBLIOGRAPHY

Deglia Azzi G., in "Thieme-Becker", I, 1907, under the appropriate heading;

Buscaroli R., *La pittura romagnola del Quattrocento*, Faenza, 1931;

Serra L., *Inventario degli oggetti d'arte*, VIII, Rome, 1936;

Berenson B., *Italian Pictures of the Renaissance*, I, Venetian school, London, 1957.

## BADILE GIOVANNI ANTONIO

Born in Verona about 1518 (but held until a few years ago to have been a good deal older), he worked in the place where he was born and died there in 1560.

His first work may be the altar-piece of Verona civic museum, of the *Madonna enthroned with St. Dennis and the Magdalen*, dating from about 1540. The painter reveals ties with Il Caroto (q.v.) and Il Torbido (q.v.), that is to say with the artistic personalities most active in and around Verona in the early sixteenth century.

The altar-piece of the church of SS.Nazaro e Celso, Verona, bears the date of 1543; there is an inscription by the artist on the back, stating that he was then twenty-five. But the work shows him starting to detach himself from the purely local environment, widening his sources of influence, to the point of including that of Titian, a painter he followed more and more closely as the years passed. Yet his works convey echoes of the art of Moretto as well, and of Lotto.

It is of interest to remark that in 1541, Badile had Paolo Veronese for a pupil, then fourteen years old. This raises the question of his influence upon the artist who became a leading protagonist of European art in the sixteenth century.

Gradually, Badile began to lose pace, remaining circumscribed by a provincial horizon after reaching perhaps the pinnacle of his career: the altar-piece of the *Madonna enthroned with saints*, made for S.Spirito and now in the Civic museum, Verona. Alongside points of contact with the painting of Titian, the artist in this work reveals a new departure, perhaps due to the prompting of the rising figure of Paolo Veronese. His late period shows the artist trying to keep abreast of the times, in the *Presentation in the Temple* at Turin art gallery. But the manner is rather flat and although clearly to be associated with the art of Paolo Veronese, neither the luminous chromatic range nor the balanced composition of Veronese can be detected.

PRINCIPAL WORKS (other than those cited)

Mazzurega (Verona), Parish church, *Pietà;*
Padua, Civic museum, *Madonna and child with saints* (from the church of
    Praglia);
Verona, S.Bernardino church, *Raising of Lazarus;*
Venice, Accademia gallery, *Fra Salvo Avanzi* (early work).

ESSENTIAL BIBLIOGRAPHY

Ridolfi C., *Le maraviglie dell'arte*, Venice, I, 1648;
Lanzi L., *Storia pittorica della Italia*, Bassano, II, 1795–6;
Fiocco G., *Paolo Veronese*, Bologna, 1928;
Venturi A., *Storia dell'arte italiana*, IX, 4, Milan, 1929;
Berenson B., *Italian Pictures of the Renaissance*, Oxford, 1932;
Pallucchini R., *La pittura veneziana del Cinquecento*, II, Novara, 1944;
Novelli M. A., in "Dizionario biografico degli italiani", Rome, 1963, under
    appropriate heading.

## BARTOLOMEO VENETO

A painter perhaps hailing originally from Bergamo, documented from 1502 to 1530. Precise data about his life is lacking. The *Madonna and child*, formerly in the Donà delle Rose collection, he signed "Bartolamio part-Venetian, part-Cremonese". Certainly trained within the orbit of lagoon art, he later approached the Lombard-Leonardesque, as may be seen in the *Lady lute-player* of the Gartner museum (1520). Later still, he was influenced by German painting, especially that of Dürer and Lucas van Leiden.
Bartolomeo Veneto may be related to the group of Venetian painters looking to Germany (like Jacopo de Barberi) and is known primarily as a portraitist, a pursuit he favoured greatly especially in the 1520s. Elegance of costume, expressive character, incisive strokes make him notable as a painter, in the tradition of Antonello da Messina but certainly not unaware of the art of Cima da Conegliano and Giorgione.
Leonardo also influenced him to a certain extent, as the *Madonna and child* of the Thyssen collection, Lugano, aptly demonstrates. Venturi regretted that his painting strove for elegance, on the side of surfeit and superficial. Forms became less sharply focused as the years passed and he tended to paint in a more fluid manner, as shown by works of his late period, for example the portrait of Ludovico Martinengo, 1530.
As an artist he was eclectic, witness the lack of stylistic continuity but his work is subtle, and bears the stamp of a cultivated mind garnering what seemed most attractive to him from among the maze of tendencies characteristic of the early decades of the sixteenth century and adapting it to his way of thinking. This alone explains the wide difference between works such as the *Courtesan* of Frankfurt museum, refined and elegant, and the perceptive humanity of the *Gentleman with cap* of Budapest museum.

PRINCIPAL WORKS

Bergamo, Carrara gallery, *Madonna and child* (1505);
Frankfurt-am-Main, Museum, *The Courtesan;*
Paris, *The Circumcision* (1506);
London, National gallery, *Lodovico Martinengo* (1530);

Milan, Brera gallery, *The lady playing the lute* (1510);
Rome, National gallery, *Portrait of a gentleman* (1512);
Rome, Albertini coll., *Madonna and child;* formerly Donà delle Rose coll.,
Venice, *Madonna and child* (1502).

ESSENTIAL BIBLIOGRAPHY

Venturi A., *Bartolomeo Veneto*, in "L'Arte", II, 1899;
D'Achiardi P., in "Thieme-Becker", Leipzig, 1908, under appropriate
heading (with bibliography to that date);
Venturi A., *Storia dell'arte italiana*, VII, 4, 1915;
Fogolari G., in "Enciclopedia Treccani", under appropriate heading, 1930;
Galletti Camesasca, Enciclopedia della littura Italiana, Milan, 1950, *ad vocem.*
Berenson B., *Italian Pictures of the Renaissance*, Venetian School, ed. 1957,
London.

## BASAITI MARCO

Born perhaps in Venice about 1470, he died after 1530. Dated works span the period from 1496 to
1521. A pupil of Alvise Vivarini, he assimilated the spirit of formal asperity characterising his
youthful period, but it mellowed by degrees under the impact of Antonello. In his earliest works,
outlines are clearly defined and the world of reality in some measure faithfully conveyed, perhaps
as a result of promptings from the Flemish artists.

With the passage of time, partly through the influence of Bellini and partly, perhaps to a major
extent, through that of Giorgione, his paint material becomes softer and more tonal, though the
qualities of contrast and pictorial vivacity remain, especially in the treatment of landscapes.

The great painting of the *Calling of the sons of Zebedee* is fundamental to understanding his manner
at the time; it dates from 1510 and is now in the Accademia gallery, Venice. The landscape is seen
from above, stressing the feel of space going into the distance and giving a setting in depth for the
gospel story depicted in the foreground.

Basaiti, who may also have had contacts with Carpaccio, was responsive to the influence of
Giorgione in late works and his portraits in particular show considerable psychological insight. As
Venturi (1915) observed, in his work the desire makes itself felt, "to steady spluttering splitting
lines, to tamp down the contrast between light and shade, to give a little grace to bodies writhing
in torment". In the "Dead Christ" of the Accademia in Venice, the forms soften as the painter
clearly searches for refinements to mitigate the initial harshness of outline.

Some of his works are highly sensitive to landscape, where the mood is rich in sun-drenched
colour and haze, as for example the *Sacra conversazione* at Urbino, redolent of the influence of
Giorgione.

PRINCIPAL WORKS

Monaco, Art gallery, *Madonna and child, two saints and donor;*
Nantes, Dobree museum, *Pietà;*
Venice, Correr museum, *Madonna and child with donors;*
ibid., *Head of a young man;*
Venice, Accademia gallery, *Calling of the sons of Zebedee* (1510); a copy on a
smaller scale in the Kunsthistorisches museum, Vienna, dated 1515);
ibid., *The Agony in the garden* (1516);

ibid., *St. George and the dragon;*
Urbino, Ducal palace, *Sacra coversazione.*

ESSENTIAL BIBLIOGRAPHY

Fogolari G., in "Thieme Becker", Leipzig, 1908, under appropriate heading
(with bibliography to that date);
Venturi A., *Storia,* VII, 4, 1915;
Berenson B., *Venetian painters in America,* 1916;
Lorenzetti G., *Venezia e il suo Estuario,* Venice, 1927;
Pallucchini R., *Mostra dei Cinque Secoli di Pittura Veneta,* Venice, 1945;
Zampetti P., *Il Palazzo Ducale di Urbino,* Rome, 1952;
Moschini Marconi S., *Gallerie dell'Accademia,* Rome, 1955;
Mariacher G., *Il Museo Correr,* Venice, 1957;
Berenson B., *Italian Pictures of the Renaissance,* Venetian School, 1957,
London.

## BASSANO FRANCESCO (the Elder)

Head of a line of artists, made famous by the great Jacopo, his son. Francesco's birth date is unknown, and his real surname was Da Ponte, it may be because he lived in "contrada Pontis". Records concerning him cover the years from 1501 to 1540, the probable year of his death.
He is known to have painted some frescoes at Cismon in Valsugana, destroyed in the course of the first world war. An *altar-piece* by him for the church of S.Giovanni, Bassano, belongs to 1519, now in Bassano museum. This work has undoubted affinities of manner with the art of Bartolomeo Montagna, whose follower Francesco may be deemed though in the absence of direct evidence. As Berenson with his customary acumen remarked, the influence upon him of (Il) Caroto and (Il) Moroni in addition cannot be ruled out. In this, he was followed by Arslan.
Arslan went on to distinguish touches in his late work, even from the art of Bonifacio Veronese, that is to say the painter that his son Jacopo was attracted by in his youth. In context, let it be added that the *Deposition,* also in Bassano museum, once held to be Jacopo's youthful work, has been restored to Francesco as a result of recent critical re-appraisal, though perhaps with his son's help.
Francesco Bassano the Elder rates as a worthy provincial painter, sensitive to developments in the realm of art surrounding him. His strongest claim to be remembered, however, consists in having paved the way for the career of his son Jacopo.

PRINCIPAL WORKS

Bassano, Civic museum, *Madonna with SS.Bartholomew and John the
Baptist;*
*Madonna with SS.Peter and Paul;*
*Madonna with a saint bishop and St. George;*
*Pietà* (in collaboration with his son Jacopo);
Solagna (Vicenza), Parish church, *Altar-piece with SS.Justina, Michael and
George.*

BIBLIOGRAPHY: (see under Bassano Jacopo)

## BASSANO FRANCESCO (the Younger)

The son of Jacopo and Elisabetta Merzari, he was born in Bassano, in the year 1549. At an early age he became part of his father's studio and they worked together on paintings. The first works to be recognisable as Francesco's own belong to the period 1565 to 1570. He is associated with his father's manner of painting and indeed consciously strove to imitate him.

As Arslan quoted, Zanetti (1733) already understood the young man's limitations. "Francesco wanted to achieve a striking effect, true, boldly coloured but he was at a disadvantage; that is, in trying to imitate his father. Being unable to avoid emphases in order to imitate his father well, the effect he produced was at times garish and at other times—since he lacked the finesse—his work came out on the thin side, not to say languid".

He was close to his father, at all events, and signed many paintings along with him. The altar-pieces of Martostica and Bassano are examples, dating from 1574 and 1577 respectively, also the works in Civezzano church in the Trentino. Undated, they belong to the decade 1570–80; in manner, the preoccupation with the scene is so intense as almost to empty the pieces of their true meaning, all of them illustrating religious subjects. A theme of Jacopo's country scenes, began to enjoy a vogue with Francesco and became very popular indeed. It is not in fact possible to determine the extent to which his hand figures in some of his father's works.

In 1579, he left Bassano for Venice and became quite active there. He began painting night scenes, with religious subjects, *Christ scorned*, the *Agony in the Garden*, the *Flagellation*. Then he was called in to work on the great series of paintings for the Palazzo ducale. He probably started in the "Sala dello Scrutinio", depicting the *Taking of Padua by the Venetians*, a dark nocturnal scene, lauded by Boschini for dramatic use of lighting.

Francesco's work in Palazzo ducale continued, on an increasing scale, some of it for the "Sala del Maggior Consiglio" too. At the same time, he produced easel paintings which were sent everywhere as a consequence of his great fame, though his father's reputation had something to do with it. He fell ill of an incurable disease and in despair took his own life, throwing himself from a window of his house, on 3 July 1592.

Judgment on Francesco must take into account his father's undoubted influence. He was more responsive to Mannerist influences which had broadly penetrated the Venetian art world. His activity was truly enormous, at times confused in addition with that of his brothers.

PRINCIPAL WORKS

> Bassano, Civic museum, *The Circumcision* (signed, in collaboration with his
>   father);
> Bergamo, Carrara gallery, *Ecce Homo*;
> Bergamo, S.Maria Maggiore, *The Last Supper*;
> Cremona, Museum, *Christ betrayed*; (signed);
> Florence, Pitti gallery, *Self-portrait*;
> Florence, Uffizi gallery, *Building of the Ark*;
> Kassel, Art gallery, *Christ in the house of Martha* (signed);
> Liverpool, Walker art gallery, *The fire* (signed);
> Madrid, Prado, *The Last Supper* (signed);
> Prague, National museum, *Christ's presentation in the Temple* (signed);
> Sarasota, Ringling museum, *Christ in the garden* (signed);
> Treviso, S.Nicolò, *Madonna with SS.Francis and Dominic* (signed);
> Venice, Palazzo ducale, *Various pieces* in the "Sala del Maggior Consiglio"
>   and the "Sala dello Scrutinio";

Vienna, Kunsthistorischesmuseum, *Winter, Summer, Autumn* (and a fragment of Spring) (all signed works).

BIBLIOGRAPHY: see under Jacopo.

## BASSANO GEROLAMO

The youngest of Jacopo's family, he was born at Bassano in 1566. After starting to train in medicine (from the will of his brother Francesco, he was said to be in Padua "studying" in 1587), he too took up painting like his brothers. Thus he returned to Bassano and lived with his mother until 1595, the year he moved to Venice on a permanent basis and remained there till his death in 1622.

There are no dated works by him but there are some which are signed. His activity has been retraced by Arslan with a fair degree of clarity, though he considered Gerolamo as the least gifted of the sons of Jacopo. In his early works, in fact, he did not hesitate to copy his father's style and recopy his works to the point of being mixed up with him. Verci, the chronicler of the Bassano family, cites these qualities and makes a merit of them.

The *altar-piece* for the parish church of Cismon (Vicenza), signed, is very important as evidence of Gerolamo's utter dedication to his father's art. It is not impossible that he also, like his brothers, worked in his father's studio. Later and clearly after the death of Jacopo, his painting lacking real originality tends to imitate that of his brothers, in particular of Leandro; unable, then, to keep abreast of developments required by changing times, he concluded his artistic career in provincial decadence, as may be clearly seen from the Grespano *altar-piece*.

PRINCIPAL WORKS

> Bassano, Civic museum, *Christ nailed on the Cross; Madonna and child* with
>> SS.Hermagoras and Fortunatus (signed);
>> *Madonna and child* with SS.Agatha and Apollonia (probab. collaboration with his father Jacopo);
> Cismon, Parish church, *Madonna and child* with SS.Mark and Justina (signed);
> Crespano (Treviso), Parish church, *SS.Francesca, Clare and Charles* (signed);
> Edinburgh, National gallery, *Virgin and child*, with St. John Baptist and donor (perhaps collaboration with his father);
> London, National gallery (no. 228), *Cleansing of the temple* (perhaps collaboration with his father);
> Vienna, Kunsthistorischesmuseum, *Nativity* (signed).

ESSENTIAL BIBLIOGRAPHY: see under the entry on Bassano Jacopo.

## BASSANO JACOPO

Little is known of his early life and indeed the information about him in general is scant. He may be held to have begun his career in the studio of his father Francesco, a late provincial painter working near the famous bridge over the Brenta from which he got his name Da Ponte and his descendants after him. His earliest activity is identifiable as that of collaboration in some of his father's works.

According to Ridolfi, he went to Venice in 1530 as a pupil of Bonifacio de' Pitati. On 15 January 1535 he was certainly in Venice, to obtain a patent for an invention of his, together with two artists

from the Trentino. The style of his first works indicates a relationship with Bonifacio beyond all shadow of doubt. There may, however, be no truth in the tale of his having been a follower of Titian. It can be taken for granted that he had plenty of contacts with the art world in Venice, and therefore took an interest in Titian, also in Lorenzo Lotto, as seen from his youthful works.

Between 1535 and 1536 he painted the *pictures for the Sale dell'Udienza* in the Palazzo Pretorio, Bassano, a clear sign of his growing reputation. It appears that he never left his own town thereafter, apart from the odd journey to Venice which was easily accessible. He remained nevertheless alive to contemporary developments in art, and ever ready to accept, almost to anticipate, the changing taste evoked by the spread of Mannerist precepts, especially in works of about 1538.

In 1541, after his father's death, he was granted tax exemption as a tribute to his artistic skill: "propter excellentiam eius artis". He married Elisabetta Merzari, a native of the same place as himself, and she bore him seven sons. The first was born in 1547 and died quite soon. In 1549 he was nominated councillor and consul of Bassano, but asked to be excused; in 1551, he was again given tax exemption.

These facts apart, nothing striking is known otherwise about his life: it was dedicated to the work of his studio where his sons were growing up, four of them—Francesco, Giovanni Battista, Leandro and Girolamo—were painters of repute. Francesco also worked with Jacopo and signed many works together with his father. It is to the sons and their studio that the spread, indeed the success, of genre painting is owed, which lasted into the seventeenth century. The result was to blur the figure of Jacopo and detract from his greatness. It had fallen to the lot of art historians in modern times to reconstruct the stupendous whole, in particular Venturi, Arslan, Bettini and Longhi.

According to Memmo, in 1586 the aged painter was in Venice to help Francesco who was working for Palazzo ducale. But in 1581 there is evidence from a letter of his son's that he "does not draw any longer and cannot work much with brushes, both on account of his sight and because he is very old". He died at Bassano on 13 February 1592 and was buried the next day in the church of S.Francesco.

Only over the last few decades has the figure of Jacopo been clearly distinguished from his sons and imitators. Works of Bassano type, even when no more than mediocre, were calmly assigned to him. Verci, however, in the eighteenth century shewed appreciation of Bassano's complex personality. He emerges different from the traditional view, a slow accretion centuries old assuming that in studio products, of genre painting, lay his chief merit.

A painter of exuberant vitality, he steered a difficult course. On the one hand were the still waters of local painting, of which his own father was an exponent. On the other, the broad but shallow waters to which over-adulation of Titian's art invited the unwary. Yet, despite the young Venetian spell-binder and the many influences he felt and used in broadening his horizon, he remained a being apart pursuing his course undeflected. The charms of culture and love of reality were the two pivots on which he turned: the contrast often created the antitheses and dramatic impact of Jacopo's art, yielding forms full of life from his surroundings and again, features whittled down to the point of over-refinement.

The truth is that this very restlessness bred vitality in his work. In many respects, it was akin to that of Lotto, respecting its causes, though resolved in a spirit of optimism quite lacking in Lotto. He was looking, on the one hand, for means of expression as offered by learning, now lost in the contemplation of nature and now caught up in the stream of everyday life.

The three works in the "Sala dell'Udienza", Palazzo Pretorio, Bassano, dating from about 1535, show how thoroughly Jacopo had learnt the lesson of Bonifazio Veronese. The scene of *Christ and the Woman taken in Adultery* is the best of the group from the point of view of composition. The architectural setting which recedes into the distance, a double row of columns, imparts a feeling of

space. The people occupy the foreground, to create a rhythm in keeping with the background. Some uncertainty may be noted in passages of the work, but it is full of promise. The tale is told with that flair and local colour which denote the work of this artist, especially as seen in the two figures of the young man who is lame, with his suffering face and uncouth gesture about to move forward, and the gentleman with the falcon on his wrist, a portrait which is keenly individual and presented with instinctive subtlety of feeling.

Perhaps the finest of his early works is the *Flight into Egypt*, using a borrowed theme from Titian freely re-worked. This painting reveals the salient poetic feature of Bassano: a spacious landscape serenely lit, and on this ground the little party wends its silent way as vividly as if from memory. The morning is still cold, unwarmed as it laps the figures, each enclosed in dignity, simple and austere. The place is enchanted but beware; deep thoughts abound.

From 1538, his painting changes register, nearer to Pordenone and Fogolino, whose influence is appreciable in the *Altar-piece* of Borso (Treviso), bearing the date of that year. His texture is more open, the scale more monumental, grandeur more extensive and the sense of space more self-aware. This is the moment at which the Mannerist crisis affects him as the movement spreads through Italy and he becomes the first among the painters living in the Veneto to welcome it as if expected, and later a leading exponent. The classical ideal fades into the past. All of a sudden, Jacopo turns to drama, his brush-work agitated, violent, as in *Samson and the Philistines*, Dresden art gallery, or again the *Martyrdom of St. Catherine*, Bassano museum. Both works, together with some frescoes in Bassano, must have been painted after he had seen a print or two, indicating what the Roman painters after Michelangelo were able to achieve.

Later, he was influenced by Parmigianino and the odd Mannerist from Tuscany. After the first furious onrush of Mannerist art, making even his colouring harsh as in the two works cited above, the painter moves gradually on to a more contemplative and meditative approach, that much the less heroic. At this juncture, that is to say after 1540, come his first masterpieces: the *Rest on the Flight* in the Ambrosiana and the *Adoration* at Hampton Court; works full of sunlight, solidly constructed, admirable in chromatic range and evidence of the balanced outlook which the artist had attained.

The period from 1540 to 1557 was filled with bursting activity, hard to trace in detail as the works are not dated. Jacopo moved with extraordinary, not to say incredible rapidity from one line of investigation to another; the stylistic rigour and inventiveness he displayed were so much his own, that any borrowing from other artists is to be totally excluded. His creativity was prodigious.

The Borghese *Supper* shewed a lively sense of reality. The paint material is bleak but ablaze with strongly contrasted colour, the white cloth dominant and on the dish the poor docked lamb's head of the bright but memorable beady eye. As Venturi and Longhi remarked, about 1550 the artist was in the throes of yet another crisis, part due on this occasion to the influence of Tintoretto. A sense of high drama emerged, achieved by stormy contrasts of light. The *Christ on the road to Calvary*, now in Budapest, was a result. The forms are not still, not straight; the colour is vibrant and contrasting, applied differently, that is to say not to accentuate the plastic as much as to surpass it, visualising drama in terms of light and colour.

The *Miracle of the Quails and Manna* presents an unreal scene of hallucinatory quality, as on an evening in Autumn when the shadows lengthen and everything looks different, sinking into the oncoming twilight. In 1557, a datable work: the *Baptist* of Bassano museum, showing the painter's achievement in this phase, the most problematic and most advanced in the course of his career.

Nervous brush-work, fretful, destroys volume and makes the scene an event right out of the ordinary. "Everything is modelled in brief, separate strokes as if form were created mysteriously out of the green shadows of the leaves into a semblance fleeting and strange" (Bettini).

Other masterpieces belong to about this time, including the *Rich Man's Feast* of Cleveland museum.

It is a stupendous and shattering work, akin to the treatment of light current in the seventeenth century. It is light and shade which informs the composition and enlivens the narrative which remains more implied than expressed. Not far distant from this work may be placed the *Country piece* of the Thyssen collection, about 1560 or soon after: country folk rest after their labours. The presentation is loving and affectionate rather than polemical. The colours are tender, almost cold. The mood belongs to Autumn when the daylight fades with a touch of chill in the air as evening draws on; the sower hurries to finish his job while the family wait and prepare their meal. For the first time, the country theme is neither idyllic nor Arcadian, as in Giorgione or Titian, but a commonplace. Nature is no longer a dream, typifying the eternal flow of things but a faithful image reflected from everyday life.

This is what "genre painting" means, the glory of Bassano's school, and a force to reckon with throughout the seventeenth century. The artist's ambition meanwhile moved on, in search of ever new discoveries. The Vienna *Adoration* resulted, the strong lighting assuaged and modified to silvery, cold colouring, supernatural and magical. El Greco's influence is at work here and for this reason, a similar work was assigned to that artist in the past.

The *Adoration of the Shepherds*, Bassano museum, belongs to 1568. The mood is cool and twilit, but the colour still more disparate and granular. During this period, Jacopo painted some large altar-pieces, as in the Duomo, Belluno and another formerly in Vicenza and now in the Brera. The *Susanna* of Nîmes museum, with its triumphant dazzling light, dates from 1585. The last work by Bassano is the *Adoration of the Shepherds* of S.Giorgio Maggiore in Venice, dating from 1592, the year he died. The night scene is unexpected in effect, because of the bright light from the body of the Child. Jacopo's long career ended, after a life apparently tranquil but rocked by the continual search for new means of expression, fused from an understanding of life as rich and sensitive as any.

PRINCIPAL WORKS (other than those cited in text)

> Bassano, Civic museum, *Sacra coversazione;*
> Cittadella Arcipretale church, *The pilgrims of Emmaus;*
> Copenhagen, Museum, *Beheading of St. John Baptist;*
> London, Hampton Court, *The good Samaritan;*
> Munich, Bavaria, Alte Pinacotek, *Altar-piece;*
> Rome, Borghese gallery, *Adoration of the Shepherds;*
> Treviso, S.Teonisto, *Crucifixion;*
> Vicenza, Museum, *Lunette with Madonna and saints;*
> Vienna, Kunsthistorischesmuseum, *Thamar led to the stake.*

ESSENTIAL BIBLIOGRAPHY

> Verci G. B., *Notizie intorno alla e vita alle opere di pittori*, etc. *della citta di Bassano*, Venice, 1775;
> Lanzi L., *Storia pittorica dell'Italia*, Bassano, 17 (1st ed.);
> Gamba B., *Dei bassanesi illustri*, Bassano, 1807;
> Gerola G., in "Thieme-Becker" 1909, III, under appropriate heading;
> Venturi A., *Storia dell'Arte Italiana*, IX, Milan, 1929;
> Bettini L., *L'Arte di Jacopo Bassano*, Bologna, 1933;
> Magagnato, *Mostra di dipinti del Bassano* (catalogue), Venice, 1952;
> Zampetti P., *Jacopo Bassano* (Exhibition catalogue), Venice, 1957, with full bibliography to that date;
> Berenson B., *The Venetian Painters of the Renaissance*, Venetian School, London, 1957;

Zampetti P., *Jacopo Bassano*, Rome, 1958;

Pallucchini R., *Jacopo Bassano ed il Manierismo*, in "Studies in the History of Art etc. to Suida", London, 1959;

Arslan W., *I Bassano*, Milan, 1960 (1st ed. Bologna, 1931);

Suida W., *Tiziano e Raffaello fonti d'ispirazione per Jacopo Bassano*, in "Arte Veneta", 1959–60;

Furlan J., *La componente tizianesca nella formazione di Jacopo Bassano*, in "Arte Veneta", 1959–60;

Rearick W., *J. Bassano, 1568–9*, in "The Burlington Magazine", 1962, pp. 524–33;

Ballarin A., *L'orto del Bassano*, in "Arte Veneta" 1964; *Chirurgia bassanesca*, in "Arte Veneta", 1966; *Jacopo Bassano e lo studio di Raffaello e dei Salviati*, in "Arte Veneta", 1967;

Rearick W., *Jacopo Bassano's last Paintings: The Baptism of the Christ*, in "Arte Veneta", 1967.

## BASSANO LEANDRO

The third son of Jacopo, he was born at Bassano in 1557. The same sources relate that from his earliest youth he worked in his father's studio. thus beginning his artistic career very young. As a result, it is not easy to disentangle his progress from that of his brothers. Quite soon his personality transpired in well-designed zonal painting, indicating a stylistic view-point diverging from that of his father and also from the manner of his brother Francesco. As Arslan remarked, his hand first shows up fairly clearly about 1575, together with that of his brother, collaborating on pastoral and biblical pictures of a kind continuously turned out by Jacopo's studio, presumably in response to a stream of requests. The chromatic range of Leandro is diverse from that of his father and Francesco; his colours are somewhat severe but uniform and never contrasted in terms of light. The effect, according to Arslan, may be likened to tapestry work, for the sake of being understood.

A typical example of Leandro's youthful period is the *Moses striking the Rock*, Dresden gallery. About 1582 (perhaps even earlier), Leandro went to Venice where he apparently remained a good while. In 1587, he was back in Bassano and was married. Alongside his work on views and pastoral scenes, he began to take up the art of portraiture, achieving great success and approaching the art of Moroni from Bergamo rather than the manner of his father.

From 1588 till almost the end of his life, he began to go to Venice more and more frequently, being entered on the painters' register from that year until 1621. As time passed, his paint material became more hard and seldom shiny; but he showed a certain quality of his own, different from the work of his father or Francesco, his brother. In 1592, he took over from the latter, to complete the painting of *Pope Alexander III and doge Sebastiano Ziani*, for the "Sala del Consiglio dei X" in the ducal palace, Venice. Also in that palace, he painted various portraits towards the close of the century, for the "Vogaria", demonstrating a confident hand and observant eye. Indeed, he continued to work as a portrait painter until his death in 1622.

Leandro Bassano continued his father's work with distinction in the pastoral sphere as well. He perhaps contributed to the success of country scenes as much as anyone, the demand for them increasing right through the seventeenth century. Yet his sensitivity (so different from his father's) and large output led to some confusion as to the character of Jacopo, whose figure has only clearly emerged as a result of recent scholarship.

Leandro lived at a time when late Mannerist art had reached a critical stage, owing to the rise of the seventeenth century movement. Against this background, his painting had no great originality.

His sensitivity is to his credit, however, and his continuing desire to be different from his father, as recent contributions have finally brought out. Leandro Bassano was a most industrious painter.

PRINCIPAL WORKS

> Bassano, Civic museum, *Madonna and child, saints and the Podestà, Lorenzo Cappello* (signed and dated 1590); *Betrothal of St. Catherine and saints* (signed); *Madonna and child, St. Jerome and the senator Girolamo Suriano* (signed);
>
> Dresden, Gemäldegalerie, *Moses striking the Rock; Christ carrying his Cross* (signed); *Marino Grimani* (signed); The dogaressa *Morosina Morosini* (signed);
>
> Florence, Uffizi, *Self-portrait;*
>
> Grumello de' Zanchi (Bergamo), Parish church, *Madonna del Rosario* (signed);
>
> Hampton Court, London, *Portrait of a sculptor* (signed);
>
> Lille, Museum, *The Cleansing of the Temple* (signed);
>
> Madrid, Prado, *The Doge embarks for the Ascension feast* (signed);
>
> Munich, Art gallery, *Leonardo Armano* (signed);
>
> Naples, Capodimonte, *Market scene* (signed);
>
> Padua, Civic museum, *Tidings told to the Shepherds* (signed);
>
> Rome, Borghese gallery, *The Trinity* (signed);
>
> Venice, Accademia gallery, *The Virgin appearing to St. Bonaventure* (signed);
>
> Venice, Palazzo ducale, Vogaria, *The three Advocates Vallaresso, Gradenigo and Marcellino venerating the Virgin;* Sala del Maggior Consiglio, *Alexander III offering the candle to doge Ziani;*
>
> Venice, S.Giorgio Maggiore, *The Miracle of St. Lucy* (signed);
>
> Vienna, Kunsthistorischesmuseum, *Scenes of the months*, and also *Carnival* (all signed).

ESSENTIAL BIBLIOGRAPHY: see under Bassano Jacopo.

## BASSETTI MARCANTONIO

Born in Verona in 1588, his career began under the wing of Felice Brusasorci (q.v.). He transferred to Venice and was associated with Tintoretto, though also influenced by Palma the Younger. Travelling to Rome, he stayed there from about 1615 to 1620. His name became linked with that of Saraceni, in executing work for S.Maria dell'Anima, work which has since been lost. Longhi took the view that he also collaborated on the frescoes for the "Sala regia" at the Quirinal. He probably made the acquaintance of Borgianni while in Rome and was thus brought within the sphere of influence of Caravaggio. In fact, he also learnt from Fetti (q.v.), increasingly as the years went by.

This artist has a personality replete with points of reference and sources of influence. He enlivened Verona with a small but notable school of painting, together with Turchi (q.v.) and Ottino (q.v.). The early years in Venice, where it was to Tintoretto that he owed most, enabled him to stay the course when face to face with a challenge as fundamental as that of Caravaggio.

Late Mannerist painting tends to serene naturalism in his work, without violence of expression. His best qualities are revealed in the luminous altar-piece of *Five bishops of Verona* at S.Nicolò in Verona. According to Zannandreis, Bassetti was the youngest of the Triad of Verona; Longhi's

view, on the evidence of Mancini, was that he and Turchi were of an age. Among the painters then in Verona, he stands out as an original, perhaps the most lively: "only Bassetti, like a painter born, had the strength to fight free of the trappings of Renaissance learning, which no longer served any useful purpose, and return unadorned to the land that bore him" (Longhi, 1928).

His activity in Verona assuredly influenced other local painters, for instance Dionisio Guerri.

He died in Verona, in the year 1630.

PRINCIPAL WORKS

Avesa (Verona), S.Maria della Camaldola, *Birth of the Virgin;*
Alcenago, Parish church, *SS.Peter and Paul with a bishop;*
Munich, Art gallery, *Martyrdom of St. Vitus;*
Rome, Borghese gallery, *Pietà;*
Rome, Quirinal palace, *Frescoes* in the "Sala regia";
Verona, Civic museum, *St. Thomas' unbelief* (1627); *Madonna in glory with Apostles* (1628), etc.

ESSENTIAL BIBLIOGRAPHY

Zannandreis, *Vite dei Pittori Veronesi*, Verona, 1891;
Trecca G., *Note per la biografia dei pittori veronesi*, in Atti dell'accademia . . . di Verona IV, XI, 1910;
Longhi R., *Il trio dei veronesi: Bassetti, Turchi, Ottino*, in "Vita artistica", 1926;
De Logu G., *Pittura Veneziana* etc., Bergamo, 1958;
Zampetti P., *Bassetti*, in "Catalogo Mostra del Seicento", Venice, 1959;
Ottani A., Marcantonio Bassetti, in "Arte Antica e Moderna", Bologna, 1964;
Donzelli-Pilo, *Il Pittori del Seicento Veneto*, Florence, 1907.

## BECCARUZZI FRANCESCO

A painter from Conegliano, perhaps a pupil of Cima. The year of his birth is not known precisely, but would date from the end of the fifteenth century. His first signed work is the *Madonna* in the church of S.Parisio monastery, Treviso, of 1527. He went to Treviso from his birth-place and settled down there. In 1544, Lorenzo Lotto was sent to value *Our Lady of the Assumption* which he had painted and which is extant in the church at Valdobbiadene. The date of his death is uncertain but must be placed later than 1545, the year of his last known work.

Beccaruzzi is a painter at provincial level, of little creative power but fitting into the framework of the rich and complex Veneto art world of the time, using hints and touches from Pordenone Titian, Bassano and other contemporary artists of higher calibre than him. His portraits are of some note. His best work is *St. Francis receiving the Stigmata*, revealing the lesson he had learnt from Giorgione, particularly in respect of the broad landscape setting.

PRINCIPAL WORKS

Bergamo, Carrara gallery, *Portrait of a gentlewoman;*
Budapest, Fine arts museum, *Madonna;*
Castelfranco, S.Liberale, *Joachim and Anna;*
Valdobbiadene, Parish church, *Our Lady of the Assumption* (1544);
Venice, Accademia gallery, *St. Francis receiving the Stigmata and saints* (1545).

ESSENTIAL BIBLIOGRAPHY

Federici D. M., *Memorie trevigiane* etc., Venice, 1803;

Moschini G. A., *Guida per la città di Venezia* etc., Venice, 1815;

Botteon, F., *Della Vita e delle opere di Francesco Beccaruzzi*, in "Nuovo Archivio Veneto", 1913;

Berenson B., *Italian Pictures of the Renaissance*, Venetian School, London, 1957;

Palmegiano M. M., *Beccheruzzi Francesco*, in "Dizionario biografico degli Italiani", VII, Rome, 1965.

## BELLINIANO VITTORE

Vittore di Matteo took the name of Belliniano in token that he was a pupil and follower of Giovanni Bellini. The date of his birth is not known and the first reference to him comes in 1507 when named, in fact with Giovanni Bellini, as at work on paintings for the halls of the ducal palace in Venice. These works were lost in that century, as a result of the terrible outbreaks of fire which ravaged the exceptional building.

In 1508, again the indication comes from his master, he served on the committee appointed to appraise the work done by Giorgione in that year for the facade of the Fondaco dei Tedeschi. Signed and dated works from his hand follow to the final one, for which he gained the most fame, namely the *Martyrdom of St. Mark*, done for the Scuola of the saint. The piece was of large dimensions and had been assigned to Gentile Bellini, and from him passed to Giovanni but when Giovanni died in 1526, it was done by Belliniano, 1526–8 and signed by him. The original drawing for the great work must go to Gentile and the extent of the collaboration from Giovanni cannot be ascertained; it is plain that a great deal of the actual task of painting was carried out by Belliniano. His figure as it emerges from his work, on the second plane, indicates ties not only with Bellini but other painters in the narrative tradition such as Carpaccio. He never came to the front rank, following changes of taste but lacking a pre-eminently original contribution in terms of creativity. There are overtones from Giorgione and Sebastiano Veneziano (del Piombo) also implicit in his work.

PRINCIPAL WORKS

Bergamo, Carrara gallery, *Young man praying before a Crucifix* (1518);

Heidelberg, Von Foerster coll., *Young man with a beard* (1521);

Spinea (Venice), Parish church, *Coronation of the Virgin, and saints* (1524).

ESSENTIAL BIBLIOGRAPHY

Venturi L., *Origini della Pittura Veneziana*, Venice, 1907;

Crowe-Cavalcaselle, *A History of Painting in North Italy*, ed. Borenius, London, 1912;

Venturi A., *Storia dell'Arte Italiana*, VII, 4, Milan, 1915;

Paoletti P., *La Scuola Grande di S.Marco*, Venice, 1929;

Marle (van) R., *The Development of the Italian Schools of Painting*, XVII, 1935;

Gamba G., *Giovanni Bellini*, Milan, 1937;

Zampetti P., *Una veduta cinquecentesca del Duomo di Ancona*, in "Le Arti", 1942;

Moschini-Marconi S., *Gallerie dell'Accademia di Venezia*, I, Rome, 1955;
Berenson B., *Italian Pictures of the Renaissance*, I, Venetian School, London,
        1957.

## BELLO MARCO

A pupil and collaborator of Giovanni Bellini, references to him are few and far between. In 1511 he was in Udine and remained there until 1523, the year in which he died. He married the daughter of Domenico da Tolmezzo, a sculptor and painter of the Friuli. It is apparent that prior to his journey to Udine, this artist—the son of a Venetian—had long lived in the city of the Lagoons, working in association with Giovanni Bellini. Indeed, the *Circumcision* of Rovigo, a rare signed work, he subscribed as a follower of Giovanni Bellini. This work appears closely related to the work by the master on the same subject, now in the National Gallery, London.

Recent critical work has sought to clarify the personality of Marco Bello, disassociating him from Marco Marziale with whom he had been confused, owing to a remark of Crowe and Cavalcaselle. The *Madonna and Child* of the State gallery in Stuttgart, which is signed, repeats a topic of Bellini (also used by Lotto in the analogous work, Naples museum). In Stuttgart gallery is another work, attributed to him, with similar iconography.

The personality of this artist emerges fairly well from these paintings, a strict follower but by no means a mediocre one of Bellini, perhaps a collaborator of his too, as recently asserted by Gibbons. He remained strictly loyal to the poetic world of his master, shewing notable chromatic sensitivity and a sustained compositional manner. The works assigned to him obviously belong to a comparatively early period, whereas his later work, which was done in the Friuli, is less well known.

Other works assigned to him are the *Madonna and child* of S.Trovaso church in Venice, and an analogous picture in the Schrafl collection, Zurich.

### ESSENTIAL BIBLIOGRAPHY

Lanzi L., *Storia pittorica* etc., III, 1809, Bassano;
Crowe-Cavalcaselle, *A History of Painting* etc., ed. Borenius, London, 1912;
Berenson B., *Italian Pictures of the Renaissance*, I, Venetian School, London,
        1957;
Gibbons F., *The Bellinesque Painter Marco Bello*, in "Arte Veneta", 1962;
Semenzato C., in "*Dizionario biografico degli Italiani*", Rome, 1965, *ad
        vocem*.

## BISSOLO PIER FRANCESCO

Born in Venice (or Treviso) in the second half of the fifteenth century. In 1492 he was assisting Giovanni Bellini with the works for the "Sala del Maggior Consiglio", Palazzo ducale. References to him are very few. He worked in Venice and the environs. In 1540 he did some work in Palazzo ducale. He left some signed works in the churches of Venice and the Veneto. He died on 20 April 1554.

Bissolo is an avowed painter after the style of Bellini. He followed his master's compositions and painting manner, at times obsequiously so. As the years went by, he responded like all the other painters of the time to the influence of Giorgione, but learnt from other artists as well, for instance from Carpaccio, Palma il Vecchio and Catena.

Undoubtedly a minor figure, following the lead of artists greater than he was. His compositions lack the quality of spirit and sprightliness; colour is at first smooth and firm but he then uses

shading to the point of making the figures indistinct and inert. On the fringes of the great painting of the time and certainly in the wake of progress, especially after the flowering of the early decades of the sixteenth century, Bissolo may nevertheless be classed with those who helped to spread the art of his day and age, often felicitously; in particular, his sensitivity to landscape may be noted.

PRINCIPAL WORKS

Lagosta (Dalmatia), Madonna in Campo church, *Altar-piece* of the Madonna enthroned with saints and the donor Bonini (signed, 1516);

London, National gallery, *Madonna and child* with SS.Paul and Catherine;

S.Floriano (Treviso), Parish church, *Madonna enthroned* with four saints (1528);

Treviso, Duomo, *Altar-piece* (signed);

Venice, Accademia gallery, *Presentation in the temple* (signed);

Venice, S.Giovanni in Bragora, *Triptych* with SS.Andrew, Martin and Jerome.

ESSENTIAL BIBLIOGRAPHY

Ridolfi C., *Le Maraviglie dell'Arte*, Venice, 1648 (ed. Hadeln, 1914);

Zanetti L., *Della Pittura Veneziana*, Venice, 1771;

Lanzi L., *Storia Pittorica* . . . Bassano, 1818;

Venturi L., *Le origini della Pittura Veneziana*, Venice, 1907;

Gronau G., in Thieme-Becker K. L., under appropriate heading, Leipzig, 1910 with bibliography to that date;

Venturi A., *Storia* . . . Milan, 1915, VII, 4;

Moschini-Marconi S., *Gallerie dell'Accademia di Venezia*, Rome, 1955;

Berenson B., *Italian Pictures* . . . I, Venetian School, London, 1957.

# BOLDRINI NICOLÒ

An artist from Vicenza, active in Venice as an engraver of woodcut illustrations and also specialising in chiaroscuro with water-colour and brush. His reputation depends on his technical ability, of no mean order, as he strove to interpret the manner of Titian, thus imparting to the art of the wood-cut a pictorial sensitivity not achieved with this technique before.

In the *Venus and Cupid*, dated 1566, the artist engraves from a Titian subject and succeeds in obtaining pictorial effects to some extent; the same holds true of the *Adoration of the Shepherds*, again from a Titian original, and a topic repeated thereafter by Bassano in a noted work.

The importance of Nicolò Boldrini lies in his role as interpreter, in the field of engraving, of the manner of Titian.

ESSENTIAL BIBLIOGRAPHY

Ridolfi C., *Le Meraviglie dell'Arte* (1648), ed. Hadeln, I, 1924;

Baseggio, *Intorno a tre celebri intagliatori in legno vicentini*, Bassano, 1893;

Pittaluga Mary, *L'incisione italiana del Cinquecento*, Milan, 1928.

# BONIFAZIO VERONESE (de Pitati)

Born in Verona about 1487, he probably went to Venice as a young man, along with his father. He is documented in Venice from 1528, remaining there until 1553, the year he died.

After an elementary stage in Verona, probable but not proven, the painter joined the studio of Palma il Vecchio; some say he also collaborated with him. At least, he learnt the latest tone painting, that is luminous colouring. Bonifazio's early works indicate he was abreast of the developments under Titian, who after the death of Giorgione rose to be the key figure in Venetian art. But Bonifazio enjoyed some fame of his own and was kept busy on commissions as a result. In 1530 he began the cycle of paintings for Palazzo dei Camerlenghi; in 1553 he signed his name to a work for the Scuola dei Sartori.

Bonifazio was very much aware of streams of art outside the Lagoon area. After 1530, elements from Mannerist art may be distinguished in his work. Mannerism had been gaining ground, especially after artists practising this style fled Rome when the city was sacked (1526) by the German mercenaries. Instead of paste-like painting, creative of mood, Bonifazio's work becomes more open-textured and articulate, enriched by a new narrative manner which became the hallmark of his character.

The most significant part of his career may be said to lie between the years 1530 and 1540. Untrammelled progress towards a new sensitivity which he achieved, became known and acceptable to a younger set of artists, to wit Bassano, Lo Schiavone, Tintoretto; he thus contributed to their formative period. Some works, like the *Miracle of the Loaves and Fishes* and that of the *Manna from Heaven* precede and perhaps are concomitant with the narrative manner as understood of Bassano. Historians of the sixteenth and seventeenth centuries held the personality of this artist in high esteem (Boschini put him on the same plane as Titian). Subsequently, his merits were scaled down and indeed he became an indistinct figure until Ludwig put the score right again. Of late years, the importance of his work has been newly understood, also in relation to developments of style in Venetian painting towards mid-sixteenth century. In this context, the ten year period between 1530 and 1540 assumes fundamental significance in tracing the evolutionary path of the Venetian school as it diverged from the classical ideals which aroused such reverence in the early decades of that century. Bonifazio was then overtaken by those who had learned from him and faded from the limelight into the shadows.

PRINCIPAL WORKS

Budapest, Fine arts museum, *Allegories of Summer and Winter; Spring and Autumn;*
Dresden, Art gallery, *The Finding of Moses; The Adoration of the Shepherds;*
Florence, Palazzo Pitti, *Rest on Flight; Christ among the doctors;*
London, National gallery, *Sacra conversazione; The Concert* (? begun by Palma il Vecchio);
Milan, Brera, *The Finding of Moses;*
Rome, Borghese gallery, *Return of the Prodigal Son;*
Venice, Accademia gallery, *Sacra conversazione; Madonna and saints* (1553); *The Rich Man's Feast; The Massacre of the Innocents; Miracle of the Loaves and the Fishes; Manna from Heaven;*
Vienna, Kunsthistorischesmuseum, *Triumph of Chastity; Triumph of Love.*

ESSENTIAL BIBLIOGRAPHY

Vasari G., *Le Vite* etc., Florence, 1550 and 1568;
Ridolfi C., *Le meraviglie dell'Arte* etc., Venice, 1648;
Boschini M., *La carta del navegar pittoresco*, Venice, 1660;
Zanetti A. M., *Della Pittura Veneziana*, Venice, 1771;

Ludwig G., *Bonifazio de Pitati da Verona*, in "Jahrb.d.Könl. preuss.Kunst-
  samm.", 1901;
Venturi A., *Storia dell'Arte Italiana*, IX, 3, Milan, 1928;
Berenson B., *The Italian Painters of the Renaissance*, Oxford, 1930;
Westphal D., *Bonifazio Veronese*, Monaco, 1931;
Pallucchini R., *La Pittura Veneziana del Cinquecento*, II, Novara, 1944;
Longhi R., *Viatico*, Florence, 1946;
Pallucchini R., *La giovinezza del Tintoretto*, Milan, 1950;
Faggin Giorgio T., *Bonifazio ai Camerlenghi*, in "Arte Veneta", 1963.

## BORDONE PARIS

Born at Treviso in 1500, he accompanied his widowed mother to Venice in 1508, where he died in 1571. A pupil of Titian according to Vasari, who had first-hand evidence about him for inclusion in *The Lives*, he subsequently came within the orbit of late Giorgione. In 1521, he frescoed a biblical episode, *Noah and his sons*, for the Loggia di Vicenza, almost competing with Titian; it was destroyed in 1539. Between 1535 and 1540 he was probably living in Lombardy. Later, he went to the court of France and to Augsburg in Bavaria. With a well-known reputation, he then settled in Venice, working for noble patrons like Maria of Austria, Governor of the Low Countries, Sigismund Augustus king of Poland and others.

The *Madonna enthroned with two saints*, Tadini di Rovere gallery, may be the oldest of the artist's works extant; the fundamentals of his vocabulary in terms of art are readily appreciable, further to the example of Titian and Giorgione. As Pallucchini observed, he "interpreted tonal colour in a more sumptuous manner, his drapes and fabrics as it were crushed as they catch the light".

Later, he became aware of Lotto (especially in portraits, which often show him to the best advantage) and of Pordenone from whom he derived a certain grandeur of scale as may be seen in the *Baptism* of the Brera and other works. The development of his style led him finally to a formal rigidity, indicative of Mannerist art as practised in France. In the *Fight of the gladiators*, an echo may be found of the frescoes at Fontainebleau.

In former times, he was highly rated but the present tendency is to qualify his achievement, according to period, youthful and mature. The former shows adherence to Giorgione as transmitted perhaps by Titian, expressing itself in lyrical forms which are most effective; in the latter an involutionary process is at work and there is a falling off, as in the *Last Supper* in the church of S.Giovanni in Bragora, Venice, becoming "extremely and in essence rhetorically Mannerist". Canova remarked that his genius "inclined to the elegiac and melancholy; Paris Bordon was at the same time drawn to intellectual over-refinement. The diversity of these two streams, on occasion directly antithetical to one another, produced his singular and by turns striking output".

PRINCIPAL WORKS

Genoa, Balbi di Piovera coll., *Portrait of a gentleman* (1537);
Glasgow, Corporation art gallery, *Sacra conversazione* with SS.Jerome, Anthony Abbot and donor; *Sacra conversazione* with SS.Baptist, Magdalen and Liberale;
Milan, Brera gallery, *Holy Family, St. Anthony and devotee; The Seduction; The Baptism of Christ;*
Rome, Vatican, *St. George and the dragon;*
Venice, Accademia gallery, *Fisherman and doge.*

ESSENTIAL BIBLIOGRAPHY

Michiel M., in F. Morelli, *Notizie d'opere del disegno*, Bassano, 1800;
Vasari G., *Vite . . .* 1560;
Boschini M., *Ricche Miniere*, Venice, 1644;
Boschini M., *La carta del navegar pitoresco*, Venice, 1660;
Zanetti A. M., *Della Pittura Veneziana . . .* Venice, 1771;
Schaffer S., in Thieme-Becker K. L., under appropriate heading, Leipzig,
 1910, with bibliography;
Venturi L., *Giorgione e il Giorgionismo*, Milan, 1913;
Venturi A., *Storia . . .* Milan, 1928, IX, 3;
Pallucchini R., *Pittura Veneziana del Cinquecento*, Bergamo, 1944;
Pallucchini R., *Cinque Secoli di Pittura Veneziana*, Venice, 1945;
Longhi R., *Viatico per Cinque Secoli di Pittura Veneziana*, Florence, 1946;
Zampetti P., *Giorgione e i Giorgioneschi*, Venice, 1955;
Berenson B., *Italian Pictures . . .* I, Venetian School, London, 1957;
Canova G., *Paris Bordone*, 1964 (with good bibliography).

## BRUSASORCI DOMENICO

Born at Verona in 1516 (where he died in 1567), he belongs to the notable group of artists working in this city, represented in chief by Paolo Caliari, called Il Veronese.

Brusasorci was a follower of Caroto, a painter in the Venetian provincial tradition, to which he avoided succumbing. Indeed, he expanded his horizon to comprise the work of Titian, during his sojourn in Venice, also Emilian mannerist art and that of central Italy, particularly of Giulio Romano whom he met in Mantua when invited there by the Gonzaga to work in the Duomo.

Vasari mentioned him in the life of Michele Sanmicheli, an architect of Verona, and praised him highly. But his reputation has had its ups-and-downs since, some writers thinking a great deal of him, others bringing him to provincial level. Berenson expounded his merits, in creating the new outlook whereby colour became almost entirely independent of line and plastic form; later, however, he revised his estimate and awarded the palm for this step forward on the road to modern art, to Veronese.

In truth, Brusasorci was an able and sensitive artist, within the bounds of the manner and aspirations of the time. He achieved a spontaneous mode of expression; his painting detaches itself from Titian's tonal work on the one hand and Tintoretto's play of light, while adhering if at all to the fashion of Veronese, the difference lying in a more reserved note. His colours are harmonised without alien violence. Undoubtedly a relationship may be distinguished between himself and Paolo; with the years, he approached the master's concept of art more closely though standing a little apart owing to the complex influences of his formative years.

Among his best-known works may be cited the lost *Entry of Charles V and Clement VII into Bologna*, a fresco at Palazzo Lisca, Verona; *Bathsheba* (Uffizi, Florence); *Portrait of a dignitary of the church* (Ca' d'Oro, Venice); the *Adoration of the Magi* (Verona, Civic museum) and many *altar-pieces* for the churches of Verona, Mantua and elsewhere.

His son Felice (1540–1615), also recorded by Vasari, was a noteworthy painter, subject to re-appraisal by modern experts. The most successful of his works are the altar-pieces for the church of Madonna di Campagna, Verona: the *Flagellation* and the *Deposition*. Arslan stated that in his final period traces might be found anticipating the "macchia" style proper to Bassetti (q.v.) and other artists of Verona in the seventeenth century.

Another son who was a painter—Giambattista—was born perhaps in 1544 and migrated in the direction of Germany, about 1586.

ESSENTIAL BIBLIOGRAPHY

Vasari G., *Le Vite* etc., ed. Milanesi, Florence, 1908;
Ridolfi C., *Le Meraviglie dell'Arte* (ed. Halden), Berlin, 1924;
Venturi A., *Storia dell'Arte*, IX, 4, Milan, 1929;
Berenson B., *The Italian Painters of the Renaissance*, Oxford, 1932 and London, 1954;
Arslan W., *Brevi appunti su alcune opere d'arte a Bolzano e a Riva*, Trent, 1937;
Zava Boccassi Franca, *Profilo di Felice Brusasorci*, in "Arte Veneta", 1967.

## BUONCONSIGLIO GIOVANNI (Il Marescalco, called)

Born at Montecchio Maggiore (Vicenza) about 1470, he went to Vicenza and thence to Venice, arriving at the end of the century. He stayed till he died, some time between 1535 and 1537. Buonconsiglio first learned from Montagna on the evidence of some early works, of slight interest. He capped his formative period with the work which is the crown of his career: the *Pietà*, now in the Civic museum, Vicenza, signed but not dated. Various influences may be distinguished in this piece, and a knowledge of Bellini and indeed of Cima da Conegliano may not be excluded. Longhi held there might be some connection with the early work of Lorenzo Lotto. Varied as the source components may be, the fact remains that the Vicenza *Pietà* reveals in Buonconsiglio a personality in his own right: the composition of the painting is original, the colour dominance cold and metal-like; the combined result is profoundly tragic in feeling, visibly conveyed by the work itself.

Thereafter, the artist favoured a more composite manner; the touch is less personal and the formal heights attained in the Vicenza masterpiece elude his grasp. So few of his works are dated, the development of his style cannot be traced. There is, however, extant a fragment of an altar-piece, dated 1497, with *SS.Benedict, Thecla and Cosmas* (Accademia gallery, Venice), akin to the Vicenza *Pietà*, strictly aligned to Montagna's style, but with something of Cima da Conegliano.

The two *altar-pieces* of S.Pietro di Montecchio Maggiore (1519) and Montagnana town hall, reveal the painter pursuing an outdated manner, with none of the poetic inspiration so present in the *Pietà* di Vicenza, several times referred to above.

PRINCIPAL WORKS

Breslau, Museum, *Madonna enthroned with SS.Stephen and John*;
Cornedo Vicentino, Parish church, *Madonna Immacolata with SS.Peter and Joseph* (1497);
Rome, Capitol museum, *Portrait of a man*;
Vicenza, Civic museum, *Madonna and saints* (1502).

ESSENTIAL BIBLIOGRAPHY

Crowe-Cavalcaselle, *A History of Painting* etc., ed. Borenius, London, 1912;
Borenius T., *I Pittori di Vicenza*, Vicenza, 1912;
Venturi A., *Storia dell'Arte Italiana*, VII, 4, Milan, 1915;
Longhi R., *Viatico per Cinque Secoli*, Florence, 1946;
Moschini-Marconi S., *Le Gallerie dell'Accademia di Venezia*, I, Rome, 1955;
Berenson B., *Italian Pictures of the Renaissance*, I, Venetian School, London, 1957;
Barbieri F., *Il Museo Civico di Vicenza*, I, Venice, 1962 (with good bibliography to that date).

## BUSATI ANDREA

A painter of the school of Cima da Conegliano, documented from 1503 to 1529, the year he signed his will. His name is linked with few paintings, among them *St. Mark in glory with SS. Andrew and Francis.* The work has been much restored, as reported by Edwards in 1783. It was in Palazzo dei Camerlenghi in Venice but was moved to the Accademia gallery during the Napoleonic period. Cima's influence must not be taken to exclude pointers from Bellini, like the figures of the St. Francis "copied from the Berlin triptych" (Moschini-Marconi S., 1955). Experts are not agreed on the date of this work; Cavalcaselle put it at 1531, not without evidence. At the National gallery in London is a *Pietà* (No. 3084) which is signed and came from the Manfrin coll., Venice; for a full account, see Davies (1961).

Busati, a minor figure, had two brothers who were painters: Luca Antonio and Francesco. Of the latter, a *Pietà* (signed) exists in Sarasota museum. He also appears to have been associated with the art of Cima da Conegliano.

ESSENTIAL BIBLIOGRAPHY

Moschini G. A., *Guida per la città di Venezia*, Venice, II, 1815;
Crowe-Cavalcaselle, *A History of Painting in North Italy*, London, 1871 (ed. Borenius, 1912);
Davies M., *National Gallery Catalogues*, The Earlier Italian Schools (ed. 1951 and 1961), London;
Berenson B., *Italian Pictures of the Renaissance*, I, Venetian School, London, 1957.

## CAMPAGNOLA DOMENICO

Born at Padua in 1500, an engraver and painter; he was the pupil and collaborator of Giulio (q.v.). The first dated engravings are of 1517, though in *The Concert* of his master some expert opinion has discerned his hand. Later he approached Pordenone, as is apparent in the *Madonna and child with saints;* lastly, he was drawn to the Roman Mannerist school, as in the *Martyrdom of St. Catherine.* In fact, Domenico soon drew away from the subtle refined manner of his master, to pursue a more solid and monumental concept in terms of composition.

As a painter, his activity is also complex. Certain *frescoes* of the Scuola del Santo in Padua have been assigned to him, though so adversely affected by age as to render them hard to assess. The *Miracle of the Drowned Woman* would seem to be his. In 1531 he painted various *figures* now in the Accademia gallery, Venice, for the church of S.Maria del Parto. In 1534, he was working in the Scuolo di S.Rocco. The *Baptism of St. Justina* is of 1562 (Civic museum, Padua); clearly Titianesque in inspiration, it is reminiscent of the Ca' Pesaro altar-piece. His last work, dated, is the *S.Omobono altar-piece* done at Padua in 1581. Nothing is known about him after that.

Domenico was eclectic as an artist, influenced by Titian but also by Romanino and Moretti. It is a moot point whether he fathered the Prague museum *altar-piece.*

ESSENTIAL BIBLIOGRAPHY

Pittaluga M., *L'incisione italiana del Cinquecento*, Milan, 1928;
Venturi A., *Storia dell'Arte Italiana*, IX, 3, Milan, 1928;
Fiocco G., *Campagnola Domenico*, in "Enciclopedia Italiana", 1930 (with bibliography to that date);
Dodgson C., *Old Master Drawings*, 1934;
Suida W., *Miscellanea Tizianesca*, in "Arte Veneta", 1952;

Klauner F., *Venezianische Landschaftsdarstellung von Jacopo Bellini bis Tizian*,
in "Jahrbuch der Kunsthistorischen Sammlungen in Wien", 1958;
Weisz De Veali S., *Campagnola Domenico*, in "Dizionario Enciclopedico",
Turin, 1955;
Muraro M., *Un'Adorazione dei Pastori affrescata da Domenico Campagnola a
Vicenza*, in "Emporium", 1959.

## CAMPAGNOLA GIULIO

Born at Padua in about 1482, he was an engraver and painter. He was in addition a man of letters
and a musician; he frequented Renaissance circles. In 1498, he was at the D'Este court in Ferrara; in
1507, in Venice. In the year 1514 he was named in the will of Aldus Manutius, the printer and
publisher of fame, active in Venice. Thereafter, nothing more is known about him.

His activity as a painter is uncertain but was not of outstanding character. Some of the frescoes rela-
tive to the *Life of the Virgin* in the Scuola del Carmine at Padua have been assigned to him. Simi-
larly, the *Judgment of Solomon* in the Uffizi gallery has been ascribed to him though it belongs more
properly to Giorgione (q.v.). There is no doubt Campagnola was close to the great painter of
Castelfranco and, together with him, was part of the movement producing the great cultural and
artistic revival which took place in the early years of the sixteenth century, in the civilisation of
Venice.

As an engraver, Giulio Campagnola has some standing. The earliest works clearly denote contact
with the manner of Mantegna and indeed of Dürer. Later on, under Giorgione's influence, he felt
it necessary to render the incisory material less harshly; he used a pointillist technique which was
then new, to make the engraving softer and to heighten its pictorial quality through more sensitive
treatment of light; in this way, he was trying to meet the challenge presented by Giorgione's new
tone-experiments.

Mention may be made of his *Young man with a skull*, the *Old Shepherd*, followed by *The Astrologer*
(1509) and a small number of other works in which the influence of Giorgione is more readily
apparent, as in the *Boy with cats* and also the *Concert champêtre*.

Domenico was his pupil and may have collaborated with him in respect of a limited number of
works.

### ESSENTIAL BIBLIOGRAPHY

Venturi L., *Giorgione e il Giorgionismo*, Milan, 1913;
Fiocco G., *La giovinezza di Giulio Campagnola*, in "L'Arte", XVIII, 1915;
Venturi A., *Storia dell'Arte italiana*, IX, 3, Milan, 1928;
Pittaluga M., *L'incisione italiana del Cinquecento*, Milan, 1928;
Suida W., *Tizian die beiden Campagnola und Ugo da Carpi*, in "Critica
d'Arte", 1936;
Weisz-De Veali S., *Campagnola Giulio*, in "Dizionario Enciclopedico",
Turin, 1955;
Tietze H. and E., *L' "Orfeo" attribuito al Bellini della National Gallery di
Washington*, in "Arte Veneta", 1949.

## CAPRIOLI DOMENICO

Born in 1494, he died in 1528 killed by the widow of his father-in-law, Pier Maria Pennacchi.
His activity as a painter is linked with the Giorgionesque manner, interpreted in a sense at once
provincial and retrogressive. More than to the master himself, he looked to other Giorgionesque

painters, such as Domenico Mancini and Pordenone. In 1512 he signed the portrait of the Grafton coll. Of his few works, the *Nativity* (1518) of Treviso museum may next be cited. Fiocco assigned to him the *Portrait of a young man* in the Hermitage, Leningrad; according to Berenson, this is a copy of the Grafton portrait.

Caprioli was an artist of mediocre quality. It must be borne in mind, however, that any final assessment of his potential as an artist inclines to the arbitrary, since the works known are few and not always certain. Berenson also ascribed to him, though with some reserve, the *Bravo* and the *Passionate Shepherd*, assigned by others to Giorgione (q.v.).

PRINCIPAL WORKS

> Barnard castle (Durham), *Portrait of Lelio Torelli*, signed (1528);
> London, Duke of Grafton, *Portrait of a young man* with statue of Venus and
>     church in background, signed (1512);
> New York, Pulitzer coll. (formerly), *The Doge Antonio Grimani* before a
>     table covered with a Turkish carpet;
> Treviso, Civic museum, *Adoration of the Shepherds*, signed (1518);
> Treviso, Duomo di S.Pietro, Annunziata chapel, *The Assumption* (1520–3);
> Venice, S.Maria dei Miracoli, *Prophets* on ceiling (with Pennacchi);
> Venice, Count Cini coll., *Gentleman with a beard* against a background of
>     pillars and reliefs;
> Venice, Prince Giovanelli (formerly), *Adoration of the Shepherds* (signed);
> Windsor castle, Royal coll., *Cardinal Domenico Grimani* (1461–1523).

ESSENTIAL BIBLIOGRAPHY

> Cook H., *Some Venetian portraits in English possession*, in "The Burlington
>     Magazine", 1906;
> Venturi A., *Storia dell'Arte Italiana*, IX, 3, Milan, 1928;
> Fiocco G., in "Rivista Italiana di Archeologia e Storia dell'Arte", Rome,
>     1929;
> Longhi R., *Viatico per Cinque Secoli* etc., Florence, 1946;
> Berenson B., *Italian Pictures of the Renaissance*, Venetian school, London,
>     1957.

## CARIANI (Giovanni Busi, called Il)

Born probably at Venice of a family originally from Bergamo, in about the year 1485, he died in Venice some time between 1547 and 1548. In 1509 he was in Venice; later, between 1518 and 1524 he was in Bergamo, then in Venice again the same year, returning to Bergamo once more between 1528 and 1530. It is not easy to establish just where he was trained. Certainly in youth he was conscious, as Berenson observed, of the impact of Giovanni Bellini and Palma, approaching closer to Giorgione at a second stage. He was, however, open to the influence of other painters, like Lotto and maybe Romanino.

His manner is provincial, causing his painting to be less refined that that practised in the area of the Lagoons; there is no doubt of its quality. The absence of youthful works (the Lonno altar-piece done in 1515 has been lost) precludes a clear exposition of his early and formative period. The change of style in the direction of Giorgione probably took place towards 1515; by 1519, the year he dated the Albani family group, his evolution was already plainly effective in that direction. In this work his colour is forceful, rich in dissonance, following a module cherished by the painters of Veneto province.

Some of Cariani's best portraits belong to this epoch, the personality coming across with vividness and immediacy; his subjects were leading personalities of Bergamo.

After 1524 on returning to Venice, there is evidence of some attachment to the manner of Palma, as may be seen in the *Visitation* of the Vienna museum. Also the *Madonna and child* (1520), of the Carrara gallery in Bergamo, is associated with Palma; but in the *Resurrection* of the Brera gallery and dating from the same year, Cariani "shed every trace of Lagoon languor, revealing his true personality, stalwart to the point of drama" (Pallucchini, 1966). Later, his colouring became more flaccid and he reverted to provincial-type formulas, while maintaining tremendous autonomy of expression. especially in portraits.

Berenson assigned to Cariani's youthful period two very well-known works: the *Madonna reading* of the Ashmolean at Oxford and the *Madonna and child in landscape* of the Hermitage, Leningrad. Both have been assigned to Giorgione on some counts, and indeed it was under this ascription that they went on view at the Venice exhibition of 1956.

PRINCIPAL WORKS

> Bergamo, *Christ and the woman taken in adultery*, (copy of the Glasgow Giorgione (?) prior to mutilation); *Giovanni Benedetto da Caravaggio; Lady playing the lute and shepherd asleep; Madonna and donor; The Holy Family;*
>
> Bergamo, Roncalli coll., *Group of young members of the Albani family*, signed (1519);
>
> Bergamo, Suardi coll., *St. Jerome;*
>
> Boston (Mass.), Quincy Adams (formerly), *Gentlewoman at a parapet*, inscribed 'V'. G;
>
> Leningrad, Hermitage, *The Seduction;*
>
> Milan, Brera, *Resurrection* with Jerome, John the Baptist and Ottaviano Visconti with his wife (1520), signed (formerly, Gerli coll.);
> Poldi Pezzoli, *Sacra conversazione* with Jerome, Francis and John, signed G.;
>
> Ottawa, *Nobleman* holding a document with seal (signed);
>
> Venice, Accademia, *Portrait of a man* (half-figure);
>
> Vienna, Kunsthistorischesmuseum, *The Visitation*, with four saints.

PRINCIPAL BIBLIOGRAPHY

> Tassi F. M., *Vite . . .* Bergamo, 1793;
>
> Lanzi L., *Storia pittorica . . .* Bassano, ed. 1818;
>
> Berenson B., *The Venetian Painters*, 1894;
>
> Hadeln D. V., in Thieme-Becker K. L., Leipzig, 1911, with bibliography to that date;
>
> Venturi L., *Giorgione e il Giorgionismo*, Milan, 1913;
>
> Venturi A., *Storia dell'Arte ital.*, Milan, 1928, IX, 3;
>
> Fiocco G., in "Enciclopedia Treceani", with bibl.;
>
> Troche G. V., in "Pantheon", Jan. 1932;
>
> Pallucchini R., *La pittura veneziana del Cinquecento*, Novaro, 1944;
>
> Longhi R., *Viatico per Cinque Secoli di Pittura Veneziana*, Florence, 1946;
>
> Zampetti P., *Giorgione e i Giorgioneschi*, Venice, 1955;
>
> Berenson B., *Italian Pictures of the Renaissance*, Venetian school, I, London, 1957.

# CAROTO GIOVAN FRANCESCO

Born at Verona in about 1480, he was subject from an early age to the influence of Liberale (q.v.) and later of Mantegna and of Bologna painting as represented by Costa and Francia.

To his early period belong the *frescoes* of the Spolverini chapel in Santa Eufemia, with the Raphael series. Later he went to Mantua and Milan, becoming painter to the lords of Monferrato. The Civic museum at Vercelli has a *Lament over the dead Christ* which belongs in point of fact to this phase of his career. During his Lombard period he was influenced by Bramantino first, and then by Luini.

Thus a whole complex of cultural elements dominated Caroto's activity; for all this, the Venetian component was never entirely bypassed, even after assimilating facets of the central Italian Mannerist school, which happened while he was in Mantua, based on the "Raphaelesque vocabulary in terms of composition" (Del Bravo, 1964).

Overall, Caroto may be deemed an artist utterly unable to respect an individuality of his own, as is well seen by surveying his works, so full of contrasts with one another. For distinct originality of subject, his *Boy with puppet* is famous, now in Verona civic museum.

Giovan Francesco had a brother called Giovanni who worked with him. Born in about 1488, he is documented to 1562 and may have died soon after. Variously evaluated as an artist of mutable qualities, he was very much aware of the development taking place over the first half of the sixteenth century, playing his own active part.

Among his works, reference may be made to the *Madonna and saints* (1514) of Verona cathedral and a further *Altar-piece* (1516) in *SS.Peter and Paul*, also at Verona: besides the influence of the local school, considerable autonomy is discernible in his colour language, by nature one of serenity and sweetness. Certain qualities of compactness in structural composition, taken together with his chromatics, have led some expert opinion to view him as a Paolo Veronese before his time.

ESSENTIAL BIBLIOGRAPHY

> Simoni L., *Nuovi documenti sui Caroto*, in "L'Arte", 1904;
> Baron B., Giovanni Caroto, in "The Burlington Magazine", 1910;
> Avena A., *G. F. Caroto e Battista Zelotti alla Corte di Mantova*, in "L'Arte", 1912;
> Bernath M. H., *Giovanni Caroto*, in Thieme-Becker, Kunstler Lexikon, 1912;
> Tea Eva, *Scuola Pittorica Veronese*, in "Madonna Verona", 1915;
> Venturi A., *Storia dell'Arte Italiana*, VII, 3, Milan, 1914; VII, 4, Milan, 1915; IX, 3, 1928;
> Arslan A., *Quattro piccoli contributi*, in "Critica d'Arte", 1938;
> Galletti Camesasca, *Enciclopedia della Pittura Italiana*, Milan, 1950;
> Del Bravo Carlo, *Per Giovan Francesco Caroto*, in "Paragone", 1964.

# CASELLI CRISTOFORO, DA PARMA, (called Il Temperello)

Born at Parma (and also known as Cristoforo de' Temperelli) in the latter half of the fifteenth century (perhaps in the year 1461), the first reference to him dates from 1488. In that year he was present in Venice, the city where he learned to be a painter. In fact, his early works shew him to be influenced by Giovanni Bellini, to the extent that Berenson deemed he might well have belonged to that master's studio. Like all the artists of his generation, Caselli also felt the influence of other artists such as Antonello and Cima da Conegliano, at the outset of his career; later he came within the orbit of the Vicenza school, due to his return to Parma at the turn of the century.

He spent a long while working in the ducal palace, Venice, along with Alvise Vivarini and other artists; but his work there has been lost, a similar fate having overtaken the organ doors for the Chiesa del Carmine. The triptych he painted for S.Cipriano on Murano is extant, signed and dated (1495); it depicts the *Madonna and child with donor, SS.Benedict and Cyprian* and in the lunette, the *Eternal Father imparting His blessing*.

The artist's gradual weaning away from Venetian modes took place in Parma, and may be observed in the *Altar-piece* for the cathedral there. This was followed by the frescoes for the Montini chapel, again in Parma cathedral, together with other works. His death dates from 1581.

Temperello is praiseworthy in that he propagated, at Parma and through Emilia, the Venetian trend in painting, with nobility of form which he was capable of adapting as a result of contact with the art of Montagna to the local manner, that is: treating form in a constructive sense, with stress on line and chromatic flair.

ESSENTIAL BIBLIOGRAPHY

Ridolfi C., *Le Meraviglie dell'Arte*. Venice, 1648;

Lanzi L., *Storia Pittorica dell'Italia*, Bassano, 1789;

Ricci C., *La Regia Galleria di Parma*, Parma, 1896;

Thieme-Becker, "Kunstler Lexikon", under appropriate heading, 1912;

Venturi A., *Storia dell'Arte Italiana*, VII, 4, Milan, 1915;

Berenson B., *Venetian Painting in America*, New York, 1916;

Sandberg Vavala E., *Attribution to Cristoforo Caselli*, in "Art in America", 1932;

Berenson B., *The Italian Pictures of the Renaissance*, I, Venetian school, London, 1957.

## CATENA VICENZO

This painter was born probably in Venice about 1470 and died there in 1531. The first references to him date from 1495. Trained in the fifteenth-century manner of Antonello and Cima, his subsequent development led him first into following Giovanni Bellini; when he was already old, he looked to Giorgione whose influence is certain even if shallow. That he was closely linked with the great painter of Castelfranco is revealed by the famous inscription on the back of the *Laura* in Vienna museum: "1506 a di primo Zugno fu fatto questo de man de maestro Zorzi da Chastelfr cholega de Maestro Vizenzo Chaena . . ." ("1506 on the first day of June this was done by the hand of master Giorgio of Castelfr colleague of master Vincenzo Catena").

In his early work, Catena's style is firm, stiff and has a metallic sheen well illustrated by the *Sacra conversazione* of the Accademia in Venice. Subsequently, the influence of Giovanni Bellini enabled him to orientate himself towards modes less chilly: a more lyrical feeling for landscape creeps in. Last, in the *Madonna and saints* of Glasgow gallery, although approaching Giovanni Bellini ever closer, he immerses his figures against a dark ground, keeping their lineaments firm and clearly defined. Catena's art took a new turn, for the first time, in the early sixteenth century. The *Adoration of the Shepherds*, Contini Bonacossi coll., evidences contact with the Giorgione picture on the same theme now in the National gallery, Washington. The brushwork is silken, the landscape lyrical, the colours more limpid: all signs clearly indicative of the new departure. Again, the *Judith* of the Querini Stampalia gallery in Venice, obviously inspired by the one in the Hermitage, shows further how complete was Catena's nearness to the master of Castelfranco. While maintaining a clear colour-register—typical of him as an artist—the Giorgione element in this piece is altogether dominant.

42

In the second decade of the sixteenth century, the artist underwent another phase of development. The masterpiece of Catena's final period is certainly represented by the altar-piece of Santa Maria Mater Domini in Venice: the *Passing of St. Catherine*, where the "soul leaves the body with a sigh and wings away from the world and its sadness, the angel host seeming to surround the soul with brightness" (Venturi).

Catena was a notable portrait painter; in this sphere also, he enjoyed a state of constant development. It carried him from Antonello-like forms (the *Senator* of Vienna museum); in other examples, the tendency was to Lotto (*Count Raimund Fugger*, Berlin museum); in conclusion, after Giorgione (the *Gentleman* of the Polli coll., Milan and perhaps the *Portrait of a man* of the Cini coll., Venice).

According to Robertson (1954), the artist long remained associated with the fifteenth-century manner; only in the terminal phase of his activity, that is to say after 1520 (the date of the altar-piece above-mentioned), did he enlarge his manner to embrace Giorgione and Titian's new departure. This may seem a rather unlikely tenet if, as pointed out at the start, his friendship with Giorgione goes right back to the year 1506.

PRINCIPAL WORKS

Venice, Accademia, *Sacra conversazione;* Correr, *Madonna enthroned with saints;*
Budapest, Museum, *Madonna and child with saints and donor in act of prayer;*
New York, Kress coll., *Christ and the woman of Samaria at the well;*
Venice, Querini Stampalia, *Judith;*
Washington, National gallery, *Portrait of a gentlewoman;*
Florence, Contini Bonacossi coll., *Adoration of the Shepherds;*
Milan, Polli coll., *Portrait of a gentleman.*

ESSENTIAL BIBLIOGRAPHY

Vasari G., *Le Vite* etc., Florence, 1568;
Zanetti A. M., *Della Pittura Veneziana . . .* , Venice, 1771;
Michiel M., in F. Morelli, *Notizie d'opere del disegno*, Bassano, 1800;
Ridolfi C., *Maraviglie dell'arte*, Venice, 1648 (ed. Hadeln, 1914);
Venturi L., *Le Origini della Pittura Veneziana*, Venice, 1907; ibid. *Giorgione e il Giorgionismo*, Milan, 1913;
Hadeln D. V., in Thieme-Becker, K.L., Leipzig, under appropriate heading, 1912, with bibliog. to that date;
Berenson B., *Italian Pictures of the Renaissance*, Oxford, 1932;
Van Marle R., *The Development . . .* 1936, XVIII;
Pallucchini R., *Cinque Secoli di Pittura Veneta*, Venice, 1945;
Longhi R., *Cinque Secoli di Pittura Veneziana*, Florence, 1946;
Fiocco G., *Pitture Veneziane ignote del Museo di Varsavia*, Arte Veneta, 1947;
Robertson G., *Vincenzo Catena*, Edinburgh, 1954;
Moschini V., *Vincenzo Catena*, The Burlington Magazine, 1955;
Pignatti T., *Vincenzo Catena*, in Arte Veneta, 1955;
Zampetti P., *Giorgione e i Giorgioneschi*, Venice, 1955;
Moschini V.-Marconi S., *Gallerie dell'Accademia di Venezia*, Rome, 1955;
Gamulin Grgo, *Due dipinti ignoti o poco conosciuti*, in Arte Veneta, 1956;
Gilbert C., *A drawing by Catena*, in The Burlington Magazine, 1956;
Berenson B., *Italian Pictures of the Renaissance*, London, 1957.

## CAVAZZOLA PAOLA (called Il Morando)

Born in Verona 1486, he was a pupil of Francesco Bonsignori and Francesco Morone. Later, he was influenced by Gianfrancesco Caroto. He died in 1522, at a fairly early age, when his personality was disclosing an artist of some power.

In early works, like the *Madonna and child* from the Cagnola alla Gazzada coll., Milan, he was able to impart a plastic quality to what he painted, with precise and forceful outlines derived from Bonsignori; while from Morone he got his intense and pellucid colouring. Later on, his horizon widened to take in elements from Venice and from Rome.

As a portrait painter he was vigorous and perceptive. Expert opinion in some quarters has assigned to him the *Young warrior with page* of the Uffizi; according to others, it belongs to Romanino; while others yet again give it to Giorgione. The issue remains unresolved, concerning as it does the tissue of relationships then current as between the schools of Verona, Brescia and Venice.

PRINCIPAL WORKS

> Bergamo, Carrara, *Portrait of a lady;*
> Dresden, Gemäldegalerie, *Portrait of a gentleman;*
> Gazzada, *Madonna* (1510);
> London, National gallery, *Madonna and child with angels;*
> Milan, Poldi Pezzoli museum, *St. Anthony of Padua;*
> Verona, Castelvecchio museum, *Madonna in glory and saints* (1522);
> ibid. *Madonna suckling the child;*
> ibid. *Polyptych of S.Bernardino;*
> Verona, S.Bernardino, frescoes, *SS.Nazarius and Celsus*, Chapel of S. Biagio, *Annunciation* (1510).

ESSENTIAL BIBLIOGRAPHY

> Zannandreis, *Vita dei Pittori Veronesi*, Verona, 1891;
> Venturi A., *Storia dell'Arte Italiana*, VII, 4, Milan, 1915;
> Tea E., *Il cromatismo di Paolo Veronese*, in "L'Arte", 1920;
> Richter G. M., *The Portrait of Isabella d'Este by Cavazzola*, in "The Burlington Magazine", 1929;
> Longhi R., *Viatico*, 1946;
> Gamba Carlo, *Il mio Giorgione*, in "Arte Veneta", 1954;
> Riccoboni A., *Giorgione, Cavazzola e Romanino*, in "Emporium", 1955, p. 169.

## CORONA LEONARDO

Born on Murano island in the Venetian lagoon in 1561, he was a follower of Tintoretto and close in painting manner to Palma il Giovane. He belonged to the late Mannerists working in Venice towards the close of the sixteenth century and the beginning of the next. He was endeavouring to carry on the Venetian tradition but it was already a matter of academics without possibility of revival. Given that he was a conformer to the prevailing taste, it may be noted that within these limits he holds the attention by a clear-cut and lively approach to form, achieved by use of chiaroscuro and contrasting passages of light, evidently drawn from Bassano's final phase.

Corona who died in 1605 still comparatively young, may be regarded as the product of an environment where the accent was on letters rather than on art, signifying the crisis undergone by Venetian civilisation at the close of the sixteenth century.

44

PRINCIPAL WORKS

Modena, Estense gallery, *Deposition;*
Murano, Museo vetrario, *Crucifixion;*
Venice, S.Giovanni in Bragora, *Flagellation;* San Fantin, *Crucifixion;*
S.Niccolò dei Mendicoli, *Miracle of the manna* (1590); Ducal palace,
Sala del Maggior Consiglio, *Caterina Cornaro offering the crown of
Cyprus to the Doge;* Ateneo Veneto (Scuola di S.Fantin), Scenes of the
*Passion of Christ* (painted from 1600 to 1605).

ESSENTIAL BIBLIOGRAPHY

Ridolfi C., *Le Meraviglie dell'Arte*, Venice, 1648, II;
Boschini M., *Le ricche minere della Pittura Veneziana*, Venice, 1674;
Lanzi L., *Storia Pittorica dell'Italia*, Bassano, 1789;
Venturi A., *Storia dell'Arte Italiana*, IX, 7, Milan, 1934;
De Logu G., *Pittura Veneziana dal XIV al XVIII secolo*, Bergamo, 1958;
Catalogue: *Mostra della Pittura Veneziana del Seicento*, Venice, 1959;
Ivanoff N., *Il ciclo pittorico della Scuola di S.Fantin*, in "Ateneo Veneto",
1962;
Donzelli-Pilo, *I Pittori del Seicento Veneto*, Florence, 1967.

## DAMINI PIETRO

Born at Castelfranco, probably in 1592 (Ridolfi), he very soon transferred to Padua and there spent his entire life. He died quite young, from the plague in the year 1631. A follower in the early days of Palma il Giovane whose Mannerist approach he appreciated, later on he was attracted by Paolo Veronese. In manner, he adopted well-balanced rhythmical composition and a colour register of his own smoky greyish tones.

Lanzi noted the multiplicity of influences upon this artist and referred to Damini's success in extricating himself from the Mannerists at their most uncompromising, producing a certain creative autonomy and measured rhythms at a period when the tendency in art was to the emphatic manner. Adherence to some of Leandro Bassano's modes has been observed by some authorities. Undoubtedly, Damini had a pictorial vein of his own, a manner at once sensitive and elegaic, though he cannot be said to have achieved the outstanding in quality.

PRINCIPAL WORKS

Asolo, Duomo, *St. Prosdocimus baptising the citizens of Asolo;*
Castelfranco Veneto, S.Maria della Chiesa Nuova, *Marriage at Cana;
Magdalen at Jesus' feet; The Last Supper; Supper at Emmaus* (and other
works);
Cividale del Friuli, National archeological museum, *S.Dominic and the
blessed Benvenuta Boiani;*
Murano (Venice), S.Maria degli Angeli, *Madonna and saints;*
Padua, Duomo, *Crucifixion* (and other works);
Treviso, Civic museum, *The Guardian Angel* (1622);
Verona, Castelvecchio museum, *Martyrdom of St. Stephen.*

ESSENTIAL BIBLIOGRAPHY

Ridolfi C., *Le Meraviglie dell'Arte*, Venice, 1648;
Zanetti M. A., *Della Pittura Veneziana*, Venice, 1771;

Venturi A., *Storia dell'Arte Italiana*, IX, 7, Milan, 1934;

Mariacher G., *La Pittura del Seicento a Venezia*, Exhibition catalogue, Venice, 1959;

Donzelli-Pilo, *I Pittori del Seicento Veneto*, Florence, 1967;

Rizzi Aldo, *Mostra della Pittura Veneta del Seicento in Friuli*, Udine, 1968.

## DE MAGISTRIS GIOVANNI ANDREA & SIMONE

Painters—father and son—working in the Marches in the course of the sixteenth century. Giovanni Andrea was Tuscan in origin and set himself up at Caldarola, soon coming into contact with works by Lorenzo Lotto whose imitator and follower he became. The altar-piece of Pievetorina, a work of 1540, shows the artist taking and reproducing the angel musicians from the Recanati altar-piece by the great Venetian master. In 1553 he sent his son Simone who was then about ten years old or little more, to the school of Lotto at the time when Lotto, old and disillusioned, had retired to Loreto where he was to die in 1556. It was at this juncture that Giovanni Andrea evinced his closest contact with the Venetian master, imitating his late style as may be seen in works of some significance, like those existing in the church of Piampolente (Camerino) and S.Maria di Rio Sacro at Acquacanina (Macerata).

His son Simone was a more notable personality. After his early training under Lotto (it remained with him, though he only stayed with the master a short while), which is basic to his personality as an artist, he welded together influences from the Tuscan Mannerists, producing paintings of a restive and pungent manner with harsh and on occasion violent colour treatments. He entered a period of decadence, more and more pronounced in the late works, carried out in collaboration with his brother Giovanni Francesco and son Solerzio. The last reference to him dates from 1608.

PRINCIPAL WORKS OF SIMONE

Ascoli Piceno, Art gallery, *Madonna del Rosario;*

Fabriano, Art gallery, *The Manger;*

Osimo, Baptistery of the cathedral, *Madonna and saints;*

Spoleto, Art gallery, *Nativity;*

Urbino, National gallery, *Madonna in glory and saints* (with his son Solerzio, 1608).

BIBLIOGRAPHY

Lorenzo Lotto "Il Libro di spese diverse", a cura di P.Z. Venice-Rome, 1969.

## DOSSO DOSSI (Giovanni Luteri, called)

Born at Ferrara about 1480, he was the leading exponent of that school in the sixteenth century, linking it very deeply with the Venetian sphere of influence. The first reference to him comes in 1512, when he was with the Gonzagas in Mantua; in 1516 he was back in Ferrara, where he passed the rest of his days, except for working visits to Mantua again (with Titian) in 1519 and elsewhere. It has been suggested that he went to Rome, in 1519-22. In 1531-2 he undertook several journeys to Trent, to carry out the frescoes in Castello del Buon Consiglio, with his brother Battista as assistant. There he found himself working alongside two other painters, Romanino and Fogolino, who had also been summoned by cardinal Clesio to paint frescoes for the same building, which constitutes the best example of Renaissance penetration to the province of Trent and the valley of the Adige. It is probable that he went to Pesaro straightway after, in response to an invitation from the

Dukes of Urbino, in order to frescoe Villa Imperiale, the work of Genga and among the most splendid examples of a patrician dwelling of the time.

In the terminal phase of his career, weary from his labours, he had a great deal of assistance from his brother and other collaborators and the upshot was loss of quality. He died in Ferrara, 1542. Nothing at all is known about his early training, though some say it happened within the frame of reference of local painting, especially that of Lorenzo Costa. Already in 1557, Dolce in "Dialogo della Pittura" stated that the artist was in Venice with Titian as a young man; besides, it is not impossible that there may have been some contact with Giorgione too. Some authorities would see in the famed *Madonna di Foligno* by Raphael (datable to 1511–2), especially in the landscape with its dynamic and vibrant treatment of colour, certainly post-Giorgionesque, if not the direct intervention leastways the influence of Dosso. This is tantamount to supposing the artist went to Rome, immediately after his training in Venice. Dossi's youthful art is thus akin to Titian's Giorgionesque period and fairly close to that of Romanino; later, it became even more dynamic in terms of colouring and more novel in terms of composition.

The official painter to Alfonso d'Este, associated with the literary world of "Orlando Furioso", he is a painter full of action, inventive and full of variety. Some of his early works (like *The Fool* of the d'Este gallery in Modena) reveal a profound capacity for psychological probing, whereas the *Nymph and Satyr* (Uffizi, Florence) discloses a vein of poetic phantasy tinged with melancholy. Besides the frescoes, at the peak of his career he painted altar-pieces displaying—together with Venetian chromatic flair—influence from Raphael which may also have reached him through the intermediary of Garofalo, another painter of Ferra. The painting of *Circe* in the Borghese gallery abounds in disparate elements and sombre tones, indicative of a new sensitivity, a mood verging on the surrealist.

PRINCIPAL WORKS

Bergamo, Carrara gallery, *Madonna* with St. George and a bishop saint;
Chantilly, Museum, *Lady wearing turban;*
Dresden, Gemäldegalerie, *Coronation*, church fathers and S.Bernardino (1532);
Ferrara, museum, Polyptych, *Madonna and saints;*
London, National gallery, *Poet and muse; Adoration of the Magi;*
Modena, d'Este gallery, *Alfonso I d'Este; Madonna* with SS.Michael and George; *The Fool;* Duomo, *Madonna* with SS.Roque, Laurence and other saints (1522);
Parma, National gallery, *The musicians; Adoration of the Magi;*
Villa Imperiale, nr. Pesaro, *frescoes* in the Hall of the Caryatids;
Rome, Borghese gallery, *Apollo and Daphne; Circe;*
Trent, Castello del Buonconsiglio, *frescoes* in the Great hall and other chambers, including: *Cardinal Clesio presented to the Madonna.*

ESSENTIAL BIBLIOGRAPHY

Vasari G., *Le vite dei più eccellenti pittori* etc., Florence, 1568 (ed. Milanesi, Florence, 1870–5);
Ridolfi C., *Le meraviglie dell'arte*, Venice, 1648;
Baruffaldi G., *Vite de pittori e scultori ferraresi* (ed. Boschini, Ferrara, 1844–6);
Cittadella L. N., *I due Dossi*, Ferrara, 1870;
Crowe-Cavalcaselle, *A history of painting in North Italy*, I, ed. 1871; ed. Borenius, London, 1912;

Venturi L., *Giorgione e il Giorgionismo*, Milan, 1913;
Venturi A., *Storia dell'Arte Italiana*, VII, 3, Milan, 1914;
Longhi R., *Precisioni nelle Gallerie italiane. Un problema di Cinquecento ferrarese* (Dosso Giovine), in "Vita Artistica", 1927;
Berenson B., *Italian Pictures of the Renaissance*, Oxford, 1932;
Longhi R., *Officina ferrarese*, 1934; 2nd ed. Florence, 1956; *Viatico per Cinque Secoli di Pittura Veneziana*, Florence, 1956;
Mezzetti A., *Opere d'arte restaurate a Ferrara*, Ferrara, 1964;
Puppi L., *Dosso al Buonconsiglio*, in "Arte Veneta", 1964;
Dreyer P., *Die Entwicklung des jungen Dosso.* in "Pantheon", 1964–5;
Mezzetti A., *Le Storie di Enea del Dosso . . .* etc. in "Paragone", 1965; *Il Dosso e Battista Ferraresi*, Milan, 1965, with full bibliography.

## DUIA PIETRO

Born in Venice, the records concerning him cover the period from 1520 to 1529. His personality is little known and the number of his works is minimal, often not unanimously assigned to him on expert authority.

Undoubtedly a retrogressive painter, a follower of Giovanni Bellini and associated with modes of Vicenzo Catena. The only work to carry his signature belongs to the Correr museum in Venice and depicts a *Madonna and child* where the modes used are firm indeed harsh as compared with the Bellini models on which the work is based.

KNOWN WORKS

    Florence, Uffizi, *Madonna and child with two saints;*
    New York, Kress foundation, *Madonna and child;*
    Rome, Capitoline gallery, *Madonna with SS.Catherine, Lucy and Peter;*
    Venice, Querini Stampalia gallery, *Madonna with St. John Baptist.*

ESSENTIAL BIBLIOGRAPHY

    Venturi A., *Storia dell'Arte Italiana*, VII, 4, Milan, 1915;
    Mariacher G., *Il Museo Correr di Venezia*, Venice, 1947;
    Berenson B., *Italian Pictures of the Renaissance*, I, Venetian School, London, 1967.

## DURANTE DA CALDAROLA

Durante Nobili came originally from Lucca but settled in Caldarola in the Marches, like his kinsmen De Magistris (q.v.). He was a painter essentially linked with Lorenzo Lotto, who repeatedly referred to him in the "Book of various expenses". Born perhaps in the second decade of the sixteenth century, in the year 1548 upon the invitation of the Venetian painter he went to Mogliano in the Marches, in connection with the altar-piece extant there at this day. In 1550 in Ancona, Durante was with him in the capacity of assistant during the painting of the great altar-piece of the Assumption of the Virgin. Again, in 1553, he was with him when the artist being old retired to Loreto, to the monastery of the Santa Casa. On 10 August that year, he left the aged artist to go and visit his sick wife and returned to Lotto no more.

He remained a painter linked with Lotto in the closest sense; indeed, in some instances he actually recopied works of his with a certain appealingness.

PRINCIPAL WORKS

Ascoli Piceno, S.Piero di Castello, *Madonna and child;*
Caldarola, S.Martino, *SS.Cosmas and Damian;*
Corridonia, S.Francesco, *Madonna in glory and saints;*
Metelica, S.Francesco, *Crucifixion;*
Mogliano (Marches), S.Gregorio, *Blessed Virgin.*

BIBLIOGRAPHY

Lorenzo Lotto, *Il libro di spese diverse*, a cura di P.Z., Venice-Rome, 1969.

## FARINATI PAOLO

Born at Verona in 1524, he belongs within that ardent band of local painters whose leading exponent was Paolo Caliari, called Il Veronese. Farinati appears to have descended from an ancient Florentine family, emigrating to Verona in the year 1262 on account of political strife in the Tuscan cities. His was the family of Farinata degli Uberti, immortalised in Dante's "Divine Comedy".

The activity of this painter is well known, besides the journal which he kept enables the evolution of his manner to be traced in comparative comfort. A pupil of his father, also a painter, he then attended the school of Nicolò Giolfino. He seems to have gone to Venice to round off his training in the light of direct knowledge of the works of Giorgione and Titian. But his predilection for Giulio Romano is apparent from his earliest works, hence his receptiveness to the Mannerists of central Italy.

The *St. Martin* painted for Mantua cathedral in 1552 is a good illustration of this phase of his career, when he was working alongside Brusasorci and indeed Paolo Veronese. It was a direct result of this encounter with his great fellow-countryman that his painting became less ponderous, less committed to ostentation in design, favouring instead a new lightness and airiness of composition. With the passage of time, Veronese's message affected him more and more intimately as the works of his prime reveal, such as *Moses and the daughters of Jethro* (1584) of the Civic museum, Verona, and the *Presentation in the Temple*, now in the Art gallery at Dresden, in manner so akin to that of his master and colleague as even to have been attributed to him.

After 1590, Farinati's art which had known moments of creative felicity in the wake of Veronese and also to some extent through contact with the manner of Brusasorci, falls off in quality perhaps through over-many commissions and taking on collaborators.

Farinati was also a first-class engraver; he had two sons, and they were both painters too: their names were Vittorio and Orazio.

ESSENTIAL BIBLIOGRAPHY

Ridolfi C., *Le Meraviglie dell'Arte*, Venice, 1648;
Pozzo B., *Le Vite dei . . . Pittori Veronesi*, Verona, 1718;
Lanzi L., *Storia Pittorica* etc., Bassano, ed. 1789;
Simeoni L., *Il giornale del pittore veronese P. Farinati*, in "Madonna Verona",
    1908;
Fiocco G., *Paolo Farinati e le sue opere per il Frassino*, in "L'Arte", 1912;
Halden in Thieme-Becker, Kunstler-Lexikon, IX, 1915;
Fiocco G., *Paolo Veronese und Farinati*, in "Jahrbuch der Kunsthistorischen
    Sammlungen in Wien", 1926, vol. I;

Venturi A., *Storia dell'Arte Italiana*, IX, 4, Milan, 1929;
Berenson B., *Italian Pictures of the Renaissance*, Oxford, 1932;
Brizio A. M., *Rileggendo il Vasari*, in "Emporium", 1932;
Tietze Conrat E., *Drawings by Farinato* etc., in "Old Master Drawings",
    1935;
Galletti-Camesasca, *Enciclopedia della pittura italiana*, Milan, 1951, under
    appropriate heading;
Arslan W., *Cinque disegni veneti* etc. in "Arte Veneta", 1954;
Puppi L., *Su alcuni disegni inediti di P. Farinati al Louvre*, in "Prospettive"
    n. 19 (1959);
Arisi F., *Cinque tele di P. Farinati a Piacenza*, in "Arte Veneta", 1962;
Puppi L., *Appunti su Paolo Farinati*, in "Arte Veneta", 1963;
Dal Forno F., *Paolo Farinati*, in "Vita Veronese", Verona, 1965.

## FASOLO GIOVANNI ANTONIO

Born at Mandello del Lario (Como) in about 1530, the first references to him occur in 1552. He was a follower of Paolo Veronese, and his frequent collaborator. In 1556 he was in Venice, apparently working with Veronese on the ceiling frescoes for the church of S.Sebastiano. In the same year, he became a member of the "Accademia Olimpica" in Vicenza, a token of the measure of recognition clearly achieved. Between 1557 and 1562, he was at work on the decor of the "Teatro Olimpico" and in 1568 frescoed the Loggia del capitano, again in Vicenza. Fasolo was then invited to paint frescoes at various villas dotted about the Vicenza countryside; examples are Codogno (1570) and that of the Colleoni at Thiene. He died, it seems due to a fall from scaffolding, in Vicenza in 1572.

His altar-pieces may be called cold in composition, a good instance being the *Madonna del Rosario*, Vicenza museum; at the same time, figures of then living personages are drawn with verve and vitality from the life. In the *Pool of Bethesda*, again in Vicenza museum, a broad scene is set after the fashion of Veronese though with signs of strain in the colour register, eclectic in origin, incorporating elements derived from Tintoretto. Very able in respect of composition, it falls short of real originality.

It was in the frescoes, particularly those of Codogno that Fasolo achieved the summit of his powers of expression. He went beyond the compromises and the cultural echoes of a host of source elements (he was also influenced by Roman Mannerist art) and contrived to create spacious genre pieces, deft and spontaneous, using elements from the life.

The same trait may be noted in his portraits. Examples are the group of the *Pagello family* in Vicenza museum, and those of *Paola Gualdo Bonanome with her daughters and Giuseppe Gualdo with his sons;* they are works of undoubted psychological acumen, in manner akin to the art of Veronese to whom Fasolo constantly looked.

Fasolo collaborated with Zelotti as well, another artist working within the sphere of influence of Paolo Veronese.

ESSENTIAL BIBLIOGRAPHY

Ridolfi C., *Maraviglie* etc., Venice, 1648;
Orlandi P., *Abecedario pittorico*, Bologna, 1719;
Lanzi L., *Storia pittorica* etc., Milan, 1821;
Venturi A., *Storia dell'arte italiana*, IX, part IV, Milan, 1929;

Barbieri F., *Due dipinti di G. A. Fasolo fortunatamente ritrovati*, in "Arte Veneta", 1958; *Un'opera pressoche ignorata di G. A. Fasolo*, in "Arte Veneta", 1961;

Crosato L., *Affreschi delle ville venete del Cinquecento*, Treviso, 1962;

Barbieri F., *Il Museo Civico di Vicenza*, Venice, 1962;

Schulz J., Review of Crosato L. *op. cit.*, "The Burlington Magazine", 1963.

## FETTI DOMENICO

Born in Rome, probably in the year 1589, he was a pupil of Cigoli but soon drawn within the circle of the painters after Caravaggio. Although pro-Caravaggio, Fetti never was on the formal plane; however, he understood the human lesson to be learned from that quarter and oriented his manner of painting to that inspired by a sensitivity as sincere as possible, both simple and succinct. Under the patronage of cardinal Ferdinando Gonzaga, he accompanied him to Mantua in 1613 and became court painter to that illustrious house, also serving them as inspector of works of art in the ducal palace. In 1621, the duke sent him to Venice and the revelation of Lagoon art exercised a dominant influence over the young artist. He returned there in 1622 and having quitted the Gonzagas, remained in Venice to the day of his death, sooner than might have been expected, a short illness proving fatal on 16 April 1623. The artist was then about 33 years old. His sojourn in Mantua and still more the brief but illuminating Venetian experience, were fundamental to the final phase of his intense artistic activity. Knowledge of the works of Bassano and Tintoretto enabled him to progress in the direction of painting ever more luminous and contour-less, as light-suffused and gauzy as a dragonfly's wing. Fetti was helped in part to achieve these effects by knowledge of the work of Rubens, sumptuous in colour and free stroke in respect of brushwork.

A meditative nature, inclined to a kindly look even at the humbler aspects of day-to-day life, Fetti assumes notable importance also in bringing about a break with the shackles of tradition, the Venetian school of his time being still tied to late Mannerist art in the great sixteenth-century tradition. From the last-named, he culled the quintessential values, applying them more to Bassano's lowly world than to the great world of Tintoretto or of Veronese. His work was thus by way of life-blood to the ailing flesh of the painting art, a tonic to artistic circles in Venice. The example he set was one of creative freedom, of disengagement from the pre-set rules and regulations of art turned academic. The repercussions on artists like Maffei and Mazzoni were beneficial, likewise Verona school artists of the stamp of Bassetti.

However, his brief life and the almost complete lack of dated works make any assessment of his stylistic evolution something of a hard task.

PRINCIPAL WORKS

Augsburg, Bayerisches Staatsgemäldesammlungen, *Christ of the coin;*

Baltimore, Walters art gallery, *Image of the Madonna held by two angels;*

Colleredo di Montalbano (Udine), Castello, *The architect presenting the model of a church to the princess Gonzaga;*

Dresden, Gemäldegalerie, *Parable of the vineyard; Parable of the good Samaritan; Parable of the blind; Parable of the bad servant;*

Florence, Uffizi, *Ecce Homo; The soothsayer, Artemisia;* Galleria palatina, Palazzo Pitti, *Parable of the lost coin;*

Hampton court, Royal coll., *Elijah and the priests of Baal; David with Goliath's head; S.Carlo Borromeo;*

London, Kensington palace, *Portrait of Vincenzo Avogadro;*
Mantua, Duomo, *The triumph of the Holy Trinity* (fresco);
Munich, Gallerie, *Ecce Homo; The Assumption;*
Paris, Louvre, *Melancholy;*
Venice, Accademia gallery, *Parable of the good Samaritan;*
Vienna, Kunsthistorischesmuseum, *Hero and Leander; The triumph of Galatea; Andromeda; The Flight into Egypt.*

ESSENTIAL BIBLIOGRAPHY

Baglione G., *Le vite de' pittori ed architetti*, Rome, 1642;
Orlandi P. A.–Guarienti P., *Abedecedario pittorico*, Venice, 1753, p. 145;
Cadioli G., *Descrizione delle pitture, sculture, architetture della città di Mantova*, Mantua, 1763;
Lanzi L., *Storia pittorica dell'Italia*, Bassano, 1789;
De Boni F., *Biografia degli artisti* etc., Venice, 1840;
Luzio A., *La galleria dei Gonzaga venduta all'Inghilterra nel 1627–8*, Milan, 1913;
Fiocco G., *La pittura veneziana del Seicento e del Settecento*, Verona, 1929, pp. 14–7;
Longhi R., *Viatico per cinque secoli di pittura veneziana*, Florence, 1946;
Ivanoff N., *Una Maddalena di Domenico Fetti*, in "Paragone", 1953, no. 41, pp. 51 & seqq.; *Un'altra redazione del dipinto precedente*, in "Paragone", 1953, no. 41, p. 53;
De Logu G., *Pittura veneziana dal XIV al XVIII secolo*, Bergamo, 1958;
Zampetti P., in *La Pittura del Seicento a Venezia*, Exhibition catalogue, Venice, 1959, pp. XXVI & seqq., pp. 35–42;
Rizzi A., *Miscellanea veneta*, in "Arte veneta", 1963, pp. 182–4;
Donzelli C.–Pilo G. M., *I pittori del Seicento veneto*, Florence, 1967 (with bibliography).

## FILIPPO DA VERONA

Active in the first two decades of the sixteenth century, he was influenced by Cima da Conegliano and by Giovanni Bellini, coming subsequently within the orbit of Giorgione. Berenson also noted signs of Raphael's ascendancy.
At Padua in 1509, he was working in the church of S.Antonio (Il Santo); he was still at Padua in 1511, working this time in the Eremitani church. The next news of him is at Savona, where he was at work in the Duomo in 1515.
He may be accounted an artist of the second rank, presenting in rhapsodic fashion a variety of elements culled from diverse artistic sources, with little to add of his own. His often sweeping and sun-lit landscapes are clearly indicative of the influence of Giorgione's style, as recorded above.

PRINCIPAL WORKS

Baltimore, Walters art gallery, *The Holy Family;*
Fabriano, Art gallery, *Madonna and child with SS.Peter and Nicholas of Bari* (1514);
Padua, Scuola di S.Antonio, *Frescoes with scene from the life of the Saint* (1510);
Turin, Albertina, *Madonna with Simeon.*

BIBLIOGRAPHY

Thieme-Becker K. L., Leipzig, under appropriate heading;
Sartori A., *L'Arinconfraternite del Santo*, Padova, 1955;
Berenson, *Italian Pictures of the Renaissance*, I, Venetian School, London, 1957;
Grossato L., *Affreschi Cinquecento in Padova*, Padova, 1966;
Molajoli B., *Guida artistica di Fabriano*, ed. 1968.

## FLORIGERIO SEBASTIANO

Born at Conegliano in the Veneto about 1500, he lived in the Friuli where he became the collaborator of Pellegrino da S.Daniele, whose daughter he married. He remained in the area until 1529; in 1525 he was commissioned to produce an altar-piece for the church of S.Maria Nova by Cividale. But in 1529 he was forced to leave the Friuli and went to Padua. Later, he returned to Cividale, finally retiring to Conegliano where it appears that he died in 1540.

Modern art historians have not yet settled his standing as an artist, part resting on no firmer foundation than that of tradition. The few works which may with certainty be ascribed to him are insufficient to arrive at an evaluation of his qualities. Indeed, various paintings have been assigned him and denied him, for instance the *Pietà* of the Cassa di Risparmio di Treviso, the subject of various attributions. It is, however, plain that alongside the influence of local painters of the mark of Pellegrino da S.Daniele and other lesser lights, he was most affected by the example of Pordenone; there is a sound enough body of evidence to warrant considering him a true follower of this artist. *St. George and the dragon* at Udine, a work well praised also by Lanzi, illustrates the manner of Florigerio, strictly aligned to that of Pordenone. A notable personality certainly, it is unfortunate that today his name is associated with only a few certain works.

PRINCIPAL WORKS

Berlin, State museum, *Cavalier and page;*
Florence, Uffizi gallery, *Portrait of a man;*
Padua, Civic museum, panels of the *Pietà di S.Bovo;*
Udine, S.Giorgio, *Madonna in glory, the Baptist and St. George;*
Venice, Accademia gallery, *St. Anne, the Virgin with SS.Roch and Sebastian.*

ESSENTIAL BIBLIOGRAPHY

Vasari G., *Le Vite dei più eccellenti pittori* etc., 1568;
Ridolfi C., *Le Meraviglie dell'Arte*, 1648;
Lanzi L., *Storia pittorica* etc., Bassano, 1789;
Venturi A., *Storia dell'arte italiana*, IX, 3, Milan, 1928;
Coletti L., *Florigerio S.* in Enciclopedia italiana, 1932;
Galletti-Camesasca, Enciclopedia della pittura italiana, Milan, 1950, under appropriate heading;
Semenzato C., *Il Florigerio*, in "Arte Veneta", 1958.

## FRANCESCO (PAGANI) DA MILANO

Of Lombard origin, he was active in the Friuli and the Treviso area from 1502 to 1542. His artistic outlook was wholly Venetian. He was influenced by Previtali, Savoldo and Pordenone, that is to say he was responsive to a current of painting which although associated with Venetian art yet shewed some detachment from mainstream development, openly or less openly.

The *Adoration of the Shepherds* (S.Martino church, Conegliano) may be among his earliest works; reminiscent of Brescian work, the manner is provincial, clearly defined and formally composed. Later, he painted on a more monumental scale with increased verve of composition, as may be seen in the *Baptism of Christ* (1529) in the church of S.Giovanni Battista at Vittorio Veneto. His allegiance to the manner of Pordenone is evident in the *altar-piece* on display in Treviso civic museum. Francesco da Milano was a populariser of other men's modes, lacking a distinctive personality of his own.

PRINCIPAL WORKS

> Caneva di Sacile (Udine), Parish church, *Triptych* (1517);
> Cavaso del Toma (Treviso), Parish church, *Madonna and saints;*
> Conegliano, S.Martino, *Adoration of the Shepherds;*
> Follina (Treviso) Abbazia, *Saints and donor* (fresco, 1527);
> Pieve di Soligo, Parish church, *The Assumption* (1540);
> Treviso, Civic museum, *Madonna and saints* (1537); *Madonna with SS.*
> *Bartholomew and Andrew* (1538);
> Venice, Accademia gallery, *Pietà with SS. Roch and Onuphrius;*
> Vittorio Veneto, S.Giovanni Battista, *Baptism of Christ* (1529);

BIBLIOGRAPHY

> Lanzi L., *Storia pittorica dell'Italia*, Bassano, 1789;
> Thieme-Becker K. L., 1913, under appropriate heading;
> Pallucchini R., *Cinque secoli di pittura veneta*, Venice, 1945;
> Galletti-Camesasca, Enciclopedia della pittura italiana, Milan, 1950;
> Fiocco G., Note on Francesco da Milano, in "Emporium", 1951;
> Berenson B., *Italian Pictures of the Renaissance*, I, Venetian School, London,
> 1957.

## FRANCO GIAMBATTISTA called IL SEMOLEI

Born in Venice in about 1498. Still a young man, he went to Rome and there came into contact with the artistic environment, at the time completely dominated by the genius of Michelangelo. Engraver as well as painter, he made copies from the works of the great Florentine, also Raphael and other artists. His style of engraving reflects that of Marcantonio Raimondi. In 1535, he appeared as a member of the Accademia di S.Luca, Rome. In 1536, he was associated with Antonio da Sangallo in preparing the decorative scheme in honour of Charles V. Later, he went to Florence, returning to Rome in 1541. He soon made another move, however, this time to Urbino, where he remained some ten years, for the purpose of frescoing the vault of the cathedral (the work of Francesco di Giorgio Martini). He painted a *Last Judgment* for that cathedral, apparently after Michelangelo's in the Sistine chapel. The work was destroyed, also the whole building, later re-constructed in the Neo-classical period by Valadier.

In 1554, after a visit to Osimo where he painted an altar-piece for the Cathedral, Giambattista Franco returned to Venice. He was straightway employed to work on the Scala d'oro, of the ducal palace, in St. Mark's library and numerous churches. He died in Venice, in the year 1561. Il Semolei was well regarded in his own day; Vasari esteemed him. The modern view rates him somewhat less highly, on account of the stress given to design almost as though it served an end in itself.

The personality which emerges, evidencing various Mannerist traits, is not one to admit of simple definition. Allegiance to Michelangelo was always accompanied by overtones from his Venetian origin. This facet of his work may be more readily discerned in the less grandiose pieces, that is to

say the more provincial, like the panels for the Osimo baptistry. In these, the working of the small figures is moving, on deeply-felt grounds and may even be read as indicating the influence of Lorenzo Lotto.

PRINCIPAL WORKS

      Florence, Pitti palace, *Allegory of the battle of Montemurlo;*
      Osimo, Battisterio, 8 *panels* on religious themes;
      Rome; Chiesa della Minerva, *Fresco decorations;*
      Urbino, Duomo, *Madonna with SS.Peter and Paul;*
      Venice, Palazzo ducale, *Decoration* of the Scala d'oro; St. Mark's library
            stairway, *Tales of Acteon and allegorical scenes.*

ESSENTIAL BIBLIOGRAPHY

      Vasari G., *Le Vite* etc., 1568;
      Lanzi L., *Storia pittorica dell'Italia*, Bassano, 1789;
      Ricci A., *Memorie storiche delle arti e degli artisti della marca di Ancona,*
            Macerata, 1834;
      Venturi A., *Storia dell'arte italiana*, IX, 6, Milan, 1933;
      Coletti L., *La crisi manieristica della pittura veneziana*, in "Convivium", 1941;
      Pallucchini R., *La giovinezza del Tintoretto*, Venice, 1949;
      Galletti-Camesasca, Enciclopedia della pittura italiana, Milan, 1950;
      Crosato L., *Affreschi delle ville Veneta del Cinquecento*, Treviso, 1962.

## F.V. (Anonymous painter)

These initials designate a painter who signed three works in this way, namely two at Riva del Garda (Trent) and one at Tenno. A fourth was cited by Bartoli in his "Guida", now lost but formerly in the church of S.Tommaso Cantuariense; it was similarly signed "F.V." but not dated. The works at Riva and Tenno are dated in close order: 1530, 1531 and 1532. Bartoli attempted to unravel the secret of the signature by assigning the lost Rovereto painting to "Francesco Veruzio, pupil of Andrea Mantegna". No works by this artist exist though Vasari referred to him; a tentative identification has been offered in modern times with Francesco Verla (q.v.). Nevertheless it is apparent that the works under consideration have nothing in common with Verla's, so that he may be excluded from holders of the potential key to the mystery. Nor are they assignable to Francesco Vecelio, Titian's older brother, as has been propounded in some quarters; the same would hold true for Filippo da Verona (q.v.).

Some assonance in terms of approach may be found with one Michele Facai di Verona; in the year 1541 he signed and dated an *Adoration of the Magi*, now in Castelvecchio museum, Verona. There are certain affinities with the mysterious F.V.'s work, though the tone of the whole may be deemed weaker; there is also the fact that the date is some ten years after that of the close-knit group from Riva-Tenno. The anonymous artist possessed undoubted personality on the evidence of this group, associated with the style of Veneto province and in particular with Moretto, Savoldo and also Romanino. His perspective is solidly structured, his foreground figures confidently worked; the mood comes across as one of excitement, even drama. This is achieved by use of sharp chiaroscuro rather than movement itself. The treatment of light to create dynamic effects in some measure anticipates the mastery typifying the seventeenth century; in contrast, other elements such as the drapery which is firm-textured and metal-like, seem rather to recall the fifteenth century.

The art of the F.V. painter thus falls within the Brescia stream; clearly individual, it embodies a vigorous resolve to revive mainland art, differing in its approach to reality from Lagoon art. No second rank artist, unfortunately no more than an incomplete picture emerges for want of relevant details outside the 3-work group described above.

PRINCIPAL WORKS

> Riva, Parish church, *Adoration of the Shepherds* (1530); *Deposition from the Cross* (1531);
> Tenno, Villa del Monte parish church, *Madonna enthroned and four saints* (1532).

BIBLIOGRAPHY

> Bomassari, *Francesco Verla ed alcuni suoi dipinti nel Trentino*, in "Berico", VII, Vicenza, 1882;
> Gerola G., *Francesco Verla e gli altri pittori della sua famiglia*, in "Arte", 1908;
> Emert, G. B., *Fonti manoscritte inedite per la storia dell'arte nel Trentino* (Guida del Bartoli), Florence, 1939, p. 100;
> Zampetti P., *Il pittore F. V.*, in "Rivista d'Arte", 1941 (with further bibliography).

## FOGOLINO MARCELLO

Born towards the close of the fifteenth century, perhaps at San Vito al Tagliamento, first documented at Vicenza and Pordenone. In 1527 he was expelled from Venetian republican territory on a murder charge and went to Trent where he long remained in the service of the city's bishop-prince, cardinal Clesio. At Trent, besides some religious paintings, he worked alongside Romanino and Dosso decorating the Castello del Buon Consiglio, the residence of this cultivated and enlightened prelate who encompassed the penetration of Renaissance art to the valley of the Adige.

Ambiguity surrounds the character of Fogolino. It seems that in order to get safe-conducts for returning to Venetian territory, he agreed to send confidential information to the Council of Ten in Venice. He is known to have been in Trent until 1548, though no doubt travelled elsewhere periodically. The recent discovery of his frescoes at Ascoli Piceno, dated 1547, fills in one of the gaps in his Trent period, at the same time indicating his availability to go where work was waiting for him. As Marchini observed, his activity at Ascoli—a place a good long way from the Veneto—may be accounted for by the fact that the bishop, Philos Rovella, was in Trent in 1545 attending the well-known Council of the church.

After 1548, when evidence shews Fogolino was in Trent again, all trace of him is lost. His standing as an artist has only recently been given serious evaluation; his former reputation in fact resided chiefly in early works, like the appealing *Adoration of the Magi*, in Vicenza museum. He emerges as a figure of far greater complexity, other works of importance—very different from the early pieces—having been ascribed to him as a result of chance discoveries and felicitous attributions. The early influence of Bartolomeo Montagna and Francesco Verla was soon supplanted by that of Pordenone, hence also the two artists at Castello del Buon Consiglio with him, namely Romaino and Dosso Dossi.

The *Adoration of the Magi* rich in narrative detail with passages such as the rock landscape above perhaps echoing Carpaccio, presents traditional forms following previous example. Speedily absorbing new lines of thought, the altar-piece of Trent cathedral and to a still greater extent the frescoes of the castles of Buon Consiglio and of Malpaga reveal a new sensitivity based on the

structural unity of the whole with a colour range much enhanced in brilliance and balance using the tonal pattern. He is merit-worthy in particular for having brought the Renaissance manner in good measure to Trent province, where a flaccid copy-book style of Gothic was still prevalent in the early decades of the sixteenth century.

PRINCIPAL WORKS

Ascoli Piceno, *Palazzo vescovile, Frescoes, life of Moses;*
Berlin, Museum, *Madonna enthroned and saints;*
Malpaga (Bergamo), Villa Colleoni, *Frescoes;*
S.Daniele del Friuli, Sant'Antonio, *Frescoes* (in collaboration with Pellegrino da S.Daniele);
Trent, Castello del Buon Consiglio, *Frescoes, various;* Palazzo Sardagna, *Frescoes,* halls of Constantine and the Zodiac; Duomo, *Altar-piece of St. Anne;*
Vicenza, Civic museum, *The Epiphany.*

ESSENTIAL BIBLIOGRAPHY

Mattioli P. A., *Il Magno Palazzo del Cardinale di Trento*, Venice, 1539;
Sardagna G. B., *La guerra rustica nel Trentino*, in R.Deputazione di Storia Patria, Venice, 1889;
Auserer-Gerola, *I Documenti clesiani del Buon Consiglio*, Venice, 1924;
Morassi A., *I Pittori alla Corte del Cardinale Clesio; Marcello Fogolino*, in Bollettino d'Arte, 1930; *The Other Painter of Malpaga*, in Burlington Magazine, 1931;
Zampetti P., *Affreschi inediti di Marcello Fogolino*, in "Arte Veneta", 1947; *Precisazioni sull'attività trentina di Marcello Fogolino*, in "Bollettino d'Arte", 1949;
Berenson B., *Italian Pictures of the Renaissance*, I, Venetian School, London, 1957;
Puppi L., *Note sui disegni del Fogolino*, in "Arte Veneta", 1961;
Marchini G., *Il Fogolino ad Ascoli Piceno*, in "Antichità Viva", Florence, 1966.

## GALIZZI GIOVANNI

A painter from Bergamo, active in Venice and his own area about mid-sixteenth century. He must have resided for a long time in the city on the lagoons (he is recorded as being there in 1543) since his painting is akin to the manner of Tintoretto. Indeed he must be rated as a follower of Tintoretto, even if the *Madonna and child* (Agliardi coll., Bergamo) signed and dated 1543 indicates strict descent from the manner of Titian. The eclectic nature of this painter may be taken as read; his name is linked with a restricted number of works, all of small artistic significance.

WORKS

Bergamo, Carrara academy, *SS.Protasio and Gervasio* (two distinct works); Agliardi coll., *Madonna and child;* Vertova (Bergamo), S.Maria Assunta, *SS.Mark, James and Patrick* (1547).

**BIBLIOGRAPHY**

> Tassi F. M., *Vite dei pittori bergamaschi*, Bergamo, 1793;
> Venturi A., *Storia dell'Arte Italiana*, Milan, VII, 7, 1934;
> Longhi R., *Viatico per Cinque Secoli*, Florence, 1946;
> Pallucchini R., *La giovinezza del Tintoretto*, Milan, 1950;
> Galletti-Camesasca, *Enciclopedia della Pittura Italiana*, I, Milan, 1950.

## GAVAZZI GIOVANNI DI GIACOMO

From Bergamo, born at Poscante in Val Brembana towards the close of the fifteenth century, active until 1512, the last dated reference to him. Some time ago Lanzi noted his allegiance to the fashion of Previtali, of whom he was a follower without ever rising to the heights of the master. According to Berenson, the artist was also influenced by Cima da Conegliano; in general, he is associated with the culture of Veneto province.

His son Agostino has had certain works ascribed him, generally assigned to his father. Tassi assigned him a *Madonna and child* in the collegiate church of Piazzatore in Val Brembana, all trace of which has been lost.

**PRINCIPAL WORKS**

> Aviatico (Bergamo), S.Salvatore, *Polyptych;*
> Bergamo, Carrara academy, *Adoration of the Shepherds;* Sant Alessandro in
>     Colonna, *Madonna and squirrel* (1512);
> Nembro (Bergamo), *St. Augustine enthroned with SS.Stephen and Laurence;*
>     S.Sebastiano, *Polyptych.*

**ESSENTIAL BIBLIOGRAPHY**

> Tassi F. M., *Vite de' Pittori . . . bergamaschi*, Bergamo, 1793;
> Lanzi L., *Storia Pittorica dell'Italia*, Bassano, 1789;
> Galletti-Camesasca, *Enciclopedia della Pittura Italiana*, I, Milan, 1950;
> Berenson B., *Italian Pictures of the Renaissance*, I, Venetian School, London,
>     1957.

## GIORGIONE

The personality of Giorgione has been pieced together by experts in modern times. Famous from the days immediately after his death, an atmosphere of fable surrounded his figure to the point of becoming a "Giorgione myth". It is as well, therefore, to see him in the light of documentary references; though few, they are useful in order to present him as realistically as possible.

He was born in approximately 1477 at Castelfranco in the Veneto, not far from Venice where he soon went. It is not known precisely when this happened but it may be presumed that he got his training there; at the same time, the notion of possible contact with circles in Padua need not be discounted altogether. The undoubted fact does emerge that Giorgione drank deep at the well of humanism, understood music, loved literature and philosophy: indeed, he may be called a typical product of the Renaissance man.

His birth date was given by Vasari in the first edition of the *Lives* (1550); but was put back to one year later by Vasari, in the second edition of his invaluable work (1568): that is to say, to the year 1478. In Venice, he was soon known well enough to receive official commissions from the authorities of the Republic. Documents shew that in 1507 the Council of Ten issued an order for the payment of

twenty ducats to this painter, for a work to be placed in the Sala delle udienze in the ducal palace. A further payment for the same work is dated 24 January 1508. It was in that same year that he finished the frescoes for the Fondaco dei tedeschi and there was an argument over payment for the job, which was settled by the mediation of Giovanni Bellini and a commission of three painters chosen by him, one of whom was Carpaccio. They agreed the sum owing.

From a letter of Isabella d'Este, dated 25 October 1510, Giorgione was said to be dead. The "marquesa" of Mantua, a great patron of the arts, had heard of the artist's death and so wrote urgently to her representative in Venice, Taddeo Albano, with instructions to purchase a painting by Giorgione of a "night", perhaps a Nativity. On 7 November that year, Taddeo wrote back that Giorgione died of plague some months previous (actually, in September that year there was a tremendous outbreak in Venice); also, that it was not possible to fulfil her wishes, as neither the work she asked for nor others were to be had: since the owners ". . . had them painted for their own delight". It thus appears that despite his very early death, the artist was famous enough for collectors to refuse to part with his works whatever the price. These then are the known facts about him. Some years after his death, he was referred to in Baldassare Castiglione's book, the *Courtier*, as a "most excellent" painter, comparable with only four others, namely "Leonardo Vincio, Mantegna, Raffaello e Michelangelo".

That he belonged to the Barbarella family of Castelfranco emerged only later, in Ridolfi (1648) when the Giorgione myth was already in being. In the course of time, this myth did a great deal of damage in occluding the real person; he began to be confused with imitations and counterfeit works also, emanating from the Venetian painter Pietro Vecchia in that century. The truth rests in his having called himself "Zorzi" of Castelfranco (the name of Giorgione was used for the first time by Paolo Pino in the *Dialogo della pittura*, 1548, an allusion to his great stature).

No work of the artist is signed and none directly documented, with the exception of a poor fragment of the Fondaco dei tedeschi frescoes, depicting a female nude, now detached and deposited at the Accademia gallery in Venice. There does exist, however, a list of his works made by the Venetian nobleman Michiel, a contemporary. He noted in his diary, from the year 1525, among other things, some of Giorgione's works which he had seen in the houses of the illustrious patricians of Venice, and regarded as impressive works of art. Three of them may be identified and are extant, namely:

(1) *The three philosophers* (now in the Kunsthistorichesmuseum, Vienna;

(2) the *Venus* (now in the gallery at Dresden);

(3) the *Gipsy and the soldier* (now at the Accademia gallery in Venice).

Probably identifiable with paintings recorded by Michiel may also be reckoned the *Sunset* so-called, formerly Donà delle Rose and now in the National gallery, London and the *Portrait of Gerolamo Marcello* (in the deposits of the Kunsthistorishesmuseum, Vienna).

By long tradition, two further works are assigned to Giorgione, namely the *Madonna enthroned with SS.Liberale and Francis* in the Duomo at Castelfranco, and the *Judith* in Leningrad. Certainly his, by a legend on the dorse which may be holograph, is the *Laura* so-called of the Kunsthistorischesmuseum, Vienna. Other works are thought very probably to be by Giorgione, either on grounds of well-established tradition or recent attributions based on style and these will now be dealt with.

However little is known of his origin and training it can readily be stated without fear of major error that he came from his native Castelfranco to the great city of Venice, then at the height of her power and became an ardent admirer of the work of Giovanni Bellini; it might perhaps be going too far to call him an actual pupil. It is possible that Carpaccio (with his narrative and phantasy painting) may also have influenced his formative years. Nor can it be forgotten that art currents intermingled for the painters travelled about and their works with them. In 1500 Leonardo

was in Venice and such an artist could not fail to fascinate the young man from Castelfranco. Leaving aside the view of Vasari, who made Giorgione a kind of follower of the Florentine, it must be agreed that he learnt a useful amount from Leonardo's work as the *Young man with the arrow* illustrates; this little masterpiece is now recognised as his by the consensus of opinion, Vienna museum.

A triumph for recent writings (and a key to understand his training) is the assigning to Giorgione of the Allendale group as they are called, namely a series of paintings on holy topics called after the *Adoration of the Shepherds*, now in the National gallery of Washington. The group comprises among other items the *Adoration of the Magi* (National gallery, London), the *Madonna* formerly Benson, again in Washington and the *Sacra conversazione* of the Accademia gallery in Venice. To these works can be added another religious painting, recently included in the slender corpus, which is the little *Madonna* of the Ashmolean at Oxford, its points of reference with the artist's known works making it undoubtedly genuine.

The assigning to Giorgione of the Allendale group means that two further paintings can straightaway be accepted as his, both at the Uffizi, depicting the *Judgement of Solomon* and the *Trial of Moses*. These are in fact the two earliest which are extant, in date order; this is illustrated by the rigid little figures which are still so small in the spatial balance, also some lack of unity in the composition. But the landscape is wide and untrammelled, full of light, while the breeze plays in and out the trees to the mountains and homesteads in the distance: hall-marks of distinction in the young artist. Stylistic elements form a steady link between these two works and the Allendale group as a whole, and indeed the splendid *Judith* of Leningrad which belongs to the early period of Giorgione as well. By this means an entire group of works is given meaning and sequence, though their paternity has been the subject of discussion and of doubt, as being the output of a single artist, Giorgione. This ground-work creates a frame of reference for appraising his subsequent progress. In the London *Epiphany*, the qualities of style of this master are decisively affirmed. The figures are replete with the austere and profound sense of humanity which became a dominant feature of his work; the colouring is so redolent of vibrant light, unmistakable in his painting.

The famous Castelfranco altar-piece must be from about 1504. This important work is not far removed in terms of composition from what was customary at the time both in Venice and elsewhere. Giorgione even seems to wish to simplify, to cut to the essentials, the *Sacra conversazione* theme, representing holy persons in rapt contemplative mood. What makes the theme so new and great lies, in essence, in the scheme. Giorgione divided the setting into two parts: beyond a parapet, he has visualised an interior dominated by a high throne where the Madonna is seated with the child in her lap, and with two saints below. The line of the eye is raised so that beyond the parapet the quiet open countryside may be seen, pasture-land to the left and distant mountains away to the right. The saints stand below while the Madonna—and she alone—dominates the interior created in the foreground, at the same time also the outdoor detail that can be discerned in the background. The Madonna thus provides the link point for the two scenes and imparts unity to the composition. This unity is rounded off, harmonised and given appeal by the warm and golden ambiance of light which falls on fields and figures, making an enchanted glow marvellously enfold the landscape and the personages alike. It has been suggested in some quarters and is not improbable that Giorgione was influenced in his search for balanced composition by the painting of central Italy.

Undoubtedly later than the Castelfranco altar-piece is the *Three philosophers* canvas of the Kunsthistorischesmuseum, Vienna. The actual meaning of this painting, as also the "Tempesta" to be referred to shortly, has been the source of endless discussion and argument without an acceptable explanation having emerged. There are certainly three philosophers, that is three thinking men, intent on the contemplation of nature. Each thinks in his own way, the unity being provided by

their common desire for knowledge. The rays of the dawning sun rouse the most varied chromatic intonation, giving life to all that appears and harmony to all creation. Thus are revealed the blue of the sky and the houses of the village; the distant mountains, the massive trees against the light and penumbra of the grotto: the mood is one of expectation and awakening to the miracle of the morning. According to Michiel who saw the work in the house of Taddeo Contarini in 1525, it was finished by Sebastiano del Piombo. But it is very difficult at this distance to distinguish the hand of the collaborator, the whole appearing so admirably unified.

Giorgione's most celebrated work, one of the famous in the absolute sense that exist in the world, is certainly "La Tempesta" (the *Gipsy and the soldier*) of the Accademia gallery in Venice. It too has led to a lot of discussion, the meaning being rather obscure. Stefanini has recently indicated it as a free rendering of a tale of that time, the "Hypnerotomachia Poliphili" of Francesco Colonna. Other experts, for instance Calvesi, have suggested other solutions, ingenious but less than satisfying all round. As Lionello Venturi aptly remarked in 1913: "the subject is nature: man, woman and child are only elements—not the principals—of nature". Nature is exalted in primordial forces, in phenomena mysterious as profound. The sky is stormy, lightning flashes across the sky; the quintessential figure of the woman has her baby at her breast; the young man stands off to the left; the stream, the ruins, the community in the background: all partakes of the unity created by Giorgione's art: it mirrors the world in its perpetual unwearying round. This exalting of life and its forces—an exaltation not in philosophic terms but rather contemplative, the issue of poetic inspiration—is rendered with a symphony of painting where light descants over all with a touch of shimmering gold and everything is stripped of body and transmuted to sheer impression in pictorial terms. This is also supported by X-ray examination, which revealed under the young man to the left that Giorgione originally painted a young female nude sitting on the river bank.

A late and unfinished work, the *Venus* of Dresden, is one of the most pure Renaissance creations. The figure most chaste in unselfconscious nudity is fused into the ground, forming an indivisible element of it. As noted, part of the scape was finished by Titian, the friend and co-worker of Giorgione, probably after his untimely death.

The working life of Giorgione was short but intense and very revolutionary. The human figure in his later years seems to have absorbed the preponderance of his attention. He was dazzled by the pictorial horizon which could be derived from life studies. The little that remains of the Fondaco dei tedeschi frescoes confirms this. Historians refer to his having painted great half-figures, latterly, "senza disegno", without design. Without pursuing the point further, it will suffice to mention the *Deriding of Christ* at S.Rocco, which is certainly his and from his final phase, also the central figure in the famous piece at Detroit museum of the three young men, probably the outcome of collaboration between Giorgione, Titian and Sebastiano del Piombo, known to have been friends. Indeed, this kind of friendship and collaboration adds up to one of the basic problems concerning the figure of Giorgione. Giorgione and Titian were close enough for it to be hard to assign some works to either one or the other. A more thorny problem relates to the *Concert champetre* at the Louvre: full of Giorgione's spirit, it yet seems to belong to the hand of Titian with its accented chromatic range and new strength of colour. If it is true that Giorgione had no real pupils, it must nevertheless be conceded that it is due to him renewal was achieved in the means of expression which raised Venetian art to the forefront of European painting, at the figurative level.

At the outset of the sixteenth century, he was in fact the only artist (prior to Lotto and Titian) capable of sensing and rendering the new requirements of the ever-changing circle of civilisation. But above all Giorgione's is the genius that having felt the living harmony of nature, approached it in a manner complete and absolute. For Giorgione, man lives in nature, is part of nature. The fifteenth century gulf between nature and man is bridged. He also contrived to lay aside the worn iconography of religion and create new pictures, secular also, to adorn the homes of the cultivated.

Giorgione's narrative needed new paint language: colour became a factor of decisive and fundamental importance, serving as the instrument to convey poetic vision, with its infinite possibilities and gradations of light. Outlines dissolve, everything is softer and shot with light, a light seeming to emanate from things themselves, as transient and sparkling as human sentiment.

This duality of colour and light is the basis upon which the wonderful work of Giorgione rests, by this means he exalted his world. The master's figures are not, as Titian's often are, dramatic or restive; the psychological content is made contemplative, pure mind and thus the real is outdone by the contemplative. Giorgione's art stands out from his day and age because of this universal character, looking so very modern in our times. His creative phantasy inhabits a realm so wide and deep that it remains unremittingly alive.

The message of Giorgione, fascinating and novel, was received by all or nearly all the Venetian painters. Giovanni Bellini was receptive to it in old age, as shewn in the S.Zaccaria altar-piece and other items. Giorgionesque in their early days were Titian and Sebastiano del Piombo, Palma il Vecchio and also Romanino. The allegiance of the first three named to the manner of this master was such, that even today many works are uncertainly attributed to one or another of them.

The *Adulteress* of Glasgow museum is typical in having been assigned to Giorgione, Titian, Sebastiano and even Cariani and Mancini. The two last named belong to the large rank of Giorgionesque artists, who in the first decades of the century fell under the master's spell and interpreted his style and manner. Catena may be mentioned along with them, at the mature stage of his working life, Paris Bordone, Francesco Torbido, Bernadino Licinio, Lorenzo Luzzo called Morto da Feltre and by the same token Pordenone and Dosso Dossi. To these must be added the anonymous Giorgionesque painters, sometimes of minor standing, whose activity may be taken to demonstrate if nothing else the fascination that the personality of this artist exerted on his contemporaries, and how his manner was copied until it had become a provincial commonplace.

This is no place to deal with the fortunes of Giorgione in art criticism. It is sufficient to state that modern contributions have patiently set about the task of reconstructing his figure, shorn of centuries' accretions, dating from Cavalvaselle and Morelli. Thereafter, two streams emerged: one tending to widen the number of works by Giorgione (Justi) and the other to pare it down to an excessive extent (Gronau).

Further, experts of the standing of Berenson, L. Venturi, Richter, Suida, Fiocco and Morassi have all helped reconstruct the personality of this artist, honoured in the memorable Exhibition held at Venice in 1955. On that occasion other publications were forthcoming, though without altering the critical configuration assembled on the topic of this artist, considered the father of modern painting.

WORKS

Berlin, Staatlichen museen, *Portrait of a youth;*
Budapest, Fine arts museum, *Portrait of Antonio Brocardo;*
Castelfranco Veneto, Duomo, *Madonna enthroned with SS.Francis and Liberale;*
Dresden, Gallery, *Sleeping Venus* (work finished by Titian);
Florence, Uffizi gallery, *Trial of Moses; Judgement of Solomon;*
Hampton court, Royal coll., *Bust of shepherd;*
Leningrad, Hermitage, *Judith;*
London, National gallery, *Epiphany; Sunset* (Aeneas and Anchises ?);
Venice, Accademia gallery, *Gipsy and the soldier; Bust of old woman* (with time); Scuola di S.Rocco, *Christ carrying the Cross;*
Vienna, Kunsthistorischesmuseum, *The three philosophers; Bust of youth; Laura ;*
Washington, *Allendale nativity; Holy Family.*

ESSENTIAL BIBLIOGRAPHY

Castiglione B., *Il cortegiano*, 1528;
Michiel A., *Notizie di opere di disegno* (c. 1545), ed. Frizzoni, Bologna, 1884;
Pino P., *Dialogo della pittura*, Venice, 1548;
Vasari G., *Le vite dei più eccellenti pittori* etc., 1st ed. 1550;
Dolce L., *Dialogo della pittura*, Venice, 1557;
Vasari G., *Le vite* etc., 2nd ed., 1568;
Boschini M., *La Carta del navegar pitoresco*, Venice, 1660;
Lanzi L., *Storia pittorica dell'Italia*, Bassano, 1789;
Crowe-Cavalcaselle, *History of Painting in North Italy* (1st ed. 1871; ed. Borenius, 1912, London);
Luzio A., *Isabella d'Este e due quadri di Giorgione*, in "Archivio storico dell' arte", Rome, 1888;
Berenson B., *Study and Criticism of Italian Art*, London, 1901;
Venturi L., *Giorgione e il Giorgionismo*, Milan, 1913;
Gronau G., *Giorgione*, in Thieme-Becker K. L., under appropriate heading, with full bibliography, Leipzig, 1921;
Justi L., *Giorgione*, Berlin, 1926;
Morassi, *Giorgione*, Milan, 1942;
Fiocco G., *Giorgione*, Bergamo, 1949;
Klauner F. K., in "*Jahrbuch der Kunsthistorischen Sammlungen*", Vienna, 1954–55;
Della Pergola P., *Giorgione*, Milan, 1955;
Coletti L., *Tutta le Pittura di Giorgione*, Milano, 1955;
Pignatti T., *Giorgione*, Verona, 1955;
Zampetti P., *Giorgione e i Giorgioneschi* (Exhibition catalogue) with full bibliography to that date, Venice, 1955;
Calvessi M., in "Commente ri", 1962;
Parronchi A., *Chi sono i tre filosofi*, in "Arte Lombardia" fuori serie, studi in onore di G. Fasola, 1965.
Baldass-Heinz, *Giorgione*, Wien-Munchen, 1966;
Volpe C., *Giorgione*, Milan, 1963; Lilli-Zampetti, *Giorgione*, Milan, 1968.

## GIOVANNI DA ASOLA

Born at Asola (Brescia), he removed to Venice at an early age, being recorded present there in 1512. Initially trained after the example of Bartolomeo Montagna and currents of Brescis art, in particular that of Moretto. Once in Venice, he became influenced by the great painters at work there, from Titian to Palma il Vecchio and others also, perhaps including Lotto himself. He is documented as still in Venice in the year 1526, when he was executing a commission with the help of his son Bernardino. The work comprised painting the organ doors for the church of S.Michele in Isola, depicting: the *Doge Pietro Orseolo before S.Romualdus; St. Benedict and two monks; St. Michael putting devils to flight;* the *Assumption of the Virgin.*
As Fiocco remarked, in these works the artist makes use of various devices based on formulas of Giorgione, perhaps taken from another Brescia painter, namely Romanino. In the Assumption, the Frari altar-piece by Titian is clearly recalled. The artist who died at Venice in 1531 is referred to in the contract deed for the S.Michele organ doors as "Maistro Zuane depentore . . . da Asola de Bressa".

Asola, S.Andrea, *Adoration of the Shepherds;*
Milan, Ambrosiana, *Martyrdom of St. Sebastian;*
Padua, Civic art gallery, *Adoration of the Shepherds and Lucrezia Muscheta;*
Venice, Correr museum, *Organ doors for S.Michele* (1526); Querini Stampalia gallery, *The Last Supper;* S.Barnaba, *St. Anthony of Padua and other saints; Deposition* (lunette); *Bernardino da Siena and saints; Coronation of the Virgin* (lunette).

ESSENTIAL BIBLIOGRAPHY

Fiocco G., *Giovanni e Bernardino da Asola*, in "Bollettino d'Arte", 1925;
Lorenzetti G., *Venezia ed il suo estuario*, I, ed. 1927;
Mariacher G., *Il Museo Correr di Venezia*, Venice, 1957;
Berenson B., The *Italian Pictures of the Renaissance*, I, Venetian School, 1957.

## GIROLAMO DEI MAGGI, DA PADOVA

Active at the close of the fifteenth and in the early sixteenth centuries, his name is exclusively associated with a *Sacra conversazione* in the Karl Lundmark collection, Stockholm. Signed: "Hieronimus De Maiis Patavinus fecit hoc opus", which is to say: "Jerome dei Maggi from Padua painted this work".
It is of a Madonna and child, with SS.Peter and John Baptist adoring, two female saints reading a holy book and the donor; it reveals intimate links with the art of Cima da Conegliano, and is not exempt from influence of Giovanni Bellini.
As to date it may be reckoned within the first decade of the sixteenth century and perhaps later, given the provincial character of the work. For the fact remains that especially in treatment of landscape, the re-thinking of Giorgione is apparent. Nothing is known of the life or other work of this rare artist.

BIBLIOGRAPHY

Berenson B., *Italian Pictures of the Renaissance*, I, Venetian School, London, 1957.

## GIROLAMO DI BERNARDINO DA UDINE

References to him span the years from 1506 to 1512, the year in which he died. The only work remaining which is documented and therefore certain is the *Coronation of the Virgin*, now in Udine museum and formerly in the church of S.Francesco there.
Girolamo da Udine on the evidence of this work and others attributed to him on grounds of stylistic affinity with it, emerges pretty close to Cima da Conegliano, imitating his manner and formal approach. Adolfo Venturi noted some trace of Carpaccio but it is worth remembering in this context that the two artists, Cima and Carpaccio, had their points of affinity and indeed at times influenced one another.
He may thus be compared to Giovanni Martini da Udine and belongs within the Friuli group of painters who reproduced in often bald but forthright terms the artistic achievements got from Venice.

Padua, Civic museum, *Madonna of the pear;*
Udine, Civic museum, *Coronation of the Virgin;*
Worcester (Mass.), Museum, *Adoration of the Shepherds;*
(location unknown), *Sacra famiglia.*

ESSENTIAL BIBLIOGRAPHY

Lanzi L., *Storia Pittorica dell'Italia*, Bassano, 1789;
De Rinaldis G., *Della pittura friulana*, Udine, 1796;
Crowe-Cavalcaselle, *A History of Painting in North Italy*, (ed. Borenius), London, 1912;
Fiocco G., *G. d. U.* in Thieme-Becker K. L., Leipzig, 1912 (with bibliography);
Marle V., *The Development of the Italian Art of the Renaissance*, XVII, The Hague, 1935;
Molajoli B., *Exhibition catalogue: Pordenone*, Udine, 1939;
Berenson B., *Italian Pictures of the Renaissance*, I, Venetian School, London, 1957.

## GIROLAMO DI TOMMASO DA TREVISO called GIROLAMO IL GIOVANE

Documented from 1497 to 1544, the year in which he died, he needs distinguishing from Girolamo Pennacchi (also called Girolamo da Treviso).

Some art historians—like Fiocco—take the view that he too belonged in the family of Treviso painters who were active in the fifteenth and the sixteenth centuries. A complex eclectic character emerges from the works of this Girolamo, associated with Titian's art and again with that of Pordenone, a clear hint of the artist taking up the incipient Mannerist approach.

With the passing of time and also in logical sequence—as Berenson rightly observed—the artist became influenced by central Italian art. Indeed, detectable traces stem from the art of Raphael and Parmigianino.

The *Adoration of the Shepherds* in the Ashmolean at Oxford serves to exemplify the complex nature of his work. It may well mark the peak of his achievement for its spacious architectonic setting and bustling figures.

PRINCIPAL WORKS

Balduina (Padua), Parish church, *Sacra famiglia;*
Bologna, S.Giovanni in Monte, *Noli me tangere;*
Castel Bolognese, S.Sebastiano, *Madonna and saints* (fresco);
Faenza, Chiesa della Commenda, *Frescoes in the apse* (1533);
London, National gallery, *Madonna enthroned with saints;*
Oxford, Ashmolean museum, *Adoration of the Shepherds;*
Rome, Borghese gallery, *Venus asleep in landscape.*

ESSENTIAL BIBLIOGRAPHY

Fiocco G., *Girolamo da Treviso*, in "Rivista del R. Istituto di Archeologia e Storia dell'Arte", Rome, 1929;
ibid., in Thieme-Becker K.L., Leipzig, 1932, under heading *Pennacchi Girolamo;*

Berenson B., *Italian Pictures of the Renaissance*, Oxford, 1932;
Galletti-Camesasca, *Enciclopedia della Pittura Italiana*, Milan, 1950;
Berenson B., *Italian Pictures of the Renaissance*, I, Venetian School, London, 1957.

## GRASSI GIOVANNI BATTISTA, DA UDINE

Architect and painter, born in Udine at the beginning of the sixteenth century. A well-informed man and an art lover, he was a friend of Vasari's and provided him with information about the painters of the Friuli which the historian from Arezzo then used in writing his *Lives*.
Documented in the year 1568, in connection with Vasari and remembered for works left in the cathedral at Gemona and other localities in the Friuli. Like all local painters of his generation, he too affords proof of strict dependence on the art of Pordenone.

BIBLIOGRAPHY

Vasari G., *Le Vite* etc., 1568;
Orlandi P., *Abecedario Pittorico*, Bologna, 1719;
Lanzi L., *Storia Pittorica dell'Italia*, Bassano, 1789;
Galletti-Camesasca, *Enciclopedia della Pittura Italiana*, Milan, 1950, under appropriate entry.

## INGANNATI PIETRO

Critical evaluation of this artist, who is certainly a minor figure, belongs in the main to modern times. The place where he was born is not known but he is taken to be Venetian. The three documents referring to him (two notarial deeds and an estimate) bear the dates 1529, 1543 and 1547, all Venetian. The reconstruction of his personality as an artist has been done by Cavalcaselle, Berenson, Venturi and Gronau. Cavalcaselle in point of fact came across and appraised two works bearing the signature: "Petrus de Ingannatis p(inxit)". Other works were discovered subsequently, adding to the restricted nucleus attributed to him.
The artist was a limp and lagging follower of Giovanni Bellini, remaining quite outside the Giorgione movement. He was close to Bissolo, indeed akin to him, using again his rather wan and boneless forms. Only in the late works, perhaps through influence of Cariani, did he in any way echo the art of Titian and Palma il Vecchio, heightening his colour range which however continued to express provincial sensitivity, not aware of the new departures under weigh elsewhere.

WORKS

Brescia, Civic art gallery, *Madonna with Catherine of Siena and other saints;*
Dresden, Gemäldegalerie, *Sacra conversazione;*
London, Seller coll., *The Holy Family;*
Portland (USA), Art museum, *Figure of a martyr;*
Ravenna, Gallery, *The Holy Family;*
Venice, Accademia gallery, *Madonna and child with saints;*
(location unknown), *Portrait of a young man with a beard.*

ESSENTIAL BIBLIOGRAPHY

Ludwig G., in "Jahrb.d.preuss.Kunsts", 1905;
Venturi A., *Storia dell'Arte Italiana*, VII, 4, Milan, 1915;
Berenson B., *Italian Pictures of the Renaissance*, Oxford, 1932;

Gronau G., *L'ultimo pittore italiano belliniano*, in "L'Arte", 1933;
Berenson B., *Italian Pictures of the Renaissance*, I, Venetian School, London, 1957;
Mariacher G., *Il Museo Correr di Venezia*, Venice, 1957;
Martini A., *La Galleria dell'Accademia di Ravenna*, Venice, 1959.

## LE CLERC JEAN

Born at Nancy in France about the year 1585, little is known of his young days. By the beginning of the seventeenth century, he was already in Rome where he became a friend of the Venetian Saraceni and also of Elsheimer with whom he incidentally collaborated. The nature of his artistic personality at this period does not emerge well-defined as of now, despite work by Henrich (1935) and Longhi (1935). Indeed, his activity has been confused at times with that of Saraceni. Longhi (1943) grouped together four paintings, akin to early Saraceni's but which could not possibly be assigned to Le Clerc; he determined rather to assign them to an anonymous painter whom he called "lodger of Saraceni".

Le Clerc subsequently went to Venice in the company of Saraceni and when the latter died in 1620 finished on his behalf and signed the large-scale piece in the Sala del Maggior Consiglio depicting *Enrico Dandolo and the crusader captains taking the oath in St. Mark's before embarking.*

After Saraceni's death—from whom he received goods and money by way of bequest—Le Clerc returned to Nancy, his home town and died there in 1633. Of notable importance both for his virtues, appreciable in the Maggior Consiglio work, and for having brought home to Lorraine the Saraceni version of Caravaggio reform which in turn influenced French artists in particular La Tour who like himself hailed from Lorraine.

#### PRINCIPAL WORKS

Florence, Corsini gallery, *Peter denying Christ;*
Munich, Bayer.Staatsgemäldesammlungen, *The Concert;*
Rome, Capitoline gallery, *Christ with the doctors in the temple;*
Venice, Chiesa del Redentore, *The Blessed Giuseppe della Leonessa;* Palazzo ducale, *The Doge Enrico Dandolo,* etc.

#### ESSENTIAL BIBLIOGRAPHY

Boschini M., *Le Minere della Pittura*, Venice, 1664;
Zanetti A. M., *Della Pittura Veneziana*, Venice, 1771;
Lanzi L., *Storia Pittorica dell'Italia*, Bassano, 1789;
Voss, H., *Die Malerei des Barock in Rom*, Berlin, 1924;
Fiocco G., *La Pittura Veneziana del Seicento e del Settecento*, Verona, 1929;
Longhi R., *Mostra del Caravaggio e dei Caravaggeschi*, Florence, 1951;
Ivanoff N., *Giovanni Le Clerc*, in "Critica d'Arte", 1962;
Pallucchini R., *L'ultima opera del Saraceni*, in "Arte Veneta", 1963;
Pilo-Donzelli, *I Pittori del Seicento Veneto*, Florence, 1967.

## LICINIO BERNARDINO

Of Bergamo origin, born perhaps at Poscante in about 1489, he was at Venice in the year 1511 which is the date of the first documentary reference to him. His activity in Venice is recorded down to 1549. The year he died is not known precisely, but may be placed prior to 1561. Like his fellow

artist from Bergamo—Cariani (to whom he is often close in manner)—Licinio's career began under the stimulus afforded by the example of Giorgione, whose triumph was complete over the Venetian art world.

To this early period the *Portrait of a member of the Ferramosca family* of Vicenza museum evidently belongs. It was formerly attributed to Giorgione himself but Arslan (1929) restored the work to Licinio. In this, he was followed by Berenson (1932) and art experts in general. The melancholy of the figure expressed, the use of tone painting are indicative of the pro-Giorgione period of this artist at his most felicitous and genuine. The portrait of a *Young man with a skull* also belongs to the same phase of culture, though in a form to some extent academic, concerned rather with the outward appearance than the inward fervour.

Later on, Licinio leant towards Titian and Palma il Vecchio and then finally turned more evidently to the work of Pordenone. His colour range shews loss of vigour and originality on an increasing scale to the point of being understated and impoverished. The altar-piece for the Frari church in Venice, of the *Madonna enthroned with saints*, describes his limitations, particularly noticeable in the immobility of the figures.

He painted love scenes (the *Concert* of Hampton Court is an instance) after late Giorgione; the topics are pleasing but there is nothing specially poetic or individual marking his invention in concept or detail. Obviously at his best in the early works, the portraits may be deemed the most favourable expression of his personality as an artist.

### PRINCIPAL WORKS

Bergamo, Carrara gallery, *Portrait of a gentlewoman;*
Boston, USA, E. D. Braudegee coll., *Portrait of a gentlewoman;*
Brescia, Art gallery, *Adoration of the shepherds;*
Budapest, Fine arts museum, *Portrait of a gentlewoman;*
Grenoble, Museum, *Madonna and saints;*
Hampton Court, *Family group; Concert;*
London, National gallery, *Portrait of Stefano Nani dall'Oro;*
Milan, Sforza castle, *Portrait of a woman;*
Oxford, Ashmolean, *Young man with a skull;*
Rome, Borghese gallery, *Family group;*
Venice, Frari church, *Madonna enthroned with saints;*
Vicenza, Civic museum, *Portrait of a member of the Ferramosca family;*
Vienna, Kunsthistorischesmuseum, *Portrait of Ottaviano Grimani.*

### ESSENTIAL BIBLIOGRAPHY

Ridolfi C., *Meraviglie dell'Arte*, Venice, 1648;
Lanzi L., *Storia pittorica dell'Italia*, Bassano, 1789;
Von Halden D., *Zum Duvre Bernardinos Licinios*, in "Repertorium für Kunstwissenschaft", 1909;
Venturi L., *Giorgione e il Giorgionismo*, Milan, 1913;
Venturi A., *Storia dell'Arte Italiana*, IX, 3, Milan, 1928;
Arslan W., *B.L.* in "Thieme-Becker K.L.", Leipzig, 1929 (with bibl.);
Berenson B., *Italian Pictures of the Renaissance*, Oxford, 1932;
Arslan W., *La Pinacoteca Civica di Vicenza*, Rome, 1934;
Pallucchini R., *La Pittura Veneziana del Cinquecento*, Novara, 1944;
Berenson B., *Italian Pictures of the Renaissance*. I, Venetian School, London, 1957;

Barbieri, *Il Museo Civico di Vicenza*, Venice, 1962;

Pallucchini R., *Due concert bergamaschi del Cinque-cento*, in "Arte Veneta", 1966;

Rearick W. R., *A Drawing by Bernardino Licinio*, in "Master Drawings", 1967;

Smirnova Irine, *Un nuovi Bernardino Licinio a Mosca*, in "Arte Veneta", 1967.

## LISS JAN

Born at Oldenburg in Holstein, Germany, about 1595. He went to Holland as a young man and remained there over the period 1616 and 1619, dwelling in Amsterdam, Haarlem and at Antwerp. Then he went to France and stopped in Paris. Last, he moved on to Venice where he arrived in the year 1620. In 1622 he travelled to Rome but by 1624 was back in Venice where he lived till his death, which may be dated to 1629 or 1630 and attributed to an outbreak of plague.

Jan Liss—also called Pan—although a German may well be counted an artist in strict alignment with Venetian painting. From his youth, his experience of art was extremely wide. First, in the busy world of Dutch and Flemish art he absorbed influences from Caravaggio, later accentuated when he visited Rome. Basically he followed the great Venetians of the sixteenth century, at the same time with an eye to the new developments then in course, for example, traces of the manner of Domenico Fetti are perceptible in his work. Of northern origin is his exuberant sense of colour, though affinity exists with Italian art. In his final period in Venice, his painting is soft and light, leavened as it were by gleaming paint material.

The genre pieces have a pleasing air of relish for the true-to-life. With time, they cede pride of place to mythological narrative and religious themes; the painting becomes lighter-bodied, freer and more alive, an effect achieved by great daintiness of touch.

His receptiveness to the silvery painting of Paolo Veronese—a painter he studied intensely, with a good grasp of the meaning of his work in terms of paint material—raises him to a level above run-of-the-mill contemporary work following Caravaggio firmly and stultifyingly. In the first decades of the seventeenth century, he may be deemed a true precursor of the painting style taken up by Sebastiano Ricci endeavouring to put new life into old colouring, and after him by Giambattista Tiepolo.

Work by Liss was admired by the German Sandrart while visiting Venice (1626–9). Though not referred to by Ridolfi (1648), he was mentioned quite favourably by Boschini, both in "Carta del Navegar Pitoresco" and "Le Minere". This artist was then pretty well forgotten, except by Lanzi at the close of the eighteenth century. Latterday experts have been taking a closer look at him, especially Fiocco (1929), whose efforts contrived to distinguish him from others of the same name and to give some account of his qualities as a painter.

Pallucchini remarked, with justification, that the *St. Jerome and the angel* of the church of S. Nicolò dei Tolentini in Venice, is a work of such ardent compositional rhythm that it served as inspiration to Piazzetta some century later. In fact the free pictorial composition, shot with unexpected highlights, places Liss not only within the orbit of Venetian painting but makes his work a fundamental part of it, at a point of time when local painters were still hamstrung by an academic approach to their art.

PRINCIPAL WORKS

Berlin, Staatlichen museen, *Ecstasy of St. Paul;*
Brunswick, Museum, *The players;*
Budapest, Fine arts museum, *Country wedding;*

Dresden, Gemäldegalerie, *Venus and Adonis;*
Florence, Uffizi gallery, *Venus and the looking-glass;*
Genoa, Basevi coll., *Cupid;*
London, Mahon coll., *Fall of Phaeton;*
Kassel, Gemäldegalerie, *Game of "morra";*
Munich, Alte Pinakothek, *Cleopatra;*
Venice, S.Nicolò dei Tolentini, *St. Jerome and the angel;*
Vienna, Kunsthistorischesmuseum, *Judith.*

ESSENTIAL BIBLIOGRAPHY

Boschini M., *La Carta del Navegar Pitoresco*, Venice, 1660; *Le Minere della Pittura*, Venice, 1664; *Le ricche minere della pittura veneziana*, Venice, 1674;
Sandrart J., *Academia nobilissimae artis pictoriae . . .* Nuremburg, 1683;
Zanetti M. A., *Della Pittura Veneziana*, Venice, 1771;
Lanzi L., *Storia Pittorica dell'Italia*, Bassano, 1789;
Peltzer R. A., in Thieme-Becker, 1929, under appropriate heading (with good bibliography);
Bloch V., *Liss and his "Fall of Phaeton"*, in "The Burlington Magazine", 1950;
Bloch V., Addenda to Liss, in "The Burlington Magazine", 1955;
Delogu G., *Pittura Veneziana dal secolo XIV al sec. XVIII*, Bergamo, 1958;
Zampetti P., in "La Pittura del Seicento a Venezia", Venice, 1959;
Donzelli-Pilo, *I Pittori del Seicento Veneto*, Florence, 1967 (with bibl. to that date).

# LOTTO LORENZO

Son of Thomas, born at Venice in the year 1480. The figure of this artist dwelled in the shadows until last century. The first monograph devoted to him came from the pen of Bernard Berenson in 1895 and since then he has emerged as of increasing stature and importance. A series of happy coincidences and the finding of documents, journals and letters have led to his becoming quite well known as a person as well as an artist. At the present time, Lotto is viewed against the background of Venetian painting during the sixteenth century as a personality in his own right constituting one of the era's loftier and more impressive aspects.

The first records about him go back to 1503, at Treviso. In 1506 he was at Recanati in the Marches (though he may have been there once before, when even younger). In 1508 he left the Marches and returned to Treviso. The following year he was in Rome working on the "Stanze" in the Vatican. In 1512, back in the Marches, at Jesi and Recanati; in 1513, he arrived at Bergamo. There he remained until 1525, though the evidence points to repeated excursions into the Marches and perhaps as far away as Rome during that period. In 1526, he was in Venice, a guest of the monks of SS.Giovanni e Paolo.

In 1532 at Treviso and in 1535 at Jesi, where he was summoned to paint a picture for Palazzo dei Priori. In 1538, at Ancona where he began keeping his "Book of accounts"; in 1540 at Venice where he lodged with a nephew of his, by name Mario d'Armano.

In 1542 he left Venice and went to Treviso for the sake of peace and quiet but in 1545 was back in Venice because of his work: in Treviso he was "not earning his keep" as he put it. The following year he fell ill and sought a haven in the house of a friend, Bartolomeo Carpan. In the summer of

1549, he again left Venice, this time for Ancona (at this stage he was close on seventy) in order to carry out his commission for the great *Assumption* altar-piece in the church of S.Francesco.

He remained in Ancona until the year 1552, and it was then he made up his mind to retire to Loreto. He ended his days as an oblate of the Santa casa there, after the month of September 1556. His life to a great extent was spent on the move, going from one place to the next. He started young and it has been suggested that his father was a merchant, a fact which would then serve to explain how he came to be at Recanati so far from home ground before he was out of his teens: that is to say, if he accompanied his father. Indeed, his "wanderlust" could be seen as a matter of heredity; whatever its origin, it stayed with him life-long.

He is not known to have had family, wife or children. In his will of 1546, he mentions being "alone with no sure guide and very troubled in mind" (Arch. Veneto, 1887). The effect of solitude comes through in jottings in his Book of accounts: an old man, searching somewhat desperately for somewhere to settle down, whether with acquaintance in Venice or Treviso and so cease wandering. He may not have been of a sociable turn and was certainly of unquiet mind but he was a good man and held deep religious convictions. His desire went unsatisfied at all events, until 1554 when at long last he was accepted by the community at Loreto and so could "stop wandering in his declining years".

The earliest work from his hand goes back to 1500 or thereabouts. In it Lotto shows influence out of Antonello, Alvise Vivarini and perhaps Bramante as well (the "paggi" of the Onigo monument at Treviso). Next, he looked to Giovanni Bellini, maintaining throughout a strong individuality. It is especially marked in his characteristic sense of the dramatic, and his distaste—constant and congenital—for the ready-fashioned formula, the taint of the academic and the classical.

He studied all the artists he came across in the course of his travels (both artists and works). In the Marches, for example, he certainly knew the work of Luca Signorelli, Melozzo da Forli (both present at Loreto) and Carlo Crivelli, another Venetian like himself but who had moved permanently to the region. The component parts of his formative period were thus many; perhaps this was the reason that left him with a personality entirely his own. For over half a century, the tide of his artistic development flowed intensely, ranking him among the most fruitful and original artists in Italian painting.

With the Recanati polyptych finished in 1508, the early period is at a close. It was the threshold of a new world; the classical spell was broken. Antonello, Piero and Giorgione were surpassed: Lotto stood alone, on his own terms. Enchanted light, tranquil austerity flared into drama and exasperation. The colouring was bright, almost aggressive with the cold blending of grey, azure and rose. Light strikes from the ground up, making the composition dramatic, from a soul in travail, a far from tranquil religious attitude felt by a storm-tossed restive mind.

Lotto was affected by the northern painters, that is clear, particularly by Dürer who was at Venice in 1505 (where he painted the *Madonna and saints*, formerly S.Bartolomeo and now Prague museum).

The *Pietà* at the top of the Recanati polyptych is among the most tragic paintings in the history of Italian art. Bellini had attempted similar subjects but in a very different spirit, as the artist narrating a religious theme in terms of paint and of poetry. Lotto lived the tragedy, part of himself is in the painting. There are no precedents for art of this kind, unless perhaps in Carlo Crivelli and his "Pietà" which is exasperated and violent, in the Ascoli polyptych.

Nothing remains from the Roman period. Certainly, the painter was overwhelmed by the art of Raphael and indeed temporarily succumbed, as shown in the works immediately post-dating the period, as the *Deposition* of 1512, now in Jesi art gallery in the Marches. It is at the same time probable that Lotto's painting affected Raphael's art, as experts nowadays tend to concur. Attentive examination of the frescoes in the "Stanze" in depth reveals surprising assonance with Lotto's

work, particularly the Room of Heliodorus, reference the portraits in the *Miracle of Bolsena*. Before Sebastiano del Piombo's influence was felt, it is therefore possible that the new chromatic sense so evidently assimilated by the painter from Urbino may in fact be due to Lorenzo Lotto.

After a short spell in the Marches, 1512, he moved on to Bergamo and there in 1513 he was commissioned to paint the great *Altar-piece* for the church of SS.Stefano e Domenico, now in the church of S.Bartolomeo but still in Bergamo. This affords clear demonstration how far he was affected by Roman feeling for space; the peak expressions of this feeling are encountered in the *altar-pieces* for the churches of S.Bernardino and S.Spirito, both of 1521, and also the *frescoes* for the Suardi chapel at Trescorre, a masterpiece he signed and dated 1524.

His innate romantic spirit found unreserved expression during the Bergamo period. Standing more and more apart from painting trends of the time, he became independent and original, giving outward form to the lack of tolerance and contentment peculiar to his art and character. He thus became one of the most independent and original artists of his time. The great Bergamo pieces express special creative felicity, unleashed after his Rome contacts. Light becomes a matter of higher and more vital value; it sheds itself and steals silently onto the scene. It then falls fitfully in every nook and cranny; where it touches, it lingers making the form of things diaphanous, ethereal and almost phosphorescent. His figures acquire insight and intimacy, inward-looking and discrete, in a way that is typical of this artist. The colours are never pale and golden (as for example in Titian) but pulsating and fickle, on occasion violent in the tone contrast. Lotto was never content to obey a set formula, however felicitous. He found himself acutely non-tolerant of art he felt he could not countenance; this made him continually on the search for new means of expression.

The restive mind so deep a part of Lotto made him an inquirer after new forms. He may be considered, in this way, a father of Mannerist art. The St. Lucy *altar-piece* is exemplary; now in Jesi art gallery, it was finished in 1532 and is stupendous in terms of sheer chromatic inventiveness.

In his prime, Lotto passed his time between Bergamo and the Marches. In 1525, he went off to Venice and was in contact with the monastery of SS.Giovanni e Paolo where he painted the St. Antonio *altar-piece*. He did not lose touch with Bergamo but went on designing the *Bible scenes* that were being carried out in intarsio-work for the church of S.Maria Maggiore in Bergamo. In addition, he often travelled in the Marches for reasons of his work, including some important pieces sent there, one of which is the *Madonna of the Rosary* in the church at Cingoli.

In 1538, he began keeping the "Book of accounts" which shows his outgoings and also contains sundry jottings, indicative of his reactions. Together with the letters he wrote from Venice to correspondents in Bergamo about the intarsio-work for S.Maria Maggiore, it becomes possible to gain some glimpse of the character of the man.

In 1531 he completed the breath-taking *Crucifixion* of Monte S.Giusto: a cry from the heart, full of forebodings of sorrow, in a tumult of souls aghast. In 1542, he finally finished the S.Antonino altar-piece for the church of SS.Giovanni e Paolo in Venice (see above). It is a splendid work especially in respect of the lower half with the crowd of poor postulants. Here the painting and the psychology are surprisingly modern.

His deep understanding of the human mind, developed through life's vicissitudes, made him a great portrait painter in so far as he was the interpreter of the moral being of the person portrayed. Some of his portraits whether of his youth, prime or old age (reference may be made to those in Naples museum, the Brera of Milan, the one at Hampton Court also others in Venice and Vienna), are as penetrating as any in Italian art annals.

As the years passed, Lotto became less and less understood by his compatriots who were full of the praises of Titian, absolutely set in favour of a manner quite different from that of Lotto. This made him wish to depart, and so he stayed first at Ancona and then in 1552 joined the Santa casa at Loreto as an oblate. In the solace of the cloister he composed his last masterpieces, like the cele-

brated *Presentation in the temple*. Again, this work may surprise the viewer in that the tone painting is drab and cold, the brush work mottled with a consistency altogether novel.

Berenson noted with justification that in other contemporary painters, the subject of the picture was the event, whereas with Lotto what mattered was the feeling aroused by the event. In this regard, the artist's importance is very great, assuming an emblematic value and revealing little-known aspects of the complex soul of the Italian sixteenth century. It is rare for an artist to see his work as engaging his whole mind, as happens in Lotto. A man without doubt of wide learning—more on the religious side than in connection with humanism. His work is not so much illustrative as an event in itself, fully experienced to the depths of conscious being. His art is seldom contemplative; it is unquiet and it is disquieting. It cannot be surveyed with detachment but rouses a strong reaction according to the receptive sensitivity of the viewer. His achievement thus takes the form of a dialogue, set in motion between the painting and the viewer. Neither hero nor hedonist, his character is profoundly moral and dramatic. His position contrasts with his contemporaries; he emerges as one of the most open-minded and forward-looking artists in Venetian painting in his century.

PRINCIPAL WORKS

> Ancona, S.Francesco, *Assumption* (1550); Civic art gallery, *Madonna enthroned with saints;*
>
> Asolo (Treviso), *Assumption with saints* (1506);
>
> Bergamo, S.Bartolomeo, *Altar-piece with Madonna enthroned and saints* (1516); S.Bernardino, *Madonna enthroned with SS.Joseph, Bernardino etc.* (1521); S.Spirito, *Madonna enthroned with SS.Catherine, Ambrose and others* (1521);
>
> Berlin, Staatlichen museen, *Christ taking leave of the Madonna* (1521);
>
> Cingoli (Macerata), S.Domenico, *Madonna del Rosario* (1539);
>
> Hampton Court, Royal coll., *Portrait of Andrea Odoni* (1527);
>
> Jesi, Civic art gallery, *Entombment* (1512); *Madonna enthroned with SS. Joseph and Jerome* (with lunette); *Altar-piece of St. Lucy and predella* (1532);
>
> Loreto, Palazzo Apostolico, *Presentation in the temple;*
>
> Milan, Brera gallery, *Portrait of Laura da Pola* and *Portrait of Febo da Brescia* (both of 1544);
>
> Monte S.Giusto (Macerata), Parish church, *Crucifixion* (1531);
>
> Paris, Louvre, *St. Jerome in the desert* (1506);
>
> Ponteranica (Bergamo), *Polyptych;*
>
> Recanati, Communel art gallery, *Polyptych* (1508); *Annunciation;*
>
> Trescore (Bergamo), Oratorio Suardi, Frescoes of the *Redeemer and the Heresies; Legend of Barbara, of Clare and other religious topics* (1524);
>
> Venice, Accademia gallery, *Portrait of a young man;*
>
> Vienna, Kunsthistorischesmuseum, *Portrait of a young person; Sacra conversazione;*
>
> Washington, National gallery, *Nativity* (1523).

ESSENTIAL BIBLIOGRAPHY

> Michiel A., *Notizie di opere di disegno etc.* (c. 1545); ed. Frizzoni, Bologna, 1884;
>
> Vasari G., *Le vite* etc. ed. Milanesi, Florence, 1550;

Ridolfi C., *Le Meraviglie dell'Arte*, Venice, 1648;

Boschini M., *Carta del Navegar Pitoresco*, Venice, 1660;

Ricci A., *Memorie storiche ecc. della Marca di Ancona*, Macerata, 1834;

Tassi F. M., *Vite dei pittori e scultori ecc. bergamaschi*, Bergamo, 1893;

Berenson B., *Lorenzo Lotto*, London, 1895;

Venturi A., *Il Libro dei Conti di Lorenzo Lotto*, in Gallerie Nazionali Italiane, 1895, Rome;

Biscaro G., *Lorenzo Lotto a Treviso nella prima decade del secolo, XVI*, in "L'Arte", 1898;

Berenson B., *The Venetian Painters of the Renaissance*, 1907;

Berken V. D., in Thieme-Becker *K.L.* under appropriate heading, Leipzig, 1929;

Venturi A., *Storia dell'Arte Italiana*, IX, 4, Milan, 1929;

Berenson B., *Pittori Italiani del Rinascimento*, Milan, 1936; *Pittura Italiana del Rinascimento*, Milan, 1936;

Pallucchini R., *La Pittura Veneziana del Cinquecento*, Novara, 1944;

Longhi R., *Viatico per Cinque Secoli ecc.*, Florence, 1946;

Banti A., *Lorenzo Lotto*, Florence, 1953;

Zampetti P., *Lorenzo Lotto nelle Marche*, Urbino, 1953; *Lorenzo Lotto* (Exhibition catalogue), Venice, 1953;

Coletti L., *Lorenzo Lotto*, Bergamo, 1953;

Pigler A., In "Acta Historiae Artum Academiae Scientiarum Hungaricae", Budapest, 1953;

Berenson B., *Lorenzo Lotto*, Milan, 1955;

Zampetti P., *Noterelle Lottesche*, in "Arte Veneta", 1956;

Berenson B., *Italian Pictures of the Renaissance*, I, Venetian School, London, 1957;

Pouncey P., *Lotto disegnatore*, Venezia, 1965;

Lorenzo Lotto, Il *"Libro di spese diverse"*, Venice-Rome, 1968.

## LUZZO LORENZO called MORTO DA FELTRE

It was Vasari who referred to this painter as "Morto da Feltre", the name by which he is generally known. Source material indicates that he was in Rome towards the close of the fifteenth century, that is to say between 1493 and 1498; then he moved on to Florence, where he is recorded in 1505. After that he was in Venice and referred to by Vasari as helping Giorgione on the frescoes for the facade of the Fondaco dei tedeschi (it is known that Titian also collaborated on this job, painting the side facade of the palace). Information about this artist is far from plentiful, often unclear and mixed up with tradition.

Two certain works of his exist, namely an *altar-piece* now in Berlin museum, dating from 1511 and a fresco of *Christ appearing to St. Anthony Abbot and St. Lucy*, done in 1522. Further, there have been assigned to him the *altar-piece* in the church of Villabruna (Feltre) and some portraits which are however of uncertain attribution.

In the works that have been listed, the artist displays knowledge of the art of Giorgione, together with other influences, such as that of Pellegrino da S.Daniele and Lorenzo Lotto. The most significant lesson he learnt was from Roman painting, broadening his composition and imparting the sense of space, out of Raphael. In fact, the Villabruna altar-piece obviously follows the *Madonna di Foligno* in inspirational depth. A. Venturi remarked that in this painting, the composition is "no

longer constricted within a dumpy pyramid as in the Berlin work; it takes nobility from the acute accord between the delicate imagery of the figures and the sweeping spatial dimension". Lionello Venturi, lastly, stressed the real meaning of Luzzo's artistic personality as lying in his "extraordinary eclectic stance between the schools of Venice and of Rome".

ESSENTIAL BIBLIOGRAPHY

> Vasari G., *Le Vite* etc., 1568;
> Ridolfi C., *Le Meraviglie dell'Arte*, Venice, 1648
>    (ed Halden, Berlin, 1914);
> Venturi L., *Pietro, Lorenzo Luzzo e il Morto da Feltre*, in "L'Arte", 1910;
>    *Giorgione e il Giorgionismo*, Milan, 1913;
> Venturi A., *Storia dell'Arte Italiana* IX, 3, Milan, 1928;
> Berenson B., *Italian Pictures of the Renaissance*, I, Venetian School, London,
>    1957.

## MAGANZA ALESSANDRO

Born at Vicenza in 1556, the son of Giambattista, likewise a painter and also a man of letters. A pupil of Fasolo (q.v.) he was attracted as his master was by the tremendous skill of Paolo Veronese, widening the bounds of his artistic experience at a subsequent stage by studying the work of Tintoretto, Palma il Giovane and Bassano as well. Fairly active in the cities of the Veneto (namely at Vicenza, Padua, Brescia and elsewhere), he had the assistance of his sons Giambattista, Marcantonio and Girolamo.

The personality of Maganza is distinct from other Mannerists of his day and age by virtue of his vivid use of polychromatic colouring based on violent contrast and a highly inventive touch when it came to interpreting the teaching of the towering figures of the sixteenth century. This in turn freed him from all risk of tamely following where his masters led, at the same time making him receptive to culturally diverse lessons. A pupil of Maganza was Francesco Maffei, a leading exponent of Venetian baroque: his treatment of light after Tintoretto, in a new key, was no doubt derived through the example of Maganza.

PRINCIPAL WORKS

> Brescia, S.Afra, *Christ in the house of Simon;*
>    S.Gaetano, *Annunciation;*
>    S.Maria delle Grazie, *The Holy Family;*
> Padua, S. Benedetto, *Transfiguration;*
>    Accademia di Scienze, Lettere ed Arti, *Coronation of the Virgin;*
> Schio, Chiesa dei Capuccini, *San Niccolò and other saints;*
> Venice, Ca' Farsetti, *Angelo Correr receiving from Vicenza the ducal commsssion;*
> Vicenza, Duomo, *St. Mark presenting Vicenza to the Madonna;*
>    S.Domenico, *Coronation of the Virgin* (other paintings in ceiling);
> Basilica di Monte Berico, *Madonna and evangelists; Baptism of Christ;*
> Civic museum, *Communion of St. Bonaventure; Portrait of a young man.*

ESSENTIAL BIBLIOGRAPHY

> Marzari G., *La Historia di Vicenza*, Vicenza, 1604;
> Ridolfi C., *Le Meraviglie dell'Arte*, Venice, II, 1648;
> Venturi A., *Storia dell'Arte Italiana* XI, 7, Milan, 1934;

Lodi F., *Un tardo manierista vicentino: Alessandro Maganza*, in "Arte Veneta", 1965;

Donzelli-Pilo, *I Pittori del Seicento Veneto*, Florence, 1967 (with full bibliography).

## MALOMBRA PIETRO

Born at Venice in 1556, he was a pupil of the Roman painter, Francesco Salviati, during the period that the latter resided in Venice. He belongs within the late Mannerist group, affected as it was by the most divergent tendencies, from the plastic treatment of form practised by the fading epigones of Michelangelo to the extreme manifestations of the brilliant sixteenth century Venetian tradition headed by Palma il Giovane.

Ridolfi held that as a young man Malombra actually set about copying work by Salviati, more for the sake of getting experience in the craft than by reason of activity as a professional painter. Later, however, partly on account of economic factors, he painted for profitability. He is recorded as a member of the painters' guild in Venice, the "Fraglia", for the year 1617, which is to say one year before his death in 1618.

An illustrative and narrative painter, his chromatic impasto on the toneless side, his name is remembered in connection with the large-scale pieces for Palazzo ducale. Questionably good as he may be deemed, he is typical and representative in terms of cultural and pictorial standing, within the context of the decadence which came upon art in Venice during the early decades of the seventeenth century.

### PRINCIPAL WORKS

Chioggia, Sacrestia del Duomo, *Christ fulminating against Chioggia* (1598);

Lendinara (Rovigo), S.Biagio, *Christ on the Cross and saints;*

Madrid, Prado museum, *The doge Leonardo Donà receiving the Spanish ambassador;*

Venice, Palazzo ducale, *Venice surrounded by the virtues receiving the entreaties of the people* (Sala della Quarantia Civil vecchia).

### ESSENTIAL BIBLIOGRAPHY

Ridolfi C., *Le Meraviglie dell'Arte*, Venice, 1648;

Boschini M., *Le ricche minere della Pittura Veneziana*, Venice, 1771;

Savini-Branca S., *Il Collezionismo Veneziano nel '600*, Padua, 1964;

Pignatti T., *La Fraglia dei Pittori di Venezia*, in "Bollettino dei Musei Civici Veneziani", 1965;

Donzelli-Pilo, *I Pittori del Seicento Veneto*, Florence, 1967.

## MANCINI DOMENICO

In the complete absence of biographical data, the only items of information that can be assembled relative to this painter stem from signed works, in particular the *Madonna and child enthroned with music-making angel* at the Duomo di Lendinara (Rovigo). The painting is signed and in addition bears the date of 1511. It forms the centre panel of a polyptych, the other parts of which have been lost.

The figure of the Madonna is taken from that of S. Zaccaria by Giovanni Bellini (1505) but the

colour treatment is flatter and less forceful, the colour range colder. It is evident that the artist belongs in the stream of Bellini, but similarly apparent that he was influenced by the spell-binding art of Giorgione. Further, the angel at the feet of the Madonna draws inspiration from that of Zerman by Palma il Vecchio, as Pallucchini with justification commented. This artist may thus be deemed of composite character, clearly identified with the new cultural climate characterising Venice in the opening years of the sixteenth century.

Other works have been assigned to Mancini: the *Sacra conversazione* of the Louvre (formerly held to be by Sebastiano del Piombo), the *Lovers* of Dresden gallery and the *Madonna with John Baptist and St. Peter* of the Gamba collection in Florence. The lack of precise information about him has however occasioned a good deal of uncertainty and differences of opinion on the attributive plane. For example, the double *Portrait of young men* at Palazzo Venezia in Rome was assigned him by Berenson, whereas Longhi takes the view that it is from the hand of Giorgione himself. The fine *Portrait of a young man* at the Hermitage, Leningrad which L. Venturi assigned him and which is signed "MDXII Dominicus", also needs to be taken with reserve.

The very controversial *Woman taken in adultery* of Glasgow museum claimed on behalf of the young Titian, Giorgione and others, has of late been tentatively assigned to Mancini as well on the basis of colour affinity with the Lendinara panel. It may be said that the figure of Mancini, pending full assessment, is receiving new critical attention. In fact, in Pallucchini's words, "his impasto in terms of paint material has a tone richness and freedom not alien to Titian himself. This Mancini comes over as a colourist of the first class" (1945).

ESSENTIAL BIBLIOGRAPHY

Crowe-Cavalcaselle, *A history of painting in North Italy;*
Venturi L., *Giorgione e il Giorgionismo*, Milan, 1913;
Morassi A., *Giorgione*, Milan, 1944;
Pallucchini R., *La pittura veneziana del '500*, Novara, 1944;
Gengaro M. L., *Umanesimo e Rinascimento*, Turin, 1944;
Pallucchini R., *Cinque secoli di pittura veneta*, Venice, 1945;
Longhi R., *Viatico per cinque secoli* etc., Florence, 1946;
Zampetti P., in "Giorgione e i Giorgioneschi", Exhibition catalogue, Venice, 1955;
Berenson B., *Italian pictures of the Renaissance*, I, Venetian School, London, 1957;
Byam Shaw — Robertson, *Sir Karl Parker and The Ashmolean*, in the "Burlington Magazine", 1962;
Zampetti P., *Giorgione*, Milan, 1967.

## MARCONI ROCCO

Date and place of his birth not known, the former may be placed somewhere in the region of 1480. First references belong to the year 1504 when he was in Venice; old sources call him a native of Treviso and indeed he spent a long while working there. He died, probably in the year 1529.

As an artist he followed the precepts of Giovanni Bellini and Cima da Conegliano. Later he turned to Giorgione and was also affected to some extent by Palma il Vecchio. He never filled more than a subordinate position relative to the masters.

Venturi singled out a new departure, dating from his prime, when restless composition swamped the contemplative outlook characterising this artist, assigning him the *Assumption* of S.Pietro Martire church on the island of Murano. Latterday experts take the view that this work belongs

more properly to Giovanni Bellini. The possibility of other strictly-Bellini type pictures being really Marconi's has found some support among scholars in the field. The latest thinking, however, rates him no higher than an imitator of leading art personalities, following now this one and now that according to the development of manner.

His best work is perhaps the altar-piece of the *Redeemer with SS.Peter and Andrew*, signed and now in the church of SS.Peter and Paul in Venice. Another topic dear to him was that of *Christ and the Adulteress*, the exemplars of this theme painted by him were numerous.

PRINCIPAL WORKS

Berlin, Gemäldegalerie, *Christ and the Adulteress;*
Leningrad, Hermitage, *The dead Christ and Mary;*
Los Angeles, Museum, *Christ with Martha and Mary;*
Milan, Sforza castle, *Christ bearing the Cross;*
Munich, Alte Pinakothek, *SS.Nicholas, John Baptist and Andrew;*
Venice, Accademia gallery, *Deposition* (as G. Bellini); *Christ and the Adulteress;*
SS.Pietro e Paolo, *Altar-piece.*

ESSENTIAL BIBLIOGRAPHY

Ridolfi C., *Le Meraviglie dell'Arte*, Venice, 1648;
Lanzi L., *Storia pittorica dell'Italia*, Bassano, 1789;
Venturi A., *Storia dell'Arte Italiana* VII, 4, Milan, 1915;
Galletti-Camesasca, *Enciclopedia della Pittura Italiana*, Milan, 1951;
Berenson B., *Italian Pictures of the Renaissance*, I, Venetian School, London, 1957.

## MARESCALCHI PIETRO called LO SPADA

Born at Feltre (Belluno) about 1520, he passed most of his life in that city and provincial territory without ever living in Venice, he died in Feltre, 1589.

Very little is known about him; Lanzi, the first historian to mention him, mixed him up with Buonconsiglio (q.v.) because of the similarity of his sobriquet, "Mariscalco". Expert opinion in modern times, principally Fiocco (1929 and 1934) has shed light on his personality, taking as basis the few works of his which are signed and dated. As a result, the altar-piece of Bassanello (Padua) has been assigned to him; this alone proclaims the standing of the painter. It became a good deal better known (further to the attribution made by Fiocco) and appreciated upon the occasion of the Exhibition "Cinque Secoli di Pittura Veneta" (Five Centuries of Venetian Painting), held in Venice in 1945.

It is curious that though Marescalchi remained as it were isolated from and extraneous to Venetian painting altogether, yet he had profound knowledge of its every mood. The results as attracted by the Mannerist approach which was gaining hold towards mid-century, with an understanding of the work of Lo Schiavone, Tintoretto and especially Jacopo Bassano (the last-named rather isolated, like himself, but abreast of cultural developments as they took place both at Venice and elsewhere). Marescalchi managed to remain apart from the pro-classical manner proper to Lagoon painting, and pursued instead new effects of colour by using tones always cold and keen but exciting.

The *Altar-piece* of the cathedral at Feltre, so close to Bassano, has plenty of movement in terms of composition; it might even be called baroque already, although the colouring is cold and cries out

with clashes and contrasts. The *Feast of Herod* in Dresden art gallery affords a striking example of the painter's detachment from Venetian work; the improvisation observable in colour and form adds up to a manner truly novel. The portrait of *Doctor Zacharias dal Pozzo* in Feltre museum is original too.

Noting the anti-conformist attitudes in Marescalchi's art and the deeply-felt spirit of religion informing his figures, Fiocco was of the mind that the artist was strongly affected by Reformation and Counter-reformation. Indeed, Fiocco developed the argument to the point of resemblance to El Greco, with Marescalchi in the guise of a precursor. Assonance of manner and approach may be taken to exist between the two artists, Marescalchi usually being granted a ten years' head start in respect of development. El Greco's burgeoning was slow, on Byzantine modules in the manner of the Veneto: on these grounds, Fiocco argued El Greco could not have preceded Marescalchi, in these words. "We can with authority conclude that it was the painter from Feltre who led the way along new roads ten years ahead of Theotocopuli" (1949).

Marescalchi's major work is the Bassanello altar-piece, to which reference has been made above. It is held to be late, almost terminal in his experimental series; the colour is not compact but granular and resonant with light. The Madonna holds the dead Christ in her lap; the symbols of the Passion are shown, also SS.Clare and Scholastica in adoration. Experience of feeling, a profound sense of humanity come across and this effect is achieved by colour tension, intense and high-pitched tonally, almost to the point of over-statement. El Greco's name has been mentioned in the context of this work on more than one occasion but conclusive evidence is lacking as to who influenced whom of these two painters. It belongs to Marescalchi's final period, thus post-dates El Greco's time in Venice.

It is worth remembering that Bassano was also verging on a kind of painting that was cold and of the half-light (see the *Adoration of the Magi*, at Vienna). It is therefore evident that some features were at this stage common to some artists, though disregarded by others. Longhi (1946) commented on the great qualities of the Bassanello altar-piece as a painting, but admitted perplexity as to the true identity of the painter. He judged it better than signed works of Marescalchi and wondered if it could be from another painter, at present unknown, after Bassano and indeed El Greco. This suggestion was countered by Fiocco and Pallucchini who concur in assessing the Bassanello altar-piece as the peak expression of Marescalchi's artistic achievement.

PRINCIPAL WORKS

> Bassanello (Padua), S.Maria Assunta, *Pietà and symbols of the Passion worshipped by SS.Clare and Scholastica;*
> Dresden, Gemäldegalerie, *The Feast of Herod* (1476);
> Farra (Belluno), S.Martino, *Madonna enthroned and saints;*
> Feltre, Art gallery, *Doctor Zacharias dal Pozzo* (1561);
> S.Maria degli Angeli, *Madonna with saints* (panels of a polyptych);
> S.Pietro, *Madonna della misericordia and Life of the Virgin* (signed);
> Lamon (Belluno), *Madonna with SS.Peter and Paul* (1571);
> New York, Chrysler coll., *Madonna with SS.James and Prosdocimus* (1564).

ESSENTIAL BIBLIOGRAPHY

> Lanzi L., *Storia pittorica della Italia*, Bassano, 1789;
> Fiocco G. — De Franceschi M.C., *Pietro de' Mariscalchi detto lo Spada*, in "Belvedere" 1929;
> Venturi A., *Storia dell'arte italiana* IX, 7, Milan, 1944;

Pallucchini R., *La Pittura veneziana del '500*, Novara, 1944;
 *Cinque secoli di pittura veneta*, Venice, 1945;
Longhi R., *Viatico* etc., Florence, 1946;
Fiocco G., *Il Pittore Pietro de Mariscalchi da Feltre*, in "Arte Veneta", 1948;
 *Un Pietro de Mariscalchi in Inghilterra ed uno in Svizzera*, in "Arte Veneta", 1949;
Galletti-Camesasca, in "Enciclopedia della Pittura Italiana", Milan, 1951;
Berenson B., *Italian Pictures of the Renaissance*, I, Venetian School, London, 1957.

## MONTEMEZZANO FRANCESCO

Born at Verona towards 1550, he died after 1600, the date of his last work, the Alberedo *Nativity*. A pupil of Paolo Veronese, he became his most noted follower, along with Brusasorci. Quite well esteemed by contemporary historians, he has been re-appraised by modern expert opinion. It is evident that the influence of Tintoretto was part of the make-up of Montemezzano as an artist; he also participated in the Mannerist crisis (due to the real life-blood becoming exhausted) which marks the progress of Venetian painting at the end of the sixteenth century and start of the seventeenth.

Boschini with real baroque emphasis dubbed this artist a "lofty peak of virtue", adding that Veronese's art lived in the same high place. The frescoes detached from Palazzo Regazzoni in Sacile (Pordenone), now in Dresden gallery, may be counted among his most spacious and freshly coloured pieces.

### PRINCIPAL WORKS

Albaredo (Verona), Chiesa parocchiale, *Nativity* (1600);
Amsterdam, Rijksmuseum, *Gentlewoman with a squirrel*;
Brunswick, Gemäldegalerie, *Portrait of a gentlewoman;*
Dresden, Gemäldegalerie, *Detached fresco;*
Lendinara, Santuario del Pilastrello, *Baptism of Christ;*
Lonigo (Vicenza), SS.Fermo & Rustico, *Martyrdom of SS.Fermo and Rustico;*
Madrid, Prado museum, *Madonna and donor;*
Venice, Accademia gallery, *Venus and two cupids;*
Verona, S.Giorgio in Braida, *Noli me tangere* (1580).

### ESSENTIAL BIBLIOGRAPHY

Ridolfi C., *Le Meraviglie dell'Arte*, Verona, 1648;
Boschini M., *Carta del Navegar Pitoresco*, Venice, 1660;
Lanzi L., *Storia Pittorica dell'Italia*, Bassano, 1789;
Zannandreis D., *Vite dei Pittori etc. veronesi*, Verona, 1891;
Brenzoni R., *M.F.* in Thieme-Becker, K. L., 1931 under appropriate heading (with bibliography);
Berenson B., *Italian Pictures of the Renaissance*, I, Venetian School, London, 1957;
Crosato L., *Affreschi delle ville Venete del Cinquecento*, Treviso, 1962;
Brenzoni R., *Per la biografia e le genealojik familiare di Francesco Montemezzano* in "L'Arte", 1963.

# MORETTO

Alessandro Bonvicino, called Il Moretto, was born at Brescia in about 1498. He was the son of a painter, one Pietro. But the chances are that Floriano Ferramola was his earliest master, for they are first named together in the year 1516 on the contract for the organ shutters in the old cathedral at Brescia (now in the church of S.Maria in Valvembra di Lovere), the work lasting until 1518. Like the other cities of Lombardy, excluding Milan, Brescia was then part of the Republic of Venice and just recovering from the French occupation and the sack which took place under Gaston de Foix (1512). Against this background, the balance of his painting between influences from the great Lagoon school and the moods of his home territory becomes readily comprehensible, and has been well conveyed by Foppa.

Not a great deal is known about his life and work. In 1517 he was admitted to the "Scuola del Duomo" and remained a member all his life. It was a group aiming to observe religious practices, to which his father before him had belonged. In 1521 he was commissioned, together with Romanino, to decorate the Cappella del Sacramento in S.Giovanni; the work took three years and was completed in 1524. In 1529 Lorenzo Lotto summoned him to Bergamo, to carry out some work in the choir of the church of S.Maria Maggiore in Lotto's stead, a sign that Lotto and he were good friends and that as an artist Lotto thought well of him.

Moretto accepted the commission. In 1535 he was at Solarolo in the Romagna, in the suite of Isabella d'Este of Mantua who was attending festivities there. The duchess of Mantua was famed as a patron of the arts and evidently thought most highly of Moretto, it seems not merely as a painter but as a lover of music and learning too. His love of music is vouched for by his friendship with the great organist, G. B. Antegnati of Milan.

In 1544, the artist was in touch with the writer Aretino and had him accept a portrait, now lost. The Florentine wrote a warm letter of thanks in return, complimenting him on the work done.

In 1550, which is rather late, Moretto married Maria Moreschini and by her had three sons. He died in December 1554. There is some affinity between this artist and two other painters from Brescia, Romanino and Savoldo. However straightforward the life he led, almost entirely in his birth place, he emerges as something of a complex figure. For reasons already indicated, his style embraced diverse tendencies with the semblance of a dilemma of contrast; a balance was struck, and this must certainly be due to a lot of re-thinking on the artist's part.

He followed rather than the modest Ferramola the painter Romanino, his senior, who introduced him to the whirl of the Venetian art world in general and to the art of Titian in particular. His Venetian training was referred to in some old histories but is not actually documented. It could have come about by indirect means, through Romanino and thus to the work on which Lotto was engaged at Bergamo, not so far away from Brescia. Against that, other elements gradually creep into Moretto's art, recalling Raphael at one end of the scale and northern art at the other, perhaps familiar from engravings of Dürer.

It thus becomes clear that the figure of this artist, who spent most of his time within a provincial orbit, results from a cultural scene in ferment; solitude may have helped him on the path to maturity for his work becomes progressively more confident in the course of not overlong existence. His painting is distinguishable for compactness of composition; leaving aside the emphatic passages of Romanino (together with the classical solemnity of the great Venetian masters of the Renaissance), he tried to present a new truth assembled out of a lively regard for the every-day world.

The events of Reformation and Counter-reformation had repercussions on the figurative arts; and although Moretto remained disengaged from Mannerist traits, he strove to achieve a sincerity of expression quite outside any particular cultural connotation. The problem as he saw it was to get at the truth, the reality inherent in things.

His initial allegiance to Venetian painting may be seen in the *S.Faustino* di Lovere (1518). This was modified and varied with touches of the austerity of Foppa, the great Lombard master who was working at Brescia. In the decoration for the Capella del Sacramento di S.Giovanni (1521-4), Moretto's colour sensitivity departs from the intense chromatics of the Veneto; the harmonies are muted, silvery, of a moon-lit quality (the same thing was happening to Savoldo). With the passage of time, this composition becomes solider, more compact through new formal solutions.

In his portraits, for example the *Gentleman* of the National Gallery in London, the accent is on the human aspect of the sitter rather than his grandeur, and in this there is some parallel with the endeavours of Lorenzo Lotto. But in other works, like the *Madonna del Soccorso* di Possagno, Moretto seems to have had in his mind's eye the Titian prototype of the Frari "Assunta", whereas in the *Madonna col pastorello* di Paitone it is plain religious feeling that is openly avowed.

Later works, for instance the *Meal in the house of the Pharisee*, the *Fall of Simon Magus* (both at Brescia) and the *Conversation of St. Paul* at Milan, show Moretto striving after new formal patterns; the composition is divided diagonally, partly by treatment of light, and this makes the subject dramatic, as if he intended to catch the attention of the beholder. In these paintings, he emerges as anti-classical as it were in anticipation of the new achievements of Caravaggio, the fine artist who paved the way for painting from reality.

This attempt to convey the truth responded in Moretto to an inner necessity, as in the *Adoration of the Shepherds*, Brescia art gallery. It needs bearing in mind that he was not alone in this, for other painters in the Veneto were turning in the same direction, as Jacopo Bassano with whom he shares some aspects of affinity especially in the Mannerist crisis.

The last works by Moretto turn again to the Veneto manner, but this is only in respect of appearances. The Monselice *Meal* (now in the Chiesa della Pietà in Venice) belongs to the Veneto for background and architectural setting; the play of colour, however, which is cool and grey and also the life-like rendering of detail are Lombard and part of his original make-up.

A great portrait painter, a great seeker after truth, he remains completely extraneous to the feast of secular art being celebrated in Venice. Moretto stands out as a genuine example of art from Veneto province, among the most original given his silvery and sere paint treatment.

PRINCIPAL WORKS

    Bergamo, Carrara academy, *Christ and donors* (1518);
        S.Alessandro in Colonna, *Nativity;*
    Brescia, Martinengo gallery, *Ecce Homo; The Crib; St. Nicholas of Bari worshipping the Madonna; Supper at Emmaus; Salome;*
    Brescia, Chiesa di S.Maria Calchera, *At table in the house of the Levite;*
        Seminario S.Angelo, *Fall of Simon Magus;*
        S.Giovanni Evangelista, *Old testament scenes* (in collaboration with Romanino, 1521-4);
        SS.Nazario e Celso, *Coronation and saints;*
    London, National gallery, *Adoring angel; Portrait of a gentleman* (internal figure);
    Milan, Ambrosiana, *St. Peter Martyr;*
        Brera, *Appearance of the Madonna;*
        S.Maria sopra S.Celso, *Fall of St. Paul;*
    Munich, Alte Pinakothek, *Portait of a man;*
    Paitone, Santuario, *Madonna and shepherd boy;*
    Naples, Capodimonte gallery, *Christ of the column;*
    Venice, Chiesa della Pietà, *Meal in the house of the Pharisee;*

Vienna, Kunsthistorisches museum, *St. Justin and devotee;*
Washington, National gallery, *Deposition.*

ESSENTIAL BIBLIOGRAPHY

Vasari G., *Le Vite* etc., 1550;
Ridolfi C., *Le Meraviglie dell'Arte*, Venice, 1648 (ed. Halden, 1914);
Lanzi L., *Storia Pittorica dell'Italia*, Bassano, 1789;
Brognoli P., *Guida di Brescia*, Brescia, 1826;
Crowe-Cavalcaselle, *History of Painting in North Italy*, London, 1871 (ed. Borenius, 1912);
Molmenti P., *Il Moretto da Brescia*, Florence, 1898;
Longhi R., *Cose bresciane del Cinquecento*, in "L'Arte", 1917;
Venturi A., *Storia dell'Arte Italiana* IX, 4, Milan, 1929;
Gronau G., *Moretto* in Thieme-Becker, K.L., XXV, 1931;
Berenson B., *Italian Pictures of the Renaissance*, Oxford, 1932;
Gombosi G., *Moretto da Brescia*, Basle, 1943;
Pallucchini R., *La pittura veneziana del '500*, Novara, 1944;
Galletti-Camesasca, Enciclopedia della Pittura Italiana, Milan, 1951 (with full bibliography);
Cipriani-Testoni, *I Pittori della realta in Lombardia*, Milan, 1953;
Berenson B., *Italian Pictures of the Renaissance*, I, Venetian School, London, 1957;
Fiocco G., *Un ritratto Monico del Moretto* etc., in "Paragone", 1965;
Cassa Salvi E., *Moretto*, Milan, 1966.

# MORONI GIOVANNI BATTISTA

Born at Albino in about 1525, he was sent to Brescia at a fairly early age by his parents, to study under Moretto (q.v.). The information about him is not plentiful but shows him to have been a quiet man, dedicated to his chosen calling. In 1549 he was at Brescia but the same year is also recorded in his native place. In 1553 he returned, after the period in Brescia, to live in Albino permanently and he spent the rest of his days there with the exception of one or two short visits elsewhere. He died in 1578, while engaged on the *Last Judgement* for the church at Gorlago (Bergamo).

Moretto was a great influence on him; at the same time, it is plain that he looked to other Brescia painters, like Romanino and Savoldo; he was not unfamiliar with the personality of Lotto, active in Bergamo over a considerable number of years.

The lack of disturbance to his everyday round enabled him to paint busily and vividly. His paintings and altar-pieces abound; mention may be made of the early *Madonna and child* derived straight out of Giovanni Bellini, the *Crucifixion* (parish church at Albino), the *St. Clare* (S.Maria Maggiore, Florence), the *Assumption* (parish church of S.Leone, Cerrate), and many more.

In these works, the personality of Moroni does not come across as entirely at ease. His compositions seem repetitive of iconographical themes taken from Moretto in many instances with a measure of untroubled allegiance, unmarked by any positive sign of participation on his own account — barring the occasional emotive spark, as in the *Crucifixion* referred to above.

Where his flair is unmistakable is in his portraiture, a branch of the art that suited him down to the ground. After his period under Moretto and in touch with the other Brescia painters, it is clear that drew him was Lotto's moving intimate touch. The early portraits reflect this attraction. Later,

the personal element became increasingly strong. He tried to paint people as they really were, conveying character in other words by hitting upon the very expression which was most peculiarly the sitter's own.

Not unaware of influences from Venetian painting, especially Titian, he remained determinedly apart from the flattering and courtly classical style. He sought instead to portray the objective reality, often on humble planes, and in this he is typical of the Lombard-Veneto group. In the comparative isolation of the small community where he worked, Moroni was nevertheless alive to the changing times, the crisis that Renaissance culture was undergoing. His characters are set against grounds that are barely indicated but allusive and never defined. They come across the more strongly for the formal emphasis which he used to make each portrait a separate composition, in the sense of demanding individual treatment.

As a result, he had no truck with conventional poses or frozen imagery; instead he portrayed them almost as it were in movement, caught in gestures characteristic of each subject. They appear in the garb of their human frailty, of mind and body.

His paint material after the fashion of Brescia is luminous and chromatically vivid though never dissociated from the psychological point he desired to make in respect of the sitter. Sometimes legends or inscriptions add to this effect, or the very action itself as in the *Unknown writer* of Brescia art gallery who has his books by him ("Del fine; Dell'Amore; Dell'Amicizia") or the *Magistrate* again at Brescia or lastly the celebrated *Tailor*, a masterpiece of psychological insight (National gallery, London), depicted as he pauses from his labour.

PRINCIPAL WORKS

Albino, Parish church, *Assumption;*
Bergamo, Palazzo Moroni, *Gian Girolamo Grumelli* (1550);
    Carrara gallery, *Spini portrait;*
    Duomo, *Madonna and child with saints* (1576);
    Agliardi coll., *Madonna and child* (early work, from Giovanni Bellini);
Berlin, Gemäldegalerie, *Portrait of a young man* (1553);
Cerrate d'Argon, Parish church of S.Leone, *Assumption;*
Brescia, Martinengo gallery, *Portrait of a writer* (1560); *Portrait of a magistrate;*
London, National gallery, *Portrait of a man at arms; The lawyer; The Tailor;*
Milan, Brera gallery, *Portrait of a Navagero;*
Trent, S.Maria Maggiore, *St. Clare* (1558);
New York, Metropolitan museum, *Abbess Lucrezia Agliardi* (1557);

ESSENTIAL BIBLIOGRAPHY

Ridolfi C., *Le Meraviglie dell'Arte*, 1648 (ed. Halden, 1914);
Lanzi L., *Storia Pittorica dell'Italia*, Bassano, 1789;
Tassi F. M., *Vite dei Pittori, Scultori, Architetti bergamaschi*, Bergamo, 1793;
Frizzoni G., *L'Arte in Bergamo*, Bergamo, 1897;
Venturi A., *Storia dell'Arte Italiana* X, 4, Milan, 1929;
Berenson B., *Italian Pictures of the Renaissance*, Oxford, 1932;
Lendorff G., *Gian Battista Moroni*, Winterthur, 1933;
Cugini D., *Moroni*, Bergamo, 1939;
Pallucchini R., *La pittura veneziana del '500*, Novara, 1944;
Longhi R., *Da Moroni al Ceruti*, in "Paragone", 1953;
Cipriani-Testoni, *I Pittori della Realta in Lombardia*, Milan, 1953;

Berenson B., *Italian Pictures of the Renaissance*, I, Venetian School, London, 1957;

Bassi Tathgeb R., *La Madonna del Morini nelle chiesa del Miracolo di Desenrano al serio*, in "Arte Veneto", 1963.

Spina E., *Moroni*, Milan, 1966;

## OLIVERIO ALESSANDRO

Of Bergamo origin, he was active in Venice where he is documented from 1532 to 1544. In 1542 Lorenzo Lotto made him a gift of some azure pigment, knowing he was "in need". At that period, Oliverio lived in the S.Lorenzo quarter of the town. Lotto affectionately referred to him as "mio compare", a close friend. A follower of Giovanni Bellini, he was also influenced by Giorgione and, according to Berenson, also by Palma il Vecchio.

The figure of Oliverio has not yet been elucidated, partly due to the scarcity of work signed and dated by him. The paintings which are attributed to him show him as a painter of the second rank, endeavouring to use figures and gestures out of Giorgione within the frame of traditional iconography, without having grasped the real essentials. The same applies to his painting technique: lack of variety and lack of warmth characterise his work, supporting the view that he remained in the dark as to the meaning of the tone-painting reform of the master from Castelfranco. In portraits he was much more successful, though even in this field the attributions to him are by no means unanimous.

PRINCIPAL WORKS

Dublin, Gallery, *Portrait of a young member of the Cornaro family; Madonna enthroned and two angels;*
Rome, Borghese gallery, *Adam and Eve;*
Venice, S.Maria della Salute, *SS.Roch, Jerome and Sebastian;*
Zurich, Scharafl coll., *Portrait of a young person.*

BIBLIOGRAPHY

Lotto L., *Libro di spese diverse* (ed. Venice-Rome, 1968), 1542;
Armstrong W., *Alessandro Oliverio* in "The Burlington Magazine", 1906;
Berenson B., *Italian Pictures of the Renaissance*, I, Venetian School, London, 1957.

## OTTINO PASQUALE

Born at Verona in the year 1570. A pupil of Brusasorci initially, he then went to Rome like Bassetti and Turchi. There were the two other painters of Verona who felt that they needed first-hand knowledge of the reforms in art achieved by Caravaggio, forsaking the tired and tardy expression of Mannerist art fettering painting in the Veneto.

In Rome he was more deeply affected than the other two by the new direction Caravaggio had imparted to the craft. In 1612, the artist was back in Verona, and was married; he returned to Rome, then again to his native city on a permanent basis. He died at Verona of the plague in 1630. His closest allegiance to the "realism" of Caravaggio may be discerned in the *Raising of Lazarus* (Borghese gallery, Rome). Violently juxtaposed passages of light and shade made for a sense of drama, giving emphasis to the figures of Lazarus and Jesus, the latter reminiscent of that by

Caravaggio in the "Calling of St. Matthew". Subsequently, Ottino modified the violent realist concept in favour of the new star of classical art, the inspiration of the Bologna school from Caracci to Reni. Lanzi was therefore substantially accurate when he wrote in 1789 of his allegiance to the art of Raphael, which had obviously reached him not direct but intermediately.

The great *Assumption* altar-piece (S.Maria in Venzo, Padua) differs again from work done when he first went to Rome; it was painted after he returned from Rome and embarked on a fresh relationship with Bologna painting. His pro-Caravaggio period must therefore be seen as a stage in the development of Ottino as an artist; art echoes from the Veneto then served to spur him in the direction of new fields, of greater classical repose.

PRINCIPAL WORKS

> Florence, Longhi coll., *Rest on the flight into Egypt;*
> Padua, S.Maria in Vanzo, *Assumption of the Virgin;*
> Rome, Quirinal palace, Sala regia, *Life of Moses* (frescoes); Borghese gallery, *Raising of Lazarus;*
> Verona, Duomo, *Coronation of Mary;* Castelvecchio museum, *Madonna and child with saints; Assumption of the Virgin; Betrothal of St. Catherine;* Sirena coll., *Assumption* (1623).

ESSENTIAL BIBLIOGRAPHY

> Ridolfi C., *Le Meraviglie dell'Arte*, Venice, 1648;
> Lanzi L., *Storia Pittorica dell'Italia*, Bassano, 1789;
> Zannandreis D., *Le Vite dei Pittori, Scultori ed Architetti Veronesi*, Verona, 1891;
> Longhi R., *Il trio dei veronesi Bassetti, Turchi, Ottino*, in "Vita Artistica", 1926;
> Longhi R., *Precisioni nelle Gallerie Italiane*, I La Galleria Borghese, Rome, 1928;
> De Logu G., *Pittura Veneziana dal XIV al XVIII secolo*, Bergamo, 1958;
> Longhi R., *Presenza alle Sala Regia*, in "Paragone", 1959.
> Pilo-Donzelli, *I Pittori del Seicento Veneto*, Florence, 1967;

## PALMA IL GIOVANE

Jacopo Negretti was born at Venice in 1544. His parents were Antonio, a painter and Giulia of the family of Bonifacio de'Pitati. Coming of a line of artists, he was the namesake of his grandfather Palma il Vecchio and so came to be known as Palma il Giovane.

His father was strictly aligned with the art of Bonifacio and became the boy's first teacher. But he soon had occasion to widen the field of his experience. Ridolfi (1648) recorded that Guidobaldo duke of Urbino had admired the young man's style and so invited him to Urbino. In fact, he left Venice in 1564 and spent the next three years at Guidobaldo's court. A fairly novel task engaged his particular attention during that period, which was the copying of paintings by Raphael and Titian in the ducal palace.

While in Urbino, he doubtless met Federico Barocci. This meeting brought him into contact with the complex Mannerism practised in central Italy. The duke suggested he should visit Rome and this he did, over a further three-year period. In 1570, he returned to Venice. But the Roman interlude is deemed both by the old historians and the present-day experts as significant in terms of his education as an artist.

No work is extant from the Roman period; he must he been drawn by the art of Michelangelo and the paintings of Polidoro da Caravaggio. When Palma il Giovane went back to Venice, he had wide cultural gleanings to his credit. In the city on the Lagoon, he entered the studio of Titian straightaway and became his favourite pupil. When the master died in extreme old age, in the year 1577, it fell to Palma il Giovane to complete the famous "Pietà" which the master's hand had left unfinished. Alongside undeniable evidence of Titian's influence, this young artist was also affected by Salviati, Tuscan by training but working in Venice.

His long jaunt into central Italy roused the younger Palma's keen interest in Mannerist forms at their most novel and lively. His work helped alter the balance of Venetian painting. Despite changing times, it was trammelled by a near-century old tradition.

In 1575 came his first major commission, to paint a series of three canvases for the sacristy of the church of S.Giacomo dell'Orio. Thereafter, the orders came in thick and fast. As the great painters of the century died — Titian, Veronese and Tintoretto — he found himself in the front rank of those that survived. Indeed he bore the heavy responsibility of representing the painting of Venice as its leading exponent: his output was prodigious and continued to the end of his life, 1628.

After Titian had left the scene, Palma il Giovane turned to Tintoretto in respect of the treatment of light; while the example of Salviati may have spurred him to attempt larger scale in his composition, attaining highly dramatic effects by this means. Pallucchini commented that the crisis "of manner, marking the changeover of century in Venice — between 1500s and 1600s — was largely attributable to the attitude of Palma il Giovane, conforming to the tenets of Tintoretto and the Mannerists. This attitude became all the rage, not for its inspiration but the facile brilliance of the results obtained. It may be said that the generation born 1550-70 and working in the 1620s was dominated by the lead of Palma il Giovane".

Yet Palma was not without independent standing, as the Oratorio dei Crociferi cycle shows. In the *Mass of doge Cicogna*, the artist pursued a manner simple and austere further to the imploding highlights of a Tintoretto. It was almost as though a new truth was to be discovered in sheer simplicity. Later, his style of painting mellowed to embrace eclectic elements including salient Mannerist features but above all a feeling for movement. Thus Palma rounds off the great Venetian tradition in the art of the sixteenth century, and leaves the stage at the very moment when Lagoon painting was in the throes of open crisis.

PRINCIPAL WORKS

Amsterdam, Rijksmuseum, *Loth and daughters;*
Bergamo, S.Alessandro della Croce, *Christ with SS.Roch and Sebastian;*
Capodistria, S.Anna, *Crucifixion;*
Castelfranco Veneto, Duomo, *Presentation of Mary in the temple;*
Como, S.Bartolomeo, *Martyrdom of St. Bartholomew;*
Dresden, Gemäldegalerie, *Presentation in the temple;*
Florence, Uffizi, *Self-portrait;*
Genoa, Palazzo Bianco, *The Samaritan woman at the well;*
Kassel, Gemäldegalerie, *Venus and cupid;*
Modena, Galleria estense, *Adoration of the Magi;*
Padua, S.Pietro, *Conversion of St. Paul;*
    Museo civico, *Exaltation of the rectors of Padua, Jacopo and Giovanni Soranzo;*
Perzagno (Bocche di Cattaro), *The Agony in the garden;*
Reggio Emilia, Duomo, *Pietà;*
Rome, Accademia di S.Luca, *Susanna bathing;*

Venice, Oratorio dei Crociferi, *Cycle of paintings*, 1586-91;
> S.Fantino, *Doge Alvise Mocenigo thanking the Virgin for the victory of Lepanto;*
> S.Giacomo dell'Orio, *St. Laurence helping the poor;* also other works;
> S.Zaccaria, *Madonna and child with saints;*
> Palazzo ducale, *Works* in Sala del Maggior Consiglio and Sala dello Scrutinio, etc.

ESSENTIAL BIBLIOGRAPHY
> Sansovino S., *Venetia città nobilissima*, Venice, 1581;
> Ridolfi C., *Le Meraviglie dell'Arte*, Venice, 1648;
> Boschini M., *La Carta del Navegar Pitoresco*, Venice, 1660;
> Zanetti A. M., *Della Pittura Veneziana*, Venice, 1771;
> Lanzi L., *Storia Pittorica della Italia*, Bassano, 1789;
> Fiocco G., *La Pittura Veneziana del Seicento e del Settecento*, Verona, 1929;
> Venturi A., *Storia dell'Arte Italiana* IX, 7, Milan, 1934;
> Pallucchini R., *Pittura Veneziana del Cinquecento*, Novara, 1944;
> Ciampi M., *Mostra de Disegni di Jacopo Palma il Giovane*, in "Arte Veneto", 1958;
> Donzelli-Pilo, *I Pittori del Seicento Veneto*, Florence, 1967 (with wide bibliography to that date).

## PALMA IL VECCHIO

Jacopo Negretti was born at Serina in Bergamo territory, in about the year 1480. He is documented as present in Venice from 1510, when he witnessed a deed. In 1512 his art-name makes its first appearance. Reference was made to him as "Jacomo Palma depentor" (it was not until much later he was called Palma il Vecchio, when some distinction was needed between him and his grandson, usually called Palma il Giovane).

His life was on the brief side, spent almost entirely in Venice. He lived first at S.Giovanni in Bragora and then at S.Moisè, finally at S.Stae. From 1513 he was entered on the register of the Scuola di San Marco. He received various commissions in Venice itself but also sent works away to smaller centres in the Po valley. It appears that in 1524 he paid a visit to his native place, and while there painted the *Adoration of the Magi*, now in the Brera gallery of Milan. Some famous pieces were done for churches in Venice: S.Antonio di Castello, S.Maria Formosa, Madonna dell'Orto and others. In July 1528 he made his will and died the 30th of that month, aged 48, according to Vasari. The date of his birth, not otherwise attested, was given in the same context.

Cavalcaselle (1871) stated that Palma shared with Giorgione and Titian the honour of modernising and regenerating Venetian art. Experts of the present-day likewise agree in recognising the outstanding importance of this artist from Bergamo, at the interesting time of the juncture between fifteenth and sixteenth centuries. Palma's origins are not as clear as may be wished, partly for lack of signed and dated works. It is, however, held that as Cavalcaselle indicated his training took place under the greatest master of Venetian art, namely Giovanni Bellini. He was also influenced by Vittore Carpaccio and by Previtali, a compatriot of his and his senior by a few years.

The *Madonna* of Berlin museum confirms this view of his early years, soon outgrown in the *Sacra conversazione* of the Borghese gallery in Rome and again the *Madonna worshipped by the artist's patrons* (Hermitage, Leningrad) and other paintings. The last-named in fact are works of great balance in terms of composition and broad mastery of technique. By this stage, the artist was

appreciating Giorgione's entrance on the artistic scene. In 1508 or thereabouts, Palma includes features from the Master of Castelfranco's work, while not oblivious of other artists then in vogue, such as Lotto, Titian and Fra Bartolomeo a painter from Florence who was in Venice at the time. The *Portrait of a young man* (1510) in the Borghese gallery put Longhi in mind of Titian, though he was younger than Palma. The Zerman *altar-piece* follows indications out of Sebastiano del Piombo and also Titian; the manner is grandiose, full of movement, and goes beyond what the artist derived from Bellini. His allegiance to Giorgione's approach may readily be discerned in a delicate dream-like quality freely imparted to figures (see the *Mars and Venus* of Brooklyn museum and the Crichton-Stuart *Concert champêtre*) typical of one phase of Palma's development. A wider and more diversified approach soon took over, seen in the *Sacra conversazione* of the Thyssen collection in Lugano. In this piece, treatment of form is more supple and steeped in light; the colouring is full-bodied, spirited and intense. This means that Palma applied Giorgione's work by heightening values proper to the Master from Castelfranco, clearly following a notion of Titian's in this regard. On the other hand, the artist had no intention of turning to the psychological as Titian had done and indeed after 1516 his results from this approach are dynamic. Palma preferred to remain on the contemplative plane where figures and landscapes merged in a paint material shot with noon-day light.

Later, Titian with his brilliance at devising new solutions became involved in the crisis of Mannerism reaching the lagoons from the centre of Italy. But Palma tended not to evolve, indeed to forfeit originality. This left him capable of producing further masterpieces none-the-less, like the fair women in his series of busts (The *three sisters* at Dresden, the *young woman* at the Poldi Pezzoli museum in Milan and the *Bust of a young woman* at the Vienna Kunsthistorisches museum).

The Capodimonte *Sacra conversazione* reveals the artist in process of change. A certain grandeur of composition springs from Pordenone; there are signs of strain, due to some measure of failure in assimilating the inner significance of the new art forms.

As a portraitist he excelled in the double painting of *Francesco and Paola Querini* (Querini Stampalia foundation, Venice), full of psychological acumen. The fact that it has remained unfinished in the two canvases is due to his death.

The *Altar-piece* of the assassination of Peter Martyr now in the church of S.Martino at Alzano Maggiore is a problem piece. On the ground of ancient local tradition, Berenson assigned it to Lotto. Longhi and Venturi attributed it to Palma with the surer criterion of manner of painting.

### PRINCIPAL WORKS

Alnwick castle, *Lady with a lute;*
Alzano (Bergamo), *Assassination of St. Peter Martyr;*
Brunswick, Museum, *Adam and Eve;*
Brooklyn museum, *Venus and Mars;*
Cambridge, Museum, *Venus and cupid in landscape;*
Chantilly, Museum, *Madonna, saints and donor;*
Dresden, Gemäldegalerie, *The Holy Family with the infant, Baptist and St. Catherine;*
Genoa, Palazzo Bianco, *Sacra conversazione;*
Leningrad, Hermitage, *Sacra conversazione; Portrait of a young man;*
London, National gallery, *A Poet;*
Lugano, Rohoncz coll., *Sacra conversazione with donor;*
Milan, Brera, *SS.Helena, Constantine, Roch and Sebastian;*
Poldi Pezzolo museum, *Sacra conversazione; Bust of a woman;*
Munich, *Young faun with pipes;*

Naples, Capodimonte gallery, *Sacra conversazione;*
Norton Hall, *Young man and lady singing;*
Paris, Louvre, *Adoration of the Shepherds;*
Rome, Borghese gallery, *Madonna and child with SS.Francis and Jerome;*
Serina (Bergamo), SS.Anunziata, *Polyptych;*
Venice, Querini Stampalia foundation, *Portrait of Paola Friuli; Portrait of Francesco Querini;*
    S.Maria Formosa, *Polyptych.*

ESSENTIAL BIBLIOGRAPHY

Vasari G., *Le Vite* etc., Florence, 1568;
Ridolfi C., *Le Meraviglie dell'Arte*, Venice, 1648;
Boschini M., *La Carta del Navegar Pitoresco*, Venice, 1660;
Zanetti A. M., *Della Pitture Veneziana*, Venice, 1771;
Lanzi L., *Storia Pittorica della Italia*, Bassano, 1789;
Venturi A., *Storia dell'Arte Italiana*, IX, 3, Milan, 1928;
Longhi R., *Precisioni nelle Gallerie Italiane* I, I Galleria Borghese, Rome, 1928;
Sphan A., *Palma il Vecchio*, Leipzig, 1932;
Gombosi G., *Palma il Vecchio*, Stockholm-Berlin, 1937;
Pallucchini R., *Pittura Veneta del Cinquecento*, Novara, 1944;
Longhi R., *Viatico* etc., Florence, 1946;
Fioco G., *Un'opera megistrale del Palma il Vecchio*, in "Emporium", 1954;
Berenson B., *Italian Pictures of the Renaissance*, I, Venetian School, London, 1957;
De Logu G., *Pittura Veneziana dal XIV al XVIII Secolo*, Bergamo, 1958;
Ballarin A., *Palma il Vecchio*, Milan, 1965;
Longhi R., *Saggi e ricerche . . .*, Firenze, 1967.

## PAOLO VERONESE

Paolo Caliari was born the son of the stone-worker Caliari, at Verona in 1528. His mother was called Catherine. He began studying painting in his birth-place and embarked on his professional career. Then he went to Venice and spent the remainder of his life there. In Venice he became known by a nickname as "Veronese" (the man from Verona), which is how he is generally known. In 1541 he was still at Verona, a documentary reference calls him the pupil of Antonio Basile ("discipulus seu garzonus"). Once he had learned his calling, he started work on his own. It needs saying that this early Verona period of his activity remains to be explored in full. This is because it is only recently that experts have been turning their attention to the problems of his formative years.

When he went to Venice to live in 1555 in premises rented in the neighbourhood of SS. Apostoli, he was mature and made as an artist. So the key to that inimitable style which made him one of the greatest masters of Venetian painting in the sixteenth century must lie somewhere in this early period. To continue for the present with the landmarks in his life story:

In 1551, with Zelotti he painted the *Villa Soranzo frescoes*. In 1552 he made his first appearance at Venice, though in close touch at this time with his native city; he painted the *Giustiniani altar-piece* for the church of S.Francesco delle Vigne, Venice. The same year he also paid a visit to Mantua; together with the painters Domenico Brusasorci, Battista da Moro, Paolo Farinati, he was com-

missioned to produce several altar-pieces for the Duomo there. In Venice his activity began to be intensely busy and intensely skilful, the details of which will follow.

In 1560 it appears that he travelled to Rome. In 1566, first he took house in the parish of S.Felice and then he married Elena Badile in Verona, of the family of his first master. After that, he went to live in Calle Ca' Mocenigo in the quarter of S.Samuele. The life of Paolo was relatively unmarked by dramatic events. He had four children, namely Gabriele who was born in 1568, Carletto (1570), Orazio (1571) and Vittoria Ottavia (1572).

In 1573 came the most talked-about episode in his whole life and a lot can be gleaned from it about his personality as an artist. After painting the great *Feast in the house of Levi* for the church of SS.Giovanni e Paolo, he was summoned to appear before the tribunal of the Inquisition on a charge of heresy, for having painted some figures after his own way of thinking in this work and not linked with the text in the Gospel. The document of the interrogatory is extant in its entirety and the evidence it affords is very interesting. Veronese defended himself by saying among other things that artists were bound to invent according to the work of art, which made its own demands upon them. His actual words were, "I make paintings considering what meets the case as my mind serves me". Thus he spoke up for creative freedom and was acquitted on the charge.

His subsequent life was serene, spent working hard in Venice and nearby. In 1575 he passed some while at Padua, engaged on work carried out with the aid of his brother Benedetto. Soon enough he had the help of his sons, in particular that of Carletto. In 1582 he bought some land in the territory of Treviso. He died in 1588 at the mere age of 60 and was buried in the church of S.Sebastiano which he had frescoed in his youth, revealing his genius as an artist to the Venetians. Ridolfi wrote of him, that his life was a plain and private one: "he had generous thoughts . . . living far removed from excess, and economical in his outgoings".

The Villa Soranzo frescoes (1551) represent the first documented work of this artist, apart from the little *altar-piece* of Bevilacqua-Lazise (1540) which comes within the context of his training under Badile. The frescoes were painted in collaboration with Zelotti; the commission came from the architect Sanmicheli. This information, given by Vasari, is most important in denoting the artistic environment within which the artist's powers were developing, nurtured culturally by streams of central Italian provenance. Paolo thus became aware of Mannerist influence, particularly to the fore at Mantua where he was working as stated above on behalf of the Gonzaga alongside other painters who also came from Verona. Paolo however soon grew beyond the excitement and drama of Mannerist art; he broadened his composition, made it serene and harmonious and gave his colour a luminous quality more and more restful and joyous.

Together with Zelotti, his fellow-worker though the level of attainment is not comparable, Veronese started getting work in Venice, first at Palazzo ducale and next at S.Sebastiano. Paolo's paint material becomes increasingly transparent, light as a feather, until even the shadows shine: "he uses the contrasts between hot tints and cold, changing swiftly from one colour to another, all the while heightening the effect of splendour by means of the inter-relationships" (Brizio).

After the results achieved at S.Sebastiano (recent restoration work having made them appreciable), the *decoration* of the Villa Barbaro at Maser, built by Palladio, ranks as the most balanced manifestation of this artist's personality, indeed a classical example in terms of the inner contemplative spirit producing values which can be called absolute. The villa is one of the most lovely of the sixteenth century, of great simplicity; its greatest virtue being comprised in the happy harmony created with the surrounding countryside.

The architect refers to this villa in his "Treatise on architecture" but does not mention the frescoes of Veronese; Vasari on the other hand, in 1568, goes into considerable detail on the subject. They are decorative paintings, implying praise of the values of life within the context of Nature's surrounding realm: the search for inner peace is lauded. They present overall views, echoing the

world outside, allegorical stories, portraits of people taken from life, all as if from some higher order of enchantment, a mood profoundly serene.

In the central salon which is cruciform, the architectural setting, the actual landscape and the painted fiction attain an equilibrium seldom possible to find anywhere else. Veronese's painting reaches one of the high-points, inwoven with light, serene and contemplative, indeed quintessential; he emerges as a force of his own, not for the sake of argument but by inner momentum, as compared with the fiery strength of Titian, or again with the troubled tossing chiaroscuro of Tintoretto. Paolo stands out: his approach luminous and clear, at once confident, complete and his own. In it, tone-painting after Giorgione by breaking down the various tints gains new light quality, openly celebrating the sunlight so that even the shadows, as stated, do not sink into darkness but counter the light: this breeds a great symphony of colour to a score of serene and sustained chords.

Thus Paolo at his most creative, in his prime. This is the period when work is produced thick and fast. One upon the heels of another, almost as though there was nothing for it but to create and create again. To this period belong the famous *Feast* paintings which were done for the refectories of various monastic institutions in Venice, now distributed through various art galleries (Venice, Turin, the Louvre); in addition, religious works, allegorical compositions and mythological scenes. In his late prime he worked in Palazzo ducale once more. His *Rape of Europe* is to be found there, painted for the Contarini family; he produced some allegorical pieces for the ceiling of the Sala del collegio, and the *Victory of Lepanto*. Last, in the Sala del maggior consiglio is his *Triumph of Venice*, with contributions from the hands of assistants. Paolo Veronese came unscathed through the Mannerist crisis, it seems; or rather, he wanted to reach further, after an equilibrium based upon knowledge and not by any means on refusal to take account of the requirements of that civilisation. Instead of yielding, he came out in his own terms, showing contemporary society how needful the higher harmony was.

With reference to his religious works, Veronese maintained a constant attitude. From the Giustiniani altar-piece (1551), clear derivation from that of Ca' Pesaro by Titian, and the famous one of S.Zazzaria, which it repeats and improves upon the structural form, Paolo was trying to achieve dense emotional content, by the rhythm of the sequence of images in the foreground and stressed by the setting of the background. A whole range of joyous tonalities heighten the visual effect, making the occasion both solemn and glad.

For innovation in terms of composition, mention may be made of the various planes of perspective in the *Preaching of the Baptist* (Borghese gallery, Rome) and the daring *Adoration of the Shepherds* painted for the Rosary chapel of SS.Giovanni e Paolo church, Venice. In this work, the influence of Tintoretto finds an echo, in the complex and intricate structural perspective seen from low down in an upwards direction, the result apparently precluding some aspects of baroque achievement.

In portraiture as well, the art of Veronese is imposing because of the serene air imparted to the persons represented. An example or two will suffice to illustrate the point: the *Portrait of Conte da Porto and his son* which is intimate and impressive at the same time; the Family Group of S.Francisco museum or the splendid *Gentlewoman* of the Louvre; or lastly, the fresco portraits of the villa at Maser, referred to earlier.

In the final phase of his activity, Paolo shows signs of decadence, of tiredness as if his creative vein were running out, perhaps due also in part to the collaboration on an increasing scale of his son Carletto, of Montemezzano and other helpers. Creative genius still occasionally flashes out, as in the *Altar-piece* of S.Pietro di Castello, the *Baptism of Christ* (Brera, Milan). In the closing period, Veronese's art strikes a lower note under the impact of Tintoretto, with some use of cold grey tones rather like Bassano. Collaboration apart, it is evident that towards the end of his life Veronese's world lost ground in terms of serenity, unsettled by the crisis of values that Venetian civilisation was undergoing.

92

Paolo Veronese died in 1588, not many years distant from the other leaders of the great Venetian tradition of the sixteenth century. The decadence of Venetian art at the end of the century was affected indirectly by his passing; against that, the effect of his art needs to be remembered upon the new flowering of Venetian painting in the eighteenth century, from Sebastiano Ricci to Tiepolo.

PRINCIPAL WORKS

Amsterdam, Rijksmuseum (ex von Rath), *Holy Family with the infant Baptist;*

Baltimore (Maryland), Walters art gallery, *Portrait of Contessa Lucia Thiene da Porto;*

Boston (Mass.), Museum, *The dead Christ sustained by angels;*
Holmes loan., *Diana and Actaeon;*

Brunswick, Museum, *Baptism;*

Budapest, Museum, *Crucifixion;*

Caen, Museum, *Judith;*

Castelfranco Veneto, S.Liberale (Duomo), Sacristy, *Fragments of frescoes from the Villa Soranzo;*

Chicago (Ill.), Museum, *Jerome in the desert; Madonna in glory, with the Baptist and Antony Abbot; Creation of Eve;*

Cleveland (Ohio), Museum, *Portrait of Agostino Barbarigo;*

Dresden, Museum, *Presentation in the temple; Cuccina family commended to the Virgin, Jerome and the Baptist by Faith, Hope and Charity; Epiphany* (from Palazzo Cuccina);

Escurial, Sala capitolare, *Annunciation;*

Florence, Pitti, *Portrait of "Daniele Barbaro";*
Uffizi, *Martyrdom of S.Justina;*
Contini Bonacossi coll., *Portrait of Conte da Porto;*

Hampton Court, Royal collections, *Marriage of St. Catherine;*

Leningrad, Hermitage, *Holy Family with saints;*

London, National gallery, *Epiphany; Family of Darius before Alexander;*

Madrid, Prado, *Venus and Adonis; Finding of Moses;*

Maser (Treviso), Villa Barbaro-Volpi, *Frescoes: allegorical scenes;*

Milan, Brera, *Feast in the house of the Pharisee;*
Rasini coll., *Rape of Europe;*

Modena, Gallery, *Organ shutters;*

New York, National gallery, *Venus and Mars united by Love;*

Padua, Museum, *Last Supper;*

Paris, Louvre, *Marriage at Cana; Feast in the house of Simon the pharisee; Christ at Emmaus; Mark meeting the theological virtues;*

Rome, Borghese gallery, *The Baptist preaching;*
Colonna gallery, *Portrait of a man in green;*

Sarasota (Florida), Museum, *Portrait of Francesco Franceschini;*

Turin, Sabauda gallery, *Feast in the house of Simon pharisee;*

Venice, Accademia gallery, *Holy family with saints; Feast in the house of Simon pharisee; Allegory of the battle of Lepanto;*
Palazzo ducale, Sala del collegio, *Thanksgiving for the victory of Lepanto;*
ibid., the ceiling, *Allegorical works;*
Sala dell'anti-collegio, *Rape of Europe;*

Sala del maggior consiglio, ceiling, *Apotheosis of Venice;*
S.Francesco della Vigna, *Holy family with SS.Catherine and Antony Abbot;*
SS.Giovanni e Paolo, Rosary chapel ceiling, *Annunciation, Assumption and Adoration;*
S.Sebastiano, ceiling and decorations;
Murano, Museo vetrario, *Madonna del rosario;*
Verona, Museum, *Giovanni Bevilacqua Lazise commended to the Virgin by Louis of Toulouse;*
Vicenza, S.Corona, *Epiphany;*
Vienna, Museum, *Hagar and Ishmael in the wilderness; Venus and Adonis;*

ESSENTIAL BIBLIOGRAPHY

Vasari G., *Le Vite de' piu eccellenti pittori, scultori ed architettori*, Florence, 1568;
Palladio A., *I quattro libri dell'architettura*, Venice, 1570;
Sansovino F., *Venetia citta nobilissima*, Venice, 1581;
Ridolfi C., *Le meraviglie dell'arte*, Venice, 1684;
Boschini M., *Le ricche minere della pittura veneziana*, 1674;
Zanetti M., *Della pittura veneziana*, Venice, 1771;
Lanzi L., *Storia pittorica della Italia*, Bassano, 1789;
Venturi A., *La Regia galleria estense di Modena*, 1883;
Coletti L., *Paesi di Paolo Veronese* in "Dedalo", 1925;
Brizio A. M., *Note per una definizione critica dello stile di Paolo Veronese* in "L'Arte", 1926 and 1928;
Venturi A., *Paolo Veronese*, Milan, 1928;
Brizio A. M., *Rileggendo Vasari* in "Emporium", 1939;
Coletti L., *Paolo a Maser* in "Emporium", 1939;
Pallucchini R., *Paolo Veronese* (Exhibition catalogue), Venice, 1939;
Delogu G., *Veronese*, Milan, 1951;
Pallucchini R., *Veronese*, Bergamo, 1953;
Berenson B., *Italian Pictures of the Renaissance*, I, Venetian School, London, 1957;
Zeri F., *Paolo Veronese una reliquia* etc, in "Paragone", 1959;
Brizio A. M., *La pittura di Paolo Veronese in rapporto con l'opera del Sammicheli e del Palladio* in "Bollettino del "Centro A. Palladio", 1960;
Berenson B. et al., *Palladio, Veronese e Vittoria a Maser*, Milan, 1960;
Vertova L., *Some late works by Veronese*, in the "Burlington Magazine", 1960;
Crosato L., *Gli affreschi nelle ville venete del cinquecento*, Treviso, 1962;
Ballarin A., *Dipinti Venezian riscoperti a Praga*, in "Arte Veneta", 1963;
Pignatti T., *Paolo Veronese a Maser*, Milan, 1965; *Le pitture di Paolo Veronese nella chiesa di S.Sebastiano a Venezia*, Venice, 1966;
Manin R., *L'opera completa del Veronese*, 1968.

## PELLEGRINO DA S. DANIELE

Martino da Udine, afterwards called Pellegrino da S. Daniele because he lived in this city of the Friuli, was born the son of Baptist, painter, in the year 1467. After the death of his father, he was put to school with another artist; the painter Antonio Fiorentino who had a studio at Udine.

Many documents refer to him: he later became the pupil of Domenico da Tolmezzo and must have known direct or indirect of the art of Giovanni Bellini. In 1493 a document refers to him for the first time as Pellegrino, a nickname given him according to Vasari by no less a person than Bellini. In 1504 he moved to Ferrara to work for the Este family and remained there until 1512. Returning to the Friuli, he set up house in S.Daniele and remained till 1540. Nearing the end of his life, he went back to his birth-place of Udine and died there in 1547.

In early works like the *Osoppo altar-piece* (1494), the artist shows himself associated with local painting under the influence of Padua, that is the painters of Tolmezzo after the manner of Mantegna. However, some trace is discernible already at this date of influence from Cima da Conegliano, in the endeavour after a rhythm of serenity despite the piecemeal composition of this contrived altar-piece.

Subsequently he drew closer to Cima and also Alvise Vivarini. Nothing whatever is known of his long spell working in Ferrara, apparently alongside the young Pordenone. It is certain that more direct contact enjoyed over this period with the new departure of Venetian art served to make his paint material more supple and striking chromatically; at the same time his composition broadened and assumed a grander scale, almost after the said Pordenone. To the new phase belong the *Annunciation* of the Accademia gallery in Venice and the *Altar-piece* of S.Maria dei Battuti in Cividale (1528).

At various times, Pellegrino was at work on the *frescoes* for S.Antonio church at S.Daniele del Friuli. Expert opinion disagrees on the subject; the problem presented is one of considerable complexity for the frescoes differ so widely both in manner and style as not to be satisfactorily explicable on grounds of having been painted over long time intervals, and on these grounds only. Indeed, other attributions have been advanced, namely for Fogolino and Sebastiano Florigerio, which would mean limiting the part played by Pellegrino in the context of a series formerly acknowledged as his masterpiece.

The figure of this painter having been held in notable esteem is thus undergoing re-assessment. The late frescoes depicting scenes from the *Life of Christ* (S.Daniele also) enter into this, revealing him a not very adept and heavy-handed copyist of the dramatic content of a Pordenone.

PRINCIPAL WORKS

Aquileia (Udine), Basilica, Presbiterio, *Polyptych;*
Cividale del Friuli, *John Baptist; Benedict, John Evangelist* (from the altar-piece of S.Maria in Valle);
S.Maria dei Battuti, *Triptych;*
Gemona (Udine), S.Maria delle Grazie, *Holy Family with Elizabeth;*
Osoppo (Udine), Parish church, *Madonna* with eight saints, putti and music-making angels;
S.Daniele del Friuli, S.Antonio, Abside del presbiterio, *frescoes* in the vaulting, *Christ* etc.;
Presbiterio, *frescoes;* the *Crucifixion* in the centre, etc.;
Treviso, Civic museum, *Outer doors of the organ* from S.Francesco, Conegliano: the *archangel Gabriel and the Virgin of the Annunciation;*
Udine, Civic museum, *Annunciation* of the confraternity of S.Maria dei Calzolai;
Organ doors of the cathedral, outer side: *Peter consecrating Hermagoras a bishop* with statues of Adam and Eve in the background;
inside: *Doctors of the church*, with statues of David and Judith in the background.

ESSENTIAL BIBLIOGRAPHY

Vasari, *Vite* etc., 1568;
Ridolfi, *Le meraviglie dell'arte*, Venice, 1648;
Crowe-Cavalcaselle, *A history of painting in North Italy;*
Cavalcaselle G. B., *Vita ed opere dei pittori friulani*, ms in Udine public library, 1876;
Venturi L., *Giorgione e il Giorgionismo;*
Venturi A., *Storia dell'arte italiana* IX, 3, Milan, 1928;
Fiocco G., *Il Pordenone*, Udine, 1939;
Zotti R., *Martino da Udine, detto P. da S,Daniele*, S.Daniele, 1942;
Pallucchini R., *Pittura veneta del 500*, Novara, 1944;
Zampetti P., *Considerazioni sull'attivita di Marcello Fogolino*, in "Bollettino d'arte", 1949;
Marini R., *Sebastiano Florigerio*, Udine, 1956;
Berenson B., *Italian Pictures of the Renaissance*, I, Venetian School, London, 1957.

## PERANDA SANTE

Born at Venice in 1566, he belongs to the group of Mannerist painters close to Palma il Giovane. In 1522 he went to Rome in the suite of the ambassador Marino Grimani; on the way back, he stopped at Loreto in the Marches. In 1594 he was registered with the guild of painters in Venice. In 1608 he visited the Mirandola court at the invitation of prince Alessandro Pico. In the period from 1614 to 1620 he also attended the court of the Este family at Modena. Lastly in 1627 he returned to Venice, where he died in 1638.

His early efforts were overshadowed by the example of Palma il Giovane, at the same time fostered by influences deriving from Paolo Fiammingo. Peranda then favoured a style of painting suggested by the art of Paolo Veronese. Clearly, he belongs within the cultural framework of Venetian painting at the turn of the century. It was a time when all the painters remained tied to the standards of their eminent predecessors, and upstanding contributions of their own were not forthcoming. Peranda's finest work dates from the period at Mirandola and Mantua. The *Psyche* series represents him at his best; the painting is refined, almost over-refined, tending to chromatic assonance which strikes a cold note and a finicky one. The scene showing *Psyche carried away*, with its grey light and great waves, denotes a power of invention the impact of which is evocative.

Peranda was also a notable portraitist, rendering his sitters with psychological subtlety as may be appreciated for example from the *Portrait of Julia d'Este* which successfully combines Veneto elements of painting with those deriving from the Flemish school. The final religious pieces, dating from his return to Venice, have a profound sense of mysticism, a seriousness which marks him out among contemporary painters.

PRINCIPAL WORKS

Carpi, Duomo, *Miracle of S.Carlo Borromeo;*
    Civic museum, *Adoration of the Magi;*
Mirandola, Duomo, *Pietà with SS.Carlo Borromeo and Francis;*
Mantua, Palazzo ducale, *Psyche series; Portrait of Julia d'Este; Portrait of Alfonso d'Este;*

Venice, S.Bartolomeo, *Manna from heaven;*
    S.Salvatore, *Pietà, S.Carlo and donors;*
    S.Stefano, *Martyrdom of St. Stephen;*
    Palazzo ducale, Sala dello scrutinio, *Battle of Jaffa.*

ESSENTIAL BIBLIOGRAPHY
    Ridolfi C., *Le meraviglie dell'arte*, Venice, 1648;
    Boschini M., *La carta del navegar pitoresco*, Venice, 1660;
    Boschini M., *Le ricche minere della pittura veneziana*, Venice, 1674;
    Lanzi L., *Storia pittorica della Italia*, Bassano, 1789;
    Fiocco G., *La pittura veneziana del Seicento e Settecento*, Verona, 1929;
    Venturi A., *Storia dell'arte italiana* IX, 7, Milan, 1934;
    Delogu G., *Pittura veneziana dal secolo XIV al XVIII*, Bergamo, 1958;
    Marchion Ascione R., *Sante Peranda alla Mirando la e a Moolena*, in "Arte Veneta", 1958;
    Mariacher G., *Sante Peranda*, in "La pittura del seicento a Venezia", Venice, 1959;
    Donzelli-Pilo, *I pittori del seicento veneto*, Florence, 1967.

## POLIDORO DA LANCIANO (also called Lanzani)

Born at Lanciano in the Abruzzo in 1515, he appeared in Venice in 1536. There he remained for the rest of his life, dying on 21st July, 1565. He was soon drawn within the orbit of Titian, whom be resembled so narrowly as at times to be confused with him.

The *Madonna and child* of Verona museum is clearly enough indicative of his pro-Titian manner to warrant certain praise, though unsupported by critical evaluation since the style of Polidoro never matched that of his master.

Later he was also affected by the examples of Bonifazio Veronese and Pordenone; thereafter Mannerist art exerted an influence upon him, which was penetrating to Venice by way of central Italy. This may be seen most especially from the *Descent of the Holy Spirit* (Accademia gallery, Venice); it is also in evidence in other works, which have been contested as between Polidoro and artists of the stamp of Schiavone and the young Tintoretto.

That the artist was abreast of current developments will not be gainsaid, though on the fringe of the major departures. After 1545, the date of the last-mentioned work, Lanzani began to lag behind the times and at the close may be shewn to have adopted forms increasingly outworn and decadent.

PRINCIPAL WORKS
    Bergamo, *Holy family in landscape;*
    Budapest, *Holy family with St. Catherine;*
    Cambridge, *Holy family with St. Catherine and Infant Baptist;*
    Dresden, *Holy family with the Magdalen, a Venetian nobleman and his son;*
    London, Frank and Henry Farrer (ex), *Holy family in landscape,* with two donors;
        Lord Melchett (ex), *Sacra conversazione* with Infant Baptist, SS.Catherine and Joseph;
    Venice, Accademia, *Madonna and Infant Baptist; Madonna* with SS.Catherine, John Evangelist and a Dominican donor; *Descent of the Holy Spirit;*
    Vienna, Lederer coll. (ex), *Madonna* in landscape worshipped by two angels.

ESSENTIAL BIBLIOGRAPHY

Zanetti A. M., *Della pittura veneziana*, Venice, 1771;
Lanzi L., *Storia pittorica della Italia*, Bassano, 1789;
Venturi A., *Museo e Galleria Borghese*, Rome, 1893;
Ludwig G., in "Jahrb. d. preuss. Kunst.", 1901-2;
Gronau G., in "Repertorium f. Kunstworken", 1910;
Berenson B., *Opere di Polidoro*, in "Rassegna d'Arte degli Abruzzi", 1912;
Venturi A., *Storia dell'arte italiana* IX, 3, Milan, 1928;
Pallucchini R., *La giovonezza del Tintoretto*, Milan, 1950;
Berenson B., *Italian pictures of the Renaissance*, I Venetian school, London, 1957.
Marciani C., *Polidoro da Lanciano, sua patria e e moi familian*, in "Arte Veneto", 1957.

## PONCHINO GIAMBATTISTA

Also called Bazzacco or Il Bozzato, he was born at Castelfranco in about 1500. Guarienti deemed he was a pupil of Badile. In 1546 he went to Rome and repeated the experience in 1558, for the sake of drawing the *Last Judgment* painted by Michelangelo in the Sistine chapel. With the assistance of a Venetian nobleman of the name of Grimani, he undertook a commission for paintings in the Palazzo ducale, 1553 and 1554, along with Veronese and Zelotti. He was also engaged on work at Castelfranco and Vicenza. When his wife died, the sister of Padovanino, he entered religious orders and painted no more. His death is dated to 1570.

Ponchino is one of the representatives of the manner of Venice after Paolo Veronese. Lanzi praised him and even saw some comparison with the figure of Giorgione since no one was more admired, after the great master, in Castelfranco. Modern research has led to a re-assessment, however, and he is now seen rather as a skilful craftsman than as an artist with an original contribution to make of his own.

His journeys to Rome point to interest in Mannerist painting, though he was unable to convey what he had learned in personal terms; a notable capacity may be remarked, to repeat models out of Paolo Veronese.

PRINCIPAL WORKS

Castelfranco, S.Liberale, *Descent of Christ into hell;*
Venice, Palazzo ducale, Sala del maggior consiglio, *Mercury and Minerva;*
Sala dei dieci, *Rebellion overcome by justice; Sacrilege overthrown.*

ESSENTIAL BIBLIOGRAPHY

Vasari G., *Le vite* etc., Florence, 1568;
Ridolfi C., *Le meraviglie dell'arte*, Venice, 1648;
Zanetti A. M., *Della pittura veneziana*, Venice, 1771;
Lanzi L., *Storia pittorica della Italia*, Bassano, 1789;
Lorenzetti G., *Venezia e il suo estuario*, Rome, 1927;
Coletti L., in "Convivium", 1941;
Pallucchini R., *La pittura veneziana del cinquecento*, Novara, 1944;
Galletti-Camesasca, Enciclopedia della pittura italiana, under appropriate heading, Milan, 1950.

## PONZONE MATTEO

Born at Arbe in Dalmatia, he moved to Venice early on and belonged to the guild of painters from 1613 to 1633. His date of death is not known but it took place prior to 1675 when a documentary reference to him is in the past tense.

He was a follower of Sante Peranda and accompanied him to Mirandola and Modena in the capacity of assistant. After returning to Venice, he went off to Dalmatia where he worked for a lot of churches in Spalato and Sebenico. Old art histories mention his original streak. Thus Zanetti, 1771, and then Lanzi who regarded him as an artist of some stature.

In effect, the work of Ponzone shows competence though the personality is scarcely different from that of his master. The fluent brush-work may be noted and also the coldness of hue in terms of colour which he took from Peranda. These elements passed in turn to his pupil, Andrea Celesti as the team of Donzelli-Pilo observed. The position he occupies is not without interest in causing a ripple, however small, upon the face of the stagnant waters of the pictorial art in the Lagoons.

### PRINCIPAL WORKS

Cividale, Duomo, *Madonna and child with saints;*
Padua, Duomo, *Madonna with child and infant Baptist;*
Rovigo, Seminary gallery, *Esther and Assuerus;*
Treviso, Civic museum, *Adoration of the Magi;*
Sebenik, S.Francesco, *ceiling* with 21 paintings;
Split, Duomo, *S.Dujmo cycle;*
Venice, Madonna dell'Orto, *Flagellation.*

### ESSENTIAL BIBLIOGRAPHY

Ridolfi C., *Le meraviglie dell'arte*, Venice, 1648;
Zanetti A. M., *Della pittura veneziana*, Venice, 1771;
Lanzi L., *Storia pittorica dell'Italia*, Bassano, 1789.
Venturi, A., *Storia dell'arte italiana* IX, 7, Milan, 1934;
Pallucchini R., *Contributi alla pittura veneziana del Seicento . . . Per Matteo Ponzone*, in "Arte Veneta", 1962;
Prijatelj K., *Le opere di Matteo Ponzone in Dalmatia*, in "Arte Veneta", 1966;
Donzelli-Pilo, *I pittori del seicento veneto*, Florence, 1967 (with good bibliography to date).

## PORDENONE

Giovanni Antonio Sacchi called Il Pordenone after the place where he was born in the Friuli, about the year 1483. A singular character, he enlivened one of the most original aspects of Veneto painting in the sixteenth century. His life was a bustling one and in his restlessness may be discerned the springs of his extraordinary resilience as a painter.

Trained in the place where he grew up, the strongest influence was exerted over him by the Padua artists following the school of Mantegna, especially Gian Francesco da Tolmezzo, the most gifted of the group. The circle was provincial but none the less lively and he contributed what was new when and where he came across it. At first, he was a pupil of Pellegrino da S.Daniele and accompanied him to Ferrara, in 1508.

The seat of the d'Este family was renowned for its humanist learning and the artist must have benefited from the opportunity to indulge his craving for the curious, further to his initial training. The craving became near-compulsive as time passed. Experimenting after Giorgione, he followed

this up with attempts after Raphael, having visited Rome in 1516. It was Raphael in his prime, his work disturbing and dramatic, no longer tied to the classical canons of the Stanza della segnature. Returning to the Veneto, Pordenone was kept busy particularly at Treviso (1520). He went to Cremona and gave his mind to a cycle of frescoes on the theme of the *Passion of Christ* (1521-2) for the Duomo. In the Friuli again (1524) and Venice, he executed *frescoes* for the church of S.Rocco and the cloister of S.Stefano. In Lombardy, he painted more *frescoes*, for the church of S.Francesco at Cortemaggiore. In Piacenza, he left a large cycle of paintings on the *Life of the Virgin* (1529-31), in the district church of Madonna di Campagna. Ever on the move, he was in Genoa (1532), then again in Venice and the Friuli.

Thus it continued until he met an untimely death, murdered in dubious circumstances at Ferrara, in the year 1539. The novelty of his dramatic and passionate contribution was just beginning to have its impact on the Venetian art world. It seemed he wanted to challenge Titian, the acknowledged leader of art circles not only in Venice but the length and breadth of Europe maybe as well. The phases of his life which was bustling rather than downright brazen, mark the progressive path of violence in his artistic expression. His work falls within the pattern of the Venetian figurative arts like a cry, strident and insistent, for something new. His early work is structurally static and large-scale but softened after he got to know Giorgione and Lotto. This may be demonstrated in the Collalto altar-piece dating from as far back as 1511, now in the Accademia gallery at Venice and depicting the *Madonna enthroned with saints*.

In the hands of Pordenone, the tone-painting of Giorgione became a means to convey fiery violence of colouring, an instrument to intensify the life-force of his figures. He therefore stood in a position quite other than the contemplative outlook of the painter from Castelfranco, in this preluding the very near future. His *Madonna of mercy with SS.Joseph and Roch* of Pordenone cathedral shewed his striving for a new truth, not to be got by culture. A new humanity, blithe and kindly, fills the foreground; whilst the background remains more or less a landscape after Giorgione.

His visit to Rome in 1516 confronted him with a very different situation from that pertaining in the Veneto. Raphael captured his allegiance and so did Roman art when his restive personality was seeking some new outlet. Returning to the Veneto (Treviso, 1520) and going on to fresco Cremona cathedral, he put into practice the new Roman concept of art based on drama of movement. The Treviso frescoes still have the chromatic splendour of the Veneto, descending out of Giorgione; but the work which he did at Cremona, the colour treatment depending on modelling, partly due to his dynamic interpretation of the gospel story. This meant that tone-painting was less prominent and chiaroscuro came into its own so as to make that which was painted move and yield the dramatic and violent serial content characterising this cycle.

The genius of Pordenone makes itself known fully and clearly: "at this point, the art of Pordenone turns theatrical with illusory effects . . . the spatial dimension of the Renaissance is gone and instead the scene is set by means of illusion, distinctly pre-Baroque in value" (Pallucchini, 1944). The same holds good for the famous *St. Martin* of Spilimbergo, and again the *St. Christopher* in the same church. In later works, the artist produced alternating approaches of varying degrees of refinement. There is obvious influence from Lotto, as in the altar-piece of S.Lorenzo Giustiniani now in the Accademia gallery, Venice. Other pieces are clarion calls from Roman mannerist art broaching the gates of Venetian civilisation, as in the church of S.Rocco (1527-8). Here the function of light in dramatising the composition apparently anticipates certain aspects of Tintoretto's art. In the works at Cortemaggiore and Piacenza, some measure of elegance is restored, perhaps drawn from influences out of Correggio and Parmigianino. In the *Life of the Virgin* at Piacenza, the personality of this artist achieved some of the finest passages within his power of expression; the various tendencies gain perspective by newly conquered equilibrium, resulting from his unremitting search for new outlets.

The closing years of his life show some signs of the pace slackening as he endeavoured after new audiences in Venice and the Veneto, tired of his restless craving. Pordenone was a controversial artist not a conformist. His constant roaming meant that like Lotto he got to know of the problematics within various artistic circles in central and northern Italy.

His nature was such that he appeared near aggressive in regard to the audience for his violent and dramatic work. In the fresco, he identified the medium fittest to convey what he wished to proclaim so very palpably. One of the most significant figures in Veneto art: together with Lotto, it was Pordenone who managed to bring home to the world of the Lagoons the implications of the Mannerist crisis at a time (1538-9) when the flare-up was so clearly taking place in the art of Jacopo Bassano in addition.

PRINCIPAL WORKS

Alviano (Terni), Parish church, *Madonna and angels with SS.Gregory and Jerome* (fresco);

Bergamo, Carrara gallery, *S.Roch and 3 gentlemen* (1534);

Budapest, Fine arts museum, *The four evangelists;*

Cividale del Friuli, Duomo, "Noli me tangere" (1539);

Cortemaggiore (Piacenza), Franciscan church, frescoes: *Church fathers, prophets and sibyls; God the Father and angels,* etc.;

Cremona, Duomo, frescoes: *Christ and Pilate; Christ on the road to Calvary; the Nailing to the Cross; the Crucifixion, the Deposition;*
Duomo, Capella Schizzi, Altar-piece: *Madonna enthroned with saints and donor* (1522);

Milan, Brera gallery, *Transfiguration* (from Collalto);

Naples, Capodimonte museum, *Disputation about the Immaculate Conception* (1529);

Piacenza, Madonna di Campagna, frescoes: *Life of the Virgin; Life of S.Catherine; Prophets; Sibyls; Mythological scenes* in monochrome (1529-35);

Pinzano, S.Stefano, *SS.Sebastian, Nicholas of Bari, Roch, Stephen and others;*

Pordenone, S.Marco, *Madonna of mercy* (1516); *S.Mark enthroned with SS.Sebastian, Jerome, John Evangelist and Alexander;*

S.Daniele del Friuli, S.Michele, *The Trinity;*

Spilimbergo, S.Maria, Organ shutters with the *Conversion of S.Paul* and the *Fall of Simon Magus;*

Susegana (Treviso), Parish church, *Madonna enthroned with saints;*

Travesio (Udine), S.Pietro: *frescoes* with gospel stories (1526);

Treviso, S.Pietro, *Frescoes* with gospel stories, the church doctors, etc. (1520);

Venice, Accademia gallery, *S.Lorenzo Giustiniani;*
S.Rocco, *frescoes;*
Murano, S.Maria degli Angeli, *Annunciation* (1537);

Villanova (S.Daniele del Friuli), *Frescoes* with gospel stories (1514).

ESSENTIAL BIBLIOGRAPHY

Vasari G., *Vite,* etc., Florence, 1568;
Ridolfi C., *Le meraviglie dell'arte,* Venice, 1648 (ed. Halden, Berlin, 1914);
Boschini M., *Le ricche minere,* etc., Venice, 1674;

Zanetti A. M., *Della pittura veneziane*, Venice, 1661;

Altan F., *Del vario stato della pitture nel Friuli*, Venice, 1772;

De Rinaldis C., *Della pittura friulana*, Udine, 1798;

Lanzi L., *Storia pittorica dell'Italia*, Bassano, 1789;

Campori G., *Il Pordenone a Ferrara*, in "Atti e memorie della deputazione di storia patria per le province modenesi e parmensi", 1865;

Crowe-Cavalcaselle, *A history of painting in north Italy*, London, 1879 (ed. Borenius, 1912);

Pettorelli A., *Il Pordenone nella cattedrale cremonese*, in "Cronache d'arte", 1925;

Venturi A., *Storia dell'arte italiana IX*, 3, Milan, 1928;

Fiocco G., *Per Giovanni Antonio da Pordenone*, in "Strenna piacentina", 1930;

Schwarzweller K., *Pordenone*, Gothingen, 1935;

Fiocco G., *Pordenone un Signorelli*, in "Pantheon", 1938;

Fiocco G., *Eredita del Pordenone*, in "L'Arte", 1938;

Bettini S., *G. A. da Pordenone*, in "Emporium", 1939;

Molajoli B., *Catalogue* of the Pordenone exhibition, Trieste, 1939;

Fiocco G., *G. A. da Pordenone*, Udine, 1939 (new ed. 1941);

Pallucchini R., *La pittura veneziana del cinquecento*, Novara, 1944;

Fiocco G., *Luca Cambiano, Girolamo da Treviso e il Pordenone*, in "Studi in onore di Matteo Marangoni", Florence, 1957;

Berenson B., *Italian pictures of the Renaissance*, I, Venetian School, London, 1957.

## POZZOSERRATO LODOVICO

Born at Antwerp in about 1550, his real name was Toeput Lodoryck; when he moved house to Italy and went to live in Treviso about 1580, he italianised his name and it is by this form that he is known today. His activity at Treviso was that of a narrative painter; the manner he adhered to was of northern origin but associated with Veneto elements taken in the main from Paolo Veronese and from Jacopo Tintoretto.

Not greatly esteemed in the past, he has received favourable critical attention in modern times. In particular as a landscape painter, he is precise and perceptive, thus anticipating a kind of manner to come into prominence at the beginning of the following century.

He carried out fresco-work for some of the villas in the Veneto; some of his genre scenes, relating to customs of the time, indicate commendable psychological insight. Among his works, mention may be made of the *Villa concert* in Treviso civic museum and the *Villa repast* preserved at Palazzo del monte di Pietà, again in Treviso, where the artist died between 1603 and 1605.

ESSENTIAL BIBLIOGRAPHY

Rigamonti A., *Descrizione delle pitture più celebri della città di Trevigi*, Treviso, 1776;

Federici G. M., *Memorie trevigiane . . .*, Venice, 1803;

Lanzi L., *Storia pittorica della Italia*, Bassano, 1789;

Pallucchini R., *La pittura veneziana del cinquecento*, Novara, 1944;

Menegazzi L., *Il Pozzoserrato*, in "Saggi e memorie di storia dell'Arte, Venice, 1957;

Menegazzi L., *Giunte a Lodovico Pozzoserrato*, in "Arte Veneta", 1961; *Il Museo civico di Treviso*, Venice, 1964.

# PREVITALI ANDREA

Born at Bergamo about 1470, he signed himself "discipulus Ioannis Bellini" on his first dated work: the *Madonna and child* of 1502 in Padua civic museum. Further works bear out this testimony. His training can be taken as Venetian while his output signifies converging influences from a number of artists working in Venice.

The Ceneda *Annunciation* (Santuario del meschio) denotes attention to the examples of Cima da Conegliano and Vittore Carpaccio. The early works are characterised by clean-cut form and crystalline surface areas using broad planes of vision. At a subsequent stage the treatment of form mellows and the chromatic scale with it, in tribute to the leading figures carrying Venetian painting in new directions at the time; the names of Giorgione and Palma il Vecchio spring to mind.

Lorenzo Lotto too was another personality obviously favoured for his suppleness and sense of drama, a contact which would date from his return to Bergamo where he was living in 1511. Lotto's influence becomes more apparent in the flow of works from this Bergamo period.

Previtali died in 1528, having enjoyed a good reputation; not highly regarded by succeeding generations, he has been regaining lost ground in more modern times. Currently assigned him also are some *mythological scenes* of undisputed Giorgione influence to the point that they entered the National gallery, London, which is their present home as works of Giorgione.

On this topic, expert opinion is not unanimous. The scenes are refined in manner and lyrical in mood and many writers have come down firmly on one side: Richter (1937), Morassi (1942), Longhi (1946); but Berenson (1951) went no further than to call them Giorgionesque in style.

## PRINCIPAL WORKS

Alzano (Bergamo), *The Trinity and two saints* (1517);
Bergamo, Carrara academy, *Madonna with SS. Dominic and Sebastian* (1506);
    *Marriage of S.Catherine; Descent of the Holy Spirit;*
Bergamo, S.Alessandro della croce, *Crucifixion* (1523);
    S.Spirito, *Madonna* and four female saints (1525);
Berlin, State gallery, *Madonna and child with saints and donor;*
Ceneda (Vittoria Veneto), Santuario del meschio, *Annunciation;*
Dresden, Gemäldegalerie, *Madonna and infant Baptist;*
London, National gallery, *Madonna and child with donor; Madonna and child*
    *with SS.John Baptist and Catherine; 4 mythological scenes;*
Milan, Brera, *Agony in the garden;*
Padua, Civic museum, *Madonna and child* (1500);
Venice, Accademia gallery, *Nativity; Crucifixion.*

## ESSENTIAL BIBLIOGRAPHY

Lanzi L., *Storia pittorica della Italia*, Bassano, 1789;
Tassi, *Vite dei pittori bergamaschi*, Milan, 1793;
Venturi A., *Storia dell'arte italiana* VII, 4, 1915;
Tarchiani N., in "Emporium", 1920;
Fiocco G., *A.P.* in "Thieme-Becker K.L.", Leipzig, 1933 (with bibliography);
Gengaro M. L., *Umanesimo e Rinascimento*, Turin, 1944;
Longhi R., *Viatico per cinque secoli*, Florence, 1946;
Berenson B., *Italian Pictures of the Renaissance*, I, Venetian School, London, 1957;
Davies M., National gallery catalogues, *Earlier Italian* schools, London, 1961
    (2nd ed.).

## RENIERI NICOLO

Born at Maubeuge in Flanders, in about 1590. His training began in his birth-place but he moved at an early age to Rome where he frequented the circle of painters associated with Caravaggio. He was especially close to Manfredi, to the extent that his works of this period are at times confused with those of his colleague. His Roman period lasted from 1615 to about 1624. In 1626 he was registered with the painters' guild in Venice and decided to remain there on a permanent basis. His date of death may be put at 1667.

It is probable that before settling in Venice, he spent some while in Bologna and was in touch with local artists and their intensely busy and thriving activity. This would explain the fact that his first works painted in Venice show the early pro-Caravaggio leaning softened through the influence of Bologna painting.

In Rome he was acquainted with the art of Simon Vouet, according to Fiocco, and would have assimilated naturalist elements for the sake of making his painting more attractive, compared with the realism he practised even earlier and which he got straight out of Caravaggio.

In Venice his manner becomes more languid, his subjects more superficially attractive and less seriously pondered. Clearly, in encountering Lagoon art the artist underwent some sort of crisis. Sight of the works of Bernardo Strozzi may have had something to do with this; the fact remains that he deviated from his initial manner owing to the effect of Bologna painting.

His language is emphatic but rather vapid in terms of composition; his female figures are always elegant but spiritually unalive. This limits his painting, patently decorative in intention. At the same time, there is some substance to the paint material and the rendering of gorgeous attire pleases the eye, likewise the attitudes which are taken as representing all kinds of people from mythology and history. The brush-work which has strength harks back to his early days pro-Caravaggio; the effect produced is quasi-metallic with great stress on the play of light and shade. Works like the *Vanitas* of Stockholm museum make his Caravaggio-like treatment of light even more apparent. His painting had marked influence in Venetian circles at the time, subject to a critical passage when the old allegiances were slackening their hold.

Renieri — his real name was Renier Nicolas — had four daughters. They were all painters, and his pupils; he often reproduces them in his paintings, dressed as the great ladies of legend of ancient times. One of them married Daniel van Dyck, another Pietro Vecchia. His will, written with his own hand, bears the date of 2 November 1567; in it, he left a greater share of his worldly goods to his daughter Lucrezia because widowed. The will also carries the signature of Carlo Zanchi, witness, and contains a bequest to Pietro Vecchia. Nicolas Renier was half-brother to Michele Desubleo, a painter active at Bologna.

PRINCIPAL WORKS

        Aschaffenburg, Gallery, *Queen Tomyris;*
        Birmingham, City museum and art gallery, *Magdalen;*
        Budapest, Fine arts museum, *Players;*
        Detroit, Institute of art, *Magdalen;*
        Dresden, Gemäldegalerie, *S.Sebastian;*
        Kassel, Staatlich gemäldegalerie, *Death of Sophonisba;*
        Paris, Louvre, *Good Fortune;*
        Turin, Palazzo reale, *Allegory of wisdom;*
        Venice, S.Canciano, *Madonna in glory with S.Filippo Neri;*
            Accademia gallery, *Strength;* the *Eritrean sibyl;*
            Palazzo ducale, *Madonna in glory* and three "Avogadori".

ESSENTIAL BIBLIOGRAPHY

Ridolfi C., *Le meraviglie dell'arte*, Venice, 1648;

Boschini M., *La carta den navegar pitoresco*, Venice, 1660; *Le ricche minere della pittura veneziana*, Venice, 1674;

Sandrart J., *Academia nobilissima artis pitoriae*, Nuremberg, 1683;

Zanetti A. M., *Della pittura veneziana*, Venice, 1771;

Lanzi L., *Storia pittorica della Italia*, Bassano, 1789;

Voss H., *Die malerei des baroch in Rom*, Berlin, 1924;

Fiocco G., *La pittura veneziana del seicento e del settecento*, Verona, 1929;

Zampetti P., in "La Pittura del seicento a Venezia", Exhibition catalogue, Venice, 1959;

Savini-Branca S., *Il collezionismo veneziano del seicento*, Padua, 1964;

Ivanoff N., *Nicolas Renier*, in "Arte Antica e Moderna", 1965;

Donzelli-Pilo, *I pittori del seicento veneto*, Florence, 1967 (with full bibliography to date).

## ROMANINO GEROLAMO

Gerolamo di Romano later called I. Romanino was born at Brescia between 1484 and 1487. He was the son of Romano di Luchino. His first dated work goes back to 1510 and was done for the church of S.Lorenzo in his birth-place. Three years later, the artist was in Padua. In 1517, he was at Cremona where as from 1519 he was engaged on some frescoes for the Duomo, interrupted in 1520. The next year, he was again in Brescia, engaged on many works which he in part dispatched outside the city.

In 1531 the painter was charged by the prince bishop of Trent, cardinal Bernardo Clesio, with the task of producing some frescoes for the "Magno palazzo", otherwise known as the Castello del Buonconsiglio. He probably remained there until 1532. Then he went back home and did a lot of work for the church of S.Maria della Neve at Pisogne, for the Duomo at Asola and Brescia cathedral. In 1556 he was registered as a noble citizen of Brescia. Other items of news about him carry his story down to 1559, the presumable year of his death.

Romanino was one of the greatest painters of Veneto province, that is to say not directly associated with the school of Venice. Yet he absorbed many qualities from the said school, blending them effectively with influences out of Lombard art. It was Cavalcaselle (1871) to whom falls the distinction of having traced the development of his style, a fairly complex matter. Since then, the experts have been set on discovering possible sources of influence and facets of his style. According to some authorities, he was initially associated with Foppa; according to others, it was with Boccaccino. On these Veneto-Lombard elements Longhi in particular has placed considerable insistence, for purposes of differentiating Paduan from Venetian in terms of art. The Venetian was more courtly and of the mind, the Paduan more down to earth. In artists of the mark of Moretto, Savoldo and indeed Romanino, Longhi perceived the antecedents of Caravaggio himself, the revolutionary who made seventeenth century painting what it was.

Fundamental importance nevertheless must be accorded to the Veneto influence in this regard. Work done in modern years is not unhelpful nor indeed unacceptable in assessing his formative period and in coming to grips with the essence of his artistic personality. In the signed and dated work, *Pietà* of 1510 (now in the Accademia gallery, Venice), the artist appeared totally immersed in the pattern of Venetian culture. Without knowing Giovanni Bellini, Giorgione and Titian, the work would be incomprehensible. Romanino has demonstrably assimilated the "tonality" which is the chief feature of Venetian colour treatment.

In the Paduan *altar-piece* of 1513, a true masterpiece, the artist's fiery colouring achieves the heights of tone-painting, vibrant and luminous, indicating influence from the frescoes painted by Titian in the "Scuola" of the saint at Padua.

It became at the same time apparent that alongside these elements Romanino's personality was endowed with an expressionist power of utterance peculiarly his own. Progressively, he cultivated this to the point of mastery. The figures he portrayed were strong-featured near violent, their movements impetuous; they crop up in his works in a natural kind of way, as if he wanted his interpretation of life, with its violence and its drama, to stand out from the painted fiction. There is the likelihood that the work of Lotto who was engaged on commitments in Bergamo had its effect here, as well as northern influence.

The *Madonna and child* of the Doria Pamphili gallery in Rome may date from this phase of his development. From a near-reflective style akin to Giorgione, his gifts carried him on other occasions towards the violent and the aggressive. An example of the trend may be seen in the frescoes of the *Passion* cycle in Cremona cathedral. In these, the stress placed on the figure as such exceeds Renaissance practice regarding perspective. The human presence comes across compulsively, as a result. Again, this is appreciable to a still greater extent in the frescoes for the Capella del sacramento in Brescia. Cumulative experiences were in process of being assessed by the artist, all aimed at finding a more constructive higher level. The extraordinary painting of *S.Matthew* resulted (S.Giovanni Evangelista, Brescia). The lighting made it intimate, setting the figure which it graced apart by a play of light and shade anticipating Caravaggio.

The search for ever-new forms of expression impelled Romanino to react like a pendulum, now inclining towards a semi-popular strain as in the Asola pieces and now to pro-classical balance of form as in the Salò cathedral altar-piece. Cardinal Clesio commissioned the frescoes at Trent from him, together with Dosso and Fogolino. The set subjects were in the nature of classical allegory: Romanino produced work even here tending to the realist, masterful and spirited.

The stimulus may have been provided by Pordenone but as time went by his painting became agitated, witness the Pisogne *Crucifixion*, or psychologically tense and overwrought as in the frescoes at S.Antonio di Breno. The search to devise new forms was continuous through the closing phase, to the last work — *Christ addressing the faithful* (S.Pietro, Modena) which has certain Mannerist over-tones reminiscent of Niccolò dell'Abate and Dosso too, whom he had met in his Trent days.

As has been observed with justification, the power of expression of Romanino is so heightened in his treatment of subjects after the classical manner and out of mythology as to touch at times on caricature, or else he made a dramatic event of them. His interpretation of the classical is quite new, namely to see humanity in perspective not as a result of contemplation and detachment but by virtue of conscious assessment of the values of human life. Akin beyond a shadow of doubt to the Venetians and in particular, as stated, to Giorgione and Titian, he approached Lagoon colour treatment in terms of chiaroscuro, displaying a failure to be satisfied with the canons of that school of art; he thus joined the counter-movement headed above all by Lorenzo Lotto in the guise of leading exponent.

PRINCIPAL WORKS

Asola, Duomo, *Organ doors;*
Bergamo, Carrara gallery, *Portrait of a gentleman;*
Bienno (Val Camonica), S.Maria Annunziata, *frescoes;*
Breno (Val Camonico), S.Antonio, *frescoes;*
Brescia, Art gallery, *Nativity; Pietà with SS.Paul and Joseph; Coronation of the Virgin* with SS.Dominic, Faustinus and others;

S.Francesco, *Madonna and child* with SS.Francis, Anthony of Padua, Bonaventure and Louis of Toulouse;

S.Giovanni Evangelista, *Madonna and child* with SS.Margaret of Cortona, Onuphrius, Anthony of Padua and Roch;

Cremona, Duomo, *Frescoes* in the nave;

London, National gallery, *Polyptych* formerly at S.Alessandro di Brescia);

Milan, Brera gallery, *Circumcision*;

Padua, Civic museum, *Altar-piece* (formerly at S.Giustina);

Pisogne (Lago d'Iseo), S.Maria della Neve, *Frescoes* with the Life of Christ;

Trent, Castello del Buonconsiglio, *Frescoes and various decorative works* illustrating passages from the Bible and mythology with genre pieces;

Venice, Accademia gallery, *Pietà*;

Verona, S.Giorgio in Braida, *St. George* cycle (organ shutters).

ESSENTIAL BIBLIOGRAPHY

Mattioli A., *Il Magno Palazzo del Cardinale di Trento*, Venice, 1539;

Vasari G., *Le vite*, etc., Florence, 1568;

Ridolfi C., *Le meraviglie dell'arte*, Venice, 1648;

Lanzi L., *Storia pittorico della Italia*, Bassano, 1789;

Crowe-Cavalcaselle, *A history of painting in north Italy*, 1871 (ed. Borenius, London, 1912);

Baldoria N., *Pitture di Gerolamo Romanino*, in "Archivio storico dell'arte", 1891;

Jacobsen E., *Die gemälde der einbeimischen Malerschule in Brescia*, in "Jahrb. der Königl. Preuss. Kunstammlungen", 1896;

Berenson B., *North Italian painters of the Renaissance*, London, 1907;

Venturi L., *Giorgione e il giorgionismo*, Milan, 1913;

Longhi R., *Cose bresciane del cinquecento*, in "L'Arte", 1917;

Nicodemi G., *Gerolamo Romanino*, Brescia, 1925;

Venturi A., *Storia dell'arte italiana* IX, 3, Milan, 1928;

Suida W., *G.R.* in Thieme-Becker, under appropriate heading, 1934;

Pallucchini R., *La pittura veneziana del cinquecento*, Novara, 1944;

Gregori M., *Altobello, il Romanino e il cinquecento cremonese*, in "Paragone", 1955;

Berenson B., *Italian pictures of the Renaissance*, I, Venetian School, London, 1957;

Ferrari M. L., *Il Romanino*, Milan, 1961;

Cassa Salvi E., *Il Romanino*, Milan, 1963;

Testori G., *Da Romanino a Giorgione*, in "Paragone", 1963;

Panazza G., *Gerolamo Romanino* (Exhibition catalogue), Brescia, 1965;

Panazza G., *Affreschi di Gerolamo Romanino*, Milan, 1965.

## SALVIATI (Giuseppe Porta, called Il)

Born at Castelnuova di Garfagnana in about 1520, he trained under Francesco Salviati whose surname he took for his own. He reached Venice in 1539 along with his master. Whereas the latter's stay was short, the former came to look on it as his second home and continued working busily until 1573 (the last year information is recorded concerning him). This sojourn in Venice was only

broken by a visit to Rome, in 1565, on the occasion of work undertaken for the Vatican. Modern critical opinion has had the personality of Giuseppe Salviati under review, to try and ascertain the role that he played in the path taken by Venetian painting in response to the Mannerist crisis. Pallucchini remarked "it may not be apposite to say he was responsible for the crisis which changed the manner of Titian, a crisis transpiring in the work of the painter from Cadore as long before as 1538".

It is plain that glimmerings of the new trends in art had been reaching Venice for some while; the arm of Roman culture reached everywhere. Yet the presence of this typical Mannerist was not without its own effect. In fact, it is certain that when he got to Venice he was associated with Tuscan and Roman culture after Michelangelo. His design for Marcolini's "works" dating from 1540 illustrates the point. The 1542 frescoes for Villa Priuli at Treville have been lost. The *Deposition* of S.Maria degli Angeli, Murano, ranking with his early works at Venice, shows cultural connotations conforming with the lines indicated.

Later as a result of cultural contacts of a local nature, a softening occurred in the clean-cut modelling of Salviati's work. The change is attributable to absorbing elements from the Veneto, especially out of Veronese and Tintoretto. Indeed, the influence of the two last-named was so strong as to make him look more like an eclectic, ready to fall in line with current fashion, than an original artist. Highly rated in the past, the personality of this artist has been subject to re-assessment by scholars in modern times. To him must go the credit for having contrived to reconcile the two cultures, Roman and Venetian. This does not mean that the Venetian manner was unaffected by his work, but at least not in a positive measure. He may be seen as instrumental in leading up to the late Mannerism observable in minor artists at Venice from the second half of the sixteenth century.

PRINCIPAL WORKS

Monselice, Cini coll., *Raising of Lazarus;*
Murano, S.Maria degli Angeli, *Deposition;*
Venice, S.Marco, *Genealogy of the Madonna* (mosaic);
    S.Francesco della Vigna, *Madonna enthroned with two saints;*
    S.Zaccaria, *Christ appearing to SS.Cosmas and Damian;*
    SS.Giovanni e Paolo, *Assumption;*
    Chiesa dei Frari, *Purification;*
    Chiesa della Salute, *Elias and the angels; Manna from heaven; Habacuc comforting Daniel.*

ESSENTIAL BIBLIOGRAPHY

Vasari G., *Vite* etc., Florence, 1568;
Ridolfi C., *Le meraviglie dell'arte*, Venice, 1648 (ed. Hadeln, 1914);
Lanzi L., *Storia pittorica della Italia*, Bassano, 1789;
Venturi A., *Storia dell'arte italiana* IX, 7, Milan, 1934;
Coletti L., *La crisi manieristica della pittura veneziana*, in "Convivium", 1941;
Pallucchini R., *La pittura veneziana del cinquecento*, Novara, 1944;
Pallucchini R., *La giovinezza del Tintoretto*, Milan, 1950;
Zava Boccazzi F., in "Arte Veneta", 1963 and 1966.

## SANTACROCE GIROLAMO

He belongs to the large family of painters from Santacroce, of whom he is the best known. It is worth noting that Francesco di Simone (q.v.) was not one of this

family, neither was his son Francesco though they were called "da Santacroce". His real surname appears to have been Rizzo (or else Galizzi?) and this was replaced by the locality he came from, namely Santacroce. It is not clear, however, if the place of that name in the neighbourhood of Bergamo is intended or another of the same name by Trieste. His birth date is generally given as about 1480. In truth there is a great deal of uncertainty surrounding his personality; it is possible that he may be identifiable with one Girolamo de Bernardino who was referred to in Venice as a pupil of Gentile Bellini (1503) and subsequently inherited some of his drawings. In 1515 this painter was married. It is plain that the young artist who signed works as Gerolamo, of which there are many in Lombardy, Venice, Istria and Dalmatia, after his formative period under Gentile — provided the signatory of the paintings and this artist are one and the same — quickly became familiar with the art of Giovanni Bellini, showing some affinity to Cima da Conegliano in addition.

He may consequently be termed a painter of the second water, tagging along in the wake of the new achievements accomplished by the great masters of the early sixteenth century; nor was he unaware of the break-through in tone painting in the work of Giorgione.

Despite his praises sung by Ridolfi and Lanzi, he cannot be rated better than as a painter of scant originality, compelled to yield pride of place to men of more drive as the art canons altered with the progress of civilisation itself. The influence of Roman painting was also felt, perceptible enough in the *Nativity of the Baptist*, now in the Este gallery at Modena. Pallucchini drew attention to Santacroce's assimilation of Roman elements. The truth is that it was all grist to his mill, in so far as any contribution would serve to leaven the flatness of his own personality. At the same time, this borrowing fell short of actual participation in responding to the various demands which brought about the change in manner of painting.

Girolamo da Santacroce died at Venice in 1556, after his commissions in later years had drawn him to the borders of Dalmatia. He had one son, Francesco, who carried on with his work (Venice, 1516-84), and a grandson Pietro Paolo, documented from 1584 to 1620. The last-named like his father before him was an eclectic, favouring a rather set and traditional pattern of proceeding in line with examples derived from the great masters of the sixteenth century, in particular Lorenzo Lotto.

PRINCIPAL WORKS

Bari, Province museum, Polyptych: *Madonna and six saints* (1531);
Bassano del Grappa, Museum, *Calling of Matthew* (1519);
Bergamo, Carrara academy, *Madonna and blessing child; Madonna with SS.Sebastian, Jerome, Francis and John Baptist* (from Bellini);
Capodistria, S.Anna, *Madonna enthroned and four female saints; Deposition;*
Isola d'Istria, Duomo, *Holy family* (1537);
Leningrad, Hermitage, *S.Liberale;*
London, National gallery, *S.John Evangelist* (1512);
Milan, Brera gallery, *Apollo and Daphne;*
Sforza castle, *Madonna with SS.John Baptist and Jerome* (1533);
Pisino (Istria), S.Francesco, *Madonna enthroned and saints* (1536);
Spalato, S.Maria delle Grazie, *Polyptych* (1549);
Venice, Accademia gallery, *Christ and the Samaritan woman at the well; Marriage of S.Catherine;*
Correr museum, *Madonna and child with saints; Baptism of Christ; Rest on the flight into Egypt.*

ESSENTIAL BIBLIOGRAPHY

Ridolfi C., *Le meraviglie dell'arte*, Venice, 1648;

Zanetti A. M., *Della pittura veneziana . . .*, Venice, 1771;

Lanzi L., *Storia pittorica della Italia*, Bassano, 1789;

Fornoni E., *I pittori da S.Croce*, 1908;

Crowe-Cavalcaselle, *A history of painting in north Italy*, London, 1876 (ed. Borenius, London, 1912);

Venturi A., *Storia dell'arte italiana* VII, 3, Milan, 1914;

Fiocco G., *I pittori da Santacroce*, in "L'Arte", 1916 (with list of works and bibliography to that date);

Gombosi G., in "Gaz. des Beaux Arts", 1932;

Pallucchini R., *I dipinti della galleria Estense*, Rome, 1945;

Galletti-Camesasca, Enciclopedia della pittura italiana, Milan, 1951;

Berenson B., *Italian pictures of the Renaissance*, I, Venetian School, London, 1957;

Mariacher G., *Il museo Correr di Venezia*, Venice, 1957.

## SARACENI CARLO

The year of his birth is not known but it took place in Venice about 1580 or soon after. He was the son of Giulio. As a youth, he went to Rome without leaving any evidence of activity in Venice. The reasons for his journey are not clear, but something may be deduced from the direction he was led to take in his work. It is now thought that a protest gesture may have been intended against the academic canons of Lagoon art. The move would then be seen as a desire for novelty, already signified in his early works.

After a while spent studying with the painter Camillo Mariani, who came from Vicenza but was living in Rome, Saraceni drew closer to the restive world that revolved round the figure of Michelangelo da Caravaggio. Saraceni was among the first to feel the spell of the great Lombard; indeed, Mancini included the name of "Carlo Veneziano" in his list of strictly pro-Caravaggio painters, drawn up in 1620.

His curiosity led him beyond the naturalist reform being accomplished by the Lombard painter and into association with Gentileschi and also Elsheimer, the German artist who arrived in Rome about 1600 bringing with him a new feeling for landscape, somewhere between the romantic and the idyllic with a preference for night scenes. Saraceni became very close to him, and the two personalities are almost indistinguishable at times, as for example in the *Mythological views* of Naples museum, recently claimed for Saraceni but in the past held to be the work of Elsheimer.

After the latter's death, Saraceni turned back to the Caravaggio vein, modifying the robust feeling for form and dramatic treatment of light with effects verging on the tragic in this painter; instead he aimed for a new soft effect by the inter-play of light and shade and in so doing his artistic sensitivity as a Venetian painter was able to emerge with a flourish.

In 1613 he entered into correspondence with the duke of Mantua and sent him some work. In 1616-7, he painted some frescoes for the Cappella paolina of the Quirinal palace in Rome; in 1618, he finished some work for the church of S.Maria dell'Anima. Two years later in 1620, he was in Venice along with Le Clerc. It is probable that he also made some arrangement with the court of Mantua.

On 13 June 1620 he made his last will and testament being suddenly fallen ill and three days later he was dead. As the register of S.Trovaso parish recorded the event: "aged about 40, sickened of a fever" (febre pechia). At the time he was engaged on a work for Palazzo ducale entitled *Enrico*

*Dandolo and the crusader captains in St. Mark's before leaving on the fourth crusade*. The painting being incomplete, it was finished by Le Clerc.

Saraceni was an artist of calibre. Associated with the new departures of Caravaggio, he nevertheless spoke a personal language, as a Venetian. This meant that he accented the role of colour and this in turn modified the relationship of light and shade. His sensitivity comes across as springing from a loving tender nature, blithely wending its way in and out of the figures in the splendid *Rest on the flight into Egypt* of the Sacro Eremo dei Camaldolesi at Frascati, to cite an example.

*S.Roch and the Angel* (Doria gallery, Rome) shows the original interpretation put by Saraceni on the art of Caravaggio; the chiaroscuro brings the figure into dramatic relief but not violent (as in Caravaggio), rather immersed in some inner dynamism. His position, at a distance of over a century, re-echoes the sensitivity of a Giorgione as it were. Saraceni may without doubt be called the greatest Venetian painter working at the start of the seventeenth century, the only one who freed himself from the trammels of the Mannerists. The final works which he undertook at Venice were of great importance in the formative period of Pietro Vecchia and Giulio Carpioni.

## PRINCIPAL WORKS

Bologna, National art gallery, *Rest on the flight;*
       Dresden, Gemäldegalerie, *Judith;*
       Frascati, Eremo dei Camaldolesi, *Rest on the flight;*
       Munich, Alte pinakothek, *S.Francis and the angel;*
       Naples, Capodimonte gallery, *The flight of Icarus; The fall of Icarus;* etc.;
       Rome, S.Maria dell'Anima, *Miracle of S.Benone;*
           Quirinal palace, *frescoes* in the Sala regia;
           National gallery, *Madonna and child with S.Anne; S.Cecilia and the angel; S.Roch and the angel;*
           Doria gallery, *S.Roch and the angel;*
       S.Giustina (Feltry), Parish church, *Annunciation;*
       Venice, Rendentore church, *S.Francis and the angel;*
           Palazzo ducale, Sala del maggior consiglio, *Enrico Dandolo and the crusader captains in the basilica of S.Mark* (in collaboration with Le Clerc);
           Accademia gallery, *Flagellation of Christ*, SS.Peter and the Magdalen.

## ESSENTIAL BIBLIOGRAPHY

Baglione G., *La vita de' pittori, scultori, architetti*, Rome, 1642;
Boschini M., *Le minere della pittura*, Venice, 1664;
Bellori G. M., *Le vite de' pittori, scultori, etc.*, Rome, 1672;
Lanzi L., *Storia pittorica della Italia*, Bassano, 1789;
Voss H., *Die Malerei des Barock in Rom*, Berlin, 1924;
Longhi R., *Quesiti caravaggeschi*, in "Pinacotheca", 1928-9;
Fiocco G., *La pittura veneziana del seicento e del settecent*, Verona, 1929;
Longhi R., *Catalogue* of the exhibition "Caravaggio ed i caravaggeschi", Florence, 1951;
Zampetti P., *Carlo Saraceni*, in "La pittura del seicento a Venezia", Venice, 1959;
Longhi R., *Presenze alla Sala Regie*, in "Paragone", 1959;
Pallucchini R., *L'ultima opera del Saraceni*, in "Arte Veneta", 1963;
Arcangeli F., *Un nuovo Saraceni*, in "Paragone", 1966;

Donzelli-Pilo, *Carlo Saraceni*, in "I pittori del seicento veneto", Florence, 1967 (with good bibliography);
Ottani Cavina A., *Per il primo tempo del Saraceni*, in "Arte Veneta", 1967.

## SAVOLDO GIROLAMO

Born at Brescia in about 1480, apparently he came of a well-to-do family. The time of his birth is taken from a letter of Aretino who referred to him in 1548 as being then quite old. The time of his death is not known but occurred after 1548, the date of the latest news of him. Indeed, information on his life is scanty.

In 1508 he was in Florence and registered with the fraternity of doctors and chemists which included painters in its ranks. In 1521 he was living in Venice, though for how long previously remains conjectural except that it was a question of some years. The brethren of S.Niccolò at Treviso commissioned him to finish an altar-piece which had been left unfinished by another hand. In 1526 he made his will. Probably towards 1530 he found himself at Milan and remained there several years because Pino writing in 1548 stated that he was in the service of the duke of Milan, Francesco II Sforza. There is little more but for the dates inscribed on some of his pictures: in 1532 he was in Venice living in Calle della Testa by the church of SS.Giovanni e Paolo; in 1539 he was appointed executor of the will of the sculptor Giovanni Antonio da Gandino; in 1548, as above, the latest news of him still in Venice.

Together with Moretto and Romanino, Savoldo composed the "Brescia trio": that is to say he was one of the three main Veneto-Lombard artists. Connected with the school of Venice by which they were conditioned, they nevertheless pursued an independent line imparting a goodly number of aspects and features to Veneto painting of the sixteenth century.

Savoldo's artistic career began at local level, close in particular to the art of Foppa. It is not clear what he gained from his stay in Florence apart from an echo or two of Leonardo. This, however, he might equally have absorbed in Lombardy; indeed, the trait is perceptible in early works, like the *Hermit saints* (Accademia gallery, Venice). Soon, Savoldo entered the world of Giorgione, perhaps with a direct encounter involving the young Titian too at the stage when the latter was still associated with the great master from Castelfranco. He was able to interpret their manner with pictorial vigour and psychological content that appeared novel.

Savoldo worked initially within their orbit. His *Venus* (Borghese gallery, Rome) in fact is straight out of Giorgione; the Giorgionesque transpires in other early works in addition. On the other hand, his block-like treatment of form has been held to warrant the suggestion that there was something in his work of the far-distant Antonello da Messina. In this connection, see the *Portrait of a man* (Brera, Milan) about which Adolfo Venturi wrote that "here the Brescian is reminiscent of the great man from Messina not unfamiliar with Flemish art: Antonello — even in the suddenness of his colour".

Like Lorenzo Lotto, Savoldo may have remained on the margins of Venetian painting but from his youth gave every indication of an outlook and artistic intention of his own. In *Tobias and the angel Raphael* (Viezzoli coll., Genoa), painted perhaps shortly after 1510, these characteristics are already apparent: cold tones, treatment of colour in terms of light with passages of contrast and a chromatic confidence quite outside the tone spectrum of the Venetians. Savoldo looked to Giorgione, as said but to new purpose: after the first contacts with Titian, what he had learned made him branch out and become utterly original. Vasari dubbed him whimsical.

The *Rest on the flight into Egypt* (Castelbarco-Albani coll., Milan) gives a decisive indication of this personality. There is also his allegiance to realist painting, by which the Veneto-Lombard exponents tried to present home-truths, far removed from the courtly or literary works produced by the

strictly Venetians. In fact, breaking with the past Savoldo used an actual Venetian setting for his sacred subject, with the broad sweep of the lagoon by St. Mark's.

His eye for reality is more evident still in other works: the *Young peasant* of the Contini-Bonacossi collection in Florence or the *Venetian* so-called (National gallery, London; copies elsewhere). In this piece, the figure of the woman is presented in a poetic light, against a landscape redolent of night; her shawl aglow with phosphoresence. The charming *Flute-player* of the Contini-Bonacossi collection contains the artist's reading of the art of Giorgione, undoubtedly under the influence of Lotto: that is to say, the contemplative rapture comes across with psychological connotations. This is done by alternating light and shade to build a mood of expectancy in deep meditation.

Other paintings like the *Archangel and Tobias* (Borghese gallery, Rome), *St. Matthew and the angel* (Metropolitan museum, New York) display the artist's free creativity with touches taken from Flemish and German painters additionally. He wanted to get away from the Venetian tradition and present people more thoughtfully and intimately including those of the lower class. This new approach to humanity gathered momentum until it triumphed in the new departures of Caravaggio. It is for this reason that his community of intent and affinity has been stressed with Romanino and Moretto, all following the same path.

Savoldo's painting is, of these, the most lyrical and lofty, his inventive powers under tight rein and deeply pondered, his chromatic texture original. In it, Venetian tone concepts are not allowed to predominate; instead there is a continual inter-change carefully modulated, as between one colour and another. It is this texture which constitutes the key to come to terms with Savoldo's strangely emotive art.

PRINCIPAL WORKS

Amsterdam, Rijksmuseum, *Bust of a bearded man;*
Berlin, Gemäldegalerie, *The Magdalen;*
Brescia, Civic art gallery, *Adoration of the shepherds; Young man reading a letter;*
Budapest, Fine arts museum, *Entombment;*
Dublin, Gallery, *Madonna with Jerome and the Baptist;*
Florence, Uffizi gallery, *Transfiguration;*
    Contini-Bonacossi coll., *The flute-player; The Young Peasant;*
Genoa, Viezzoli coll., *Tobias and the angel;*
Hampton Court, *Gaston de Foix; Madonna and child;*
London, National gallery, *The Venetian* (also called The Magdalen); *S. Jerome in the desert; Man in a large black hat;*
Milan, Brera gallery, *Madonna in glory with saints; Portrait of a man;*
    Castelbarco Albani coll., *Rest on the flight into Egypt;*
Paris, Louvre, *Gaston de Foix;*
Rome, Borghese gallery, *Tobias and the angel Raphael;*
Treviso, S. Niccolò, *Madonna and saints;*
Venice, Accademia gallery, *The hermits Anthony and Paul;*
    S. Giobbe, *Adoration of the shepherds;*
Verona, S. Maria in Organo, *Madonna in glory and saints.*

ESSENTIAL BIBLIOGRAPHY

Pino P., *Dialogo di pittura*, Venice, 1548 (ed. R. and A. Pallucchini, Venice, 1946);
Vasari G., *Le Vite* etc., Florence, 1568;

Boschini M., *La carta del navegar pitoresco*, Venice, 1660;

Lanzi L., *Storia pittorica della Italia*, Bassano, 1789;

Crowe-Cavalcaselle, *A history of painting in north Italy*, London, 1871 (ed. Borenius, London, 1912);

Venturi L., *Giorgione e il giorgionismo*, Milan, 1913;

Longhi R., *Cose bresciane del cinquecento*, in "L'Arte", 1917;

Ortolani S., *Di Gian Gerolamo Savoldo*, in "Arte", 1925;

Halden D., *Notes on Savoldo*, in "Art in America", 1925;

Longhi R., *Due dipinti inediti di G. Savoldo*, in "Vita Artistica", 1927;

Venturi A., *Storia dell'arte italiana* IX, 3, 1928;

Suida W., *Savoldo*, in Thieme-Becker, 1935, under appropriate heading;

Nicco Fasola G., *Lineamenti del Savoldo*, in "L'Arte", 1940;

Pallucchini R., *La pittura veneziana del cinquecento*, Novara, 1944;

Gilbert C., *Milan and Savoldo*, in "The Art Bulletin", 1945;

Longhi R., *Viatico per cinque secoli*, etc., Florence, 1946;

Zampetti P., *Savoldo* in Giorgione e i Giorgioneschi, Venice, 1955;

Berenson B., *Italian pictures of the Renaissance*, I, Venetian School, London, 1957;

Ballarin A., *Girolamo Savoldo*, Milan, 1966.

## SCHIAVONE (Andrea Meldola, called Lo)

Born at a point between 1510 and 1520 at Zara in Dalmatia, then in the territory of the Republic of Venice. While young, the painter moved to Venice where he trained. He became a pupil of Bonifacio Veronese and thus acquired some inkling into the work of Jacopo Bassano and Tintoretto. During his formative period, he was not immune to repercussions of Mannerist art, Emilian brand, particularly as expressed by Parmigianino.

He was moving in the sense of colour treatment by free and fluent application of a rich impasto, unfettered by any under-drawing rigidly adhered to. His artistic personality, as Pallucchini put it, made him "draw substance and savour from a notational stream of jostling colour notes, merging into one another; the tone painting he achieved by this approach shied off from formal stress except by inference in quasi-sensual language" (1944).

As well as being a painter, La Schiavone was a noted engraver. He often used motifs from Parmigianino; indeed, his etchings often follow work of the Emilian artist. Parmigianino's artistic response produced a linear rhythm in the treatment of human figures; they came across elongated and fluid, as aristocratic and fantastic as could be, in an entirely intellectual evocation of Mannerist art. The effect on Schiavone was to prompt him into adducing something of the Emilian mannerist approach in his own tone painting, and his work was fluid even when engraving.

As an engraver, Schiavone produced some masterpieces, for instance the *Circumcision of Jesus*, the *Holy Family* and *Moses and the burning bush*.

The artist thus played a notable part in the Mannerist crisis as it has been called, which assailed Venetian painting about the year 1538, to the extent of involving Titian. Pallucchini remarked "a certain problem activity counter-distinguishing the work of Schiavone and the incipient career of Tintoretto, who had also emerged from the circle of Bonifazio Veronese". These two artists were fundamentally diverse: Schiavone's painting lacks the inner formal structure and sounds an elegaic lyric note absent from the work of Tintoretto.

Schiavone's pet subjects were mythological and historical, often painted on small canvases, with a quality of dream conjured up by means of fluent granular paint material dappled with light. To

sum up, Schiavone may not be one of the greatest figures of Venetian painting in the sixteenth century; his personality stands out, all the same, for a strong and subtle sensitivity, a poetic lyricism undoubtedly the perquisite of a thoroughgoing classical background, looking longingly at the past to instil the present with much poetry of the heart.

PRINCIPAL WORKS

Belluno, S.Maria Assunta, *S.Bernardino of Siena with SS. Jerome and John Baptist;*
S.Pietro, *Organ shutters;*
Dresden, Gemäldegalerie, *Pietà;*
Florence, Pitti palace, *Samson killing a philistine;*
Hampton court, *The judgment of Midas; Meeting of Jacob and Rachel; Landscape with figures;*
London, National gallery, *Apollo and nymph;*
Milan, Ambrosiana, *Adoration of the Magi;*
Venice, Accademia gallery, *Christ before Pilate; The circumcision; Story of Psyche; Deucalion and Pyrrha;*
Querini Stampalia foundation, *Conversion of S.Paul;*
Sansovino library, *Two philosophers* and *3 tondi* in the ceiling of the salon;
S.Maria del Carmelo, *Adoration of the Shepherds;*
Vienna, Kunsthistorisches museum, *Marriage of S.Catherine; Diana and Acteon; Cupid and Psyche; Apollo and Daphne; Adoration of the Shepherds.*

ESSENTIAL BIBLIOGRAPHY

Pino P., *Dialogo di pittura*, Venice, 1548;
Vasari G., *Le vite*, Florence, 1568;
Ridolfi C., *Le meraviglie dell'arte*, Florence, 1648 (ed. Hadeln, Berlin, 1914);
Frochlich-Bum L., *Andrea Meldolla gennant Schiavone*, in "Jahrb. der Kunsth. Samm. der allerh. Kaiser." XXXI, 1913-4;
Pittaluga M., *L'incisione veneziana del cinquecento*, Milan, 1928;
Venturi A., *Storia dell'arte italiana IX*, 4, Milan, 1929;
Moschini V., *Capolavori di Andrea Schiavone*, in "Emporium", 1943;
Pallucchini R., *La pittura veneziana del cinquecento*, Novara, 1944; *La giovinezza del Tintoretto*, Milan, 1950;
Fiocco G., *Nuovi aspetti dell' arte di A. Schiavone*, in "Arte Veneta", 1950;
Berenson B., *Italian pictures of the Renaissance*, I, Venetian School, London, 1957;
Arslan W., *I Bassano*, Milan, 1960.

# SEBASTIANO DEL PIOMBO

Luciani Sebastiano, better known as Sebastiano del Piombo, was born at Venice in about 1485; his activity as a painter started in the school of Giovanni Bellini. Vasari has it that his natural inclination then led him to music, and he became particularly expert as a lutenist. This information makes it more readily appreciable how the young artist soon came to be drawn within the orbit of Giorgione, since the master of Castelfranco was also a devotee of music and the arts. Since works

by Sebastiano associated with the manner of Giovanni Bellini are lacking, the result has been that the first authentic documents of his activity tie in strictly with the Giorgione approach proper.

Indeed, Michiel states (as if attesting the friendship between the two artists) that the *Three philosophers* of Vienna museum — left incomplete on the premature death of Giorgione (1510) — were in fact finished by Sebastiano. Today, it is fairly difficult to be able to support this statement, the work appearing so wholly unified. There is another painting, the so-called *Richiamo* of Detroit museum which seems the fruit of collaboration between Giorgione, Titian and Sebastian in that each of the three figures composing the work reflects the formal manner of one of them. This would certainly prove fraternal feeling joining the artists and the collaboration to which such brotherliness gave rise.

However that may be, clearly an art atmosphere that was alive surrounded the master of Castelfranco and within it, Sebastiano moved and had his being. Several works painted between 1508 and 1509 supply the proof; an example is the altar-piece of S.Grisostomo in Venice, depicting *SS.Chrysostom, John Baptist, Liberale, Mary Magdalen, Agnes and Catherine*. Vasari (1550) assigned the work to Giorgione but later (1568) corrected this and restored it to Sebastiano. As a painting it is very important, in terms of composition also in so far as the artist — discarding the usual concept of front-facing figures — distributes them freely in a spatial perspective of extreme singularity. The figures strike various attitudes, assymmetrically: in short, the altar-piece sheds its traditional guise to become a gathering of personages, enjoying full liberty. The individual figures appear pretty close to Giorgione's manner in the dream-like attitude which distinguishes them, each bound up as it were in some inner delight. The colour is shaded and modified by light, and echoes the tone-painting of the master of Castelfranco.

Sebastiano's allegiance to the manner of Giorgione comes across even more clearly in *SS.Bartholomew, Sebastian, Louis of Toulouse and Sinibald*, four figures comprising the organ shutters in the church of S.Bartolomeo, Venice. The personages are isolated in niches or framed by architectural settings, breathing new vigour into the formal plane while at the same time conveying genuine depth of feeling and tone painting values. They thus reveal Luciani embarking in further directions, perhaps attributable to the presence in the city of Venice about the year 1508 of the Florentine, fra Bartolomeo della Porta.

The *Salome* of the National gallery, London is also of the early period, together with a small number of other pieces in half-figure, of bust length only; in spirit they may be defined as still taking after Giorgione, the colour material is rich and reactive to light, but there is a psychological inquisitiveness revealing the artist's new potential in the field of portraiture.

In 1511 Agostino Chigi, the Roman patrician and celebrated banker, was in Venice and got the artist to follow him back to Rome for the adornment of the famed Villa Farnesina he was having built beside the Tiber and where Baldassare Peruzzi and indeed Raphael were already working. Sebastiano's share in decorating the great house shows how strongly he remained associated with the Veneto manner. The *Death of Adonis* (Uffizi, Florence) is Veneto in addition, with a fine view of the Bacino S.Marco.

In Rome, however, the painter was attracted first by Raphael and then by the personality of Michelangelo, whose admirer he became, striving to imitate this redoubtable master. Among the portraits dating from this early Roman period is the so-called *Fornarina* (Pitti, Florence). Contact with Raphael was fruitful for both men; contrary to an old tradition, it needs saying that the new chromatic response Veneto-style appearing in Raphael's work at this point is due not so much to the influence of Sebastiano as to Lorenzo Lotto. Lotto was in Rome by 1509, thus in time for interchange before Raphael began on the *Miracle of Bolsena* and other frescoes in the "Stanza di Eliodoro".

The influence of Michelangelo on Sebastiano becomes increasingly evident after 1516. The Veneto

116

artist remains autonomous and his approach to composition strikes a personal note too which is refreshing in the complex artistic circle flourishing at the papal court under Julius II and Leo X, that is to say at the flash-point of Renaissance civilisation. Sebastiano's chromatic treatment obviously aiming at Michelangelo's moulded forms grows less mellow and dulcet; instead, the tone work turns austere and brownish, inspired by deep inward meditation.

The artist's transfer from Venice to Rome clearly meant something of a spiritual adventure to one of his acute sensitivity; in the process, he emerged as a prominent figure in the Mannerist crisis which began to get under way once Michelangelo's frescoes — especially those in the Sistine chapel — were known. Now the Renaissance with its emphasis on form and secular elements had almost entirely lost sight of the religious content, particularly in the treatment of sacred subjects and this he recaptured with a contribution both directly concerning the topic represented and distinctly his own.

To this period belong the *Deposition* in Leningrad and the famous *Pietà* of Viterbo (inspired by Michelangelo), and indeed the *Raising of Lazarus* which the artist painted for a commission from Giulio dei Medici, precisely while Raphael was working on the *Transfiguration* (1517). Further portraits date from this time, including the one of pope *Clement VII* (1526) with its profound psychological insight.

From 1527 to 1531 Sebastiano was back in Venice. However, he returned to Rome and was given by pope Clement VII the office (more or less honorary) of Sealer of papal bulls whence his surname of Sebastiano del Piombo (of the seal). The final period in Rome is indicative of renewed and still more severe efforts in regard to composition. The moving work, *Christ carrying the cross* in Budapest museum, comes to mind: the dark ground against which the figure is set making the impact one of great brilliance on the viewer from the plane of the foreground, creating a very telling figure. The final works testify to the crisis under which Roman painting then laboured, Sebastiano being numbered among the leading exponents. Other painters, his contemporaries, favoured a rather fullsome and academic narrative approach; during the Mannerist crisis, Sebastiano afforded some contrast with their work by his simplicity of composition and formal austerity.

PRINCIPAL WORKS

Barcelona, Museum, *Portrait of lady;*
Berlin, Museum, *Portrait of young Roman woman;*
Budapest, Museum, *Christ carrying the cross;*
Cambridge, Museum, *Adoration of the shepherds;*
Dublin, Museum, *Portrait of cardinal Antonio Ciocchi;*
Florence, Uffizi, *Death of Adonis; The Fornarina; Portrait of a young man* (called the Sick man);
London, National gallery, *Raising of Lazarus; Holy family; Salome with the head of John baptist;*
Naples, Capodimonte museum, *Portrait of Clement VII;*
New York, Metropolitan museum, *Portrait of Christopher Colombus;*
Paris, Louvre, *The visitation;*
Rome, Farnesina, Sala della Galatea, *Frescoes:* scenes from Ovid's Metamorphoses;
 S.Pietro in Montorio, *Frescoes:* scenes from the Passion;
Senigallia, Arsilli coll., *Portrait of Francesco Arsilli;*
Venice, S.Bartolomeo, *Organ-shutters* with SS.Bartholomew, Louis, Sinibaldus and Sebastian;
Viterbo, Museum, *Pietà.*

ESSENTIAL BIBLIOGRAPHY

Sanuto, M., *I Diarii* (1496-1533), Venice, 1890;

Michiel, M., *Pittori e pitture in diversi luoghi* ms, della Marciana 1521-43, edito da D. Jacopa Morelli col titolo *Notizia d'opere di disegno nella prima metà del secola XVI . . .* , Bologna, 1884;

Aretino, P., *Lettere*, I e II, (1527-46), Ed. Bari, 1913;

Pino, P., *Dialogo di pittura*, Venice, 1548;

Vasari, G., *Le Vite degli Architetti, Pittori et Scultori*, Firenza, 1550;

Vasari, G., *Le Vite de' più eccellenti pittori, scultori e architetti*, Vol. 1, parte 3, 1568 (ed. Milanesi, Vol. V, 1880, pp 565-86);

Sansovino, F., *Venetia città nobilissima et singolare descritta . . .* , Venice, 1581;

Ridolfi, C., *Le Meraviglie dell'Arte*, Venice 1648 (ed. Von Hadeln, 1914-24);

Boschini, M., *La carta del navegar pitoresco*, Venice, 1664;

Boschini, M., *Le minere della pitture*, Venice, 1664;

Boschini, M., *Le ricche minere della pittura Veneziana*, Venice, 1674;

Zanetti, A. M., *Della pitture veneziana . . .* , Venice, 1771;

Lanzi, L., *Storia pittorica dell'Italia*, Bassano, 1789;

Biagi, P., *Memorie storico-critiche intorno alla vita ed alle opere F. Sebastiano Luciani soprannominato del Piombo*, Venice, 1826;

Ticozzi, S., *Dizionario degli architetti, scultori, pittori ecc.*, Milan, 1830-33;

Crowe-Cavalcaselle, *Geschichte der italienischen Malerei*, Lipsia, 1869-76 ed. London, 1912;

Lermolieff, I., (G. Morelli), *Die Werke italienischer Meister in den von Munchen*, Lipsia, 1880 (Ed. Bologna 1886);

Berenson, B., *The Venetian Painters of the Renaissance*, New York, 1894;

Fischel, O., *Sebastiano del Piombo*, in "Museum", 1900;

D'Achiardi, P., *Sebastiano del Piombo*, Rome, 1908;

Bernardini, G., *Sebastiano del Piombo*, Bergamo, 1908;

Fiocco, G., *Di alcune opere dimenticate di Sebastiano del Piombo*, in "Bolletino d'Arte", 1910;

Gombosi, G., in "Thieme-Becker", voll. XXXVI, Lipsia, 1933;

Pallucchini, R., *L'arte di fra Sebastiano del Piombo*, Bologna, 1940;

Pallucchini, R., *Vicende delle ante d'organo di Sebastiano del Piombo per S.Bartolomeo a Rialto*, in "le Arti", 1941;

Dussler, L., *Sebastiano del Piombo*, Basilea, 1942;

Pallucchini, R., *La pittura veneziana del Cinquecento*, Novara, 1944;

Pallucchini, R., *Sebastian Viniziano . . .* , Milan, 1944;

Berenson, B., *Italian Pictures of the Renaissance*, I, Venetian School, London, 1957.

## SOLARIO ANTONIO da

A painter belonging to the Veneto school though his origins remain obscure. He is also called "Lo Zingaro" (the gipsy), perhaps because he was so much on the move. It is probable that he really came from Lombardy and was related somehow to Andrea Solario, the noted painter and follower of Leonardo. The researches of Modigliani, Rinaldis and Venturi enable some conclusions to be drawn as to this artist's genuine activity, traces being scattered through various regions of Italy: the Veneto, the Marches, Campania and perhaps also in Lombardy.

The artist's training clearly retained Venetian art as its focal point, echoing Giovanni Bellini, Antonello da Messina and again certain artists of the Vicenza area, as Montagna. The altar-piece of the church of S.Maria del Carmine, at Fermo, results as dating from 1502; the Sacra conversazione model after Antonello is clearly repeated, indeed the pattern closely copied is that of the lost S.Cassiano altar-piece with which Antonello revolutionised Venetian painting. The figure of the Madonna remains enthroned in an apse, flanked by SS.Bernard, Catherine, Lucy and Jerome; by this means, a spatial harmony was created, comprising both architectural features and personages. Solario appears to have spent a long while at work in the Marches and about this same time he was commissioned to finish a polyptych which had been left incomplete by Carlo Crivelli and is now lost. Another work of Solario's is extant at Osimo, namely in the Leopardi chapel, church of S.Francesco. The work was left unfinished by Solario himself but was completed in the year 1506 by the painter Giuliano Presutti di Fano. This was the piece taken by Venturi as showing that the training of Solario as an artist must have taken place within the Veneto province.

Again, the fresco in the church of S.Esuperanzio at Cingoli affords further indication of the allegiance of Solario to models after Antonello, though elements are also apparent that derive from Umbrian painting.

Solario's activity in Naples was of some importance for having conveyed to that city the treasures of the Venetian tradition of which local painters were not unappreciative as a result.

PRINCIPAL WORKS

Bristol, City art gallery, *Madonna and child with saints;*
Copenhagen, Royal museum, *Madonna and child with two angels;*
Fermo, S.Maria del Carmine, *Sacra conversazione;*
Macerata, Oratorio della Trinita, *Our lady of mercy;*
Milan, Ambrosiana, *Head of the baptist;*
Naples, Capodimonte museum, *Madonna and donor;*
Osimo, S.Giuseppe, *Sacra conversazione* with donor Boccalino Guzzoni;
Rome, Doria Pamphili gallery, *Salome with viola.*

ESSENTIAL BIBLIOGRAPHY

Modigliani E., *Antonio da Solario veneto*, in "Bollettino d'Arte", 1907; also in "The Burlington Magazine", 1907;
De Rinaldis A., Catalogo del Museo Nazionale di Napoli, Naples, 1911;
Venturi L., *Attraverso le Marche*, in "L'Arte", 1915;
Salmi M., *Le origini di B. Luini*, in "Bollettino d'Arte", 1931-2;
Serra L., *L'Arte nelle Marche*, Rome, 1934;
Galletti-Camesasca, Enciclopedia della Pittura Italiana, Milan, 1950 (with bibliography);
Berenson B., *Italian Pictures of the Renaissance*, I, Venetian School, London, 1957.

## STROZZI BERNARDO

Born at Genoa in 1581, he dedicated himself first to the study of letters. When he was fifteen, he was left an orphan and so followed his natural inclination and began to study painting at the school of Pietro Sorri, a Tuscan mannerist who was nevertheless well versed in the Venetian painting of the time. A restive character, at the age of 17 he became a Capuchin monk and then, not liking the life, turned priest. These are the facts behind his being called, first, "Cappuccino" and then "Prete

genovese". Weary of the religious life, he wanted to quit but was imprisoned. It is not known quite how he did it, but with all these worries on his shoulders he got clean away to Venice, where he remained the rest of his life, namely to 1644 the year in which he died.

A complex and turbulent character, his art likewise reveals a strange and exuberant sensitivity. There has been a lot of discussion among the experts over the problem of his formative period. It is certain that he was among the innovators in Genoa painting of the seventeenth century and in the absolute sense among the most notable Italian painters of that day and age. There is some ground for thinking that Sorri may have influenced the opening stages of his activity; more lasting and profounder effects upon him came from Barocci (a work of whom hung in the church of S.Lorenzo), from Lombard artists like Cerano and Procaccini and last, from Flemish artists quite flourishing in Genoa. For present purposes, it is enough to say that Strozzi painted one work, now in Palazzo Rosso at Genoa, namely *The cook* after a subject by Aerstzen.

That was not all, for Strozzi also knew of Rubens and the unbounding vitality of this Flemish painter was a predominant influence with him. From his first works, the artist broke with the late Mannerist tradition favoured in Genoa, for the sake of a more instinctive and open way of painting direct from everyday life, due in part to Caravaggio's new departures.

A born painter, he found himself using dense paint material with plenty of body. As the years passed, the luminous quality in his work increases. This was well advanced even before he left Genoa, as may be seen from the lovely "bozzetto" for the *Paradiso*, a fresco which he painted c.1625 for the now-demolished church of S.Domenico, to cite a single instance. Another example of the maturity he attained is the altar-piece for the Sordomuti church in Genoa; it dates from 1629, the year before he finally left Genoa.

In Venice he did his greatest work. The environment was just right to enrich still further his already complicated make-up and lead him to a feast of colour quite outside his range had he remained in Genoa, and obviously drawn from the great days of Venetian art in the previous century.

His colour treatment becomes more intense and his brush stroke more fluent. With gifts such as these he brought a breath of fresh air to Lagoon art circles, which had become enclosed in the late luminist tradition after Tintoretto and grown flaccid under the burden of the academic respect for that tradition. With his inventive freedom, his lack of prejudice when it came to pictorial inspiration, the phenomenon was one to which the artists of Venice had grown unaccustomed. In this way, he was able to get the Venetians to take up the true values of their own tradition. The lead he gave was like vigorous new blood to the body of seventeenth century art in Venice and in his turn he influenced Maffei, Forabosco and in particular Sebastiano Mazzoni.

Some of his works, like the *S.Sebastian* of the church of S.Benedetto in Venice and the *Carità di S.Lorenzo*, also in Venice at the church of S.Nicolò dei Tolentini, rank with the masterpieces of Venetian painting in the seventeenth century; similarly, some of his portraits are to be considered — despite the clear derivation from Rubens — among the most significant of the century.

PRINCIPAL WORKS

Budapest, Fine arts museum, *Annunciation; Christ and the piece of silver;*
Dresden, Art gallery, *Lady playing cello; David and Bathsheba;*
Genoa, Sordomuti church, *Madonna in glory and S.Lawrence* (1629);
    Palazzo Rozzo, *S.Cecilia; The cook; Charity; Doubting Thomas;*
    Accademia Ligustica, *Bozzetto* for the fresco in the church of S.Domenico now destroyed;
    Sampierdarena, Palazzo Centuriore, *Frescoes* with scenes of Roman legends;
    Palazzo Durazzo-Giustiniani, *Portrait of a bishop;*

Milan, Brera, *Portrait of a knight of Malta;*
Poznan, Museum, *Rape of Europa;*
Venice, S.Bendetto, *S.Sebastian;*
 Accademia gallery, *Portrait of the doge Francesco Erizzo;*
 Querini Stampalia gallery, *Madonna and child;*
 Palazzo Barbaro Curtis, *Portrait of the procurator Grimani;*
 Brass coll., *Portrait of a chevalier; Madonna della pappa;*
 Donà della Rose coll., *The furies; The theological virtues;*
Vienna, Kunsthistorisches museum, *The lute-player; Portrait of the doge Erizzo.*

ESSENTIAL BIBLIOGRAPHY

Baschini M., *La carta del navegar pitoresco;*
Soprani R., *Vite dei pittori . . . genovesi*, Genoa, 1674;
Ratti G., *Descrizione delle pitture . . .*, Genoa, 1780;
Lanzi L., *Storia pittorica dell'Italia*, Bassano, 1789;
Alizeri F., *Notizie dei professori dei disegno* etc., Genoa, 1864;
Voss H., *Die Malerei des Barock in Rom*, Berlin, 1924;
Fiocco G., *La pittura veneziana del seicento e settecento*, Verona, 1929;
Zampetti P., *Inediti di Bernardo Strozzi*, in "Emporium", 1949; Catalogo della Mostra del Seicento veneziano, 1959;
Mortari L., *Bernardo Strozzi*, Rome, 1966 (with list of works and good bibliography);
Donzelli-Pilo, *I pittori del seicento veneto*, Florence, 1967.

## SUSTRIS LAMBERT

Born at Amsterdam about 1515 A.D., he moved away to Italy fairly soon and resided in Venice. Later he went to Rome but in the year 1545 he was in Venice again and became the collaborator of Titian. He accompanied Titian to the court of the emperor Maximilian at Augsburg in the period 1548-50. He was very active while there and painted many portraits. On returning once more to Italy he became the collaborator of Lo Schiavone (Andrea Meldolle) and together with him, painted in the Villa Pellegrini at Monselice on the outskirts of Padua. In 1560 he settled in Padua and died there in 1568.

His painting stands out as the product of converging manners: the Flemish one he had inherited as his birthright and the Venetian he had acquired during long years spent in Italy. With the passage of time, the influence of Titian on him became more compelling though his colour treatment never lost its cold tones, in complete contrast with the utter warmth of the master.

Besides, the contacts with Lo Schiavone and some favouring of Mannerist features helped his composition in the direction of a more fluent mobile line, linking objects and background in order to impart some unity to the representation overall.

In the past, many of his works were given to Lo Schiavone. This is what happened to the *Rest on the flight into Egypt* of Vicenza museum; the dominant note stems from the northern manner, characteristic of Sustris. Berenson observed that he was also influenced by Bonifacio Veronese and Tintoretto.

PRINCIPAL WORKS

 Amsterdam, Rijksmuseum, *Rape of Europa;*
 Augsburg, Art gallery, *Wilhelm IV of Waldburg-Trauchburg* (1548);

Brussels, Museum, *Portrait of a gentleman;*
Caen, Museum, *Baptism of Christ;*
Chicago US, Museum of fine arts, *Flight into Egypt;*
Cologne, Wallraf-Richartz museum, *Portrait of Erhard Vöhlin von Fricken-hausen* (1552);
Florence, Longhi coll., *Triumph of love;*
Lille, Museum, *Noli me tangere;*
London, National galley, *Solomon and the queen of Sheba;*
Milan, Brera, *Christ on the road to Calvary;*
Munich, Art gallery, *Portrait of Hans Christoph Vöhlin von Frickenhausen* (1552);
Padua, S.Maria in Vanzo, *Altar-piece;*
Paris, Louvre, *Venus and cupid;*
Venice, Accademia, *Bound Christ being led to Jerusalem;*
Vicenza, Museum, *Rest on the flight into Egypt.*

ESSENTIAL BIBLIOGRAPHY

Vasari, *La vite* etc., Florence, 1568;
Ridolfi C., *Le meraviglie dell'arte*, Venice, 1648;
Peltzer A. A., *Lambert Sustris*, in "Jahrb. d. Kunsthist. Samm. d. Allerh. Kaiserb.", 1913-4;
Pallucchini R., *Cinque secoli di pittura veneziana*, Venice, 1945;
Berenson B., *Italian pictures of the Renaissance*, I, Venetian School, London, 1957;
Barbieri F., *Il museo civico di Vicenza*, Venice, 1962.
Ballarin A., *Profilo di Lamberto d'Amsterdam*, in "Arte Veneta", 1962;
Ballarin A., *Una Villa interamente affrescata da Lamberto Sustris*, in "Arte Veneta", 1966.

## TINELLI TIBERIO

Born at Venice in 1586, he was a pupil first of Giovanni Contarini and then of Leandro Bassano. His reputation rested in particular on his gift for portrait painting; it was for services in this direction that king Louis XIII of France made him a knight. This gift is referred to by both Ridolfi (1648) and Moschini (1660).

Ridolfi re-affirmed that he "painted many portraits which gave the greatest pleasure, for besides the likeness he endowed them with more than ordinary grace and nobility, and a pure inventive touch now and again".

Tinelli painted sacred works but his name is associated in the main with portraiture. It is evident that there is influence of Van Dyck. Fiocco (1929) stated that his painting seemed to herald that of Forabosco and Bombelli, two of the most noted portrait painters in Venice during the second half of the seventeenth century.

PRINCIPAL WORKS

Florence, Uffizi gallery, *Portrait of the poet Giulio Strozzi;*
Lovere, Galleria Tadini, *Portrait of a magistrate;*
Milan, Brera gallery, *Portrait of a gentleman;*

Padua, Civic museum, *Portrait of Emilia Pappafava Borromeo;*
Venice, Palazzo ducale, Sala dell'Avogaria, *Madonna in glory* with three
  advocates.

ESSENTIAL BIBLIOGRAPHY

Ridolfi C., *Le meraviglie dell'arte*, Venice, 1648;

Boschini M., *La carta del navegar pitoresco*, Venice, 1660;

Lanzi L., *Storia pittorica della Italia*, Bassano, 1789;

Pallucchini R., *Contributi alla pittura veneziana del Seicento* . . . Nuovi
  ritratti di Tiberio Tinelli, in "Arte Veneta", 1962;

Savini-Branca S., *Il collezionismo veneziano nel Seicento*, Padua, 1964;

Donzelli-Pilo, *I pittori del Seicento veneto*, Florence, 1967.

# TINTORETTO

Jacopo Robusti, later called Tintoretto, was born at Venice in 1518. The date is calculated from an
entry in the "Necrologio di S.Marziale" (listing deaths) which runs as follows: "this day 31 May
1594 the magnifico Jacobo di Robusti called Il Tintoretto aged 75". This means that both Ridolfi
and Borghini are in error over his birth, the former giving it as 1512 while the latter puts it back
to 1524. As Coletti remarked, the credibility of the information from the register of deaths is
borne out by the portrait of the artist, engraved in 1588, when he declared he was 70 years old.
Ridolfi stated that the young artist began his career in the school of Titian but that he was sent
away from the studio, for reasons of jealousy or some other cause. The incident may have been
exaggerated by the seventeenth-century chronicler but the fact remains that the two painters were
poles apart by nature and not likely to get on well. The first works from the young Jacopo's hand
are straightway indicative of a personality pursuing ideals far different from those of the great
man from Cadore.
In 1539, Jacopo was called a "master", a sign of independent status. His life was not eventful and
turned entirely on his work. He left his native city on two occasions only, as far as is known. That
is to say, in 1545-6 when he visited Rome and later, when he went to Mantua having work con-
nections with the Gonzaga. His reputation was won early on and his activity as a painter is widely
documented, partly due to his correspondence with Pietro Aretino the erudite man of letters and
mischief-maker from Tuscany who was on friendly terms with him (and with Titian and Lotto
as well).
In 1545 he painted two mythological pieces for Aretino, one of which, *Apollo and Marsyas* is extant.
In 1548, he painted the *Miracle of the slave* for the Scuola di S.Marco and in 1550 he was at work
on pictures for the Procuratie. That same year probably he married Faustina di Vescovi who bore
him six children, four of whom became painters like himself. Two in particular distinguished
themselves, namely Domenico and Marietta. Marietta was specially good at portraits, Domenico
worked with his father as a collaborator, generally in the later works. (It is a thorny problem to try
and disentangle the true nature of Domenico's personality; it is, however, envisageable that some
falling-off in quality observable in some of Jacopo's late pieces may be attributed to aid from
his son).
Meanwhile in 1555 Tintoretto received commissions from the Republic to paint two vast canvases
in Palazzo ducale: *The crowning of Barbarossa* and *Excommunication of Alexander III against the
Emperor himself*, the said works being lost during the terrible fire that devastated the building in

1577. The artist's fame spread fast and his activity became more intense and frenetic. He painted pictures for the churches of Venice, for the "Scuole", of which those for the Scuola di S.Marco are famous (Re-finding of the body of the saint, its theft and the Miracle of the saracen), all carried out between 1562 and 1566. They bring to a close the cycle begun in 1548 with the Miracle of the slave mentioned earlier.

In 1562, the artist embarked on the greatest undertaking of his life. For the effort required it is comparable with that of Michelangelo in the Sistine chapel. The task was to decorate the Scuola di S.Rocco. In order to win the competition for the job, the artist resorted to the following stratagem. Instead of sending in the drawing for the completed work, he actually painted the *Saint in glory* life-size, being afraid — not without justification — that the competition would do him no good. Then, he contrived to have the painting set up in the Scuola and the brethren being unable to withhold their approbation, he won the commission and this work was only the first in a series that occupied him for over 25 years.

The scheme comprises three groups of paintings, presenting a sequence of diverse episodes, executed in successive stages over a protracted period. First, the artist painted the Sala dell'albergo; here were shown the Saint in glory and scenes from the *Life of Christ*. Two masterpieces dominate the room, *Christ before Pilate* and the *Crucifixion*. This first cycle was finished in 1566.

At a second stage, the artist passed to the Sala grande. In the ceiling, a series of scenes from the bible; on the walls, New Testament paintings afford a parallel in religious terms.

These items date from the period 1576 to 1581 and thus follow an interval from the completion of the first group. The intervening period was occupied by the artist with plenty of other commissions. Finally, from 1583 to 1587, the third series on the ground-floor was carried out, depicting the *Life of the Virgin* and the *Visions* of Mary Magdalen and Mary of Egypt.

Tintoretto's output was nothing short of prodigious. He would engage in other work while on or resting from the S.Rocco series. Thus, works emanated from him for the Scuola della Trinità (1553), for the church of Madonna dell'Orto; there were mythological scenes too. The palm goes to *Susanna bathing*, now in the Kunsthistorisches museum, Vienna.

The closing phase of his working life is once more associated with Palazzo ducale (various works of his over various periods). This time it was for the Sala del collegio. Then, in 1588 he was commissioned to produce the *Paradiso* for the Sala del maggior consiglio, perhaps the biggest canvas painting in the world in terms of sheer size. For this he had assistance from his children Domenico and Marietta. To this closing phase belong the *Manna from heaven* and the *Last Supper* painted for the Palladian church of S.Giorgio maggiore; active and inventive to the last, he died on 31 May 1594. With his death, the glorious flowering of the art of painting in the sixteenth century also came to an end, since Titian, Veronese and Bassano were also lately dead. Tintoretto was well-known from his youth. It was soon clear he was not in line with the tone painting associated with the Giorgione-Titian tradition, and that he conceived of the problem of artistic creation in quite other terms. It was said of him at the outset that he wanted to fuse Venetian painting with Tuscan drawing, meaning create a blend of Titian and Michelangelo in art. There was a grain of truth in the notion. But it needed a closer looking into, and the experts in modern times have spent a good deal of time and trouble seeking the answer to Tintoretto's true formation and how far his painting achievement matches up to his ambitions, the achievement being measured by the means of expression of his personality.

Tintoretto began his activity when Roman mannerism had already exerted a profound influence over Lagoon painting. This came through the presence of a few artists from central Italy, like Salviati; it was also aided by sight of the prints and drawings that went the rounds, and again there was the fact of Venetian painters (and our artist with them) visiting Florence and Rome.

Above all other, Tintoretto is the artist who is aware by some inner process of cogitation of the

consequences of the revolution Michelangelo brought down on art. He thus became a painter altogether new; for him all living was summed up in intensive activity, ever-seeking and never quite satisfied with himself it may be said: what he aimed at was the utmost pictorial impact — in open contrast with the serenity of a Veronese — got through the use of colour made living by light. The luminist quality in his work is often hallucinatory and breathtaking.

It has been remarked and it may be with good reason that Tintoretto's first useful contacts were in the direction of Bonifacio Veronese and Lo Schiavone, and perhaps Paris Bordone as well. The formative period of the artist was no sudden lightning kind of process; it was rather a meditative and slowgoing affair, and this very fact makes it difficult to follow through a maze of incipient leanings due to musing and close study of the works of various painters of that time. It is certain that he was drawn to the Mannerists and drank deep of their cultural concepts. It is only proper to stress the point, since it is fundamental to the artist's future and that of the whole of Venetian painting.

In youthful works, like the *Presentation in the temple* (church of the Carmine, Venice) or others dating from the 1540s or just after, his rendering of figures is inclined to the fragile and elongated on the modules of Parmigianino (indeed, Bassano was also under the spell of this Emilian artist at that very time). Later on, he approached Lo Schiavone as referred to earlier, who was most sensitive and meticulous in his work; Tintoretto collaborated with him on some frescoes for Palazzo Zen, 1542-6, later lost.

To this period belong the *Bible scenes* of Vienna museum (decorative panels from "cassoni"). The brushwork is fast and free-flowing, the effect enhanced by an intensely vibrant quality of light. The manner somewhat reminiscent of the future El Greco in his Venetian period. Later, the art of Tintoretto aimed at power and this was achieved by the counterplay of colour with abrupt alternation of light and shade breaking on the contour lines.

At this stage, the awareness dawned on Tintoretto that light rather than colour was the very pith of his painting. The great works begin from 1545 to 1550, some of the topics treated are on the popular side but nevertheless the magical effect remains. The vision of the artist leaves the common-place far behind; the origins of light are pluriform, which heightens the dramatic impact of the compositions dashed off with a feckless frayed brush stroke which carries the scene forward to the outside world and culminates in creating insight to a magical violent world. The art of Tintoretto is by no means contemplative but combative; it enjoins the onlooker to react in a positive way as if he too were a moving figure within the scene unfolding before his eyes.

The *Miracle of the slave*, which is a youthful work, makes light the main features of the picture: light which is typical of Tintoretto (not intimate nor discrete as in Lotto), and being thus thrusting or phantastical and leaving truth aside, takes over the scene by storm while the elements of composition fulfil the function, by their contrasts, of giving dramatic sense to the whole. In later works, after 1550, the tension lessens as if salient features from earlier works were being singled out and given again. Dramatic light effects remain to the fore, for the sake of subserving dynamic tension of movement where reality becomes transformed on the wings of vision. To this phase, *Susanna and the elders* of Vienna museum already mentioned, belongs with its play of light in an unreal world. The work is as it were symbolic of the vision of Tintoretto; the landscape loses consistency and becomes commentary, the counterpoint to stress the chromatic values of the women's flesh, remaining cold in near-livid light, other than human and abstracted.

Towards 1553 some approach to Veronese has been noticed; according to Coletti, Tintoretto found himself trying a hand at Veronese's game, at the same time assimilating and transforming what were to him extraneous cultural elements into his own language on a higher plane. At this point, his painting becomes clearer, more tender and fresh, as in the *S. Severus crucifixion* (now Accademia gallery, Venice) and the bible scenes of the Prado. By the end of that decade, the treatment of light

becomes paramount with him again, the structures of his compositions more deliberate and deeply violent. The three St. Mark paintings illustrate this, serving to prelude with other important works such as the *Last supper* (S.Trovaso, Venice) the vast cycle for the Scuola di S.Rocco. Here colour is torn to shreds under streams of light and the pendulum of Tintoretto's art reaches the maximum of its range (1565).

However the further phases of the continual development of his art are marked out by works of the highest order. *The crucifixion* (Sala dell'albergo) is one such, with its dark-hued vibrant colours. Seen from below looking upwards, the mood is sombre and the troubled groups move within their roles in the tragedy. The scene of *Christ before Pilate* is another stupendous example, the figure made spectral by the light. In the great upper room, Moses striking water from the rock, the Agony in the garden, the Nativity with its boldness of composition: these are formidable creative acts. There is a progressive narrative rhythm which is discernible as the same technical resources are pared down yet succeed with the deployment of few means in attaining the heights of allusion. Lastly in the ground floor hall of the Scuola Tintoretto's vision turns ghostly. It is as if his long search were forcing him to creative channels with no other alternative; his figurative language becomes visionary in the *Mary Magdalen*, and *Mary of Egypt* is shot with light from a dark nocturnal scene. "The saint is reading and looks up to the horizon, sulphureous splendours illuminating the scene. The branches and the water, the distant mountains and the shadowy houses seem to glow and rise. Tintoretto's luminist chromatic scale has become bare-bone and whittled down to a monochrome husk of burnt-out tonal values" (Pignatti).

The *Fasti dei Gonzaga* formerly in Mantua and now in Dresden art gallery were painted between 1579 and 1580. They show the artist in a somewhat meditative phase. To approximately the same period belong some large decorative paintings and also the canvases for Palazzo ducale though the hand of collaborators is present in these to a greater or lesser extent according to the piece. The *Paradiso* was entrusted in the first instance to Paolo Veronese and to Jacopo Bassano; the former died in 1580 and the work was done by Tintoretto. The complex composition, impressive and austere as it is, seems to rely on out-of-date solutions. It has to be borne in mind that other artists were assisting him at this time, in particular his son Domenico.

The art of Jacopo never stood still, even in old age and despite the odd sign of tiredness. *St. Michael* of Dresden is a work of violent luminosity; the *St. Catherine* scenes painted for the church of that name in Venice and now in the Accademia galleries (except for the obvious passages from assistants) bear the imprint of his inventive genius, ever new and afresh. In fact the two last works, *Manna from heaven* and the Supper finished in 1594, the year he died, comprise as it were his spiritual testament, witnessing the originality and the very precious quality of his vision. The former is full of an almost idyllic atmosphere where humanity is in repose and even the light is serene; the latter, by contrast, sears away true colour by magical reflections and is replete with blinding flashes of light offsetting impenetrable areas of shade, imparting the sense of anguish proper to the tragedy about to fall upon Christ and all mankind.

The art of Tintoretto bursts asunder the equilibrium of the sixteenth century; it cuts clear from all relationship with tone painting, it turns away from attitudes of contemplation. It is an art of action, of movement, of deep commitment. There were those who praised it but many often found fault with it from the artist's own times onwards. Pietro Aretino was one who criticised his painting, so far from the Florentine preference for considered design. Francesco Sansovino and others also repeated the views of Aretino and attacked the haste with which Tintoretto worked. This was an academic charge at root and assumed added weight in the neo-classical era. What was not understood was that such a technique alone served to give unique and inevitable expression to Tintoretto's artistic sensitivity. Experts in modern times have restored the balance though some reservation is still expressed by notable figures, such as Longhi in his Viatico (1946).

Amsterdam, Rijksmuseum, *Christ and the adulteress; The archangel Gabriel and Virgin of the annunciation;*

Boston, Isabella Garden museum, *Portrait of a lady;*

Budapest, Fine arts museum, *Supper at Emmaus;*

Chicago, Museum of fine arts, *Venus and Mars;*

Copenhagen, Royal museum, *Christ and the adulteress;*

Dresden, Art gallery, *Archangel Michael casting out Satan; Rescue of Arsinoë;*

Dublin, Museum, *Portrait of a young man;*

Florence, Uffizi gallery, *Portrait of Jacopo Sansovino; Christ and the Samaritan woman at the well;*

London, National gallery, *St. George and the dragon; Christ washing the feet of the apostles; Origin of the Milky way;*

Madrid, Prado, *Susanna and the elders; Joseph and Potiphar's wife; Christ washing the feet of the apostles;*

Milan, Brera gallery, *Finding the body of St. Mark; Pietà;*
Duomo museum, *Christ among the doctors;*

Paris, Louvre, *Self-portrait;*

Rome, National gallery, *Christ and the adulteress;*

Venice, Accademia gallery, *St. Mark rescuing a slave; Portrait of Jacopo Soranzo; Purification of the virgin; Body of St. Mark coming over from Alexandria; St. Mark rescues a man from shipwreck;*
Palazzo ducale, Sala dell'Anticollegio, *Mercury and the three graces; Vulcan's forge; Bacchus and Ariadne;*
Sala del Gran consiglio, *Paradiso;*
S.Giorgio Maggiore, *Gathering of the manna; The last supper;*
Madonna dell'Orto, *Moses receiving the tables of the law;* and other bible scenes;
S.Marcuola, *The last supper;*
Scuola di S.Rocco, *Decorative scheme* in the Sala dell'Albergo, the Salone centrale and the Salone terreno, with Old and New Testament scenes and other sacred subjects;

Vienna, Kunsthistorisches museum, *Belshazzar's feast; Solomon and the queen of Sheba; David carrying the ark to Jerusalem; Susanna and the elders.*

ESSENTIAL BIBLIOGRAPHY

Vasari G., *Le vite de' più eccellenti pittori*, etc., Florence, 1568;

Sansovino F., *Venetia città noblissima*, Venice, 1581;

Borghini V., *Il riposo*, Florence, 1584;

Aretino P., *Le lettere* ed. 1609, Paris;

Ridolfi C., *La vita di G. Robusti*, Venice, 1642;

Ridolfi C., *Le meraviglia dell'arte*, Venice, 1648 (ed. Halden, Berlin, 1914 etc.);

Boschini M., *Le minere della pittura veneziana*, Venice, 1664; *Le ricche minere della pittura veneziana*, Venice, 1674;

Lanzi L., *Storia pittorica della Italia*, Bossano, 1789;

Berenson B., *The Ventian painters of the Renaissance*, New York-London, 1894;

Thode H., *Tintoretto*, Leipzig, 1901;

Pittaluga M., *Il Tintoretto*, Bologna, 1925;

Venturi A., *Storia dell'arte italiana* IX, 4, Milan, 1929;

Lorenzetti G., *Il Tintoretto e l'Aretino*, in "La mostra del Tintoretto a Venezia", Venice, 1937;

Coletti L., *Tintoretto*, Bergamo, 1940;

Pallucchini R., *La critica d'arte a Venezia nel Cinquecento*, Venice, 1943; *La pittura veneziana del Cinquecento*, Novara, 1944;

Longhi R., *Viatico per cinque secoli di pittura veneta*, Florence, 1946;

Pallucchini R., *La giovinezza del Tintoretto*, Milan, 1950;

Berenson B., *Italian pictures of the Renaissance*, I, Venetian School, London, 1957;

Mazzariol G.-Pignatti T., *Storia dell'arte italiana* III, Milan, 1958.

## TIZIANO VECELIO

Born at Pieve di Cadore in about 1488 (and not in 1477 as an old tradition avers), when still a lad he removed to Venice in the company of his elder brother Francesco who first of all put him to school with Zuccato, a mosaic worker engaged in St. Mark's. The young Titian soon entered the circle of Giovanni Bellini, the leading painter of the time. Some echo of this apprenticeship may be noted to this day in the Antwerp painting and the Casa Balbi *Madonna*.

The young artist approached Giorgione and they quickly became firm friends, sharing ideals and working practice. Titian helped Giorgione with the frescoes for the facade of Fondaco dei Tedeschi, 1508-9. Titian worked on the side of the building while the front was done by Giorgione. Unfortunately the passage of time has almost completely destroyed their work, though admiring comments of their contemporaries remain, likewise the engravings of Zanetti. According to Pino, Titian was so close to the master as almost to be mistaken for him.

It is clear, however, that the young man from Cadore favoured the grand manner of the foreground figures, distinguishable in the closing phases of the meteoric artistic career of Giorgione who died, as is known, in 1510 at the untimely age of 33. Their closeness was such that doubts still revolve round certain works where traces of Giorgione may be observed or the gropings of the artist destined to take his place in output and in reputation.

Titian is known to have completed the *Sleeping Venus* of Dresden which Giorgione left unfinished, working on the landscape to the right-hand side (very like that in the *Noli me tangere* of the National gallery, London). But whose is the *Concert champêtre* of the Louvre? The fact that the question needs asking is significant of itself. With all probability, the idea was Giorgione's and the work Titian's. It is true Giorgione had already moved on, away from contemplative enchantment, focusing on problems of the human figure. The Concert denotes some more active presence, more openness of feeling being discernible than even in Giorgione's latest works.

Besides the paintings discussed, others have now been assigned to the young Titian by common agreement: the *Sacra conversazione* of the Prado; the *Concert* of Palazzo Pitti and the *Knight of Malta* (same location); the *Gipsy Madonna* of the Kunsthistorisches museum, Vienna and finally the *S.Marco altar-piece* in the chiesa della Salute, Venice, dated c.1511.

Titian's personality explodes in fully autonomous stature with the frescoes of three scenes from the *Life of St. Anthony* in the Scuola del santo in Padua, also dated 1511. They mark the arrival of a new "name" standing as much for action as Giorgione stood for the contemplative mood. Titian's approach is not visionary, from some spiritually rarefied home; it treats of living reality, of lasting validity, is generous and impassioned. The result is to make his colours in tonal values and paint material confident, intense and glowing. The figures are full of movement and impressive, also

they are definitely descended from the ones he painted on Fondaco dei Tedeschi alongside Giorgione. On that building, they were no more than figures, each enclosed and conclusive in itself; but now it is all composition and dialogue, the impact of beings on one another. They move in spatial terms, not limitlessly as in nature but man-sized where they take their stance, singly or in groups, in bustling juxtaposition.

This involves matters of sentiment, an acute and penetrating probing below the surface, a play of light and shade, achieved with some violence chromatically which gives strength and life to the human condition in this guise. His figures are no longer detached, envisaged against a lyrical ground but living and breathing, of recognisable moral tenour in terms of their inner life. Even when Titian has echoes of Giorgione (and he goes on having them, it may be said, throughout his life), his characters inhabit no lyrical world; he makes them look true to life with an immediacy that makes the viewer aware of their precise point of reality. The *Salome* of the Doria collection and the *Flora* of the Uffizi illustrate the intensely human presence flourishing in front of the onlooker's eyes and engendering sympathetic human interest.

The *Noli me tangere* is pure Titian: the colouring like glowing coals, the gesture of the Magdalen, lively and near-dramatic, clean contrary to the enchantment characteristic of the work of Giorgione. The *Sacred and profane love* (Borghese gallery, Rome) is an offering of obscure significance, which many writers have tried in vain to fathom and if there is an iconographic reference it is nevertheless utterly surpassed by the substance of the vision. The compositional rhythm centres on the two splendid female figures, one clothed and the other nude. A feeling of serenity and ease flows throughout, the landscape functioning as background while the figures stand out for their human semblance. This means the arrival of a new element, not from Giorgione. The landscape stretches away at the two sides and to the back, little rural scenes adding a note of interest and comprising diverse elements. Nature indeed is seen in many manifestations, complex and multiform, but the living touch comes with man's presence on the scene and his works. The figures occupy the foreground and represent the predominant element, the focal points of the piece; the landscape is only the ground, an element unto itself, without relation to the two figures looking out of the picture into the eyes of the viewer.

The famous altar-piece of *the Assumption* painted by Titian for the Frari church in Venice represents a first real revolution in dramatic terms, seeming to follow through from a stream of thought already identifiable in the Padua frescoes. It was begun in 1515 and finished in 1518 and the city took it for an event of exceptional importance. The composition, conceived with three super-imposed orders — may be reminiscent of Raphael and the "Disputa" of the Stanza vaticane but the rhythm is dramatic and whirling. With the definitive break away from residual enchantment out of Giorgione, it marks the advent of the art of Michelangelo to the Venetian world as well. The whole great altar-piece has pace and a spiral sense of movement, yet shimmers in glowing light and glorious colour which is a commentary, by the broad spectrum of chromatic emphases it embodies, on the exceptional nature of the artist's vision.

The *Assumption* crowns Titian's achievement. The *Madonna in glory* of Ancona gallery is his first signed and dated work, it belongs to 1520. In this work, the chromatic impasto is becoming freer and less trammelled. The basin of St. Mark's, which rounds off the painting below, is all on fire in sunset glow, a little gem of an entirely new kind of landscape and a signpost for the future. The Brescia polyptych was completed in 1522 and again reveals a new aspect of the work of this artist. The figure of St. Sebastian, in particular, tied to the tree but dynamically posed, shows how Michelangelo's lesson was being read with reference to form, even in Venice. Titian, however, interpreted it in a Venetian key, that is to say pictorially, vibrant with a moving inner lyricism far removed from the lofty personality of the great Tuscan.

About 1520, Titian was producing masterpieces, one after the other and another major work of

this time is the *Pesaro Madonna*, begun in 1519 and hung in the Frari church in 1526. Again, the artist affirms his spiritual need to quit tradition and create an altar-piece according to dynamic new basal concepts. Instead of a front-facing Madonna, he places her to one side. The composition is thus no longer based on equilibrium but on dynamics, the rhythm ascending from left to right. Colonnades extend upwards as if to convey the notion of vast space. Light rains down from heaven, founders on cloud and is reflected from the human figures creating an animated interchange in which the pictorial tone values combine and converge in a downward direction where the members of the Pesaro family are kneeling in adoration.

The artist's growing reputation brought him a prodigious burden of work, some of it as a portrait painter. In these items, he succeeds in seeing into the character portrayed, creating a type in whom the elements visual and psychological contrive to triumph in the name of overwhelming truth. The *Male portrait* of his early period is an example (the so-called Ariosto, of the National gallery in London); or again, the *Man with glove* (Louvre, Paris), the so-called *Englishman* (Pitti, Florence) and others, rounding off with leading figures from the court of Urbino, with Charles V (1533) and Francis I (1538). As time went by, his endeavour after truth, more intense and saddened in human terms, becomes as it were the hall-mark of his art. The two portraits of Charles V are indicative: one on horseback at the battle of Mürlberg, severe and tragic at one and the same time (1548); the other, seated, aged, of a melancholy saddening and uncomforted despite the dignity of the royal subject.

From 1516 Titian enjoyed working relationships with the illustrious families of Italy. First, with Alfonso d'Este, the duke of Ferrara; then with Federico Gonzaga, the marquis of Mantua, with Francesco Maria della Rovere, duke of Urbino after that. His meeting with Charles V took place in Bologna, the first time, when the emperor went there for his crowning (1529-30). In 1533, Charles V appointed him count palatine and knight of the golden spur, as a tribute to his artistic prowess. For all these great people Titian painted numberless works, many of mythological character: for Alfonso d'Este, the *Bacchus and Ariadne*, the *Bacchanal* and the *Worship of Venus* (the first in London at the National gallery and the others at the Prado, Madrid). Covering the period 1518 to 1523, they show the full heights of the artist's classical approach, celebrating the beauty of life like some ancient pagan hymn and expressed in warm, indeed glowing colour terms. The *Venus of Urbino* is a later work (1538), with a warm and sensual humanity sounding the main note. It is the custom at this stage to draw comparisons with Giorgione's Venus: in that work the sleeping figure is seen in a landscape, almost as a natural element in itself, without allusive significance; in this work, she knows she is beautiful and is seen within doors. No enchantment but the reality of the human condition with all its implications impresses itself on our consciousness.

Towards 1538 Titian went through a crisis which was common to Venetian painting as a whole and stemmed from the influence of the Mannerists, Roman and Emilian schools. It lasted quite a while and marked a lassitude in creativity, resembling a crisis of conscience. The joyful chromatic intensity which had been Titian's tool in the creation of so many masterpieces went into abeyance; instead he turned to more covert tone values and attempted to define the composition by drawing. This is certainly the result of influence from the Roman school, contact with Aretino and with Sansovino who had become his friends, the three of them forming the dominant group in the Venetian art world for many years.

It is to this period also that his antagonism towards Pordenone may be traced. Pordenone died in 1539 at Ferrara in dubious circumstances. In 1530 Titian had painted St. Peter Martyr for the church of SS.Giovanni & Paolo, a lost work, though copies of it remain. The movement and energetic forms re-echo Michelangelo; but later, besides paintings like the Venus of Urbino which took up themes from Giorgione to new intent, Titian sought a new equilibrium and motivation. The *Presentation of Mary in the temple* illustrates this, the narrative module harking back to an ancient

130

tradition with Venetian painters although he broke new ground as well: the Battle of Cadore is an instance (destroyed in 1577 by fire but known from copies). Such magniloquent and milling compositions were the fruit of his contacts with Giulio Romano's work at Mantua. The Salute ceilings, painted between 1542 and 1544, represent the most obvious and least sincere phase of Titian's interest in Mannerism; at the same time, they signalise the most serious stage in his transitory tiredness.

After his journey to Rome in 1545, Titian seems to have thought back over all his preceding work. A new need shows up in his painting; a more deeply considered and intensely active phase of his career begins. Even the pictorial treatments are endowed with new possibilities, a fluency and a luminosity unknown in the annals of painting before his time. The emphatic violence of the *Crowning with thorns* at the Louvre (1542) gives way to inner re-thinking which finds outward expression in the solemn *Portrait of Paul III and nephews*, a marvel of psychological insight, without bias and outspokenly courageous in conveying the moral attitudes of the subjects however deeply secreted.

The Roman interlude seems not to have spurred the artist in the direction of local taste (namely, in the domain of Michelangelo), but rather to have restored him with renewed certainty to paint without under-drawing, simply to paint. His art comprises chromatic impasto, laying on colour in symphonic harmony and thus rendering each and every element, conveying movement and evoking the response.

In 1548, Titian went to Augsburg to the court of Charles V and continued visiting there until 1551. To this period belong the two famous portraits of the Emperor, referred to above. The art of baring the human soul had perhaps never before reached a level so intense and penetrative as that Titian succeeded in achieving in these two works. A richly famed series of portraits also belongs to the same phase: the Grand elector of Saxony (1550), those of Philip of Spain (Charles V's future successor) and the Self-portrait with collar.

This period of his late prime is characterised by the artist's devotion to works sacred and profane. The latter had been the delight of his youth, though now painted with deepening sensitivity. He became the favourite painter of Philip II of Spain and sent him sacred subjects and new pieces on pagan themes which he set store by in earlier days, calling them "poems" by which he meant pure flights of fancy. Yet at this very stage, the work of Titian is the most deep and dramatic in his experience. The sacred pieces offer profound meditative themes, with a paint material dramatically executed by means of percussive colour impasto, sometimes unmixed and now dulled to brownish tonal values, now shot with sudden light.

As Pallucchini has expressed it, "the final attitude in the language of Titian finds utterance in a chromatic scale fiery and magical, in an environment garbed with light". Titian in fact tends increasingly to fragment form and represent it as segmental; the spatial concept is left aside (on which Tintoretto was then working), for the sake of a concept intensely chromatic.

The *Danae* of the Prado, the *Diana*, *Acteon and Callisto* (London, Bridgewater) are among the greatest achievements in this respect: the reflections of light are conveyed by a technique of quite outstanding competence. *The education of Eros*, Borghese gallery in Rome (close to the early work, Sacred and profane love, showing the long road the artist had travelled) again comprises these elements with a colour treatment that is totally fragmented and shorn of substantial content. The famed and hallucinatory *Tarquin and Lucretia* (Fine arts academy, Vienna) is another illustration, the action is untoward and violent, the figures gesturing ghosts on the reddish-brown hangings of the background.

The sacred paintings also show Titian's renewed awareness in the knowledge of life's meaning and death's import. The *Crucifixion* of the church of S.Domenico in Ancona (1558) demonstrates the point, a deeply committed work in human and religious terms, painted intensely and sombrely;

again, at the other end of the scale, the *Martyrdom of St. Lawrence* from the Jesuit church in Venice (completed in 1559). Further confirmation may be drawn from the most moving *Pietà*, left unfinished on his death, the very theme that was tormenting the aged Michelangelo.

Titian was an artist profoundly aware of the great moral values. Often he left works unfinished, going back to them after an interval of time, considering and trying out new solutions, always on the look-out for a "truth" that would be new because out of his own consciousness.

His importance to Venetian painting of his time was exceptional. No great painter of that day and age remained unaffected by his personality: not Veronese, nor Bassano, nor Tintoretto, and cetainly not El Greco. In the seventeenth century, it was the great painters of Europe — Van Dyck, Rubens, Rembrandt and also Poussin — who turned their attention to the epoch-making art of Titian, not to mention other Italians.

For this reason it remains inconceivable how a philosopher like Sartre could publicly give vent to the view that he was not particularly praiseworthy, charging him with being superficial and not deeply committed in terms of humanity.

PRINCIPAL WORKS

Ajaccio, Civic museum, *Portrait of man holding glove;*

Ancona, Civic museum, *Madonna* appearing to Francis, Aloysius and the donor Alvise Gozio Ragusino (1520);
  S.Domenico, apse, *Christ on the cross* with Mary, John evangelist and Dominic;

Antwerp, Museum, *Pope Alexander VI presenting doge Baffo to Peter;*

Berlin, Gemäldegalerie, *Portrait of Clarissa,* daughter of Roberto Strozzi; *Self-portrait; Portrait of a gentleman;*

Boston (Mass.), Museum of fine arts, *Portrait of a gentleman;*
  Isabella Gardner museum, *Rape of Europa;*

Brescia, SS.Nazzaro and Celso, High altar, *Polyptych:* The resurrection; to the left, Nazarus, Celsus and the Papal legate Altobello Averoldo; to the right, Sebastian; above, the archangel Gabriel and Virgin of the annunciation (1522);

Budapest, Fine arts museum, *Portrait of a lady* (? Vittoria Farnese); *Portrait of the doge Marcantonio Trevisani;*

Dresden, State gallery, *The tribute money; Lavinia with ostrich plume; Gentleman with palm branch; Sleeping Venus* (begun by Giorgione);

Edinburgh, Ellesmere loan (Bridgewater house no. 17), *Diana and Acteon; The three ages of man;*

Escurial, Chapter hall, *Jerome;*

Florence, Pitti, *La bella; Portrait of Pietro Aretino; The Magdalen; Portrait of a young man* (? Ippolito Grimaldi); *The concert; Cardinal Ippolito de' Medici in Hungarian costume; Portrait of a gentleman* (? Don Diego de Mendoza); *Portrait of Tommaso Mosti* at the age of 25;
  Uffizi, *Francesco Maria della Rovere,* duke of Urbino; *Madonna with infant baptist and Anthony abbot; Venus and owl; Venus of Urbino; Flora;*

Hampton court, Royal coll., *Portrait* said to be of Jacopo Sannazzaro;

Harewood house (Yorks.), Earl of Harewood, *Diana and Acteon;*

Kansas city (Miss.), Museum, *Antonio Perrenot of Granvelle;*

Kingston Lacy (Wimborne, Dorset), Bankes coll., *Portrait of the marquis Savignano;*

Kremsier, Archiepiscopal gallery, *Flaying of Marsyas;*

Leningrad, Hermitage, *The Magdalen; Cardinal Antonio Pallavicini; Girl in fur, with plumed hat;*

London, National gallery, *Bacchus and Ariadne; The tribute money; Noli me tangere; Male portrait; Mond Madonna; Caterina Cornaro* or La Schiavona;

London, Wallace coll., *Perseus and Andromeda; Cupid wounded complains to Venus;*

Madrid, Prado museum, *Self-portrait; Federico Gonzaga; Charles V, with dog; Charles V, on horseback; Philip II in armour; Daniele Barbaro; Empress Isabel; Bacchanal; Worship of Venus; Venus and Adonis; Danae and serving-woman; The fall of man; Philip II offering the infant don Fernando to victory; Glory of the Holy Trinity* with portraits of Charles V, Isabel and Philip II; *Madonna with Ulfus and Bridget; Ecce homo; Christ carrying the cross,* with Zuccato as Simon of Cyrene; *Mater dolorosa; Margaret and the dragon;*

Medole (Mantua), Parish church, High altar, *Christ appearing to his mother;*

Milan, Brera, *Portrait of Antonio Porcio; Jerome in the wilderness;*

Munich, Bayerischen Staatsgemäldesammlungen, *Madonna; Vanitas; Portrait of Charles V,* seated; *Crowning with thorns;*

Naples, Capodimonte museum, *Pier Luigi Farnese* and standard bearer; *Pope Paul III* with Alessandro and Ottavio Farnese; *Pope Paul III;* Palazzo reale, *Pier Luigi Farnese* with hand on sword;

New York, Metropolitan museum, *Venus and the lute-player; Portrait of gentleman; Madonna; Venus and Adonis;*

Padua, Palazzo Liviano, Sala dei giganti, *Frescoe:* full-figure portrait of cardinal Zabarella;

Scuola del santo, *frescoes:* Anthony of Padua giving speech to the new-born child; Healing of the youth's leg; The jealous husband (1511);

Paris, Louvre, *La vierge au lapin; Supper at Emmaus; Concert champetre; Crowning with thorns; The entombment; Jerome in the wilderness; Alfonso d'Este and Laura de' Dianti; Portrait of man* with hand on belt; *L'homme au gant;*

Pieve di Cadore (Belluno), Chiesa arcidiaconale, Third chapel left, *Madonna* with bishop Titian, Andrea and Titian himself as donor;

Rome, Borghese gallery, *Sacred and profane love; Education of Cupid;* Doria Pamphili gallery, *Old man at table; Salome;* Vatican galleries, *Virgin appearing to six saints;*

Urbino, Palazzo ducale, Sala V, *Processional banner:* The last supper; *The resurrection;*

Venice, Accademia gallery, *Presentation of the Virgin;* Palazzo ducale, Staircase to doge's private apartments, Fresco: *St. Christopher;* S.Maria dei Frari, Second altar left, *The Pesaro Madonna;* High altar, *Assumption of the Virgin;* Chiesa della Salute, Sacristy, *Mark with Roch, Sebastian, Cosmas and Damian;* Scuola di S.Rocco, *Annunciation;* S.Sebastiano, First altar right, *Nicholas of Bari* (1563);

Vienna, Kunsthistorisches museum, *Fabrizio Salvaresio; The gipsy Madonna; Ecce homo; The entombment; Portrait of Jacopo da Strada; Nymph and shepherd; Portrait of John Frederick of Saxony; Girl in fur;*

Washington (D.C.), National gallery (Mellon coll.), *Venus with the looking-glass; Portrait of Andrea de' Franceschi;* (Kress coll.), *Cupid with wheel of fortune; Portrait of man behind parapet* (ex Goldman); (Widener coll.), *Venus and Adonis;* (Kress coll.), *Cardinal Pietro Bembo; Ranuccio Farnese; Portrait of the admiral Vincenzo Cappello.*

ESSENTIAL BIBLIOGRAPHY

Sanudo M., *I diari* (1496-1533), Venice (ed. 1879-1902);

Michiel M. A., *Notizie d'opere di disegno* (1521-43), ed. Bassano, 1800;

Aretino P., *Lettere* (1537-57), ed. Paris, 1609;

Pino P., *Dialogo della pittura*, Venice, 1548;

Vasari G., *Le vite*, etc., Florence, 1550 and 1568;

Sansovino F., *Venetia citta nobilissima*, Venice, 1581;

Ridolfi C., *Le meraviglie dell'arte*, Venice, 1648 (ed. Hadeln, 1914);

Boschini M., *La carta del navegar pitoresco*, Venice, 1660; *Le ricche minere della pittura veneziana*, Venice, 1674;

Zanetti A. M., *Della pittura veneziana*, Venice, 1771;

Lanzi L., *Storri pittorica della Italia;*

Zandonella G. B., *Elogio di Tiziano Vecellio*, Venice, 1802;

Ticozzi S., *Vite dei pittori Vecelli di Cadore*, Milan, 1817;

Ruskin J., *Modern painters*, London, 1843-60;

Waagen G. F., *Treasures of art in Great Britain*, London, 1854-7;

Cavalcaselle-Crowe, *Tiziano, la sua vita e i suoi tempi*, Florence, 1872-8;

Morelli G., *Die werke italienischer meister in den galerien von München, Dresden und Berlin*, Leipzig, 1880;

Richter J. P., *Italian art in the National gallery*, London, 1883;

Venturi A., *Il museo e la galleria Borghese*, Rome, 1893;

Berenson B., *The Venetian painters of the Renaissance*, New York-London, 1894;

Fischel O., *Tizian*, Stuttgart, 1904;

Miles H., *Tizian*, London, 1906;

Basch V., *Titien*, Paris, 1918;

Jühnig K., *Tizian*, Munich, 1921;

Waldmann E., *Tizian*, Berlin, 1922;

Dulberg F., *Tizian*, Leipzig, 1924;

Longhi R., *Cartella tizianesca*, in "Vita artistica", 1927;

Venturi A., Storia dell'arte italiana, La pittura del Cinquecento IX, 3, Milan, 1928;

Suida W., *Tiziano*, Rome, n.d.;

Pallucchini R., *La pittura veneziana del Cinquecento*, Novara, 1944;

Longhi R., *Viatico per cinque secoli*, Florence, 1946;

Huyghe R., *Le Titien*, Paris, 1949;

De Logu G., *Tiziano*, Bergamo, 1951;

Vertova L., *Tiziano*, Florence, 1951;

Moressi A., *Tiziano*, Milan, 1954;

Venturi L., *Titian*, New York, 1954;

Berenson B., *Italian pictures of the Renaissance*, I, Venetian School, London, 1957;

Dell'Acqua G. A., *Tiziano*, Milan, 1958;

Pallucchini R., *Tiziano*, Milan;

## TORBIDO FRANCESCO

Born at Venice about 1480 (or perhaps a little earlier), he spent his life in Verona where his family came from. It is, however, most probable that his artistic training took place at Venice, close to Giorgione. The problem of his formative period awaits definitive study, though the development of his personality after 1510, once he was back in Verona, follows a pretty clear path.

In Verona he entered the studio of Liberale and became his favourite pupil. In his prime, the artist demonstrated having assimilated Mannerist culture, absorbed from Giulio Romano. In 1526, he decorated the Fontanelli chapel in the church of S.Maria in Organo. In the frescoes for the choir of the cathedral, again in Verona, he made use of designs supplied to him by Giulio Romano.

After completing this work, in 1534, the artist travelled elsewhere, into the Friuli, painting more frescoes for Rosazzo abbey. Returning to Verona, he set off once more, this time in the direction of Venice where he stayed over a long spell, in 1547 work being commissioned from him for the Scuola della Trinità. After 1550 he made his way back to Verona and remained there until he died in the year 1562.

In his early works, like the *Young man with chanter* (Civic museum, Padua), Torbido gave clear indications of his allegiance to Giorgione though his working methods are less refined than the great master's; "the tender image is forsaken and a melancholic lassitude draws the hands with flute down to the balustrade while in the distance evening mists the vague landscape of rocks and trees" (A. Venturi, 1928). Again, the *Young man with rose* carrying an allusive tag in Latin (Art gallery, Munich) is strictly aligned with the manner of Giorgione, the figure breathing an air of melancholy enchantment.

The celebrated *Old woman* of the Accademia gallery in Venice was assigned to Torbido in the past though modern expertise now unanimously agrees it should go to Giorgione (Berenson, Suida, Morassi, Moschini, and so on). Pallucchini assigned *The Concert* at Hampton court to Torbido, though the work represents one of the thorniest questions connected with Venetian painting in the period post-Giorgione.

It can be stated with enough certainty that Torbido's Giorgione period was an early phase only, and that he later adhered to the Roman mannerists. His personality is on a minor plane, occasionally, flashes of the Venetian manner emerge, reminiscent of the work of Titian.

PRINCIPAL WORKS

Amsterdam, Rijksmuseum, *Sacra conversazione;*
Messina, Museum, *The circumcision;*
Munich, Gallery, *Portrait of a young man* (1516); *The Transfiguration* (lunette);
Potsdam, New palace, *Mystic marriage of St. Catherine;*
Rome, Doria gallery, *Bust of a young man;*
Rosazza (Udine), the abbey church, *Frescoes;*
Verona, Museum, *Madonna and child;*
Verona, S.Fermo Maggiore, *Madonna and child with saints* (1523);
    Duomo, *Frescoes* (1534).

ESSENTIAL BIBLIOGRAPHY

Vasari G., *Le vite* etc., Florence, 1568;
Cignaroli G. B., *Serie di pittori veronesi*, Verona, 1718;
Lanzi L., *Storia pittorica della Italia*, Bassano, 1789;
Zannandreis D., *Vite dei pittori . . . veronesi*, Verona, 1891;
Venturi L., *Giorgione e il giorgionismo*, Milan, 1913;
Venturi A., *Storia dell'Arte italiana* IX, 3, Milan, 1928;
Pallucchini R., *Pittura Veneziana del 500*, Novara, 1944;
Avena A., *Capolavori della pittura veronese*, Verona, 1947;
Berenson B., *Italian pictures of the Renaissance*, Venetian School, London,
     1957.

## TURCHI ALESSANDRO called L'ORBETTO

According to local sources, he was born at Verona about 1582. Longhi argues for a later date around 1588-90 on the strength of the biography by Mancini written in 1620 (i.e. in the artist's life-time); what Mancini said was that the artist was then thirty or thirty-two.

By about 1620 he was in Rome, together with Bassetti and Ottino. Mancini cited two works carried out shortly before this: the *Altar-piece* of S.Salvatore in Lauro and the canvas of *Hercules spinning* now in Munich. The artist has been given thorough-going consideration at the hands of Longhi (1928), who traced his relation with the two artists above-mentioned.

Through contact with the Roman school of Caravaggio, these three assumed noteworthy importance in the revival of painting in Verona. Zannandreis (1891) remarked upon this, noting with reference to the artist's manner that "if in the first work he overplays the tonal values of shadow, in the Veneto manner (indicative of influence from Tintoretto), in later works he tempers his earlier dark-tinged accents, departing from them in favour of a colour scale which is fresh and strong, but clear and natural as well".

Of the three pro-Caravaggio painters of Verona, Turchi — as Longhi emphasised — is "un-emphatic and endearing. He tends rather slavishly on the one hand to the decorative canons preached at Bologna, which he transposed to a working method more typically Veneto, and on the other hand over-inclined to express sentimental motifs unwarrantably feminine".

Turchi died in Rome about 1650. A lot of discussion has been concerned with his relationship towards Saraceni; there is no doubt that some inter-connection between the two existed. The up-shot is that Turchi must have been in Rome a good deal earlier than generally given. That is to say, it seems he was already in Rome by 1604. It would then have been simple for him to have known Saraceni from that time, the pair of them working together on the Sala regia of the Quirinal palace.

PRINCIPAL WORKS

Avignon, Calvet museum, *Marriage feast at Cana;*
Camerino, S.Venanzio, *Coronation of the Virgin* with SS.Eubaldus and Carlo
     Borromeo;
Dresden, Gemäldegalerie, *Adoration of the shepherds* (signed); *Presentation in
     the temple;*
Milan, Brera gallery, *Madonna della neve;*
Modena, Galleria Estense, *St. Peter freed from prison;*
Paris, Louvre, *The flood; Death of Anthony and Cleopatra;*
Pommersfelden, Schönborn gallery, *Judgment of Midas;*
Rome, Quirinal palace, *Manna from heaven;*

Borghese gallery, *Raising of Lazarus;*
 Galleria nazionale di arte antica, *St. Peter and St. Agatha;*
Verona, Castelvecchio museum, *Battle of Noventa; St. Bernard and the Redeemer; Madonna with SS.Catherine and Cecilia; Massacre of the innocents; Nativity* (and other works);
Venice, Academia gallery, *Agony in the garden;*
Vienna, Kunsthistorisches museum, *Deposition; Massacre of the innocents.*

ESSENTIAL BIBLIOGRAPHY

Ridolfi C., *Le Meraviglie dell'Arte*, Venice, 1648;
Lanzi L., *Storia pittorica dell'Italia*, Bassano, 1789;
Zannandreis D., *Le vite de' pittori, scultori e architetti veronesi*, Verona, 1891;
Longhi R., *Il trio dei veronesi: Bassetti, Turchi, Ottino* in "Vita artistica", 1926;
Mancini G., *Considerazione sulla pittura*, 1617-21 (ed. Marucchi-Salerno, Rome, 1956-7);
Donzelli-Pilo, *I pittori del seicento veneto*, Florence, 1967 (with good bibliography to date).

## VAROTARI ALESSANDRO called IL PADOVANINO

Son of the painter Dario, a one-time pupil of Paolo Veronese, he was born at Padua in 1588. He followed the examples, academic and eclectic, of his father and uncle Ponchino. His name appeared on the Venetian painters' guild register from 1615 to 1639. He died at Venice in 1648.

Varotari presents a rather complex figure, not to be confused with that of the academic painters much in vogue at Venice over the period — end of the sixteenth century and early seventeenth century. He may be deemed a non-progressive in so far as he took for his model the art of the great days, of the early sixteenth century, rather than fall in with the then-current manner.

Zanetti (1771) in addition remarked that he "was entirely dedicated to the pursuit of Titian's manner and such were the powers with which he was by nature endowed to tread in the steps of so distinguished a master that it was not long before he approached something of his ideal's grand manner".

Critical opinion in later times has found this claim on the artist's behalf unacceptable, and consequently rated him on a lower level, as an imitator with scant personal contribution of his own (Venturi). However Fiocco has pointed out that he had the good sense to remain within a tradition capable of development, while contemporary artists were papering over their lack of originality by the acquisition of elements borrowed out of all kinds of traditions, some from outside Venice. Close scrutiny of his works releases him from any shadow of blame attaching to the charge of having been an obsequious imitator of Titian. Quite the reverse, his work is refreshingly candid, tending to revert to a straightforward approach otherwise lost sight of in his day and age, and which is indicative of an independent outlook. He discarded the grandiloquent language of contemporary painting for quieter and humbler lines of thought. He tried to get back to the old days, also in respect of Titian himself. That is to say, he was no imitator of the late diffuse tongue of Titian, but rather of Titian in his youthful days. The two fine narrative pieces on the topic of *S.Andrea Avellino* (S. Nicolò da Tolentino church, Venice) support this view. Relative to the rigid brand of Mannerist art then popular, he appeared to occupy a position that was reactionary, though in fact trying to put the clock back to the period of true classic art. His position is therefore fairly like that of Peranda, Ponzone and indeed, the solitary figure of Carboncino.

The position of Padovanino is of some importance in connection with future developments in

Venetian painting. For he was the continuator of the classical position, to be taken up again by Carpioni and other artists of the seventeenth century, cutting clean across the academic currents which came down on the side of pronounced chiaroscuro in the manner favoured by Tintoretto in his work.

PRINCIPAL WORKS

Bassano del Grappa, Civic museum, *Allegory of prudence;*
Bergamo, Carrara academy, *Feast of Venus* (after Titian);
Genoa, Palazzo Rozzo, *Portrait of a cardinal;*
Milan, S.Sempliciano, *Vittoria dei Camotesi sui Normanni* (1618);
Padua, S.Benedetto, *Moses striking water from the rock;*
    S.Francesco, *St. Laurence;*
    Civic museum, *Joseph and Potiphar's wife;*
Pordenone, Museum, *Mystic marriage of St. Catherine;*
Pommersfelden, Schönborn coll., *Samson and Delilah;*
Rome, Borghese gallery, *Deposition;*
Treviso, S.Teonisto, *Circumcision; Nativity* (both works on deposit at the Civic museum);
Venice, S.Pantaleone, *Deposition of Christ;*
    S.Nicolò da Tolentino, *S.Andrea Avellino sustained by angels; S.Andrea Avellino fallen from his horse.*

ESSENTIAL BIBLIOGRAPHY

Ridolfi C., *La meraviglie dell'arte*, Venice, 1648;
Boschini M., *La carta del navegar pitoresco*, Venice, 1660; *Le ricche minere della pittura veneziana*, Venice, 1674;
Zanetti A. M., *Della pittura venziana*, Venice, 1771;
Lanzi L., *Storia pittorica della Italia*, Bassano, 1789;
Fiocco G., *La pittura veneziana del seicento e del settecento*, Verona, 1929;
Venturi A., Storia dell'arte italiana IX, VII, Milan, 1934;
Voss H., in Thieme-Becker K.L. XXXIV, 1940, q.v.;
De Logu G., *Pittura veneziana dal XIV al XVIII secolo*, Bergamo, 1958;
Donzelli-Pilo, *I pittori del seicento veneto*, Florence, 1967 (with good bibliography to date).

## VASSILLACCHI ANTONIO called L'ALIENSE

Aliense Antonio (called Vassillacchi) was born on the Greek island of Milo about mid-sixteenth century but soon went with his father to Venice where he was put to study with Paolo Veronese and became his assistant. He spent a while at Padua and then back in Venice worked as collaborator with Tintoretto, who was busy in the Palazzo ducale. He died in 1629. A fairly active artist, he emerges as an eclectic, associated in fact with Veronese. Ridolfi referred to a quarrel between master and pupil but nevertheless documents the strict relationship between the painting of Aliense and that of the master; not long after, preponderant influence from Tintoretto may be detected. Although he worked mainly at Venice, Aliense has also left records of his activity in central Italy, at Perugia in 1594, works by him in the church of S.Pietro, and elsewhere. But Venice was the main scene of his activity. Together with Tintoretto, he worked at Palazzo ducale, designed

cartoons for the basilica of St. Mark, and made the design for the high altar of the church of S.Giorgio Maggiore though the work was done by Gerolamo Campagna 1591-3.

In Palazzo ducale, he painted work for the Sala del senato; and in that of the Consiglio dei Dieci in the same palace, the *Adoration of the Magi* which was completed in 1600 and is considered among his best work. There is plenty by him in the Sala del maggior consiglio also (where he was working alongside Tintoretto) and in that dello Scrutinio, again rich in pieces from his hand.

A Mannerist painter, dazzled by the brilliance of Veronese and Tintoretto, he found himself painting an inordinate number of works on commission. His output marks him as a minor artist. The works over which he took most time and trouble do reveal distinct personality: the inventive touch is quick and easy-flowing, the design free and strong, the chromatic scale of lively quality but throughout the genius of Tintoretto sounds the dominant note.

PRINCIPAL WORKS

> Florence, Uffizi, *Autoritratto;*
> Montecchua (Padova), Villa Emo Capodilista, *Scene mitlogiche* (affrechi);
> Perugia, S.Pietro, *Various pictures;*
> Venice, Zitelle, *The Virgin and child . . . ;*
> > S.Giovanni Evangelista, *Martirio di Sebastiano;*
> > Angelo Raffaele, *Il Castigo dei serpenti;*
> > S.Zaccaria, *Various pictures;*
> > Palazzo Ducale, Sala dello Scrutinio; Sala del Maggior Consiglio; Sala
> > > del Consiglio dei Dieci; Sala del Senato, *Episodi di Storia Veneziana;*
> > Correr Museum, *Sbarco a Venezia della Regina di Cipro . . . ;*
> > Accademia Gallery, *Annunciation.*

ESSENTIAL BIBLIOGRAPHY

> Ridolfi C., *Le Meraviglie dell'arte*, Venice, 1648 (ed. Hadeln, Berlin, 1924,
> > II, pp.207 ss);
> Boschini M., *La carta del navegar pitoresco*, Venice, 1660, p421;
> Sansovino F.-Martinioni G., *Venetia citta nobilissima et singolare . . .*, Venice,
> > 1663;
> Boschini M., *le minere della pittura*, Venice, 1664;
> Zanetti A. M., *Della pittura veneziana*, Venice, 1771;
> Lanzi L., *Storia pittorica dell'Italia*, Bassano, 1789 (Ed. Milan, 1823, III);
> Moschini G. A., *Guida per la città di Venezia all'amico delle Belle Arti*, Venice,
> > 1815;
> Venturi A., *Storia dell'arte italiana*, Milan, 1929, Vol. IX, parte IV;
> "Thieme-Becker A. L.", XXXIV, 1940;
> Pallucchini R., *La pittura veneziana del '500*, Novara, 1944;
> Boccassini G., *Le tele dell'Aliense a Perugia*, in "Arte Veneta", 1957, p.186-190;
> Boccassini G., *Profilo dell'Aliense*, in "Arte Veneta", 1958, pp.111-125;
> De Logu G., *Pittura veneziana del XIV al XVIII secola*, Bergamo, 1958;
> Pallucchini R., *La pittura veneziana del Seicento*, Padova, 1959-60, I.

## VECELLIO FRANCESCO

Born at Pieve di Cadore in about 1475, he was close to Giovanni Bellini, to Giorgione and became in fact the imitator of his brother Titian. Recent work has dealt with him, especially that of Fiocco.

Francesco was a few years senior to Titian and embarked on an artistic career at Venice a year or two prior to Titian himself. He too was associated with Giorgione.

Youthful works, like the *Adoration of the child* in the Kress collection, are strictly aligned with the manner of the Master from Castelfranco. To this phase of his activity Fiocco assigned the *Madonna and child* of Sedico church; Suida preferred an attribution to the young Titian. In effect, if the work is really by Francesco it represents the point at which the two most nearly resembled each other, and in which Francesco was sufficiently stimulated by the environment to produce the most felicitous expression of his creative potential, at least in the early period.

When Giorgione chose Titian as his collaborator on the Fondaco dei Tedeschi project (1508), Francesco felt obliged to down tools and then enrol in the army of the Republic. Fiocco asserted that his motive was to assuage the grief he suffered at Giorgione having thus slighted the elder brother. His military career was long and lasted till about 1521 when it ended with a set-back: he was wounded and walked with a limp for the rest of his life.

The most recent documentation unearthed makes him present at Padua in 1511, a clear sign that warring had its peaceful intervals when he could get back to painting. Fiocco inclined to the view that during this period he worked with his brother on the frescoes for the Scuola del Santo, in particular the episode showing the *Miracle of the miser*.

After his army days were over, Francesco turned again to painting, though world-weary at first. Later he achieved some stature, as may be discerned from works such as the organ shutters for the church of S.Salvador in Venice, depicting *St. Theodore as a chevalier* and *St. Augustine giving his order to the monks*. These are his greatest achievements.

The later activity of Francesco who was often at work alongside his brother is not distinguished by specially important pieces. Fiocco assigned to him the *Deposition* (Monti di Pietà, Treviso) citing his grounds for doing so. It remains, however, a controversial work and has also been assigned to Florigerio and indeed to other artists.

PRINCIPAL WORKS

Berlin, Dahlem, Art gallery, *Madonna enthroned with saints;*
Domegge (Belluno), *Madonna enthroned and saints;*
Houston (USA), Museum, Kress coll., *Adoration of the Shepherds;*
Munich, Art gallery, *Sacra conversazione;*
Oriago sul Brenta, Parish church, *Noli me tangere;*
S.Vito di Cadore (Belluno), *Madonna enthroned and saints;*
Venice, Accademia gallery, *Annunciation;*
    S.Salvatore, *Organ shutters;*
Vienna, Kunsthistorisches museum, *Bust of a young man;*
Zagreb, Art gallery, *S.Nicola da Bari.*

ESSENTIAL BIBLIOGRAPHY

Piloni G., *Historia di Belluno*, Venice, 1607;
Ticozzi S., *Vite dei Pittori Vecellio di Cadore*, Milan, 1817;
Crowe-Cavalcaselle, *Tiziano*, Florence, 1877-8;
Fiocco-Valcanover, *Catalogue* of the "Mostra dei Vecellio", Belluno, 1951;
Suida W., *Miscellanea Tizianesca*, in "Arte veneta", 1952;
Fiocco G., *Profilo di Francesco Vecellio*, in "Arte Veneta", 1953(I); 1955(II);
    1956(III); *Francesco Vecellio e Jacopo Bassano*, in "Arte veneta", 1957;
Berenson B., *Italian pictures of the Renaissance*, I, Venetian School, London,
    1957.

## VERLA FRANCESCO

Born probably at Vicenza, documentation concerning him covers the period 1499 to 1521; he died it may be at Rovereto, a city of Trent province. A follower of Bartolomeo Montagna, he approached the painting of Umbria at quite an early age, perhaps taking after Marcello Fogolino and certainly looking to proto-typical models of Perugino.

The altar-piece for the church of S.Francesco at Schio (Vicenza) illustrates the artist's virtues clearly enough. He attempted to reconcile the strong-bodied treatment of form out of the work of Montagna with the refinement of art from Umbria.

The *Circumcision* of Vicenza museum is a work recently restored to his name, an apocryphal signature reading "Petrus Vannucci" which would mean assigning the work to Perugino direct. In this piece there are marked stylistic affinities with Fogolino's *Nativity*, now in the museum at Castelvecchio, Verona, which serves as confirmation of the links between the two artists.

A further altar-piece is also from the hand of Verla, namely the *Madonna enthroned with saints*. Here the fundamentals attest a composite cultural background on the Umbro-Veneto pattern. In recent times, some frescoes have been assigned to Verla in a little oratory outside Terlago (Trent); the artist in the scene representing the *Babe in the manger* has repeated a work of Perugino's, as it were almost word for word.

#### PRINCIPAL WORKS

Milan, Brera gallery, *Madonna enthroned with saints;*
Mori (Trent), Parish church, *Mystic marriage of St. Catherine;*
Schio (Vicenza), *Mystic marriage of St. Catherine* and *God the father* (lunette);
Terlago (Trent), S.Pantaleone, *Frescoes* with scenes from the Life of Christ;
Vicenza, Civic museum, *Circumcision.*

#### ESSENTIAL BIBLIOGRAPHY

Bonmassari A., *Francesco Verla e alcuni suoi dipinti nel Trentino,* in "Berico", 1882;
Gerola G., *Francesco Verla e gli altri pittori della sua famiglia,* in "L'arte", 1908;
Venturi A., *Storia dell'arte italiana* VII, 4, Milan, 1915;
Berenson B., *Italian pictures of the Renaissance,* I, Venetian School, London, 1957;
Barbieri F., *Il museo civico di Vicenza,* Venice, 1962.
Puppi L., *Francesco Verla,* Trento, 1967.

## ZELOTTI BATTISTA

Born at Verona in 1526, he associated his name with that of Paolo Veronese, whose collaborator he was. He stands out, however, as one of the most gifted of the group of artists who — alongside the master — undertook the fresco decorations of villas and palaces alike built by Sanmicheli and Palladio, the two greatest architects of the Veneto in the sixteenth century.

Zelotti may have been a pupil of Badile. As Ridolfi stated, his artistic career began with the frescoing of two houses at Sarego, now gone. In 1551 Sanmicheli called on him to work at the Villa Soranzo di Treville. Paolo Veronese was there with him and indeed did the main part of the work. Again with Veronese, in 1552 he frescoed the Palazzo Porto, Vicenza, all work now lost. In 1555, once more with Veronese and Fasolo, he executed frescoes for the Villa Da Porto-Colleoni at Thiene (Vicenza). After that, he worked on the Villa Godi at Lonedo — alone; similarly, in 1558,

on the ceiling of Palazzo Chiericati in Vicenza and then passed on to the Villa Emo di Fanzolo which he frescoed, leaving some record of his artistic potential. Zelotti also worked in the Villa Malcontenta of Palladio's, in the Castello degli Obizzi called Il Cataio (1570), and elsewhere.

Of all the fresco-painters of the Veneto, though far short of Veronese in stature he was otherwise the most highly gifted and culturally aware. As observed, he was able to maintain his own manner, stronger and more dramatic than Paolo's art. His work points to influence from the Roman mannerist artists, with features captured out of the great Michelangelo.

Zelotti's activity was long-lived and intensive; in the closing phases, he tempered his strong dramatic flair which was innate. He may have done so through effect of Paolo's work or for Palladio's sake. Indeed, the architect was always keen on creating harmony between his houses and the decorative interiors, on the criterion of serenity and self-containment. This inclination shows to particular advantage in the Fanzolo frescoes and those of the Malcontenta, unfortunately in a poor state of preservation.

### PRINCIPAL WORKS

Battaglia, Castello del Catajo, *Frescoes* with the life of Obizzo degli Obizzi (1571);

Fanzolo (Treviso), Villa Emo, *Frescoes* of scenes classical and allegorical (1567-70);

Leningrad, Hermitage, *Christ with the doctors;*

Malcontenta (Venice), Villa Foscari, *Frescoes* of classical subjects (1561);

Praglia, The abbey, *Frescoes* in church and monastery;

Venice, Palazzo ducale, Sala dei Dieci, *Justice and gods; Venice with Mars and Neptune,* etc.;

Vicenza, Palazzo Chiericati, *Mount Olympus;*

S.Rocco, *Pentecost.*

### ESSENTIAL BIBLIOGRAPHY

Vasari G., *Le vite* etc., Florence, 1568;

Ridolfi C., *Le meraviglie dell'Arte,* Venice, 1648;

Zanetti A. M., *Della pittura veneziana,* Venice, 1771;

Lanzi L., *Storia pittorica della Italia,* Bassano, 1789;

Zannandreis D., *Vite dei pittori . . . veronesi,* Verona, 1891;

Pallucchini R., *La pittura veneziana del '500,* Novara, 1944;

Berenson B., *Italian pictures of the Renaissance,* I, Venetian School, London, 1957;

Crosato L., *Gli affreschi nelle ville venete del Cinquecento,* Treviso, 1962;

Mazzotti G., *Ville venete* (new ed.), Rome, 1963.

## ZUCCATO

Family of Venetian painters active in the fifteenth and sixteenth centuries. Sebastiano, head of the family, lived in the second half of the fifteenth century. Certain works of his are not known though generally remembered as a minor artist. According to the chroniclers he was the first master of Titian who then transferred, it seems at the suggestion of Zuccato himself, to the school of Giovanni Bellini.

He had two sons, Francesco and Valerio, who became famous as master mosaic-workers and were

specially active on work for St. Mark's. Lanzi (1789) stated he had seen paintings by them, including a portrait of cardinal Bembo, the work of Valerio, and a St. Jerome signed by Francesco, respectively in the Uffizi at Florence and with the dukes of Savoy in Turin.

But the reputation of these two brothers rests in the main on their mosaics for St. Mark's, executed after cartoons by the leading Venetian artists of the time: Titian, Lotto, Pordenone and Salviati. In 1563, their success led to a lawsuit begun by other mosaic-workers who envied their good fortune. Titian came to the defence of the two brothers but at the hearing, Sansovino and Tintoretto were also called upon for opinions. It may be noted that at this time Sansovino was the "Proto di S.Marco" meaning responsible for the superintendence of the fabric of the basilica. The suit concerned the practice of many mosaic-workers in re-touching the tesserae with colour to increase the range of tonal values.

Arminio, Valerio's son, was a mosaic-worker too of some note and worked on cartoons supplied to him within the basilica of St. Mark's.

PRINCIPAL WORKS

Venice, St. Mark's atrium, *Crucifixion; Deposition; Raising of Lazarus;*
(mosaics to cartoons attrib. G. Salviati and Pordenone);
*St. Mark in ecstasy* (mosaic to cartoon by Lotto, 1545);
*St Clement* (by Valerio, 1532);
*S.Geminiano* (by Francesco, cartoon of Titian, 1535);
Sacristy, *SS.Theodore and George* (by Francesco).

ESSENTIAL BIBLIOGRAPHY

Vasari G., *Le vite*, etc., Florence, 1568;
Ridolfi C., *Le meraviglie dell'arte*, Venice, 1648;
Zanetti A. M., *Della pittura veneziana*, Venice, 1771;
Lanzi L., *Storia pittorica della Italia*, Bassano. 1789;
Venturi A., *Storia dell'arte italiana* VII, 4, Milan, 1915;
Lorenzetti G., *Venezia e il suo estuario*, Rome, 1927 (2nd. Rome, ed. 1956);
Moschini V., *Zuccato*, in "Enciclopedia italiana", Rome, 1937;

# ILLUSTRATIONS

*(Arranged chronologically – showing the development of style in Venetian painting)*

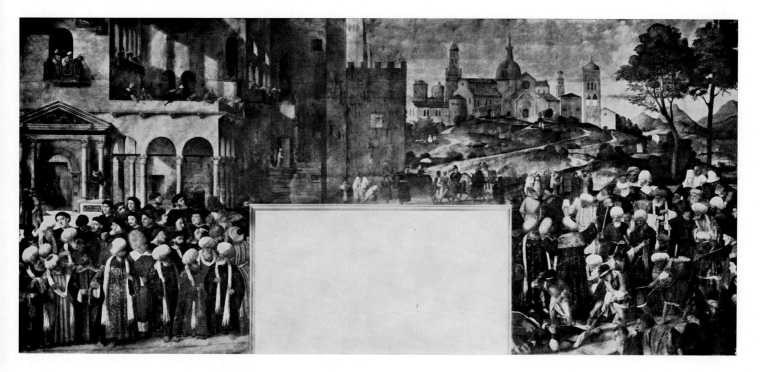

BELLINIANO VITTORE
*Martyrdom of St. Mark*
School of St. Mark, Venice

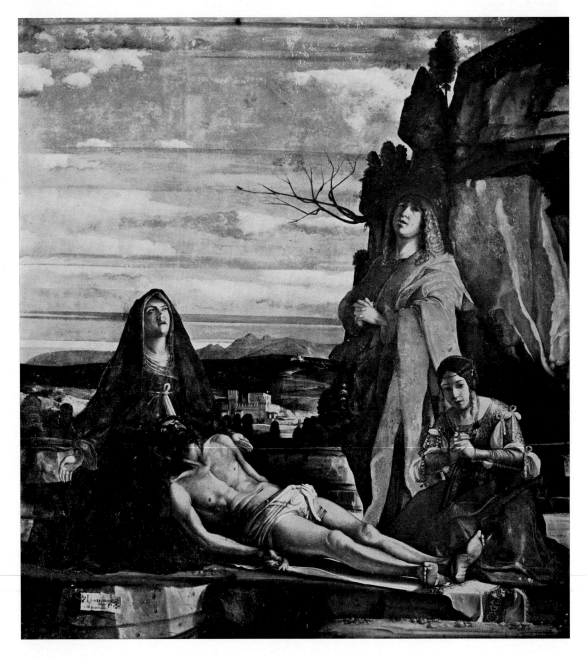

BUONCONSIGLIO GIOVANNI (Il Marescalco, called)
*Pietà*
Civic Museum, Vicenza

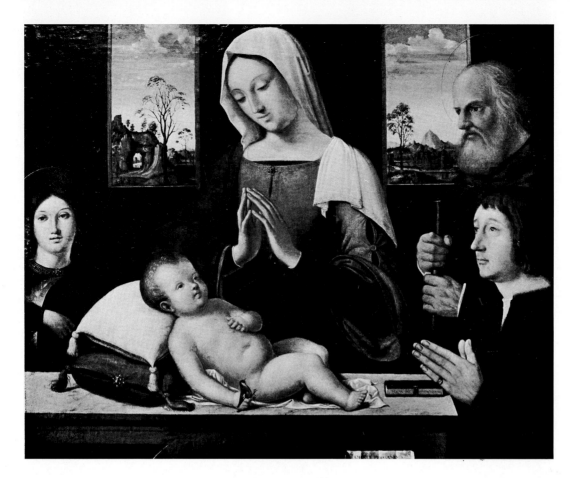

SOLARIO ANTONIO
*Holy Family with Angel Musician*
City Art Gallery, Bristol

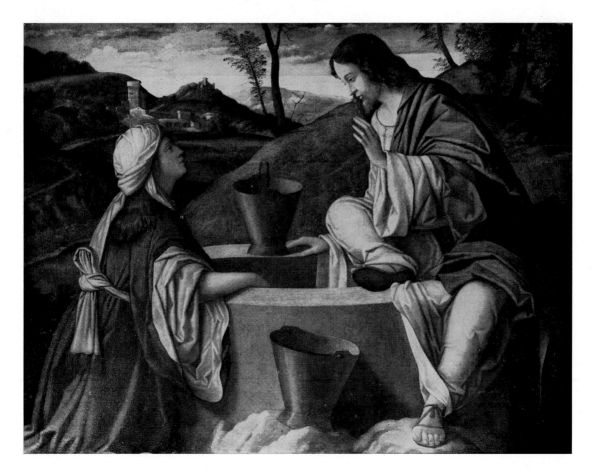

CATENA VICENZO
*Christ and the woman of Samaria at the Well*
S. H. Kress Foundation, New York

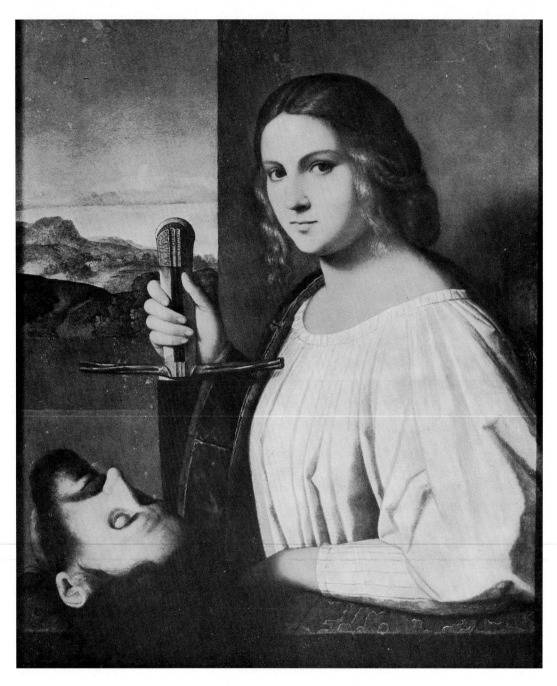

CATENA VICENZO
*Judith*
Querina Stampalia Gallery, Venice

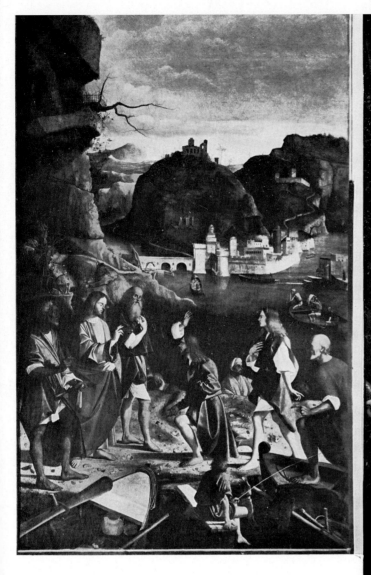

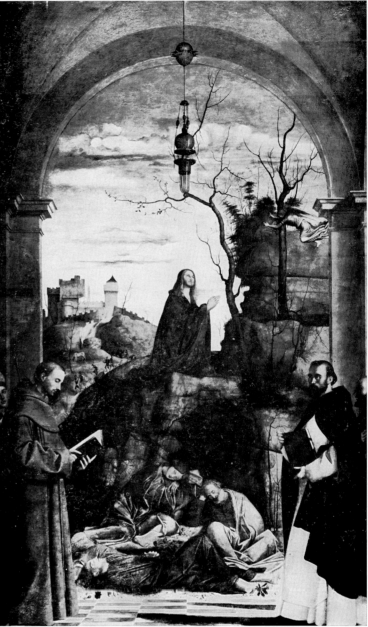

BASAITI MARCO
*Calling of the Sons of Zebedee*
Accademia Gallery, Venice

BASAITI MARCO
*The Agony in the Garden*
Accademia Gallery, Venice

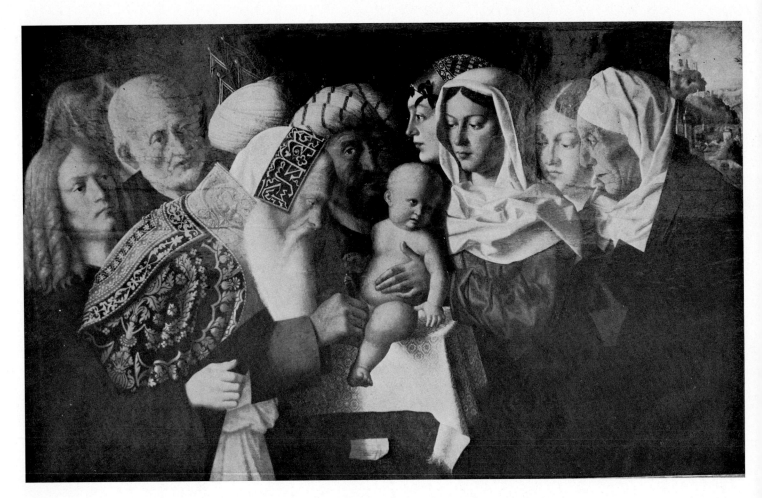

BARTOLOMEO VENETO
*The Circumcision*
Louvre, Paris

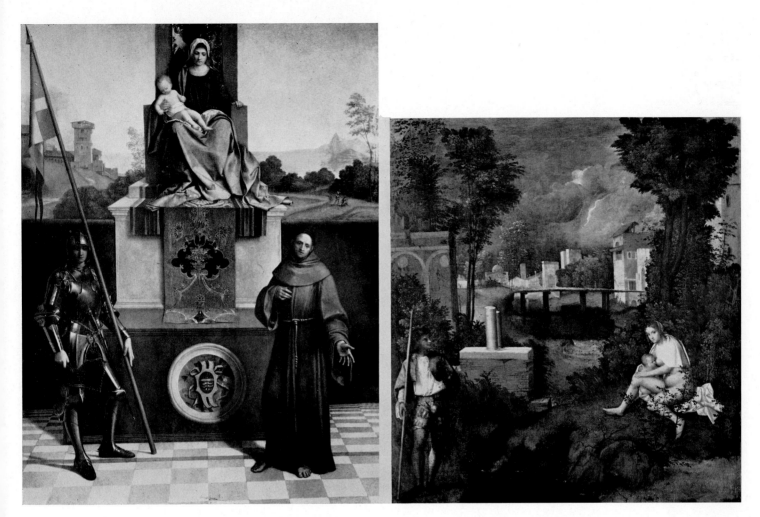

GIORGIONE
*Madonna enthroned with SS. Francis and Liberale*
Duomo, Castelfranco Veneto

GIORGIONE
*The Tempest (The Gipsy and the Soldier)*
Accademia Gallery, Venice

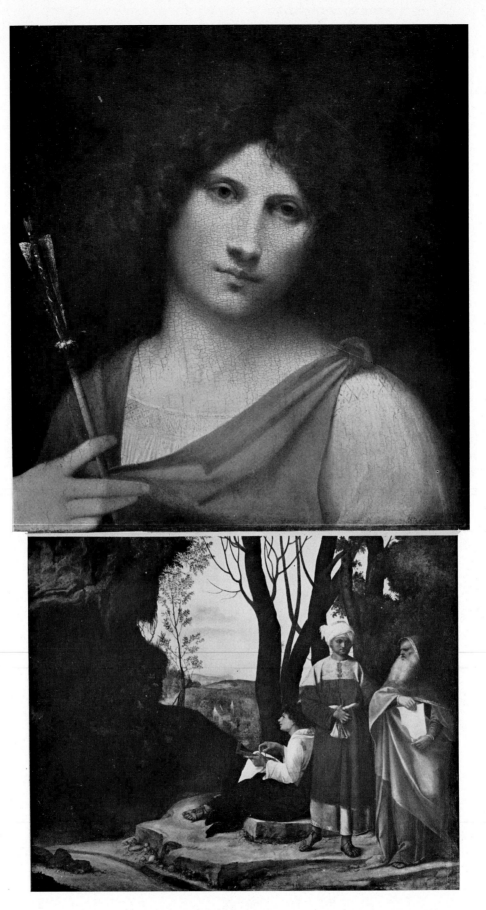

(top) GIORGIONE
*Bust of Youth*
Kunsthistorisches Museum, Vienna

(bottom) GIORGIONE
*The Three Philosophers*
Kunsthistorisches Museum, Vienna

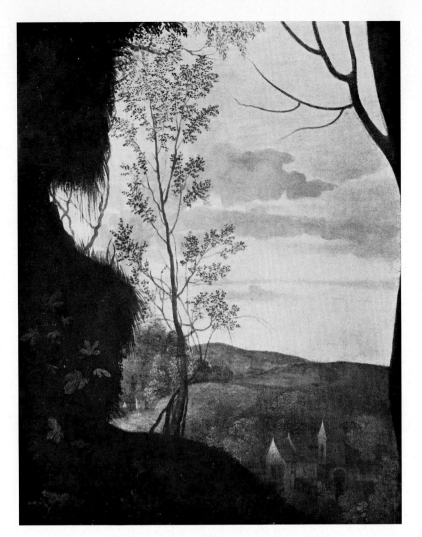

GIORGIONE
*Landscape of the Three Philosophers*
Kunsthistorisches Museum, Vienna

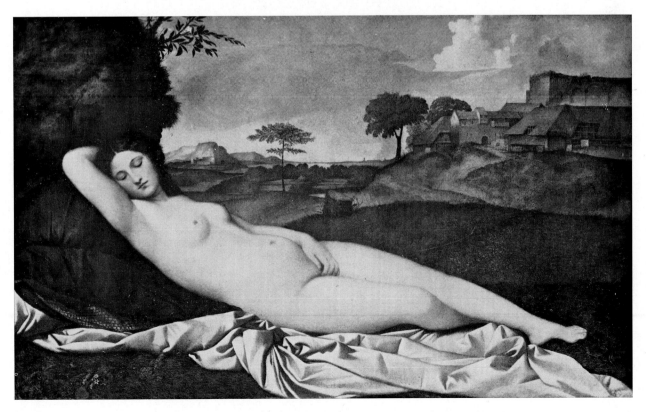

GIORGIONE
*The Venus*
Gemaldegalerie, Dresden

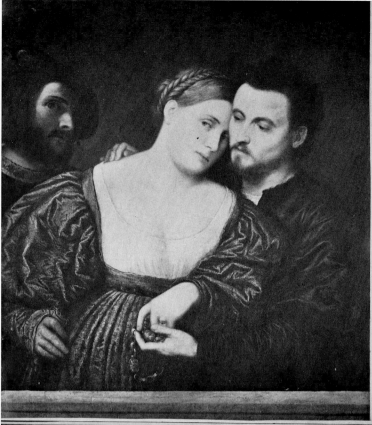

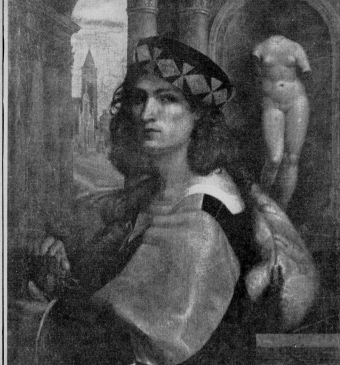

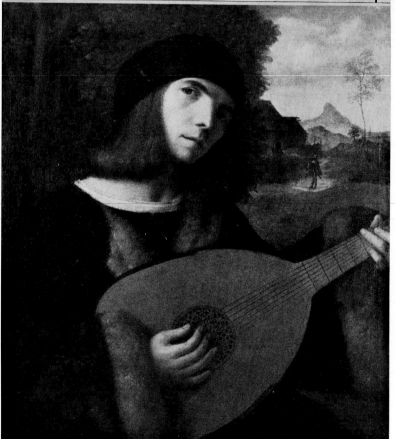

(top left) PARIS BORDONE
*The Seduction*
Brera Gallery, Milan

(top right) DOMENICO CAPRIOLI
*Portrait of a Man*
The Hermitage, Leningrad

(bottom left) CARIANI (called IL GIOVANNI BUSI)
*Man playing the Lute*
Strasbourg Museum

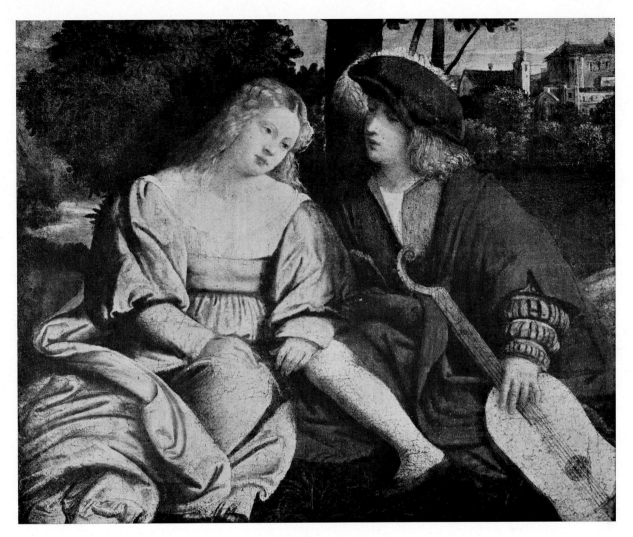

CARIANI (called IL GIOVANNI BUSI)
*Young Lovers*
Palazzo Venezia, Rome

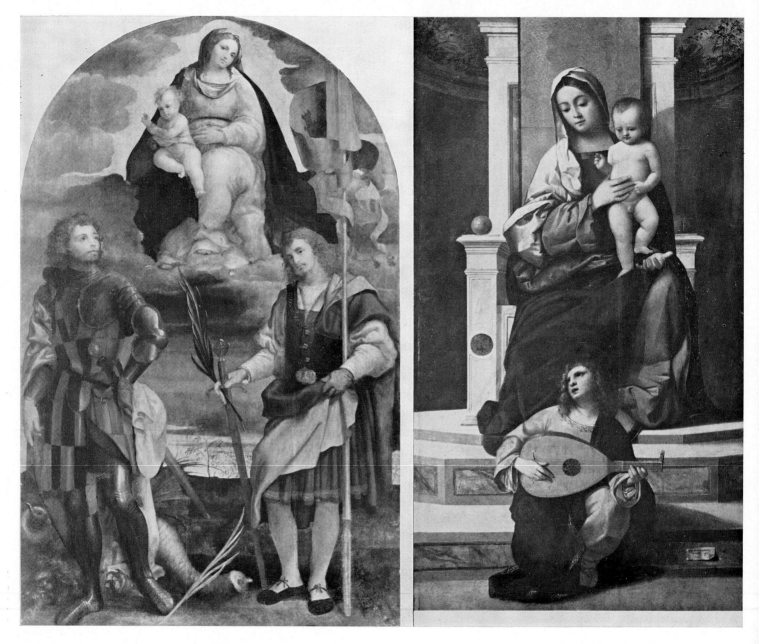

LORENZO LUZZO (called MORTO DE FELTRE)
*Madonna and Saints*
Church of Villabruna, Feltre

DOMENICO MANCINI
*Madonna and child enthroned with angel musician*
The Duomo, Lendinara, Rovigo

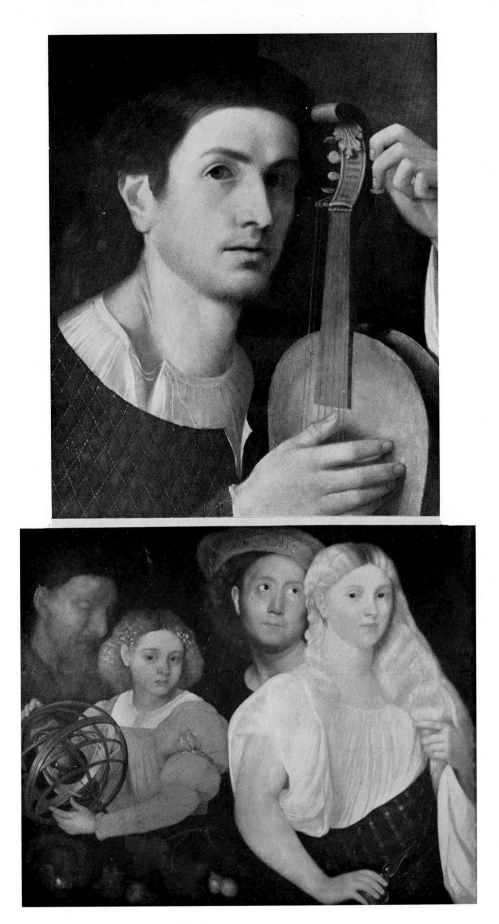

(top) DOMENICO MANCINI
*Viola Player*
Kunsthistorisches Museum, Vienna

(bottom) BERNARDINO LICINIO
*Allegory*
Samuel H. Kress Collection, Columbia Museum of Art, U.S.A.

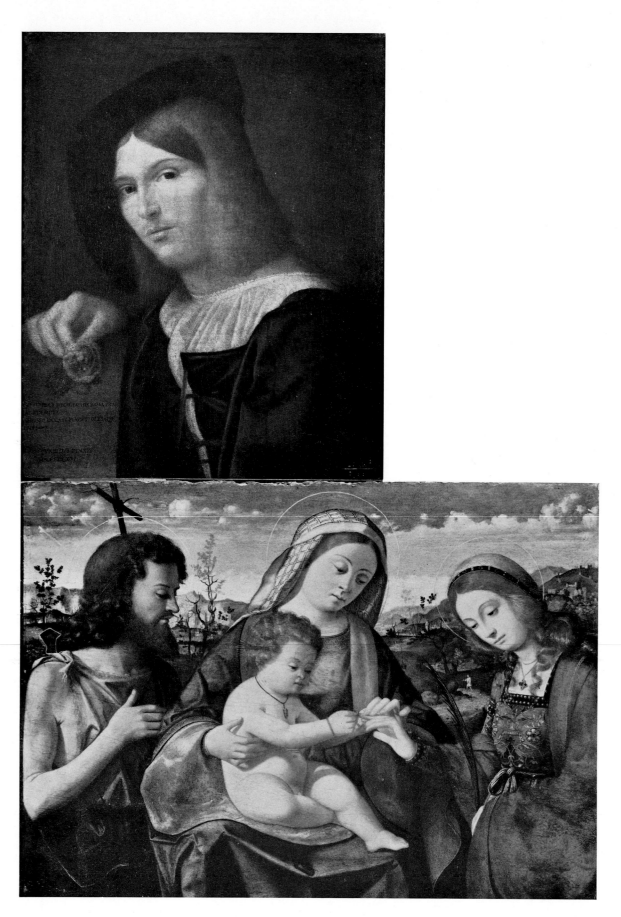

(top) FRANCESCO TORBIDO
*Man with a Rose*
Bavarian State Collection of Paintings, Munich

(bottom) ANDREA PREVITALI
*Madonna and child with SS. John the Baptist and Catherine*
National Gallery, London

(top) PELLEGRINO DA S. DANIELE
*Crucifixion (part)*
Church of S. Antonio, S. Daniele del Friuli

(bottom) F. V. (Anonymous painter)
*Deposition from the Cross*
Parish Church, Riva (Trento)

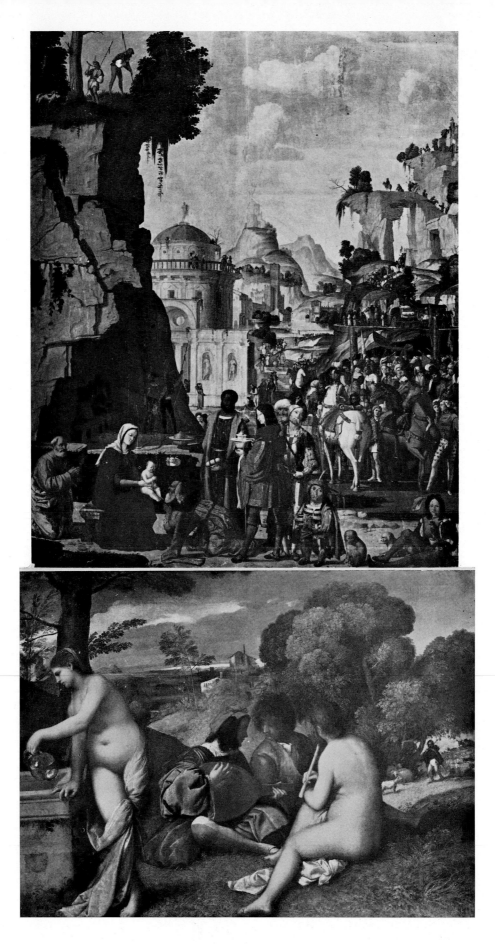

(top) MARCELLO FOGOLINO
*Adoration of the Magi*
Civic Muzeum, Verona

(bottom) VECELIO TIZIANO (TITIAN)
*Concert champetre*
Louvre, Paris

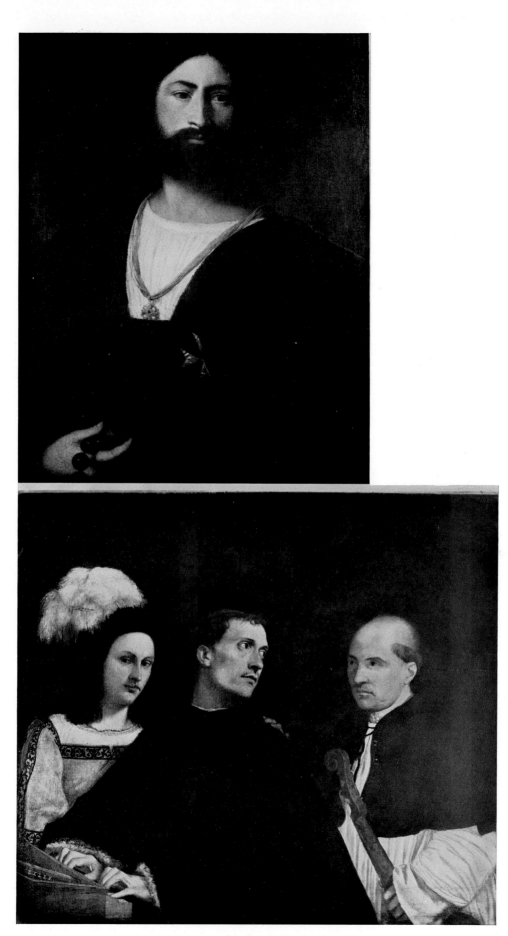

(top) TITIAN
*Portrait of a Knight of Malta*
Uffizi Gallery, Florence

(bottom) TITIAN
*Concert*
Pitti Gallery, Florence

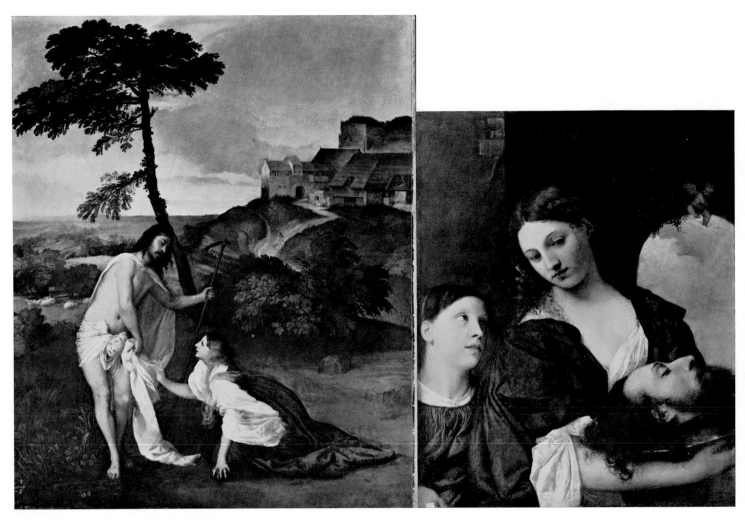

TITIAN
*Christ and the Magdalen: "Noli me tangere"*
National Gallery, London

TITIAN
*Salome*
Doria Pamphili Gallery, Rome

(left) TITIAN
*Madonna appearing to Francis, Aloysius and the donor Alvise Gozio Ragusino*
Civic Museum, Ancona

(right) TITIAN
*The presentation in the Temple (part)*
Accademia Gallery, Venice

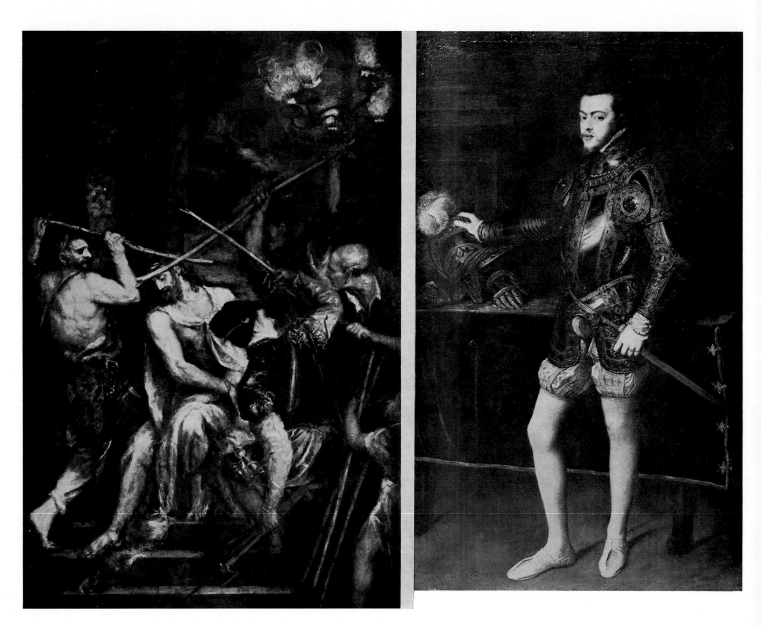

TITIAN
*Crowning with Thorns*
Bavarian State Gallery, Munich

TITIAN
*Philip II in armour*
Prado Museum, Madrid

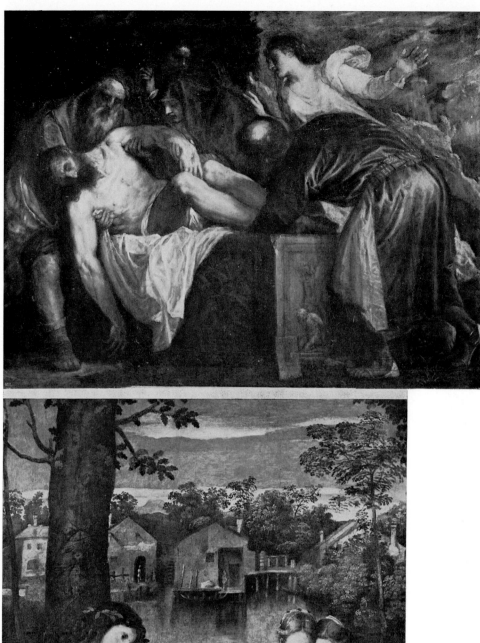

(top) TITIAN
*Entombment of Christ with self-portrait*
Prado Museum, Madrid

(bottom) PALMA IL VECCHIO
*Concert Champetre*
Lady Crichton-Stuart

PALMA IL VECCHIO
*Portrait of a young woman*
Kunsthistorisches Museum, Vienna

PALMA IL VECCHIO
*Portrait of Paola Friuli*
Querina Stampalia Gallery, Venice

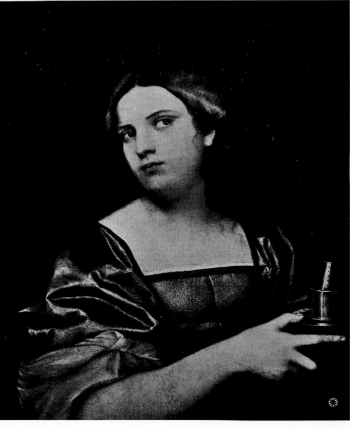

SEBASTIANO DEL PIOMBO
*Sacred conversation*
Church of S. Christopher, Venice

SEBASTIANO DEL PIOMBO
*Portrait of a young woman*
Cook collection, Richmond

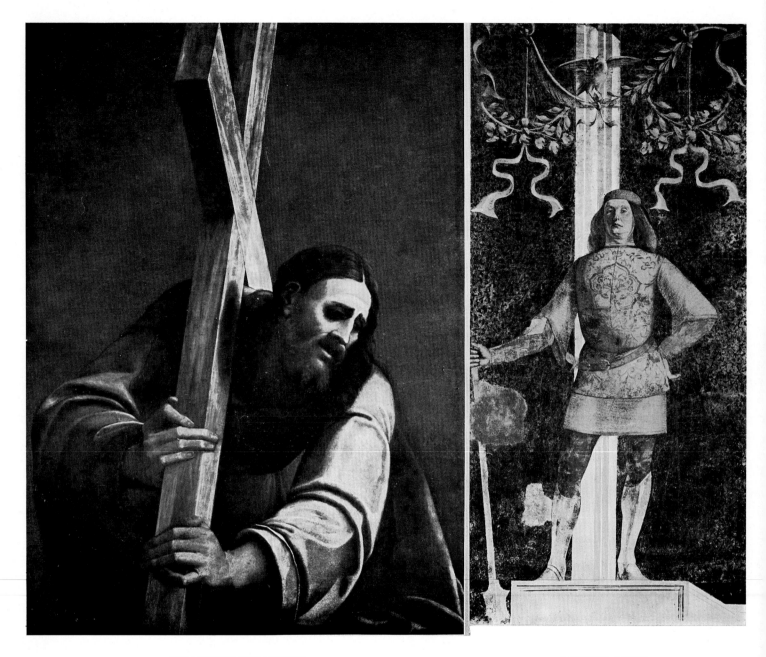

SEBASTIANO DEL PIOMBO
*Christ carrying the cross*
Museum of Fine Arts, Budapest

LORENZO LOTTO
*The Page in armour of the Onigo monument*
Church of S. Nicolo, Treviso

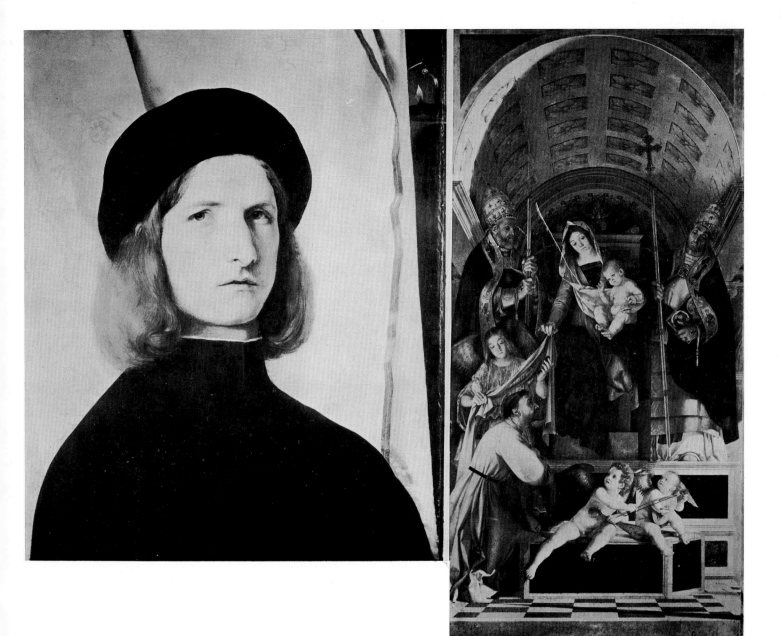

(left) LORENZO LOTTO
*Portrait of young man in a Berretto*
Kunsthistorisches Museum, Vienna

(right) LORENZO LOTTO
*Madonna and child enthroned with S. Domenico and other Saints*
Civic Museum, Recanati

LORENZO LOTTO
*Madonna and child enthroned with Saints and heavenly angels above*
Church of S. Spirito, Bergamo

LORENZO LOTTO
*Annunciation*
Civic Museum, Recanati

LORENZO LOTTO
*St. Lucy before the Judge*
Civic Art Gallery, Jesi

LORENZO LOTTO
*Madonna of the Rosary (part)*
Church of S. Domenico, Cingoli

LORENZO LOTTO
*Presentation in the Temple*
Palazzo Apostolico, Loreto

DE MAGISTRIS SIMONE
*Madonna and Saints*
Baptistery of the Cathedral, Osimo

DOSSO DOSSI (GIOVANNI LUTERI called)
*The Nymph Calipso*
Borghese Gallery, Rome

DOSSO DOSSI (GIOVANNI LUTERI called)
*Warrior with a Maiden*
Cini collection, Venice

GIOVANNI ANTONIO PORDENONE
*Madonna of Mercy*
Duoma of S. Marco, Pordenone

GIOVANNI ANTONIO PORDENONE
*Man with a book*
Samuel H. Kress collection, Columbia Museum of Art, U.S.A

GIOVANNI ANTONIO PORDENONE
*Transfiguration*
Brera Gallery, Milan

GIROLAMO SAVOLDO
*Adoration of the child Jesus*
Civic Museum, Brescia

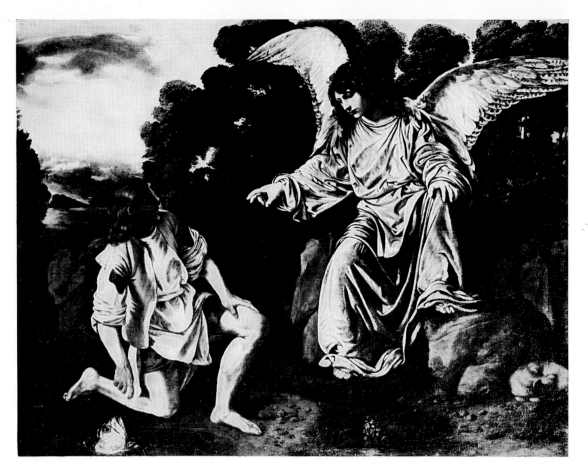

GIROLAMO SAVOLDO
*The Archangel and Tobias*
Borghese Gallery, Rome

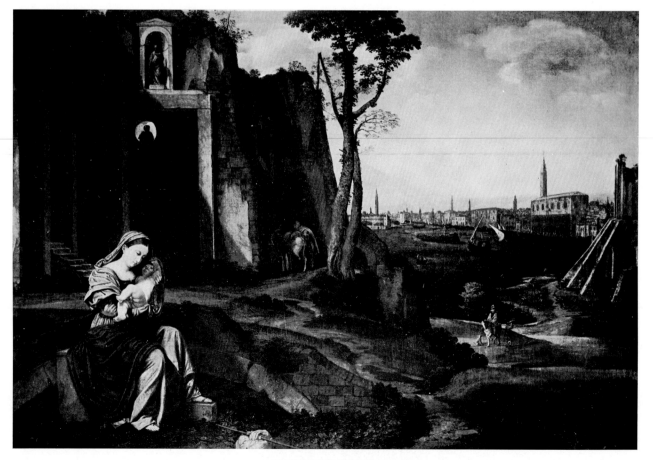

GIROLAMO SAVOLDO
*Rest on the flight into Egypt*
Castelbarco-Albani collection, Milan

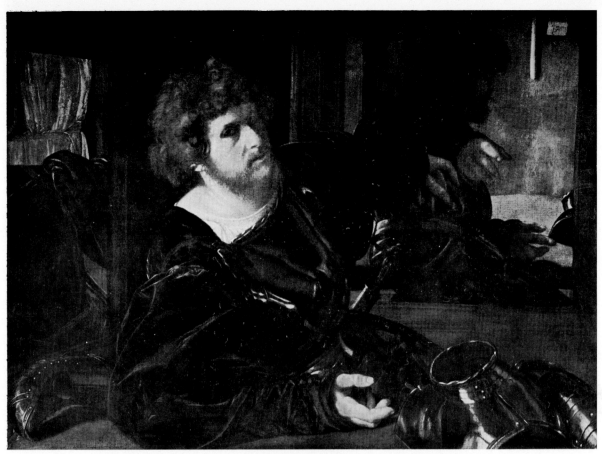

GIROLAMO SAVOLDO
*Portrait of Gaston de Foix*
Louvre Museum, Paris

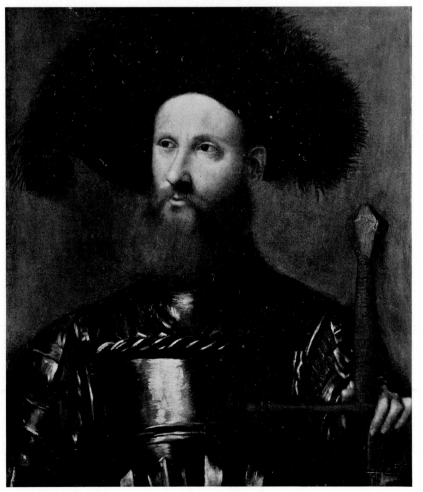

GIROLAMO ROMANINO
*A man in armour*
Samuel H. Kress collection, Columbia Museum of Art, U.S.A.

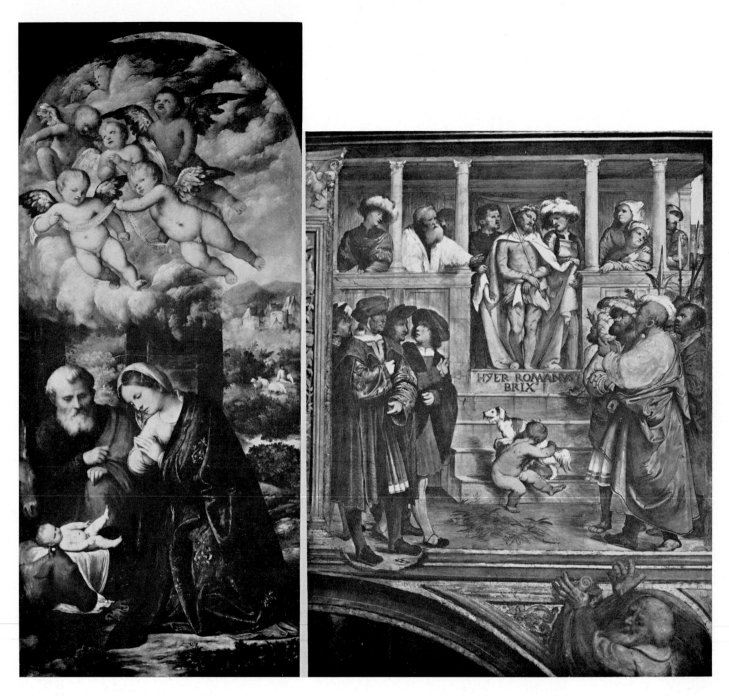

GIROLAMO ROMANINO
*The Nativity. Polyptich. Central compartment*
National Gallery, London

GIROLAMO ROMANINO
*Flagellation of Christ*
Duomo, Cremona

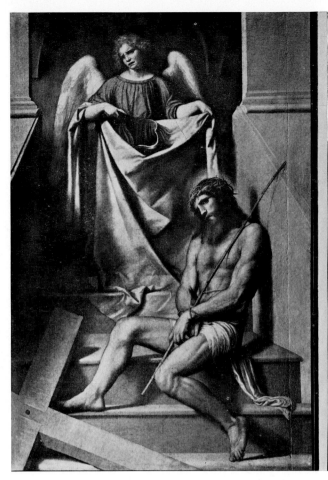

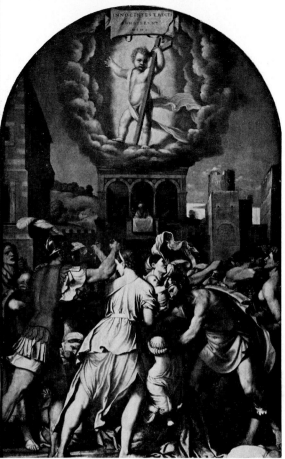

MORETTO DA BRESCIA
*Ecce Homo*
Civic Museum, Brescia

MORETTO DA BRESCIA
*Massacre of the Innocents*
S. Giovanni Evangelista, Brescia

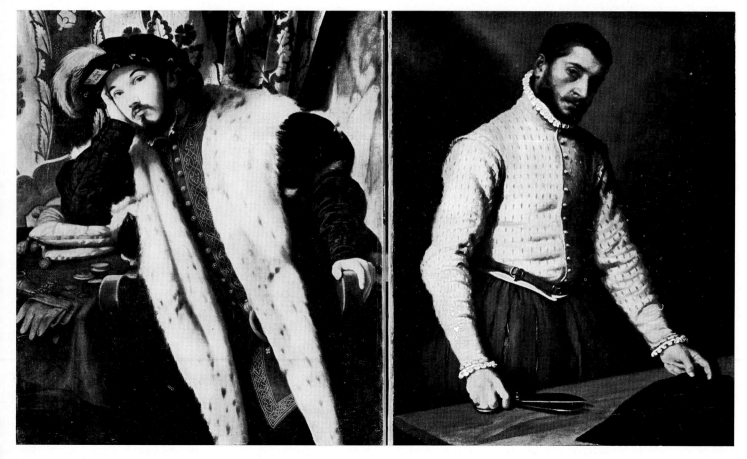

MORETTO DA BRESCIA
*Portrait of Conte Sciarra Martinengo Cesaresco*
National Gallery, London

GIOVANNI BATTISTA MORONI
*"The Tailor"*
National Gallery, London

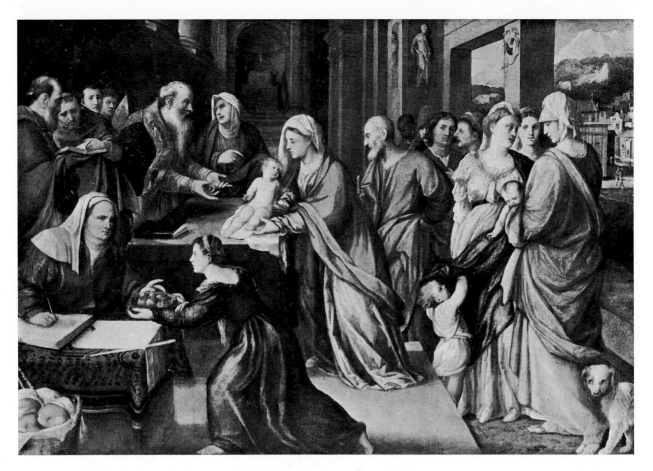

VERONESE BONIFAZIO (DI PITATI)
*The presentation in the Temple*
National Museum, Stockholm

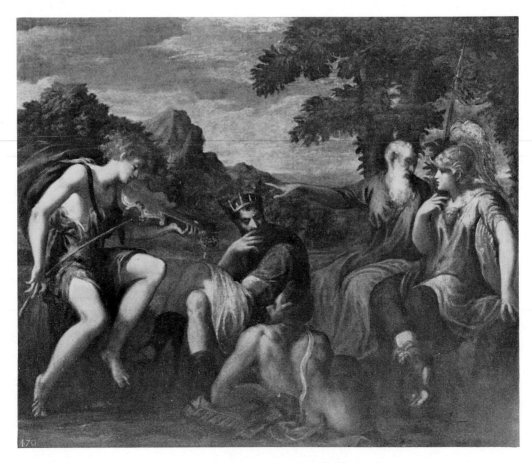

ANDREA MELDOLA SCHIAVONE (called LO)
*The Judgment of Midas*
Hampton Court Palace

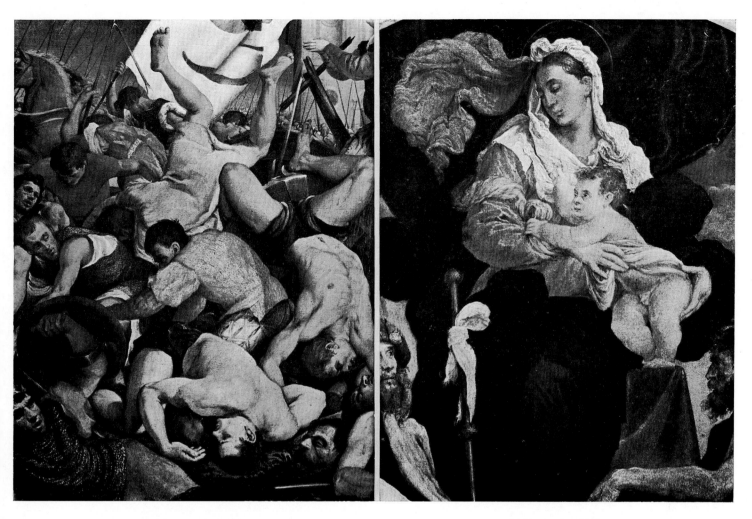

JACOPO BASSANO
*Martyrdom of S. Catherine (part)*
Civic Museum, Bassano

JACOPO BASSANO
*Madonna and child*
Pinocotek, Munich

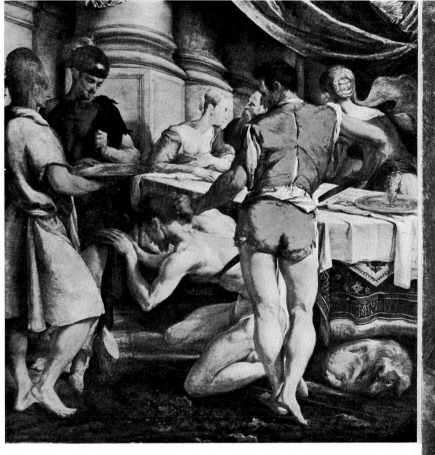

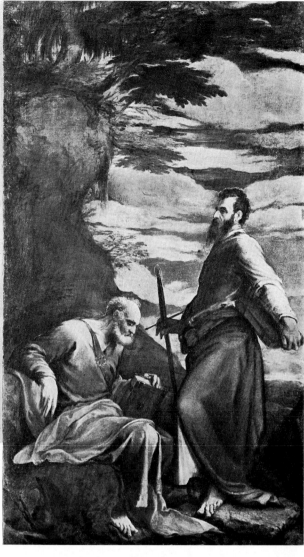

JACOPO BASSANO
*Beheading of S. John the Baptist*
Royal Museum of Fine Arts, Copenhagen

JACOPO BASSANO
*S. Peter and Paul*
Estense Gallery, Modena

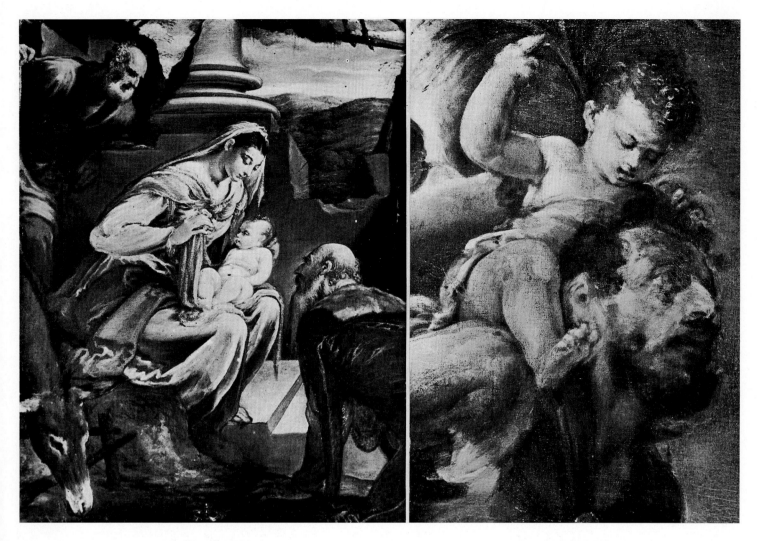

JACOPO BASSANO
*The Adoration*
Kunsthistorisches Museum, Vienna

JACOPA BASSANO
*S. Christopher*
L'Avana Museum

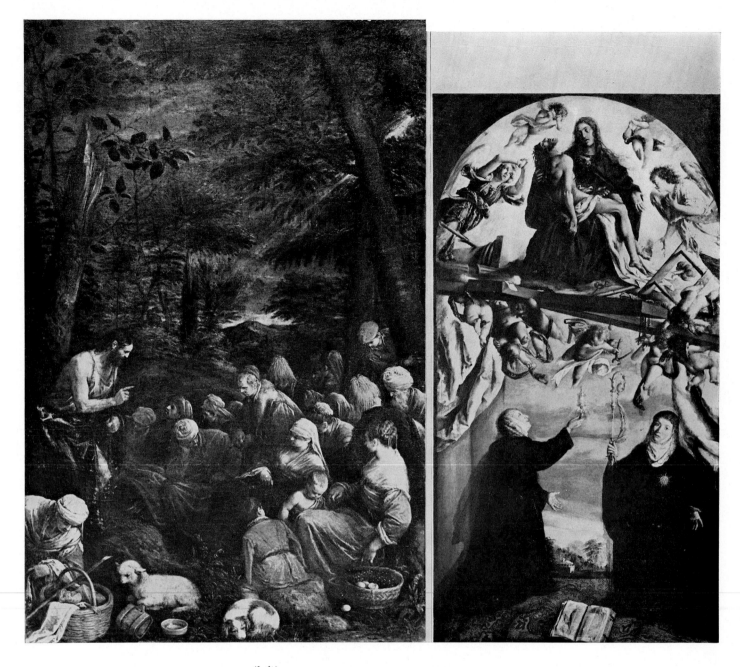

(left) FRANCESCO BASSANO THE YOUNGER
*Jesus' Sermon on the Mount (in collaboration with Jacopa)*
Parish Church of Civezzano

(right) PIETRO MARESCALCHI (called LO SPADA)
*Pieta and symbols of the Passion worshipped by SS. Clare and Scholastica*
Church of S. Maria Assunta, Bassanello (Padua)

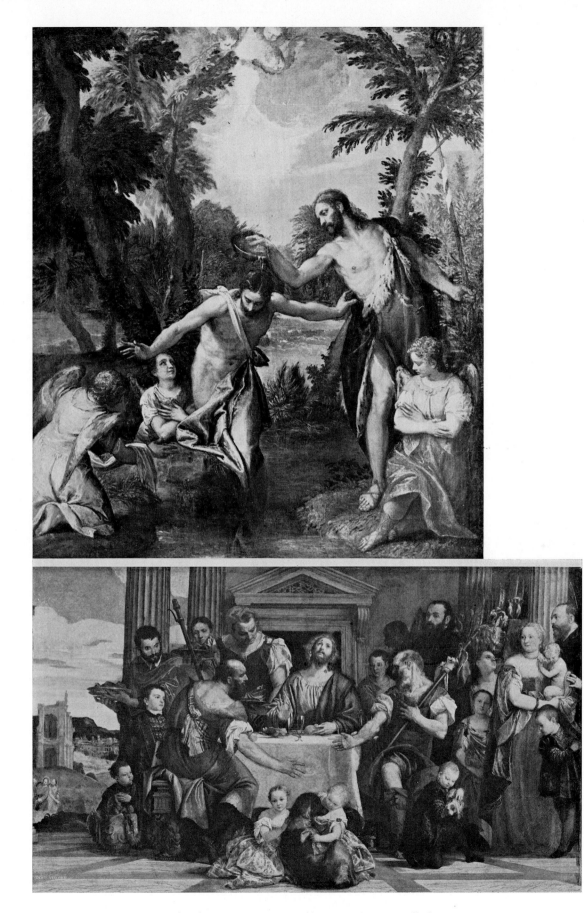

(top) PAOLO VERONESE (PAOLA CALIARI called)
*The Baptism of Christ*
The Hallsborough Gallery, London

(bottom) PAOLA VERONESE
*Supper at Emmaus*
The Louvre, Paris

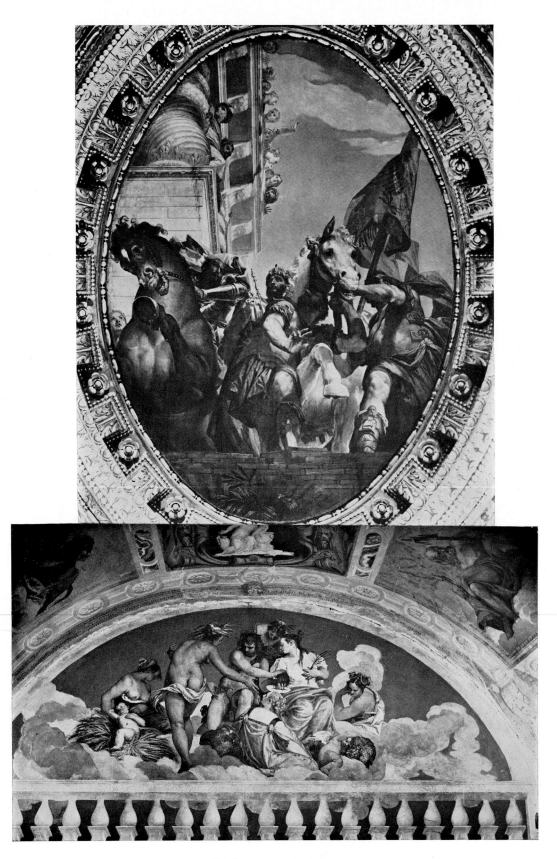

(top) PAOLA VERONESE
*The triumph of Mordecai*
Church of S. Sebastiano, Venice

(bottom) PAOLA VERONESE
*Allegory (fresco)*
Villa Barbaro-Volpi, Maser

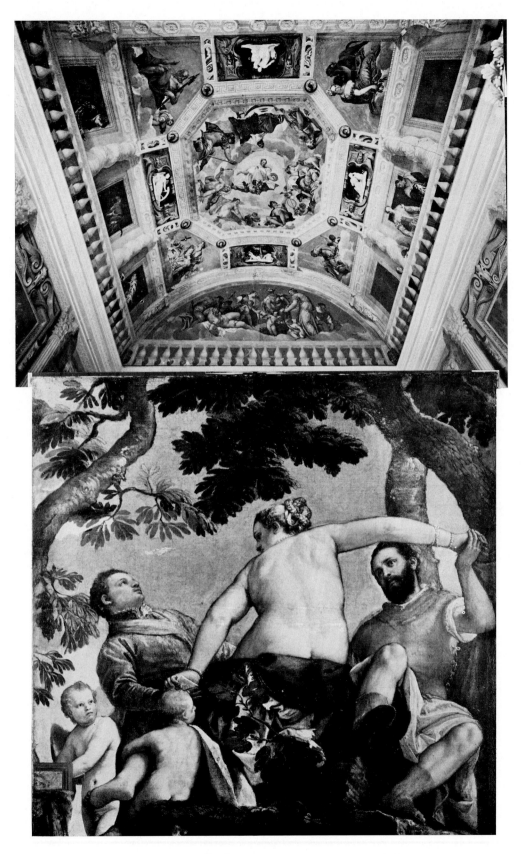

(top) PAOLA VERONESE
*Summer and Autumn (fresco)*
Villa Barbaro-Volpi, Maser

(bottom) PAOLA VERONESE
*Unfaithfulness*
National Gallery, London

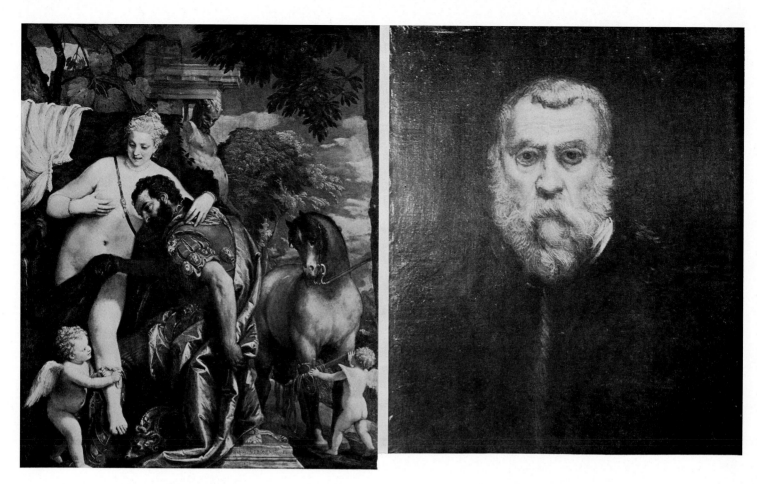

PAOLA VERONESE
*Mars and Venus united by Love*
Metropolitan Museum of Art, New York (Kennedy Fund, 1910)

TINTORETTO (JACOPA ROBUSTI called)
*Self portrait*
The Louvre, Paris

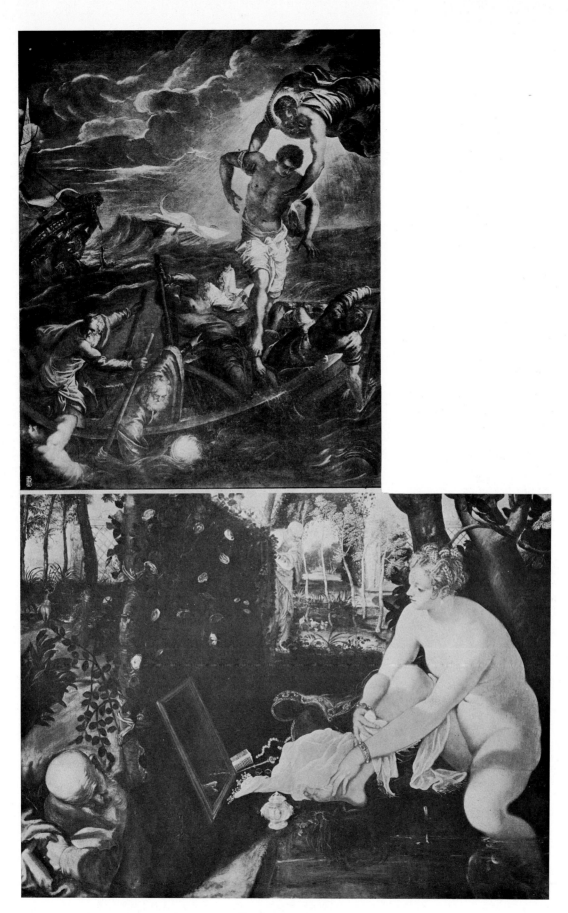

(top) TINTORETTO
*S. Mark rescues a man from a Shipwreck*
Accademia Gallery, Venice

(bottom) TINTORETTO
*Susanna and the Elders*
Kunsthistorisches Museum, Vienna

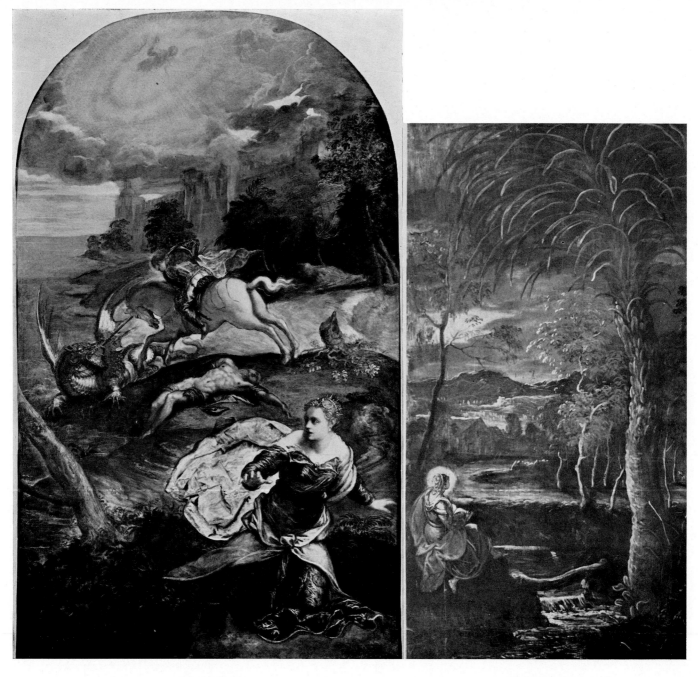

TINTORETTO
*S. George and the Dragon*
National Gallery, London

TINTORETTO
*Mary of Egypt*
School of S. Rocco

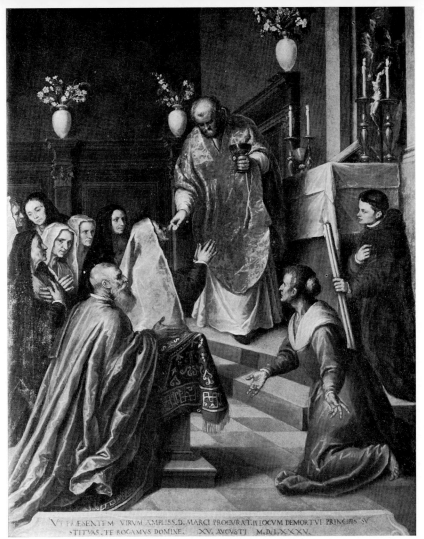

GIOVANE PALMA
*The Mass of the Doge Cicogna*
Oratorio dei Crociferi, Venice

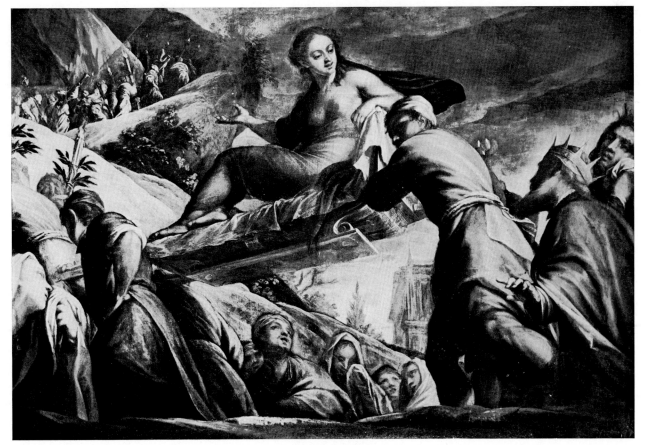

SANTE PERANDA
*Pysche carried away*
Ducal Palace, Mantua

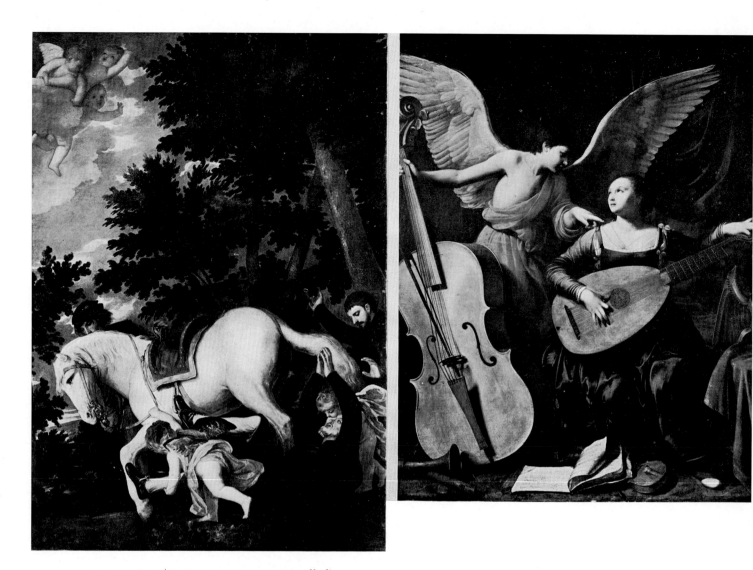

PADOVANINO (ALESSANDRO VAROTARI called)
*St. Nicholas falls from his horse*
Church of S. Nicolo, Tolentini, Venice

CARLO SARACENI
*S. Cecilia and the Angel*
Gallery Barberini, Rome

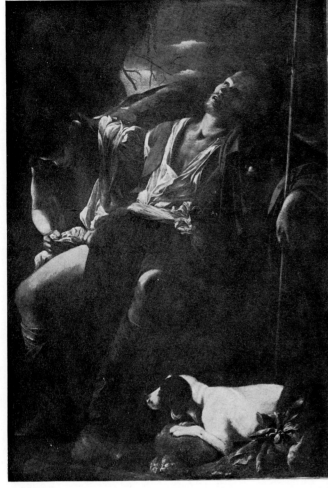

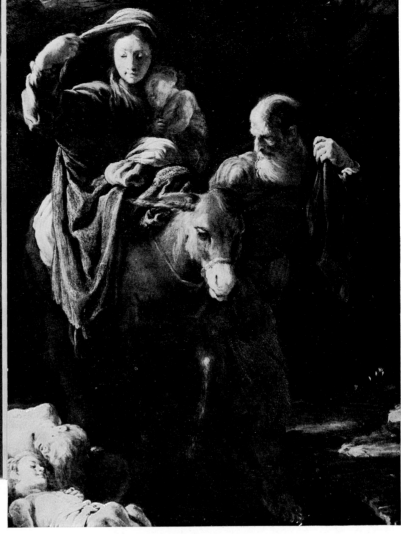

CARLO SARACENI
*S. Roch and the Angel*
Gallery Doria, Rome

DOMENICO FETTI
*The flight into Egypt*
Kunsthistorisches Museum, Vienna

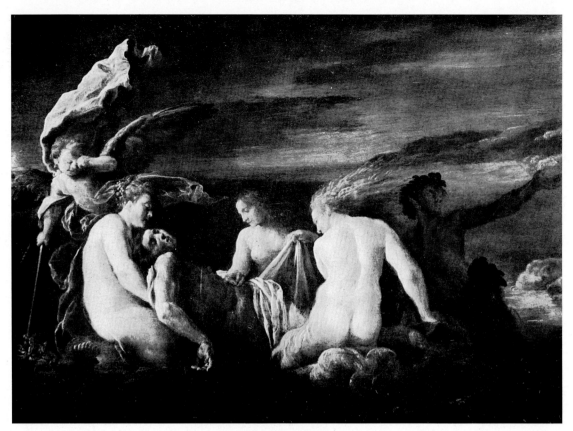

DOMENICO FETTI
*The death of Leander*
Kunsthistorisches Museum, Vienna

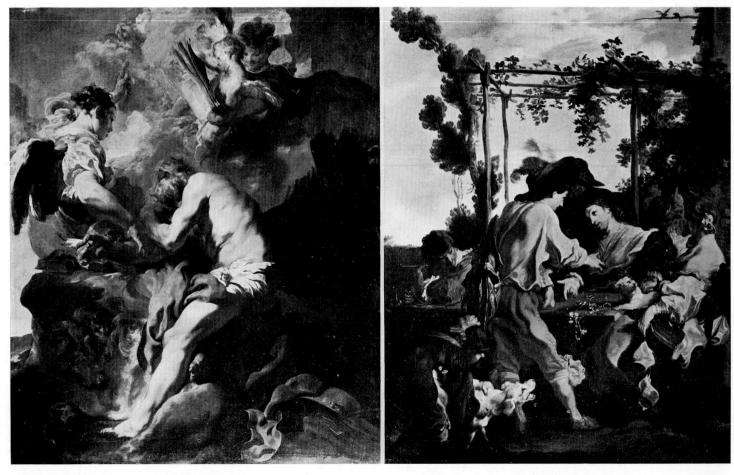

JAN LISS
*St. Jerome and the Angel*
Church of S. Nicolo, Tolentini, Venice

JAN LISS
*Game of "morra"*
State Art Gallery, Kassel

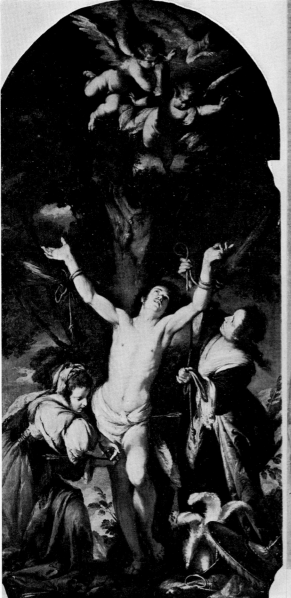

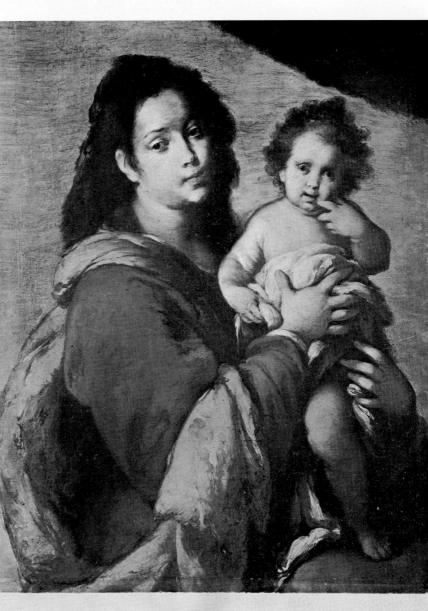

BERNARDO STROZZI
*S. Sebastian*
Church of S. Benedetto, Venice

BERNADO STROZZI
*Madonna and Child*
Querini Stampalia Gallery, Venice

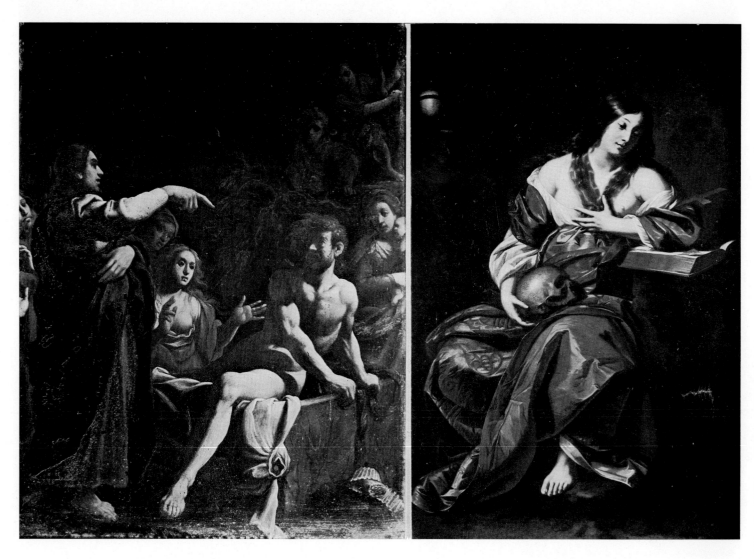

PASQUALE OTTINO
*The raising of Lazarus*
Borghese Gallery, Rome

NICOLÒ RENIERI
*S. Mary Magdalen*
City Museum and Art Gallery, Birmingham